KNOWING AUDIENCES: JUDGE DREDD

KNOWING AUDIENCES: JUDGE DREDD, ITS FRIENDS, FANS AND FOES

MARTIN BARKER & KATE BROOKS

UNIVERSITY
OF LUTON

press

2626091

British Library Cataloguing in Publication Data
A catalogue record for this book is available from the British Library

ISBN: 1 86020 549 6

791.43019 BAR

Published by
University of Luton Press
University of Luton
75 Castle Street
Luton
Bedfordshire LU1 3AJ
United Kingdom
Tel: +44 (0)1582 743297
Fax: +44 (0)1582 743298
e-mail: ulp@luton.ac.uk

Typeset in Times, Helvetica and Judgement Medium Italic
Printed in Great Britain by Whitstable Litho Ltd, Whitstable, Kent, UK

CONTENTS

ACKNOWLEDGEMENTS

A research project of this complexity owes many debts, and we want to record appropriate thanks to a large number of people. If we have missed anyone important, we extend our apologies and thanks anyway. However, thanks to, first and importantly, the Economic and Social Research Council whose project grant (R000221446) enabled this research to happen. Social science research is frequently embattled because of its political resonances, and ours was no exception. Our thanks to the helpfulness and courtesy of ESRC staff who helped us walk the minefields of problematic publicity.

Thanks then to: the management of the Odeon and Orpheus Cinemas in Bristol, who trusted us with access to their Judge Dredd audiences, and the manager of Video Solent who allowed us to use her premises to try to reach potential interviewees.

To many friends at Fleetway Comics who over many years and with quizzical forbearance have given many kinds of help to Martin Barker as he pursued his doggedly odd research interests.

To colleagues at Southampton Institute of Higher Education, Queen Mary's College (Edinburgh), Derby University, the Institute of Education (London), and the Watershed Media Centre (Bristol) for allowing us to test and dry-run parts of our research and its difficulties out on you.

Quite seriously, to the 136 people who allowed us to interview you, who trusted us to take your views seriously - we hope we have dealt fairly with them, and we hope at least some of you will get to read this and tell us.

To Philip Dodd, then at *Sight & Sound*, for enabling us to see the film at the earliest opportunity.

To Michael Baxandall, for friendly responses to questions about his work on responses to medieval paintings – and to Martin Lister, for drawing our attention to this extraordinary work; Jay Blumler, for giving generously of his time and scones when we came calling with our difficult questions.

To all our colleagues and students at the University of the West of England who stomached with only occasional protests the endless examples and preliminary statements of our research.

We wish to include a new category, the academic equivalent of Esther Rantzen's 'JobsWorth' awards, for those who made life difficult for us, even though it would have cost them very little to help:

The management structure of Showcase Cinemas, who 'referred upwards' our request for help until someone could be found to say no.

Guild Entertainment, who never quite got round to notifying local cinemas, as they promised – though the bottled water and the *Judge Dredd* badge were nice, thanks.

The more than a thousand people who looked the other way and passed us by as they left the cinema, ignoring our request for a little of their time – though in the end from your refusals something important emerged.

We want to give the usual heart-felt thanks to friends and family, for all the usual – but still best – reasons. Martin Barker wants to thank his wife Judith who has tolerated this obsessive interest in a not-very-good film with great good humour, even agreeing to watch it!; and his brother Colin, who has always found time to take ideas seriously, even at early stages, and generously responded with goodly-critical thoughts. Kate Brooks would like to thank Michael and Judy Brooks for their love, support and relevant newspaper cuttings; Rhona Jackson, for being such a good friend and inspiring colleague; and Deborah Finn, Spencer Jordan and Mark Neath, who have all been a much appreciated source of entertainment, wine and sympathy during the course of this project, and many other times besides. Both of us want to say thanks to Roger Sabin, good friend and colleague, who has put us up and put up with us on our frequent visits to London – and who has stared down the barrel of this research too often not to get a mention!

Last but unquestionably most of all, Martin Barker sets down his thanks and appreciation to his co-researcher and co-author Kate Brooks, who took a risk on her career to take the post of Research Assistant on the project: for your thorough and dedicated work on it; for your tolerant, amused attitude to a demanding supervisor; for your unstinted intelligence at a desperately low rate of pay; and a hope that your life-plans will recover, and maybe even benefit a little, from your work on the project. Though you didn't want this acknowledgement, you get it. Tough. And thanks again.

1

WHY STUDY JUDGE DREDD?

This book is the story of some research which didn't go as planned. Which began as, simply, an attempt to study the audiences of a popular action film, *Judge Dredd* (Cinergi 1995), and the ways in which different audiences responded to it. Which took us over because it (a) went so well but (b) did so by confronting us with a series of large problems: problems that were empirical, methodological or theoretical and sometimes all three at the same moment. Facing these problems forced us to widen our brief, and to challenge a whole series of assumptions which are very common in thinking about and research on media audiences. Because of all these, this book is about the audiences of *Judge Dredd*, and about *Judge Dredd* itself (and himself); it is also about films and cinema-going. It's about people talking about films and cinema-going, about how they talk about these, and about how we as researchers can best understand how they talk about them. It's about the assumptions that commonly get made about cinema audiences, the 'harm done by violence', for instance – and it's about the harm done by the public presence of those very views. It's about a hundred other topics to which we found ourselves pushed and pulled by a strangeness that overtook our research.

In short, the research and consequently the book got big, and that set us a problem. Toward the end of this chapter, we explain what we have done to try to manage that problem. But we begin here, as we began then, with why we did the research in the first place.

At last ... *Judge Dredd:* the movie!

In July 1995, the film version of *Judge Dredd* finally hit the cinemas. 'Finally' is an apt word, since for many readers of the comic *2000AD*, where the character Dredd originated, it had been a long wait – up to 18 years. Long-circulating rumours about the film version were finally substantiated some 20 months earlier by Fleetway Comics, the publishers of *2000AD*, and the speculations about who might star ended: it would be Sly Stallone. A readers' collective groan was heard in many places. A deep wish resurfaced in the comics, which viewed the coming film with a mixture of excitement, concern and (oh dear, this is the only time we'll do this) 'dredd', that Clint Eastwood could be rejuvenated – for there was the real *Judge Dredd*, the 'Dirty Harry' of the next millennium.

Martin Barker knew about these hopes, fears and expectations because he had been researching in the field of comics for some 13 years. More in hope than expectation, Barker prepared an application to the Economic & Social Research

Council. In September 1994, he heard that his application had succeeded. The proposal accepted by the ESRC was for an 18-month study of the audiences of the film version of *Judge Dredd*, paying particular attention to the ways in which different groups might 'negotiate the meanings of the film' – a phrase which returned to haunt us.

Why study a film like *Judge Dredd*? There is a problem in that many people seemed to know what our research must be about, well before we began it or even before – or in the face of – our trying to explain it. The problem is that there is a strongly-founded public agenda about what researching around films must be all about. And it is remarkably narrow, and fixated.

We can see how narrow the range of questions is, first, from the ways Dredd, and our research, were received in the months around its release. In brief, the responses can be summed with virtually no distortion along the following dimensions: The film is/looks as though it's going to be pretty trashy. It's a 'typical Hollywood blockbuster' and very derivative with it, so the idea of saying anything good about it is silly. A good example of this attitude was Derek Malcolm's discussion of blockbusters in general: 'Never had the major companies spent so much to achieve so little. You couldn't really call this summer's blockbusters – *Mission Impossible*, *Twister*, and *Independence Day* – hardly memorable, but they made vast profits for the companies that produce them. In their favour – and we should never forget this – the blockbusters have kept the cinemas open. Not so long ago, many people were predicting the death of the cinema as we know it. It's just that the absence of much else worth seeing is hugely depressing'.[1] It's throwaway culture at best, and therefore might manage to be slightly entertaining. But definitely, our main response can only be one of superior regret that it isn't worth anything better – in itself, it is not to be taken seriously. So, what on earth might be taken seriously about it? Why might a public funding body fund research on something so ill-deserving of attention? There can only be two possible reasons: either it is an assessment of potential harm; or it is a case of stupid academics making work where others find waste.

Consider some of the headlines that greeted our research: 'Stallone study on violence' (*Sunday Express*, 25 June 1995), 'Stallone violence probe' (*Mail on Sunday*, 1 January 1995). These were accompanied by repeated assertions that we were 'studying the effects' of the film: 'A major research project into the effects of violence in films will centre on a movie starring Sylvester Stallone as trigger-happy policeman *Judge Dredd* ... Dr Barker, 48, plans to test the theory that film violence leads to copycat violence' (*Mail on Sunday*). If it wasn't that, then it had to be a complete waste of time and money. Some of these were tasty enough to be worth quoting at length. Nigella Lawson inveighed against us in her *Times* column (4 July 1995): 'Is this trivia really worth studying?' After a general assault on any who think that 'popular culture' is made worthwhile by being written about, she turned on us:

> This has been taken to ridiculous extremes by the University of the West of England (in other words, a poly with pretensions) which has just allocated a grant of £30,000 to one of its lecturers to find out why people seem so keen to go and see Sylvester Stallone's new film, *Judge Dredd*.

'We want to find out what people see in the film', says one Dr Barker, head of cultural studies. This is not the purpose of education. It's not just the idiocy of the project that rankles, it's the unimaginativeness. And what a waste of money when resources for education are low.[2]

Let *The Times* not be alone in this dismissal. *The Sun* had just the same view: 'DREDD-FUL WASTE', wrote 'The Watchdog' Leo McKinstry, writing generally on 'yet another scandal' within the education system, about Universities apparently accepting students without A-levels. We were part of this problem, too:

What worries me most are some of the courses they are teaching. And I'm not just talking about trendy media studies where lecturers and students are given grants to watch ('analyse' in their jargon) their favourite films and soaps ('contemporary cultural drama interfaces'). Last month, for instance, the Head of Cultural Studies at Bristol's West of England University won £30,000 from the Government to study the effects of Sylvester Stallone's movie *Judge Dredd*. The full cost to the public of each student place each year is about £7,500 in grants and fees. The Government will spend more than £3 billion on grants in higher education this year. Yet large sums are squandered on a bizarre cocktail of irrelevant, jargon-ridden, PC nonsense, dressed up as academic teaching. (1 August 1995)

THE WATCHDOG
LEO McKINSTRY
DREDD-FUL WASTE

FILM STUDIES ... Judge Dredd

YET another scandal has arisen in our education system, this time over claims that universities, desperate to fill places, are accepting students without any A-levels.

But what worries me most are some of the courses they're teaching.

And I'm not just talking about trendy media studies where lecturers and students are given grants to watch ("analyse" in their jargon) their favourite films and soaps ("contemporary cultural drama interfaces").

Last month, for instance, the Head of Cultural Studies at Bristol's West Of England University won £30,000 from the Government to study the effects of Sylvester Stallone's movie Judge Dredd.

The full cost to the public of each student place each year is about £7,500 in grants and fees. The Government will spend more than £3billion on grants in higher education this year.

Yet large sums are squandered on a bizarre cocktail of irrelevant, jargon-ridden, PC nonsense, dressed up as academic teaching.

Which do you prefer – Blur or Oasis? You don't know? Well, you can spend a few taxpayer-funded years finding out on the BA in Popular Music studies course at Bretton Hall college.

If that sounds too tough you could try for a diploma in Play Therapy at the Roehampton Institute. And here's one for the real couch potatoes: Leisure And Food Studies at Sheffield Hallam University.

Far more disturbing than these absurdities are the exercises in PC brainwashing, like the three-year BA in Peace Studies at Bradford, or Race And Ethnic Studies at Central Lancashire University.

Knowledge

There are at least 32 courses covering Gender And Women's Studies including the BA at East London University, which deals with Women And The Visual Media and Lesbian And Gay Cultures.

Just as bad are the post-graduate studies, like the MSc in Race Relations And Community Studies at Bradford, or the MA in Women's Studies at Kent, which examines "contemporary issues of black women."

Universities should be about gaining knowledge, not swallowing propaganda. Is it surprising that one in six of our graduates is now out of work?

What employer would be impressed by these PC qualifications, except our old friends, the left-wingers in local government?

Ssh! Left bans office gossip

COUNCILLORS in Labour-controlled Greenwich have taken political correctness to new depths of lunacy.

They have decided to outlaw office gossip.

According to the council's new "Guidelines On Harassment On Grounds Of Sexual Identity," gossip about colleagues can be a form of verbal intimidation. It has therefore become a disciplin-ary offence. The document was drawn up by Stephen Norton, who is both an official in the Greenwich Leisure Services Department and the council's Sexuality Issues Adviser (now there's a ridiculous local government position if ever there was one).

So far reaching is this farcical new code that Greenwich employees can break it without even knowing. They are warned that harassment can sometimes be "unconscious." Under the new rules, it is wrong to assume that "the person you are dealing with has the same sexual identity as yourself."

Just as offensive is "avoiding physical contact with individuals, albeit unknowingly."

You can't win nowadays. If you touch a colleague you might be charged with sexual harassment.

But now, according to Greenwich, it's a crime if you don't.

Only a gay rights extremist could invent an offence called "unconscious sexual harassment."

Such attempts at mind control would be ludicrous if they weren't so sinister.

The Sun, *1 August 1995*

3

There you go, that's us all over. This was our favourite!

This latter strand of course resonated strongly with an extraordinary assault mounted over several years into 'media studies'. The viciousness of this assault is a phenomenon deserving closer examination; it expressed itself in radio debates, in much pundit-speak, and in headlines such as the following: 'The Trendy Travesty' (Lucy Hodges, full page in *The Independent*, 31 October 1996,[3] 'Way Off Course' (half-page in *The Guardian*, 11 August 1997 – 'Media studies degrees have soared in popularity but, asks John Crace, do they give an entry to the business?'), and (another gem) 'Dons despair as students spurn science in favour of "media studies"'.[4]

Our reason for dwelling on these responses and their context is not just to reveal our sore places, or to dismiss these attacks as ignorant, stupid and contemptible (though they are all that). Rather, we want to emphasise two aspects:

1 While the media are an ever-present and all-penetrating aspect of almost everyone's lives in a country like Britain, the agenda of questions which it is seen as appropriate to ask is wickedly narrow – a matter of crude swings between seeing the media as 'harmless entertainment' (worthy of opinions and no research) and 'entertaining harm' (worthy of research that will substantiate opinions). This narrow agenda isn't limited to populist journalism. It is widely present within academia itself. Witness the number of occasions on which other academics, even others in our own field, assumed that we must be doing a study about 'effects'.

2 These discourses about what is 'proper to ask about the media' are themselves very powerful. They invade many parts of our public culture. They surrounded and constrained our research in a host of ways. And, we will show in this study, they even penetrated people's sense of how they dared to respond to the film itself. Our being shouted at by *The Times* and *The Sun* is of a piece with many individual film-goers feeling embarrassed, or constrained, or even subject to disciplinary forces, over what they are entitled to enjoy, and how.

Let us here cite just one piece of curious evidence on how this works. *2000AD* itself carried a letter from a fan who had heard about us. He wrote:

> Dear Green Butt,
>
> I recently read in my daily rag that a University doctor has been given £30,000 to interview people before and after the *Judge Dredd* film to find out if the movie will lead to violent and aggressive behaviour. Well let me tell you something, boy. I have been reading *2000AD* and *Judge Dredd* since you joined forces with *Tornado* (a blast from the past) and it's never done me any harm, so why don't they give me the money for my plastic sten gun?
>
> Earthlet Scott Penman, Fife, Scotland[5]

Written in the letters-style of the comic, this response is still revealing. He certainly isn't going to go along with what he thinks our assumptions are – though it is clear from his letter that he thinks we have in some sense already 'made up

our minds'. But he does feel he has to distance himself from those assumptions – they are a small but unignorable pressure he must navigate round.[6]

The sad and worrying thing is how far that same narrow agenda has penetrated academic study. Not just in the remarkable resilience of the daft 'effects' research tradition, but even among those who seem to perceive things more widely. Consider two cases where apparently thoughtful work ends up in the same place as the naffest unthinking journalism.

Doing Good to the Children: a Moral Critique of the Media

Francis Hutchinson's *Educating Beyond Violent Futures* provides a good illustration of one way in which the media get addressed within academia.[7] What drives Hutchinson's book is a moral impulse and moral agenda. Not bad things in themselves, these become problems inasmuch as they predetermine what he can find in his examination of the media, and intrude assumptions which are untested, but pass muster because they have an air of 'reasonableness'. That reasonableness is in part because he seems on the 'side of the good' and in part also because in the end he also is speaking the common language of 'effects' and 'harm'.

Hutchinson's book is an appeal for the teaching 'cultures of peace' and holistic values, for concern for others and for the environment of the world. Against these goals, then, education and the mass media are measured, and found wanting. In the course of discussing the mass media, he lands four-square on both the comic book and the film version of *Dredd*. Read closely how he constructs his mention of the film:

> The *Teenage Mutant Ninja Turtles* marketing blitz has been followed by several others. One of these accompanied the release in Australia on commercial television of *The Toxic Crusaders*. This hit American cartoon animation series takes as its main storyline the adventures of an 'environmentally informed and hideously deformed' band who fight 'the evil pollutant mutant' Dr Killemoff. It is not hard to discern how children's insecurities and fears about an environmentally degraded future might be exploited for commercial ends. Feelings of helplessness and needs-deprivation are played on, in a variation of Nietzschean themes, when 'hideously deformed creatures of superhuman size and strength' come to the rescue and engage in combat to resist Dr Killemoff's efforts to pollute the local environment. As with other similar toy lines, such as the integrated marketing artefacts associated with the films *Jurassic Park* (1993) and *Judge Dredd* (1995) or the *Mighty Morphin Power Rangers* (1995) television series, manufacturers and merchandisers commonly rationalise restricted offerings for imaginative play as simply 'meeting market demand'.[8]

Making this an exemplar of arguments of this kind, let us enumerate just some of the unargued assumptions and suppressed premises in this argument:

1 Children are prone to 'insecurities and fears', 'feelings of helplessness and needs-deprivation' not only in general but of a kind that can be manipulated by

an animated cartoon. (This second part is important, since there could well be such insecurities etc which are not open to manipulation in this way.)

2 *Jurassic Park, Judge Dredd, Mighty Morphin Power Rangers* and *Turtles* along with *Toxic Crusaders* – all by many measures wildly different from each other, and (we would guess) perceived to be so by most audiences – in fact constitute a 'restricted offering', because they do not include what Hutchinson wishes was on offer.

3 One of the most striking – because it does not immediately strike – components of this argument is the expression 'It is not hard to discern'. Actually, it is very hard, because a series of linkages are presumed which Hutchinson, like so many media-commentators, either does not bother, or does not know how, to enumerate.

Being an academic, Hutchinson is somewhat more explicit about the premises of his argument than many. But they turn out to be virtually the same as when unstated. So, his account of media-influence is relentlessly cumulative: 'A steady diet of gendered toys, gendered games and other gendered forms of media such as television violence, in which male role-models handle conflict situations aggressively and often with hi-tech fire-power, is likely to have a cumulatively disabling effect on whether a boy grows up with pro-social skills such as conflict-resolution literacy'.[9] Note just the word 'diet': a very common metaphor for our ways of attending to a real mixed mode of leisure-forms, with the implication of these things somehow entering and becoming part of us – and with no need of evidence that such things happen.

But perhaps Hutchinson's most interesting claim arises from his worry about the failure of dreams of hope about the future, a kind of 'utopian' thinking which he believes is disabling us. From that premise, he argues of the comic *2000AD* that it has a 'strong tendency to foreclosure of the future' (p.58), that (as exemplified in 'Rogue Trooper', one of its long-running stories) it reduces to a 'world-view [which] is narrowly masculinist and mechanistic. It is a compassionless world in which humanity survives in a neo-social Darwinist landscape as a fighting machine' (p.57).[10] The same judgement is enacted on the film version:

> A deep sense of essence-pessimism about the human capacity to shape the future in peaceful, compassionate and sustainable ways permeates many recent works ... such as *Demon Seed* (1977), *Alien* (1979), *Blade Runner* (1984), *The Terminator* (1984), *Robocop: the Future of Law Enforcement* (1987), *Terminator 2: Judgement Day* (1993), *Species* (1995) and *Judge Dredd* (1995).[11]

What would Hutchinson say in response to any of the following challenges to these claims: that many audiences would draw sharp distinctions within his list – for instance, vastly preferring *Terminator 2* to the first, and seeing *Demon Seed* as belonging to another kind of film altogether; that many have seen *Alien* as remarkably different because of its central female character; that it is hard to understand how *Terminator* can be called 'pessimistic' when it ends – and drives towards an end – with hope for control of the future resurrected?[12] We're not saying

he could have no further responses – it is the very fact that, as ever, none are deemed necessary because it seems 'obvious' that concerns us here. But in tackling his argument, our main concern is over one link which doesn't ever get stated at all. It is this: pessimistic films = pessimistic audiences. Just as, violent media = violent audiences. And so on. Once again, the key to the argument is a lurking premise about how audiences relate to their media. We will show in a moment that this present research arose out of some preliminary results which simply stood that premise on its head.

The Culture-Critics Take their Toll

Apparently quite different are the comments on the film of two film theorists, both well in tune with contemporary ways of theorising contemporary cultural phenomena. In their *Postmodern After-images*, Peter and Will Brooker develop sophisticated arguments about the complex and interwoven nature of meaning-making in contemporary society. But the same core assumption as Hutchinson's can be found in the Brookers' discussions of *Dredd*. At its heart is a comparison of *Dredd* with *Star Wars* – which they infinitely prefer, because the latter 'is built around a trajectory towards liberation, emancipation and the overthrow of a tyrannical state'.[13]

Dredd, for the Brookers, is to be understood within a postmodern framework which sees contemporary culture created around a tissue of intertextual references:

> As Jim Collins suggests, the entertainment of a film such as *Back To The Future III* lies in its layering of cinematic references and in-jokes, amounting to an 'emergent type of genericity' in which 'different sets of generic conventions ... intermingle constituting a profoundly intertextual diegesis'. In their 'quotations' from films of barely a decade ago, *Judge Dredd*, *Tank Girl* and *Strange Days* are further conspicuous examples of an even more recent 'meta'-postmodernism along these lines.[14]

What are they saying, and why might it matter? Again, we need to unpack premises and assumptions. Their first assumption – and not as innocent a one as might seem at first – is that people go to see these films for something called 'entertainment'. Actually, we will see that this is a highly qualified truth, only relevant to some viewers. But also, they assume that the entertainment consists in spotting references, or not at all. Will Brooker's more extended discussion of *Judge Dredd* cites *Star Wars*, *Demolition Man*, *Robocop*, *Terminator* and *Blade Runner* as among the main sources from which, supposedly, it constructs a 'Baudrillardan aesthetic of pure surfaces' (p.104). He is certainly right that some audiences, including the two of us, did spot those references (though people we spoke to saw this just as a sign that the film was not very well made – the references were too close, the uses too unoriginal.[15] But what would he say if, for some audiences at least, the comparisons are not with other films at all – these might be noticed, but set aside as just not relevant – but with the comic book as ur-source, an ideal template to which the film ought to live up? Or what if the comparisons and 'intertextual connections' made are for others with all Stallone's

earlier films – not seen, though, as a series of ironic cross-references but as the construction of a coherent career? What, finally, if for many viewers those 'surfaces' which Brooker remarks as evidence of a certain cultural weakness or failure in the film are just the point – because 'action movies' are to be enjoyed for their loudness, their paciness, their visual explosiveness? (These, we will show, are part of real patterns of response we discovered.)

We are not just scoring points. If the Brookers were writing just their personal responses to these films, that would be interesting. But they aren't – they are simultaneously ascribing cultural significance to the films, presenting their own 'readings' as more than personal, and on the back of these, imputing consequences to a vast 'other': the mass of people who went to see these films.

Brooker's ultimate judgement on *Dredd* curiously parallels Hutchinson's, albeit the points of contrast are different. Where Hutchinson wants utopian dreams and holistic embracing of the world, Brooker seeks optimistic narratives. *Star Wars* offered, he claims, a triumph of faith and innocence over cynicism and despair: 'To claim the same for *Judge Dredd* would be inconceivable'.[16] Instead, he sees it as offering 'bleak narratives of joyriders, shoplifters, ravers and dealers', as opposed to the small paean to hope which is supposedly why '*Star Wars* has retained, or regained, such poignancy'.

Once again, those assumptions, albeit now posed in terms of 'representations': media messages = media effects. If *Judge Dredd* is bleak, then its audiences are either already bleak, or being inducted into bleakness. This is a relationship only ever claimed for certain kinds of popular culture: great tragedies can be said to uplift, in and through the deaths of their errant heroes; comedies can be bitter-sweet, and raise questions through the laughter. But not comics, not action films. As we show in a moment, this is not necessarily the case.

To illustrate our point about the exceeding narrowness of public debates about films and their audiences, we offer this list of significant questions which *could* be asked about our film. In each case, we could with ease show what the pay-off from the research could be, and to whom it could be useful. In fact, in many cases, research of these kinds already exists and has been used:

1 What qualities in a cinema are seen by audiences to best 'suit' films such as Dredd? How likely are these to affect actual decisions to attend a screening?

2 What is the relationship between the film and comic book (in terms of story-lines, characters, cultural status, etc)? What is the evidence of the effects of film adaptations on comic book sales?

3 How does *Judge Dredd* relate to people's images of law and order? What role do fantasies about crime and its control play in the lives of delinquents, and non-delinquents?

4 What part in Sylvester Stallone's career has *Judge Dredd* been perceived to play? For how many was it perceived as continuous, a new development or a disruption?

5 What role do images of the future play among different age-groups, and how do science fiction images (such as *Dredd*) contribute?

6 Who made key decisions in planning and producing the film? On what bases of information were these decisions made?

7 How do people process information to gain understanding from films, compared with other media?

8 How does 'hype' affect film-going? What kinds of talk get generated by films, and how do these work to turn some films into box office hits?

9 What combinations of stars generate particular expectations and hopes in audiences, and how far do these translate into improved cinema attendances?

10 What legal devices (copyright and trademark, for instance) surrounded the film version of Dredd? What effects did these have on the nature of the film and its spin-offs?

11 How did the British and US publicity regimes for the film differ? What measures are there of the effectiveness of each?

We hope readers will take this opportunity to work out for yourselves how and for whom each of these could be important – and to see that in every case, directly or indirectly, there are implications for our understanding of *Dredd*'s audience. None of these is in fact what we set out to do, although our findings in fact have clear relevance to almost all of them.

The current state of research and understanding

There has been a pretty explosive growth in studies of media audiences in the last 20 years. Quite how large, is hard to tell exactly. There are many kinds of writing about audiences, including at least the following:

(a) statistical studies of audience numbers, and of their distribution – a good example would be *The Last Picture Show?*, an important evaluation of why cinema audiences declined drastically in Britain between 1949 and 1984, which we discuss in chapter 6;

(b) studies of the audience for a particular kind of media product – Janice Radway's in-depth investigation of the audiences for romance novels is a fine example;[17]

(c) studies of audience activities in fan groups and subcultures – to our mind, one of the best of these to date is Camille Bacon-Smith's startling book on women in *Star Trek* fandom;[18]

(d) illustrative case-studies of individuals and their use of particular media – Valerie Walkerdine's study of one man's pleasures in violent films is a good, thought-provoking case;[19]

(e) the blurring of boundaries between some programmes and their audiences, and the connections with the development of 'confessional' television which blurs public and private – Livingstone and Lunt's recent writings are examples of this kind of work;[20]

(f) studies of the circumstances in which watching, listening or reading takes place – Ann Gray's account of the domestic organisation of video use would fall mainly into this kind;[21]

(g) studies of the history of audience responses – the recent work on the reception of *John Doe*,[22] on crying in the cinema,[23] and on the careful management of the release of *Psycho* [24] are significant examples;

(h) studies of the public face of films, reviews and other critical responses which may help to set the terms of public response – this is a source which Janet Staiger has recently mined to great effect;[25]

(i) studies of the management of audiences by the media – Ien Ang's study of the involvement of official research bureaux in trying to control difficult audiences is a classic of this kind;[26]

(j) the media industries themselves conduct a vast amount of research of many kinds, only a tiny proportion of which ever makes it into the public domain;

(k) alongside these, are the virtually endless studies on the possible dangers of various media, some conducted by private bodies, others sponsored by various opinion-forming or public bodies – very few of which ever rise beyond the crudest forms of 'effects' questioning;[27]

(l) then there are the meta-studies of the evidence, the methodologies, the concepts, and the development of research traditions – unsurprisingly, academic journals have recently devoted a fair amount of space to this kind of writing.

Many of these have multiplied their output in recent years, giving a rosy appearance to the prospects for understanding audiences. Still, though, the largest amount of research being conducted, and passing itself off as 'audience research', is the policy-driven, psychologically-oriented 'effects' research. This easily gets the bulk of the funding, because there are so many parties with an interest in getting the 'right kinds of results'.[28] This research is primarily important because it so consistently gets noticed in the public sphere. As a result, as we've seen, it is very hard indeed to do any other kind of research that is not immediately measured against this public discourse and its associated 'folk theory' of the media.[29] It is now very common for anyone in the field of media studies to face being 'rubbished' for stepping outside the apparent consensus and arguing at odds or presenting divergent findings. In the opposite direction, the triumphalist response to the awful Newson Report – produced as it was by a group of people with absolutely no knowledge of or research-experience on the media in any shape or form – shows that the quality of a piece of writing is almost completely irrelevant to its reception.

This has consequences for people in our field, and has produced a number of responses. The first is to encourage compromise – toning down the radical consequences of research findings that might set off the alarm bells of the censorious campaigners.[30] This tendency may be accentuated by the fact that, paradoxically, some of the best recent research and re-examinations around the 'effects' debate has been funded by or published under the auspices of the leading statutory bodies associated with control and censorship. That is of course a major development in itself. It's not yet wholly clear what we should make of the British Board of Film Classification and the Broadcasting Standards Council questioning the premises of their own activities, and supporting research which does the

same.[31] Whatever the causes, the results have been mixed – good research with radical implications has been presented in ways that have softened and blunted it.

A second, sadder consequence has been the retreat of many academics in our fields into a kind of academic Vogon – speaking about media issues and conducting research in a language hardly accessible to each other, terrifyingly abstruse to hear, and therefore avoided like the plague by general audiences. This, along with an astonishing avoidance (bordering on cowardice) of the issues about the media which are 'hot' in the public domain, has been powerfully disabling.

Nevertheless there is a growing body of important new research. Certainly the biggest impulse to its growth has the rise and sedimentation into academia of the fields of communication, media, film and cultural studies; and shifts in border-disciplines such as sociology and literary studies have encouraged mutual borrowings. This has happened internationally, and the recent richer dialogue between rather different national traditions of these academic fields has helped to spur such research. Audience research is difficult and expensive to undertake. It is enormously time-consuming, and its setting up and conduct is complex and very demanding. We should not kid ourselves that one of the reasons for the persistence of the laboratory mode of investigation, with all its proven unreality, derives from this. Add in the wish to appear properly 'scientific' by being able to produce results in statistical format, and the drive to design and conduct simple tabulatable research is hard to resist. The kinds of in-depth, qualitative research which can take account of the complexities of interpretation and response which real audiences consistently reveal, when given the opportunity, are therefore much rarer. We have been extremely lucky to receive quite good funding to undertake our study; and we have only respect for those of our colleagues who have in small ways carried out careful, in-depth research with little or no financial backing. We know, from our own experience, that it will have been at considerable cost to their own lives.

Although there is nothing as clear as a consensus, there are a number of generally shared principles behind a good deal of recent research. This is our best attempt at summarising that consensus:

1 The very term 'audience' is misleading because it homogenises what is in fact very diverse, and because it assumes an almost reverential concentrated attention to their chosen media (when in fact most media use is casual, discontinuous, and often interrupted).

2 Audiences relate to the media in complex ways, but at the heart of the relationship between media and audiences are meanings: films, television, advertisements, music, the press organise and disseminate ideas, images and accounts of the world and of ourselves; audiences respond to these by making sense of those meanings, responding and incorporating those into their continuing personal and social lives.

3 Audiences are always social: that is to say, there are no audiences who do not respond to the meanings produced as part of living their lives in and through social conditions, social groups and social possibilities.

4 Children are not different in principle from other audiences, despite all the social fears that surround them; they are in fact often using the media as part of learning how to be members of their culture generally, and more particularly of their local groups.

5 Particular media forms are complex, and must be studied in their complexity: for where and how they came to be produced, for their form and their ways of involving their potential audiences, for the kinds (genres) they belong to, and how audiences learn the rules of these genres, and for their cultural status.

6 There are no intrinsic differences between different media which could lead us to suppose there is a hierarchy among them in terms of 'capacity to influence', or 'cultural worth', or complexity or depth of meaning. On the other hand, there are plenty of powerful discourses claiming that such a hierarchy exists, and these themselves need close examination to discover their effects, both on many aspects of public policy, and on individuals' freedom to enjoy and use their preferred media.

7 A good deal of the relations between media and audiences has to be thought in relation to issues of social power: the media belong to powerful interests in society, and often speak on their and associated groups' behalf. They control flows of information, they speak in ways that border on propaganda; more informally, they circulate images, stories and senses of who we are that correspond with the interests of the powerful.

This minimal account misses much out and ignores some rich on-going debates. But we believe that it marks down the differences between the approaches which have emerged from recent qualitative research, and the 'effects' tradition with its simplistic notions of 'effects' and 'harm', its de-socialised image of the audience, and its wilful refusal to listen to audience talk and understandings.

Once pass beyond this list of general characteristics, and this is where the real richness begins. Researchers have studied: how women enjoy and make sense of popular romances; patterns of responses to a news magazine programme on television; the shaping of audience recollections of the 1983-4 miners' strike; British Asian people's uses of television; television and Chinese opposition; women's (and men's) responses to their magazines;[32] children's responses to violence and horror; the meanings of a violent comic to its fans; audience pleasures in the new violent movies of the 1980s; why people cry in the cinema; how children learn about fantasy through cartoons. These are just for openers in an endlessly unfurling list.

The problem of evidence and theory

But here, we hit a problem. While there have been these and many more studies which have given us rich new materials and insights, there is an abiding problem of theorising their results. That raises many questions about what counts as appropriate theory. What traditions of ideas are available, on which we are invited to draw? This isn't difficult to determine. Turn to any of a large number of recent books about audiences, and read the opening chapter, and – with but a few

exceptions – the same 'story' will be told. Once upon a time there was the 'effects' tradition. Then came a brave sociological alternative, the uses and gratifications tradition. But that, though an important break, proved inadequate. Along came a real breakthrough: the encoding/decoding approach, which for the first time incorporated a proper consideration of the meanings embodied in media texts. We've had to amend that since, to take account of the impact of contexts and settings on audience responses, the role of interpretive communities, the possibility of resistant meanings and uses, and the role of unconscious (psychoanalytically-deduced) response-structures, and we're still arguing over the ways to balance these. But the model is now largely there.[33]

Our argument with this is not simply that the history is weak, as for instance James Curran has argued.[34] Rather, we are concerned that the current 'theory' is not a theory at all. And what can be learnt from the best of recent researches, is learnt at the points where their evidence outruns and ignores the supposed theoretical basis. It is also the case that such histories are remarkably selective, and one of the problems for our research is that it is set in a tradition which hardly gets mentioned, if at all, in those histories. For this reason, we don't apologise for giving space to rehearsing the background to this research in Barker's previous researches.

The background to our research

These researches began with a study of the 1950s campaign against 'horror comics', a campaign which succeeded in having these comics banned by Act of Parliament in 1955.[35] What Barker's research showed, however, was a strange confluence. Here was a campaign mounted and run largely by the British Communist Party – but nobody else knew, even thirty years on. This campaign shifted its rhetoric between 1952-4, from (politicised) talk of defending 'British culture' against 'American cultural imperialism', to (moralised) talk of protecting 'children' from 'horror'. Moreover it ended, sadly and paradoxically, attacking one of the few forces within American popular culture mounting a resistance to the anti-Communist hysteria of Senator Joseph McCarthy; for the comics dismissed as 'degrading' and 'horrible' turned out, on examination, to use fictional narratives to inveigh against these and other irrationalities and prejudices. The Communist Party had become so wrapped in their own rhetorics that they could not tell friends from enemies.

Although published ten years before the *Dredd* research, this study was formative in several respects. It focused attention on the ways in which narrative forms could be misread and misunderstood by moral campaigners. It explored in some detail the public impact of the moralising rhetorics of the campaigners – all done in the name of that instant reference point: 'children'; to be on the wrong side in a campaign to 'protect children' is to risk a lot. What that research couldn't do, was to explore what the ordinary readers of the horror comics made of them – for the main reason that they aren't too easy to find![36] The opportunity was not long coming.

Barker's fascination with the gaps between official rhetorics about dangerous media and their actual nature stayed with him, first in a study of the 'video nasties'

campaign,[37] then in a study of a campaign against a 1976 boys' comic, *Action*. [38] Part of the research involved reconstructing how and why the comic was conceived and published in the first place, the story of the campaign, and why the publishers eventually conceded defeat. It also involved a ransacking of the publishers' archives, to find all the stories which were altered or suppressed, so as to be able to examine the politics of acceptable stories.[39] But *Action* was close enough to hand to allow an attempt at retrospective audience research. Using a questionnaire with both quantitative and qualitative sections, Barker managed to gather the responses of 135 former readers of the comic. The results were plain unexpected and fascinating.

The key to these results was a distinction which respondents were asked to make between having been 'Casual', 'Regular' or 'Committed' readers of the comic. Analysis of the questionnaires showed some remarkable differences between casual and regular (Casregs, for short), on the one hand, and committed readers on the other. 'Casregs' consistently called the stories 'violent', 'gratuitous' and designed for 'people of low intelligence'; and many said they read it mainly because they knew their parents disapproved. Many 'Committeds' on the other hand talked of the comic as 'intelligent', saying 'it made me think' or 'the idea that the heroes were not always good guys and did not always win helped destroy the black and white image I had learned'.

Along with these discursive differences went other curious features: the committed readers were on the whole slightly younger than the casreg readers – but they thought that the comic was aimed at older readers than did the casregs. And while the casregs showed some interest in the personal qualities of the central characters, what seemed to provide the focus for the Committeds was their attitude to authority.

These results had to be tentative, of course, being based on a quite small sample, and with the problems of 10 years' retrospection. But equally, they couldn't be ignored. What they suggested was the exact opposite of much 'commonsense' thinking about media audiences. There is no question that Action was very important to many of its readers – it did influence them, no question – but not at all in the ways in which what we have come to call 'folk theories of the media' suppose. It is the Casual readers who worry about identification with characters; but the Committed readers relate to the ideas within the story, and debate with them. Or in other words, it appeared that the closer the connection, and the greater the 'influence', of the comic, the more readers were made to think and reflect and argue.

Barker followed up his *Action* research with a more ambitious study of the comic *2000AD*, which was designed as the successor to Action, and was released even as the controversy over that was reaching its climax. *2000AD*'s publication was a highly significant event in the history of British comics, and it established for itself a significant cult following. It was of course the comic which, from Prog.2 onwards, featured the character and world of '*Judge Dredd*'. Using a complex questionnaire incorporating a range of quantitative indicators, a Semantic Differential Test, and opportunities for open-ended responses, he gathered 250 responses which were analysed using a computer package. The results were markedly unclear (especially when compared with the sharpness of the results

from the *Action* research). Using such small clusters as did emerge, Barker therefore carried out in-depth interviews with a number of 15 respondents who typified certain emergent groupings of responses. The analysis of these provided some key clues as to the nature of people's uses of *2000AD* – and incidentally suggested an explanation for the much greater clarity of the *Action* responses.[40]

One particular emergent result, though, did directly shape this current research. Among the issues to emerge from the interviews with representative fans were two significant relationships. First, fans' relationship with *2000AD* seemed to turn in important ways on how they categorised their reading of the comic in relation to the rest of their lives. It was possible for a reader to say, without self-contradiction, that he collected every single publication, that he even had a shrine to the comic in his bedroom, but then to assert that the comic was not important to him. The explanation lay in its being categorised as 'entertainment', which would be irrelevant to his future life. But the second finding was even more striking: for those who did take the comic seriously, and allow it to cross into other parts of their thinking, a paradox emerged. The very pessimism and bleakness of the comic constituted it as a source for hope in the future. The explanation seemed to be that in the context of the lived experience of these readers, 'bleakness' represented a kind of realism which allowed them to 'keep their imagination alive'. The significance, of course, is that this finding is the exact inverse of the frequently-claimed relationship, that the contents of a mass medium tend to reproduce themselves, in the same form, in the heads of audiences, 'violence' breeding violence, 'horror' breeding horrificness, and so on.

One other aspect of Barker's earlier researches needs recounting: this was the proposal of a distinctive theory to account for the things he had found. In his *Comics*, he developed the idea of a 'contract' between media and their (committed) audiences.[41] The core of this was to formulate an alternative to the tradition which has viewed close audience involvement as a sign of passivity and vulnerability. Instead, Barker argued that the most critical audiences are likely to be those who know the genre, and have expectations based on a history of involvement. This idea was developed and tested through some small case-studies on comic audiences. One main idea was that it isn't enough to consider regular readers – we have to look for those who are a medium's natural readers – that is, those who have the social characteristics that lead to their entering wholeheartedly into the proffered contract. In an interesting essay, Gemma Moss has criticised this contract theory.[42] She argues that to search for a 'natural audience' can lead to arguments of convenience: 'all too easily it will lead to the dismissal of any data which don't fit the critic's existing assumptions about what the natural audience's relationship with the text in question should be'.[43] We accept that this is a danger, but our view is that it is simply one that cannot be avoided. For the alternative does not avoid analysts' assumptions, it merely offers others in the same way. Our solution to this dilemma is outlined in Chapter 6.

All these researches and arguments, and the attempt at an alternative theorisation, provided the background and rationale for the ESRC application for this present research into the audiences of *Judge Dredd*: the Movie. What happened then, is the story of the next twelve chapters.

What this book doesn't do...

As we have already made clear, we hope, this book has hit its head against many walls. In consequence, explaining how the research proceeded, and what finally we make of the outcomes of it, has meant explaining our responses to a very wide range of theoretical, methodological, practical and empirical issues. The danger was that the book would be about everything. We have had to circumscribe, very consciously, what we allowed it to cover. Elsewhere, we hope to let our hair down a little and explore some of the margins of the research, and its border wars with other traditions of work.[44]

...and what it does

The book, as we've said, follows closely the processes of our research and the ways in which our thinking encountered and hopefully solved problems. For that reason, the model and explanatory account we eventually evolved does not appear until Chapters 7-9. Some readers may prefer to go directly to those, and skip for now our first confrontations with our recalcitrant materials, and our comings-to-terms with theories of the audience, and theories of discourse and discourse analysis. Which ever way you choose to read it, we hope readers will gain something from the encounter. Whether it is the same things we feel we gained, is not for us to speak on.

1 Malcolm, Derek, 'Hollywood or bust', *Guardian*, 30 July 1996.
2 It wasn't of course UWE who had funded us, and if Lawson had read our proposal, I doubt she could have found it 'unimaginative'. But it is a marker of a good deal of contemporary journalism that she didn't bother. She never spoke to either of us, and never knew what the project involved.
3 Hodges plagiarised herself in another article, this time in the *London Evening Standard* (14 May 1997): 'A degree in futility'.
4 A small test: (a) which kinds of lecturers and researchers are excluded from the category 'dons' by this headline, (b) what difference would it make if *science* were given the scare-quotes and 'media studies' presented unqualified, (c) what reasons does it suggest for students taking media studies instead of science? What evidence would you be looking for, to support this claim?
5 See *2000AD*, Prog. 953, 18 August 1995.
6 See below, Chapter 12, for an extended discussion of this.
7 Francis P Hutchinson, *Educating Beyond Violent Futures*, London: Routledge 1996.
8 Hutchinson, *Educating Beyond Violent Futures*, p.50. We'd remark in passing that we have hardly ever heard a publisher saying that they are 'only meeting public demand' – but we have seen that view imputed to them by hostile critics. What we have heard is publishers saying, plaintively, that they hope there is a public demand for their wares, since cultural producers, and film producers in particular, work in an arena of very high risks. See below, Chapter 9 for more on the consequences of this.
9 Hutchinson, *Educating Beyond Violent Futures*, p.48.
10 Finding 'world-views' in materials such as comics, and then imputing their 'effects', is a standard academic game, and one which academics can hardly lose since their methods for finding the world views are deeply subjective. For more detailed exemplification and explication of these processes, see Martin Barker's *Comics: Ideology, Power and the Critics*, Manchester: Manchester University Press 1989 and also David Bordwell, *Making Meaning: Inference and Rhetoric in the Interpretation of Cinema*, Boston, Mass: Harvard University Press 1991.
11 Hutchinson, *Educating Beyond Violent Futures*, p.141.
12 Nor, come to that, *Judge Dredd* where morals and friendship ensure that the heroes overcome technology and baddies. See below, Chapter 9.
13 Peter Brooker & Will Brooker (eds), *Postmodern After-Images: A Reader in Film, Television and Video*, London: Edward Arnold 1997. This quote, p.105.

14 Brooker & Brooker (eds), *Postmodern After-Images*, p.1. The reference is to Jim Collins, 'Genericity in the movies', in J Collins, H Radner, and A Preacher-Collins (eds), *Film Theory Goes to the Movies*, London: Routledge 1993, pp.248-9.

15 Judgements of quality have long sat awkwardly within cultural studies, where its address to popular culture has made practitioners embarrassed about saying some things are bad, even of their kind – as if to judge anything good or bad is to adopt a problem that has never, to our knowledge, bothered those for whom particular forms of popular culture are just part of their lives: witness any weekend when a football team is booed off the pitch after a bad performance.

16 Brooker and Brooker (eds), *Postmodern After-Images*, p.105.

17 Janice Radway, *Reading The Romance*, London: Verso 1986.

18 Camille-Bacon Smith, *Enterprising Women: Television Fandom and the Creation of Popular Myth*, Philadelphia: University of Pennsylvania Press 1992.

19 Valerie Walkerdine, 'Video replay: families, films and fantasy', in Victor Burgin, James Donald & Cora Kaplan (eds), *Formations of Fantasy*, London: Routledge 1985, pp.167-99.

20 Sonia Livingstone & Peter Lunt, *Talk on Television: Audience Participation and Public Debate*, London: Routledge 1994.

21 Ann Gray, *Video Playtime: The Gendering of a Leisure Technology*, London: Routledge 1992.

22 Eric Smoodin, '"This business of America": fan mail, film reception and Meet John Doe', *Screen*, Vol 37, No.2, 1996, pp.111-29.

23 Sue Harper & Vincent Porter, 'Moved to tears: weeping in the cinema in postwar Britain', *Screen*, Vol.37, No.2, 1996, pp.152-73.

24 Linda Williams, 'Learning to scream', *Sight & Sound*, December 1984, pp.14-16.

25 Janet Staiger, *Interpreting Films: Studies in the Historical Reception of American Film*, Boston: Princeton University Press 1992.

26 Ien Ang, *Desperately Seeking The Audience*, London: Routledge 1991.

27 On some of the recent examples of this, see Martin Barker & Julian Petley (eds), *Ill Effects: the Media-Violence Debate*, London: Routledge 1997.

28 See, on this, Willard D Rowland, *The Politics of Television Violence: Policy Uses of Communication Research*, London: Sage 1983; Martin Barker (ed), *The Video Nasties: Freedom and Censorship in the Arts*, London, Pluto Press 1984; and Barker & Petley, *Ill Effects*. This tradition has also produced a variant in what has become known as Cultivation Analysis, where much of framework of the research remains but the kind of effects is differently conceived. Founded on the work of George Gerbner at the Annenberg Institute, Cultivation Analysis still insistently put 'violence' as its key term, but now changed the question a little: instead of asking how people might be made violent by watching violent media, it asked whether people might become frightened of violence by getting a 'continuous picture' of a 'mean society'. See for instance George Gerbner, Larry Gross, Michael Morgan & Nancy Signorelli, 'The scary world of TV's heavy viewer', *Psychology Today*, April 1976, pp.41-5, 89, and George Gerbner, Larry Gross, Michael Morgan, Nancy Signorelli & M Jackson-Beeck, 'The demonstration of power: Violence Profile No. 10, *Journal of Communication*, Vol.29, No.3, 1979, pp.177-96.

29 We return to this idea of 'folk theories of the media' in Chapter 13.

30 Sadly, it seems to us that this has even been true to an extent of the very best researcher in the media studies tradition, David Buckingham. See Barker's review of Buckingham's *Moving Images* in *British Journal of Educational Studies*, Vol.45, No.1, 1997, pp.83-4.

31 As we are writing this, moves are afoot to reform these bodies, and the signs are that the new Labour Government, led by the nose of its drive for 'moral leadership', will require new stringency in controlling 'dangerous media output'.

32 On men's responses to magazines, see the forthcoming K Brooks, P Jackson & N Stevenson, *Reading Men's Magazines*, Cambridge: Polity Press.

33 For examples of this sort of account, see the introductory chapters to any of the following: David Buckingham, *Moving Images: Understanding Children's Emotional Responses to Television*, Manchester: Manchester University Press 1996; Ann Gray, *Video Playtime*; Shaun Moores, *Interpreting Audiences: the Ethnography of Media Consumption*, London: Sage 1993. As an example of the 'stuck' position in which audience studies now find themselves, consider the following quotation from a generally fine contribution to our understanding of audiences: 'The issue that now faces the once influential subfield of spectatorship within cinema – and indeed all visual – studies is whether it is still possible to maintain a theoretical grasp of the relations

between moving images and viewers without succumbing to an anything-goes pluralism.' (Linda Williams, 'Introduction' to her (ed), *Viewing Positions: Ways of Seeing Film*, Brunswick, NJ: Rutgers University Press 1994, p.4.).

34 James Curran, 'The new revisionism in mass communication research: a reappraisal', in James Curran, David Morley & Valerie Walkerdine (eds), *Cultural Studies and Communications*, London: Edward Arnold 1996, pp.257-78. See Chapter 4 for a further discussion of this.

35 See Martin Barker, *A Haunt of Fears: the Strange History of the British Horror Comics Campaign*, London: Pluto Press 1984.

36 In fact, in a recent essay, Barker has returned to this topic, in the light of a fascinating statistic subsequently found: according to a survey published in 1954 by Thorpe and Porter, one of the three main publishers of the horror comics, two thirds of their readers were young married women. It is impossible now to be sure how reliable or valid this survey was, but it does raise some fascinating questions – and of course would make further nonsense of the ritual appeals to the 'protection of children'. See Martin Barker, 'Getting a conviction, or: How the British horror comics campaign only just succeeded', in John A Lent (ed), *Pulp Demons*, Cranbury, NJ: Fairleigh Dickinson 1998.

37 See Martin Barker (ed), *The Video Nasties*.

38 The main results of this research were published as two chapters in Barker's *Comics*.

39 See Martin Barker, *Action: the Story of a Violent Comic*, London: Titan Books 1991. This book reprinted a number of the main stories as they had originally been intended, and examined in detail the processes and impacts of censorship on the meanings of the stories. This virtually unique opportunity was entirely down to the generous help of Fleetway Comics, and in particular John Sanders, then Managing Director.

40 See Martin Barker, 'Seeing how far you can see: on being a fan of *2000AD*', in David Buckingham (ed), *Reading Audiences: Young People and the Media*, Manchester: Manchester University Press 1993, pp.159-83. The reason for the much greater simplicity and clarity of the *Action* responses, we suspect, is a function of two differences. First, *Action* was surrounded and bathed in public discourses of danger from its launch, whereas *2000AD*, although touched occasionally by disputes, consciously insulated itself with the 'distance' that science fiction imposed. The effects of disciplinary discourses, we argue in this book, are one of the great un-researched phenomena of the mass media, and there is reason to suppose that they may occasion a polarisation of responses by fans, who wish to protect their beloved objects. But also, while the original *Action* lasted only nine months, and therefore had little time to evolve in its contents and in its relations to its audiences, *2000AD*, at the time of Barker's research, had been published for nearly 20 years. The problems in identifying 'typical' audiences only heightens the points we make throughout this study about the historicity of audiences.

41 See Barker, *Comics*, Chapter 11.

42 Gemma Moss, 'Girls tell the teen romance: four reading histories', in David Buckingham (ed), *Reading Audiences*, pp.116-34.

43 Moss, 'Girls tell the teen romance', p.119. Moss has another criticism: she argues that while a 'contract theory' might be applicable to comics such as *Beano* and *Action* (which were two of Barker's case-studies), it cannot so readily be applied to girls' magazines because 'romance is seen to work so comprehensively against the interests of its main readership' (p.118). It's not at all clear from the context whether Moss holds this view herself, or if she thinks (quite wrongly, let it be said here) that Barker holds this view – the reply would clearly have to be quite different in each case.

44 One other essay is already in press, as we write, which explores the relations between the theorisation we develop in this book, and the ideas of Pierre Bourdieu. See Martin Barker & Kate Brooks, 'On looking into Bourdieu's black box', in Roger Dickinson, Olga Linné & Ramaswami Harindranath (eds), *Approaches to Audiences*, London: Edward Arnold, forthcoming 1998. See also our 'Bleak futures by proxy', paper presented to the International Conference on 'Hollywood and its Audiences: 1895-1995', University College, London, February 1998. This is to be published in a subsequent volume of conference proceedings.

2 THE BOYS FROM THE CLUB

On 21 July, 1995, *Judge Dredd* opened in Bristol, in three cinemas. It commanded three screens out of 14 in the new local multiplex, the Showcase; had the largest screen in the city-centre Odeon; and took one screen at a north suburban cinema the Orpheus. It did not perform well. After just three weeks, the Showcase had reduced its commitment to one screen, and the Orpheus had discontinued the film. The Odeon stopped after another week. During this time, and in the weeks that followed, we were busily setting up and conducting our interviews.

Conducting the research

The research project had got underway two months earlier in April 1995, with the appointment of Kate Brooks as research assistant. Shortly before this it had been announced that the film, which had been scheduled for release in late May, was delayed for two months. We took advantage of the interim to do a number of things, such as library searches. We also took a decision to use the time to attempt a number of pre-interviews, to explore people's expectations of the film in advance of their seeing it. We hoped to be able to follow up these pre-interviews with matching interviews after people had seen the film. There were risks in this, in as much as we could not know how we might structure the post-film interviews until we ourselves had seen it. But we saw potential gains in tapping people's expectations unedited, that is, before they might be restructured retrospectively by the experience of seeing the film. We also saw benefits in being able to 'trial' our general question schedule with a number of groups.

The original proposal to the ESRC had indicated that we would attempt between 20-24 focus groups, covering a range of kinds of interest in the film. In the outcome, in fact, 52 interviews were conducted, with a wide range of group sizes. The reasons for this will become clear shortly. The key principle was heterogeneity. This was not intended in any sense to be a 'representative' study, sampling either the general population or specific sub-groups. It was therefore very important to us not to select groups in ways which might pre-classify their expected responses. What we wanted then, was as interesting a range of responses as possible, from which afterward we could with good fortune 'map out' patterns of talking about film-watching and cinema-going – in short, we wanted to be surprised by our findings.

We did have some stipulations: we were looking for some 'naturally-occurring' groups, such as groups of friends; other groups we would organise ourselves. We

wanted to explore the ways this might affect how people talk, debate and discuss. We wanted some of the latter groups to be homogenous as regards their expected 'viewing position' on the film, others not so, again to try to explore the impact of this difference on the way people might talk about the film.

Finding our focus groups

We went about getting our groups in a number of ways, with various degrees of success. Initially, to obtain 'naturally occurring' groups, we contacted a range of existing groups we thought might either be intending to see the film, or who might be persuaded to see it for the sake of the research. Our principle was that they might have an interesting angle on the film.

For example, we tried a couple of women's groups, as an 'Action film' such as *Judge Dredd* is usually seen as a 'male film' and we thought a women's group might have something to say about this; a police group we thought might have opinions on the film's theme of a dystopian future of justice gone wrong; and we wondered how different ethnic groups would view the spectacle of a white action hero. More obviously, Bristol has a Science Fiction Club, who would be likely to want to see the film and have a perhaps specialised interest in it.

This approach was not very successful: after all we were giving these groups no incentives to go and watch the film, and as we will discuss further down, when cinema-going is 'just something you do', it is not always easy to get people to commit time to talk about it. The minor successes we did have with this approach were a boys' club, which gave us two focus groups and a link to a girls' club which meant a further two groups, and a men's group, the address for which was spotted in a shop window. The role of accident in research of this kind is easy to understate.

'Snowballing' proved fruitful: we extensively worked our friendship and acquaintance networks to recruit more respondents: no-one who came to the door, or who worked in the same department, or was a friend-of-a-friend who might have once read *2000AD* or loved or hated Action films, was safe. Martin Barker's contacts with a local teacher resulted in four interesting focus groups of young media studies pupils – whose orientation to the film turned out to have almost nothing to do with their taking media studies; and a teachers' group after school hours. This method of approach also led us to the Bristol Family Life Association, a now-defunct evangelical group which for a time was quite active in the Bristol area; and to a group of retired businessmen. Informal networks were often time-consuming to arrange: we spent a lot of time waiting for acquaintances to 'get back to us' with arrangements. Some failed completely: even using the good offices of a friend who was a Special Constable failed to get us the group of police we very much wanted.

On the other hand, these groups could at best be productive and surprising: a group of bikers for example, who were long term Dredd fans, also had some interesting things to say about video watching, which lead us to rethink one of our questions.

We made use of the local media wherever possible, although – having already seen some of the national coverage our research – we knew that this carried risks. On

the other hand, secrecy was impossible, and refusal to talk might generate uncontrolled speculative responses. We were interviewed by two local papers, the *Western Daily Press* and the Bristol *Evening Post,* both of which ran articles including an invitation to potential Dredd-viewers to write in. The story of our project was also covered in Bristol's listing magazine, *Venue* (charmingly describing Martin Barker as 'the Bristol Boffin'). A friendly local video shop and comic shops were 'leafleted' with a specially-prepared card asking people if they planned to see the film and would be willing to talk to us about it.

Once the film was out, we attempted to recruit by standing in the foyers of the Odeon and Orpheus cinemas (with permission, which was refused in the case of the Showcase), asking people if they would give us their name and address for us to contact subsequently. This was remarkably unsuccessful, getting a response rate of below 1 in 50. The researchers wish here to record the sheer misery of being ignored by hundreds of people whom we could overhear talking interestingly as they come out of a film we wanted to discuss with them...

Other opportunities were less problematic and very fruitful. In September, the annual United Kingdom Comic Art Convention was held in London. We held an informal 'drop in and tell us what you think' taped discussion, which gave us a good few hours' worth of often lively debate. And Martin Barker reapproached those people whom he had interviewed as part of the second stage of his *2000AD* audience research, to ask if they would participate again. A number did, and were (as before) asked to talk their answers to our schedule of questions onto an audio cassette.

We tell these stories not simply to record the processes but to highlight something which we came to see as very important. Interviews are hard to organise, and very many people have all kinds of reasons for not wishing to take part. The processes are inevitably messy, and researchers who say otherwise, we believe, are either concealing the mess and not thinking about its implications, or they operate with a captive audience – and that has other kinds of serious consequences.[1] We will go further, later in this book, and suggest that those who avoid being interviewed may pose particular problems of theorisation. Why might people not want to be interviewed about viewing a film like *Dredd*? Because they view it as a waste of time ... because they are too busy ... because they don't feel they could have anything interesting to say about it ... because they wonder what it is we are after, and might even have read one of those reports about us ... because it might make serious what they think of as 'just entertainment' ... add your own, endless further reasons. Now try to do the opposite: why might people agree to be interviewed?

The interesting thing is that our list here is much shorter, and raises issues about social processes of inclusion and exclusion in such research. They might agree: out of pity for us, or to get us off their backs ... because they really like talking about films ... because they feel very strongly about this particular film ... No doubt there are others, but in retrospect we can see why more people refused than were willing – and we can also see some of the implications. These feature largely in our analysis later.

All potential respondents were sent a form, on which they were asked to write their name, age, gender, and reasons why they were going to see this film. An amended version was produced once the film came out, to ask why and when they saw it, and asking them to say in one sentence what they thought of it. This information was used to organise respondents into focus groups.

For this, we believed that age might be significant, in giving shared cultural references and group rapport, and also gender in that this film was being publicised as a sci-fi/action movie, a genre typically taken to be 'male'. 'Reasons for going' and 'main response' would, we hoped, enable us to set up our homogeneous and non-homogenous groups. Of course we were fully aware that many other factors might be as relevant, or more, in shaping people's responses. But we hoped that these would be enough to ensure sufficient common ground to generate discussion. In the event, some groups were determined much more by who we could get together on a particular occasion. Mostly, though, non-naturally-occurring groups were organised by the following: whether they were 'pre-film' or 'post-film'; their age, gender, and their stated reasons for going.

Respondents were given an option: we could visit them, or they could come us at the University campus, where we set up a 'focus group' room with posters of Dredd and refreshments.

Organising our respondents: viewing positions

We had early on developed a 'wish-list' of kinds of orientation to the film, which we hoped would be exemplified among our interviewees. This included: self-acknowledged, long term *Dredd* fans (who would probably be the easiest to recruit); casual film goers who had just chanced on this film; Action fans; science fiction fans; fans of Sylvester Stallone; under-age young people (the film was classified as a 15); 'concerned' viewers who might worry about the effects of a film of this sort; and people who might have seen it and just disliked it. We also, we believe unusually, sought out some non-viewers, including some who would refuse to see it. We were, of course, wide open to other kinds of viewers, and we certainly got them! As our list of replies grew, we drew up a loose list of the different kinds of 'viewing positions' taken up by those who had gone or were going to see the film: their hopes, expectations, fears, opinions and so on.

Problems and issues

A number of problems were highlighted for us by our failures and successes in our interviews.

We sought the permission of every local secondary school in the north and east Bristol area to come and talk with groups of their students, explaining that this was publicly-funded research and outlining its purposes. Only one even bothered to reply, and that was to say a flat 'no'. All attempts failed. And we tried hard to get an interview with the Bristol Science Fiction Club. They were very willing in principle, but the interview took place in a noisy pub, after their normal meeting – and the tape was untranscribable.

One group contained a man who turned out to be a serious long term fan of Sylvester Stallone. His case highlighted a problem with organising a non-homogenous focus group. Initially, he came along to a group which included two action film fans and a long-term *Dredd* fan. Arriving early, the Stallone enthusiast had been very talkative on his own, yet he hardly said a word during the focus group. We therefore asked him back alone, as we sensed he had a lot to say – and we were right!

The lack of response in the cinema foyers highlighted for us the problems of researching something that people 'just enjoy': they go to the cinema to 'escape', to 'unwind' or to 'relax', so they are not that likely to fill in forms about the experience afterwards, nor, if they have just gone to the cinema casually, just to pass an evening, are they likely to commit themselves to another evening discussing it. The few casual film-goers we did get were usually the long-suffering girlfriend of a male *Dredd* fan, who would generally be reticent to talk ('Well it was OK! It was just a night out really'). Those who did talk and debate, were either students (used to the format of seminar debates) and / or long term *Dredd* fans.

There is a stock of issues in here well known to sociolinguists, about why and how people talk at all. The fact is that 'having an opinion' on a film is not an obvious process, and having one that you might feel comfortable expressing to an 'expert' is even more tricky. The idea, indeed, of debating ideas is quite specialist, best known either to those who participate in some kinds of public fora (politics, trade unions, churches, or whatever) or who make a profession of it as students or lecturers. The success or failure of our interviews, we discovered, turned on the extent to which we enabled people to feel that they weren't being interviewed at all – they were having a conversation about the film that was very like what they liked to have, anyway.[2]

The exception to this were those people, and especially the '*Dredd*-heads', who felt that they had a right to an opinion. This is something we came to regard as highly important: some people wished to assert rights and control over the viewing experience, and that viewing experience appeared to include being interviewed about it afterwards. That was an opportunity too good to be missed!

The focus group

In a sentence, then, our intention was to work with a number of focus groups, with different social and cultural characteristics, and to analyse their talk about the film. The origins of this method of research lie in Robert Merton's sociological studies of wartime propaganda. At the time, the fact that he and his colleagues had used focus groups was only mentioned in passing in his work: the 'real' stuff was tabulations for survey data. The idea of focus groups as a method of social research did not much take off at that time: where it did take off, was in market research, where focus groups formed the main tool for gathering information and insight on future sales, new product, and customer responses.

Focus groups in the realm of the social sciences are essentially group interviews, with the emphasis on group interaction.[3] The researcher's role is to supply the topic, and to moderate the discussion, keeping it focused on the topic though not at the expense of letting participants say what they want. Focus groups should not just be structured question-and-answer routines. According to one writer, '[H]earing how

participants respond to each other gives insight not just into their natural vocabulary on a topic, but also when they are willing to challenge others and how they respond to such challenges.'[4] Our wish was to use focus groups as a way of exploring how viewers made sense of a film in light of their assumptions, experiences and expectations, and to see what 'natural vocabularies' they used. We also wanted to explore how they positioned themselves in relation to others, and their perspectives.

To sum up this dream focus-group scenario, then, it should be of a high level of group interactive discussion on a researcher-given topic, focused yet casual, moderated by the researcher who guides but does not lead, controls but does not inhibit the conversation, and who (among other things) ensures every one has equal opportunity to express their natural vocabulary: in short, the researcher is a perfect combination of 'understanding empathy' and 'disciplined detachment',[5] while the 'respondents' are orderly, natural, interactive, and utterly self-revealing. In other words, impossible.

No academic researcher can expect to be a neutral moderating focus, as some of the literature on this kind of research requires. But this was spectacularly absurd for research on our topic, namely, the audiences of an Action film. To most people (including most academics), 'academics + popular films + audiences' can only mean one thing: we were looking at Film Violence and its Effects. And we, of course, were knowing, superior ones who (rightly or wrongly) would know things that 'they' could not. A number of our correspondents told us afterwards that they were surprised that we haven't asked them about 'violence' in films. Others, asked the 'simple' question 'What did you do after seeing the film?' responded with versions of 'Oh, turned into a raging psychopath, I expect!'.

This isn't an argument against the benefits of this kind of research, at all. It is an argument designed to position what we did, against two competing versions of focus groups. The first sees their problems as essentially practical: design your set up carefully, manage the situation carefully, relax the participants, ask properly designed questions – and all will be well. If they don't, then you weren't a clever enough or experienced enough researcher. Our objections to this are pretty obvious. But in the other direction, we would equally challenge a view currently very popular within cultural studies, which sees discussions of this kind in a bipolar way: either we are objectifying and reifying those whom we interview, or we are 'on their side'. Ien Ang has recently presented this view:

> [W]e cannot afford ignoring the political dimensions of the process and practice of knowledge production. What does it mean to subject audiences to the researcher's gaze? How can we develop insights that do not reproduce the kind of objectified knowledge served up by, say, market research or empiricist effects research? How is it possible to do audience research which is 'on the side' of the audience? These are nagging political questions which cannot be smoothed out by comforting canons of epistemology, methodology, and 'science'.[6]

We have many problems with this way of presenting a genuine set of issues, about how researchers should relate to their 'subjects', not least of which are the following. Unlike Ang, we wish academic audience researches could get near the rigour and

effectiveness of a lot of research done from within the media industries – where it faces tests far more rigorous than any we apply to ourselves. When a major TV company researches the significance of a presenter to young audiences, and with that test the acceptability of several possible candidates, it faces a short-stop critical test: how well does the resultant programme work with audiences? We have few such checks on our research, and that is a problem. Ang also asks how we can be 'on the side' of the audience. But supposing we don't want to be – does that make an audience un-researchable?[7] The danger is that the ambiguities concealed in the notion of being 'on the side' of the audience can lead to us researching only 'safe' audiences, people we like who like materials we also like. That is very deleterious.

Designing the research implements

Our schedules of questions evolved over quite a long period of time. Partly, this was in response to changing circumstances (clearly, pre-film and post-film interviews had to be conducted differently, and those conducted by post had to be more formally structured than face-to-face interviews). Partly, though, this was in response to problems encountered. Two areas of questioning, especially, gave us repeated headaches. We wanted to find out how interviewees had participated in the process of the film between opening titles and closing credits, and for us that meant asking about it as story. Unfortunately, though we tried several ways of introducing this possibility, we encountered difficulties. Many people simply did not appear to respond to the film as story. At the most extreme, it was regarded as a problem if the film had to be described in this way – that was a sign that the film had become overly complicated, and therefore was not living up to its own promises as an 'Action film'.

Also, it was important to us to give interviewees an invitation to talk about what 'meanings' they saw in the film, or whether they perceived any explicit 'messages' being projected by it. Unfortunately, in a series of early interviews no matter how cautiously we stated this, there was almost a knee-jerk reaction, as if to say: 'Now we know why you wanted to interview us! It is about "violence", after all, isn't it?' Or they would say to us 'Sorry, I didn't get the message ...', thus changing the relations of the interview so that we became experts with hidden knowledge that they had missed. Our eventual solution was to rephrase the issue such that we were asking them to comment on someone else's views of the film. Though not perfect, this was as near as we got to a solution to this problem.

On the other hand, one question changed its status and importance as we began our analysis of early transcripts. One question had originally been included as an 'ice-breaker', a non-threatening opener which might help any interviewee to feel that they had something to say, they were 'experts about themselves', and therefore could participate in the discussions without worry. The question was: Tell us about your typical night out at the cinema. This question proved, over time, to be central to the new understanding which we developed.

Here, then, are our schedules of questions. In virtually all our interviews we stayed very close to this agenda, and explored all these areas.[8] Clearly, since it is a schedule of questions not a questionnaire, not all questions got formally introduced, since some of the areas were covered spontaneously, or out of

Table 1: Table of Interviews and

Int. No.	Age Range	Participants[1]	Page Count	Words per Person[2]	Interviewer Index[3]	Inter-viewer(s)	Group Kind[4]
1	19-24	Zoe, Fran	8.5	2250	5.3	KB/MB	NO
2	25-35	Brian, Gary, Herb, Mark, Munro	17.5	1660	2.2	KB	NO
3	25-30	Dan, Sean, Jag	14	2130	2.8	KB	KG
4	20-30	Sol[1], Martin[2], Caroline[3]	13.25	2300	3.6	KB/MB	KG
5	25-35	Mike[4], Christian, Steve[5]	17.5	3300	3.1	KB	NO
6	14-15	John, Mike, Turtle[6]	14	1960	5.2	KB	KG
7	24-32	Paul[7], Gareth, Denzil[8]	15	2760	2.8	KB	NO
8	10-12	Toby, Jonathon, Wayne, Jon, Nick	12.25	980	5.5	KB	KG
9	–	–	–	–	–	KB	NO
10	25-35	Jason[9], Stephen[10], Squid[11], Richard[12]	13.5	2030	2.1	KB	RA
11	20-25	Jeff[13], Maggie[14], Richard[15], Paul[16]	11.75	1670	2.5	KB	KG
12	30-35	Dave, Darian, Craig	14	2500	3.1	KB	NO
13	20-25	Les, Jimmy[17]	8.5	2770	3.2	KB	RA
14	15	Angus[18]	9	3200	4.4	KB	SI
15	13	Hannah, Tamara, Sarah, Angela, Rachel	15	1460	4.3	KB	KG
16	20-25	Jeff[13], Maggie[14], Richard[15], Paul[16]	12.25	1770	1.9	KB	KG
17	25-35	Jason[9], Squid[11]	9.25	2340	2.5	KB	RA
18	20-30	Nick, Duncan	14.5	4210	1.9	KB	RA
19	16-19	Kirsty, Keith	11.5	2650	8.3	KB	NO
20	30-35	Nick, Ian	9.5	2480	3.2	KB	KG
21	20-25	Martyn, Jimmy[17], Paul	11.75	1960	6.5	KB	KG
22	26	Richard[12]	24	17500	2.3	KB	SI
23	50	John	11.75	6300	4.3	KB	SI
24	20-26	Simon, David	13	3700	3.7	KB	RA
25	30-35	Bob, Stephen[10], Jeff	10.25	2010	2.9	KB	RA
26	25-35	Alison, Teresa	7.75	1750	6.1	KB	RA
27	15	Angus[18]	8	3900	5.7	KB	SI

Notes:
1. Seventeen individuals were interviewed twice, both before and after seeing the film. These pairs are indicated by italic superscript numbers.
2. These figures allow a crude comparison of the contribution to our research of each interview. In arriving at these figures we have not attempted to deduct interviewers' contributions. This is dealt with separately, under Interviewer Index.

Interviewees

28	18-30	Stuart, Rachel, David, Don, Lawrence, Richard, Elaine, Ben, Chico, Graham, Sean, Sarah, Owen, Phillip, Ralph	35	1430	4.2	KB/MB	RA
29	14-15	Joe, Chris, Gerard, Anthony	7.5	870	6.1	KB/MB	KG
30	14-15	Veronica, Oliver, Roger, Steve	6.25	670	7.7	KB/MB	KG
31	14-15	Kate, Paul, David, Colleen	8	1020	10.3	KB/MB	KG
32	14-15	Johnny, Mike, Jenny, Andrew	9	1050	6.1	KB/MB	KG
33	23	Mike	9	5200	6.1	KB	SI
34	25-35	Fabian, Richard, Samantha, Jason, Patrick	13	1380	3.3	KB/MB	NO
35	25-28	Matthew, David	11	3650	3.4	KB/MB	NO
36	25-30	Sol[1], Caroline[3], Martin[2]	11.75	1960	2.6	KB	KG
37	17	Rob	10	5500	4.9	KB/MB	SI
38	14-15	Turtle[6], James, Matthew	8.5	1200	7.0	KB	KG
39	30	Amanda	9.5	3870	2.2	KB	SI
40	16-18	Johnny, Lee, Martin	13	1800	7.2	KB	NO
41	24-32	Paul[7], Denzil[8]	14	4200	2.6	KB	NO
42	25-35	Michael[4], Steve[5]	12.75	3650	2.5	KB	NO
43	35-45	Toby, Peter, John	14.75	2860	1.7	KB	NO
44	65-78	Arthur, Bob, Gareth, Jim, Charles, Gwyn, Roger	15	1180	1.7	KB/MB	NO
45	13-15	Karen, Zoe, Sarah, Sue, Tara	5.25	380	9.5	KB	KG
46	30-55	Karen, Jim, Linda,Sue, Diane	13.5	1440	2.3	KB/MB	NO
47	30-40	Mary, Hugh	8.75	2320	2.5	MB	NO
48	50-52	John, Janet	11	3250	2.5	KB/MB	NO
49	22	Alex	4	1900	NA	POSTAL	SI
50	24	Meri	5	3100	NA	POSTAL	SI
51	19	Simon	3.5	1700	NA	POSTAL	SI
52	30	Ian	7	4200	NA	POSTAL	SI

3. This is an index of the role of the interviewer(s), arrived at by dividing the number of pages of transcript by the number of occasions on which the interviewer(s) make significant intervention to steer or refresh the conversation. A low index therefore signals that the discussion ran itself to a considerable degree, and vice versa.

4. NO = naturally occurring group, KG = group of interviewees who knew each other in some context, RA = assembled solely for our research, SI = single individual.

discussions on other topics. In any individual interview, of course, we felt able to ask additional prompting questions as topics were unfolding, in order to maintain a flow of responses and to be appropriately participative.

GENERAL SCHEDULE OF QUESTIONS

1 Do you go to the cinema? Describe for us a typical evening out to the cinema that you would have. Do you visit the cinema alone and/or with others? What difference does it make? What kind of cinema do you tend to visit? Why is this? How do you decide what to see? Do you watch videos? What are the main differences for you between seeing things on video and at the cinema?

2 What prompts you to see a film? How do you normally get to hear and know about new films? What would, if anything, influence or encourage you to see a film? What would put you off going?

3 What had you heard about *Judge Dredd* ? What are you expecting/had you expected it to be like? Have you had any contact with the comics, with Stallone films, with Action movies before?

4 Who did you (each) go with? What did you do that was connected, before and after? Was that typical of what you normally do? When did you decide to go?

5 Could you have a go at just telling us what you remember of the film? Imagine you were telling a friend about it – how would you describe it to them?

6 Did you enjoy it? How did it compare with what you had expected? What was good or bad about it for you? Was there anything you found yourself comparing it with?

7 What were your reactions to the start of the film? What did you think of Stallone as Dredd? How did you feel about the ending of the film?

8 [Original version] Did it seem to you to have a 'message' of any sort? [Revised version] The film-makers worried that they might be making a 'fascist' film. What do you think about this? [Final version] Did the film seem to you to have any 'point' or 'argument'? Did it leave you thinking about anything?

9 Would you watch it again? At the cinema? On video? Why, or why not?

10 Dredd's story is set in our 'future'. What kind of a future was it? What did you feel about it?

11 Who did you feel the film was aimed at? In the end did that include you, do you feel?

12 Have you come across much of the merchandising? What did you think of it?

13 Did you come across much in the way of press or magazine or TV reviews of the film? What did you think of them?

14 What would you do with a *Judge Dredd*: II? What should it be like?

15 Anything else you think it's important to say about the film, or about going to see it?

The results

In total we contacted 198 people, excluding those approached as possible lines to people other than themselves. Of these, 62 either didn't get back to us, or didn't turn up at the agreed time and place. All 62 were contacted at least three times until we took the hint! We interviewed 132 people in 48 focus groups, and 4 by posted audio cassette. Of these, 103 were male, 33 were female. Eighteen people were interviewed twice, both before and after viewing the film. Most interviews lasted between half an hour and an hour, therefore the materials generated approached 48 hours, and approximately 200,000 words, of transcribable talk.[9] Table 1 sets out the nature of these groups.

As one check of the effectiveness of the interviews, in all cases where we were able, we gave interviewees a brief questionnaire upon completion of the interview, asking them about the process: had they felt able to say everything they wanted? had the discussion made them develop or take up positions they hadn't previously held? could we have improved on the way the discussion went? and how did they feel about the process as a whole? 21 people returned these. This number is too small, as a proportion of the total number of interviewees, to be worth close analysis.[10] But we take comfort from the fact that the most common comment, and predominant tone, of all the replies is that the discussions did not feel like interviews at all, more like an ordinary conversation.

So what did we get for our pains?

Here is a sample pair of interviews. We have chosen these because they were important, both in giving us real problems when we first read them, then in providing us with 'clues' on which we gradually built our eventual theorisation. Conducted with a group of boys at a local youth club in Bristol, it had been hoped to have the identical group before and after seeing the film. In fact, only one boy attended both interviews, though those who came instead to the post-film interview were part of the same circle of friends.

BRISTOL BOYS' CLUB: BOYS AGED 14/15
PRE-FILM INTERVIEW

KB:	Right, so, firstly then: Do you go to the cinema?
All:	Yes!
KB:	And who, who do you, sort of, usually go with, or what do you-?
John:	Um, my friends, or...girls
KB:	Don't you have girls as friends?! [laughter]
John:	Yeah!
Mike:	Do you watch any of the film?! [laughter]
KB:	We can get on to that..you can say what you like. So, normally, you'd, I mean who would sort of, arrange an evening out, say, if you were gonna go..?
Mike:	All of us, yeah
John:	Yeah... just phone up my friends and say, "d'you want to go to the cinema tonight?" Or ask him – or her – at school.
KB:	Yeah. So that's, that's with your friends then, what is, what happens if it's like, a girl then?
Turtle:	They organise it!
KB:	Do they?!
John:	You just meet them there..
Turtle:	Yeah, they say.."oh are you going down town", and you say, "yeah"
John:	And you go to the cinema ..
Turtle:	.. "Do you wanna go to the cinema then?".."oh all right then"
KB:	Oh right! And how do you decide um, what film you're gonna watch.
Turtle:	If you can get into it.
KB:	Yeah?
Turtle:	Yeah...if there's something

	like, you want to see, and it's a bit, like, if it's a 18.
John:	You just go to the Showcase if you wanna watch an 18! [laughter]
Turtle:	Cos they just let you in! But otherwise you just gotta like..
John:	Hope
Turtle:	Hope that you get in. But, sometimes they just say, "Oh, what's your date of birth?" and then that's all they say and you just get in
KB:	So do, are the films that you normally wanna see then, 18s?
John:	Yeah..
Turtle:	Well some of them yeah..
Mike:	Not all of em
John:	[..?..] Yeah 15s or 18s
Mike:	I'm 15 so!
John:	I'm, like, 14..and can get into 18s..
Turtle:	But cartoons are good as well..
John:	At the Showcase and the Gaiety
Mike:	Cartoons?
Turtle:	Yeah
Mike:	Like *The Lion King* and stuff?!
KB:	So, how do you go about trying to get into an 18 then, if you've ever...?
Turtle:	Just, ask if you can get in!
John:	Just go up, put on a bit of a deep voice and say "I wanna see this please"
Turtle:	Wait til you grow a moustache or summat!...ay, can I have a ticket for, whatever it is, and if they don't think you're old

enough, they won't give you it, and you just ask for a 15 and if they don't give you that, you just ask for a PG.

KB: *Right. So you might off, you might start off trying to see something like* Reservoir Dogs

Turtle: Yeah

KB: *And end up seeing the Lion King or something.*

Turtle: Yeah!.. It happened to me!....[laughter]..

KB: *Bit of a crap way to spend your evening!*

Turtle: Yeah! [laughter]

KB: *Um, so, I mean, is it, different, say, when you go to the cinema like with a group of friends, or just one person, or your mum and dad, or like a girl or something?*

Turtle: Better with friends cos you've got like, more of an atmosphere

John: Yeah when there's loads of us, like

Mike: Cos we muck about

Turtle: Yeah. You don't really watch the film, you just pick up little bits, like.. as you go through..

Mike: Popcorn!..

KB: *Yeah?*

John: Throw em at people! [laughter]

John: Especially if you're not enjoying the film

KB: *And what, what else, would you do on an evening like that then? I mean, you say you'd all meet up in town and..?*

John: Goes bowling or something like that

Turtle: Mostly we're up here [at the Boys' Club]

KB: *Yeah?*

All: yeah

KB: *And where would you go? Which cinema do you normally go to?*

Turtle: Odeon downtown or.. Showcase..

John: Showcase..

KB: *And why is, why is that then? Is it just cos they let -*

Turtle: Close

John: Showcase you got everything, you got like, cinema, bowling, food places, sport shop

Turtle: And they maybe got everything on at the same time

KB: *Right*

Turtle: So you can get to see what you want

Mike: 15...or 14 cinema screens

KB: *Yeah. And um, you'd pick somewhere you'd be more likely to get in, would you?*

Turtle: Yeah. Usually the Show-case. You can just walk in there, and they couldn't care. You just say "I want to see this" and if you're 15 and it's an 18 they just let you in

KB: *Right*

Mike: You can, uh, you can get, you can get um, you can uh phone up for a ticket by credit card, at the Showcase, you just go in, you got a little machine that you stick in your credit card...number in, and you get your tickets out, and just walk through the door

KB: *Right*

Mike: You can get in any show you want

John: You don't need to, say how

31

old you are or nothing
KB: *And do you do that? Is that- [laughter]*
John: I ain't got a credit card yet!
KB: *Do you use like your parents credit cards?*
John: I've never done that
Turtle: My Dad lets me sometimes, but I has to pay it back
KB: *Yeah. But would he let you do it for an 18 film, or?*
Turtle: Probably. He just rents em out and I just watches em, he don't mind
KB: *Right. Um, I was gonna ask you about um, videos and stuff. I mean, do you watch, do you watch videos?*
All: Yeah
KB: *And how do you watch them, is it with the same group of friends or-?*
Mike: Yeah just get me mates round, or watch it yourself or with the family
KB: *And what, I mean, do you watch films on video you wouldn't be able to see at the cinema?*
Mike: Well you just tape them off from the TV
Turtle: But they cut it off on the TV, they cut all the good bits out so, better to rent it, really, or go and see it
KB: *Yeah, and I mean you were saying like your Dad – I'm obviously not going to send this like to your school or your family!- [laughter] I mean you were saying like your Dad rents out videos and you watch, do you tend to watch videos that you're not supposed to-*
John: Yeah..all the time.. [laughter]

KB: *Well everybody does, don't they, we all know this.. Like, what kind of thing?*
Turtle: Oh, if I wanted to see summat, and I couldn't get it rented out or summat, our Dad would just come down with me and he'll get it out for him, and I'll just watch it, if it's, if it's older than what I am, he'll get it for me
John: Or if, if your Mum don't want you to watch it and you can't get it yourself-
Turtle: Your Dad'll get it [laughter]..
John: Just get.. No, just get one of your older friends to buy it for you
KB: *Oh right. And where, where will you watch those then, if like your parents..?*
John: In my bedroom, probably
KB: *And your parents wouldn't come in and-?*
John: No
[...?...]
Turtle: My Dad'd just watch it with me!
KB: *But your parents don't like you watching...*
John: She, she doesn't mind! It's just...there's some things she draws the line with...like stuff like *Basic Instinct*, sort of thing [giggles]
KB: *So she doesn't mind you watching people having their heads blown up and things like that, that's all right*
Mike: No that's fine!..
KB: *It's just women's legs.. [laughter] I mean is that, do you find that then, your, your, it's all right to watch like um, your parents don't*

	mind you watching like violent films, but they wouldn't want you to watch something like Basic Instinct*?*
John:	I've got *Basic Instinct* on tape at home
Mike:	And me
John:	My Mum knows I got it. Now she knows, she knows that I'm getting older and all that, she realises, it's like...
Turtle:	Don't matter like
John:	Yeah!
Turtle:	My Dad, I don't think my Dad's ever cared what I watch, he just lets me watch it
KB:	*Yeah? What sort of things have you watched then, that people of your age don't normally watch?*
Turtle:	I dunno, it's like, when *Alien 3* come out I was too young for that, so when it come out on video our Dad just rented that for me, he watched it with me, don't think that was pretty bad, that, wasn't as bad as it was meant to be, and just all things like, I want to see, um, *Fortress*, but I can't get that yet
John:	I've seen that, it's pretty – it's good....It's in the future, it's 30 storeys down underground prison, and this one innocent man escapes. Usual stuff!
KB:	*[laughter] Sounds familiar. So, I mean, do you go round to like, um, you know, like if one of you got a video out or something, you 'd all like, go -*
Mike:	Yeah, go round someone's house

Mike:	Pile round.....get some food..
KB:	*That happens..a lot, does it?*
Mike:	Yeah, quite a lot
KB:	*Um, good...what prompts you to see a film, what makes you think, I wanna go..and see that..?*
John:	The hype..
Turtle:	Yeah
John:	The hype surrounding it
Turtle:	People hype it up like
John:	"It's brilliant, it's brilliant"
Mike:	Yeah.. show, show the best the clips of it
Turtle:	Yeah, they show all the, like, guns and car crashes and stuff like that, and you think, "well, I wanna see that" so you just go along and see it or something
KB:	*So it's sort of trailers is it?*
All:	Yes
KB:	*Trailers and...?*
Turtle:	Clips
KB:	*What about, um types of film and things like that?*
John:	I usually get Karate films, Van Damme stuff. That's what I usually watch at the cinema as well
Turtle:	I likes watching like Action adventure films. Like *Die Hards*. I want to see *Die Hard with a Vengeance* as well
John:	*Die Hard 3*?
Mike:	I just watch anything
KB:	*Yeah?*
Mike:	Anything suits me as long as it's good
KB:	*So do you go to the cinema quite a lot then?*
Mike:	Not really. Can't afford it
John:	I go to the cinema quite often. On weekends and stuff, with my schoolmates

KB:	Right. Is that in the evening, would you go in the evening, or do you go in the afternoon or-?
Turtle:	Depends really. What time it's showing. If you miss one then you just wait for the next one.
John:	We either, if, if we get there too late for the 7.30 showing, we usually go into the bowling place and play on the arcade then we go in for the late show at like 10 or summat
KB:	Right. Don't you have to be home?!
John:	Yeah. If it's like that, if it's the late show, then I gotta get a taxi home
Turtle:	Just tell our Mum I'll be late, and..
John:	Yeah. As long as you phone up
KB:	Sound very laid back!
Mike:	My mother'd go mad!
KB:	Um..so what would um, what would put you off going? I mean what sort of films would you be like, "no"
Turtle:	*My Girl 2*, or something like that. I went to see that, I nearly fell asleep!
Mike:	*The Lion King*
John:	I fell asleep during *Circle of Friends*
KB:	Why, why were you watching those films then?
John:	It's.... not being sexist, it's a girl's film, it is, it's a film like that.
KB:	Why were you, why, oh, you'd gone with a girl, had you?
John:	Yeah [laughter] and she wanted to watch it. I wanted to watch summat

	else. Wanted to watch *Bad Boys* with, um Fresh Prince
KB:	But she won
John:	No, she didn't wanna know,...So I gave in
KB:	Is it early days then, is it, this..?
John:	It was
KB:	Oh [laughter] Well you don't want somebody to boss you around like that. And what about, what about you? Why were you watching um, whatever film it was that you didn't..?
Mike:	I don't like, I don't like watching any cartoons, or summat, any long feature length cartoons
KB:	Right. Why, why is that then?
Mike:	Dunno, they just get like boring in the middle, or somewhere..
KB:	Right. What, what was the film that you watched that you didn't-?
Turtle:	I didn't like *My Girl 2*
KB:	And why were you watching that then?
Turtle:	Cos I watched *My Girl 1* when I was like, littler, and I thought that was pretty good so I thought 'Oh, I'll go and see *My Girl 2* so, me and my mate went down, and we nearly fell asleep half way through! Boring!
KB:	So I mean, what, what kinds of films – I mean you were saying about, you know, there are, girls' films, I mean what do you mean by those kind of, you know, what kind of films are girls'?
John:	I went, right, me and my friend, went down with

about four girls, and uh, they wanted...

KB: *Two each?!*

John: No! [laughter] And uh, it was like uh, it had a really soppy ending, it was like a Lassie movie! [laughter] And all the girls were like, "ohh, it's so sad!" And me and Ben were like there going 'yeah, really'. [laughter]

KB: *So what is it about them then that makes them girls' films?*

John: Well just that all the girls in the cinema..were going..

Turtle: It's like..soppy sort of thing, it's like-

John: Yeah, love in it..

Turtle: Love stuff, like

Mike: Yeah!

John: There were a couple of sex scenes in it which weren't bad! [laughter]

KB: *You woke up for them, then, did you?*

John: Yeah! I did do that

KB: *So, um, you're saying then that there are girls' films which are um, about love and...what have you. What would you say were boys' films then?*

John: Violent

Turtle: I dunno..cos.., some girls like violent stuff

Mike: Bruce Willis..

Turtle: Like blowing people's heads off..

John: Yeah, yeah..

Turtle: Violent stuff like that. So I don't think there is really a girls' and a boys' film

All: Hmm, yes

John: But some are definitely made for a sex, for one sex, like *Circle of*

Friends...terrible that was!

KB: *Right. Um, do you know anything about the forthcoming film of* Judge Dredd *?*

Turtle: Yes!..

John: Sylvester Stallone..set in the 2029AD

Turtle: And he's got a nice motorbike! [laughter]

John: Yeah! And he goes round beating people up!

Turtle: He just Upholds The Law in like, the 20th century, sort of thing...I think I wanna see it cos I've got like, I buys his magazines and stuff, and

John: I like Sylvester Stallone anyway, so I'll probably watch it

Mike: He was good in, uh, *Demolition Man*

John: Yeah, that was a good film

Mike: That was good that was

KB: *So what is it that you, you like about him then?*

Turtle: He's just like, he does all these good Action films and, takes people's heads off and stuff like that

John: He's, he's a good actor I reckon, I liked him in all the *Rocky* films as well, I got all the *Rocky* films at home

KB: *Right. What is it about them, then?*

John: It's just good..

Turtle/
Mike: Violence!..[laughter]

John: It's good cos he always gets beat up and then just comes back and decks em...That's pretty good! [laughter]

KB: *So why, why do you think you like, them then, those kind of films?*

John:	Someone to look up to, like someone
Mike:	Yeah, role model
Turtle:	Someone that's, that's powerfuller than you and you thinks, "Oh I wanna be like them" so you wanna go to see it like, to, just to...
John:	To style yourself in a way
Turtle:	Yeah, just to dream, that you could be like them, sort of thing
KB:	*Oh right. So um, how, how have you got this idea of the film then, where have you read it or heard it or..?*
John:	Friends
Turtle:	Yeah..Read it in magazines
John:	Trailers
Mike:	Watch it on the telly
Turtle:	When you go to see an other film, you'll see a..feature on it..
John:	Trailers..
Turtle:	It'll just show you trailers of it
KB:	*Yeah. And what, what do you expect, from what you've like heard so far, I mean what do you expect this film's gonna be like*
John:	Safe..
Turtle:	I reckon..it looks pretty good
John:	Yeah it does! It's looks [?] wicked
KB:	*What did you say before?*
John:	Safe [laughter]
KB:	*Is that like, a young person's word?*
John:	Yeah it's like, means its good, brilliant
Mike:	It's bad, yeah
KB:	*Oh right. I see! [laughter] So what sort of things do you expect there to be in it..?*
John:	Violence

Turtle:	Violence, yeah
John:	Bashing people over the head with a big stick thing..like, truncheon
Mike:	Yeah his truncheon thingy
John:	There's loads of posters up where he's got this big, like...
Turtle:	And I like, I think I like stuff like bad side of everything, is pretty good, all the baddies and stuff
KB:	*Yeah*
John:	I like watching futuristic films cos you sees peoples' ideas of the future, weapons and..stuff..
Turtle:	And you get ideas..of like what it's gonna be and you think, "well, can't wait till it gets to like that year, sort of thing"
KB:	*Right*
John:	Like *Back to the Future 2.* I...I..
Mike:	That weren't really violent though was it
John:	Yeah, but that still gave you a pretty good idea of the future I thought
Turtle:	Comedy films, they're pretty good as well
KB:	*Right. Why, why do you like comedy then as well as...?*
Turtle:	I dunno, just makes you laugh...makes you feel good
Mike:	Laughing
Turtle:	It's like *Forrest Gump,* that was good...it was also like soppy at the same time
John:	Like *Ace Ventura,* that was so funny..He..He annoys me so much but his facial expressions are just brilliant
Turtle:	*The Mask,* yeah, he was good in *The Mask.* That was so funny

John:	I wanna see *Dumb and Dumber* but I'll wait til that comes out on video now cos...
Turtle:	No point in trying to see it
John:	Yeah
KB:	*Are there certain films then that you'd do that, I mean, are certain film better at the cinema, than on video, and are certain films better on video than..?*
John:	Horror films are definitely better at the cinema!
KB:	*Why is that?*
Mike:	You get, you get..
John:	Cos you get like a dark atmosphere and people are screaming, and stuff!
Mike:	Surround sound.. all around your head, you get all the feeling of.. you're there
Turtle:	And you hope that you're at the back so no-one can chuck stuff at you cos if you [jumps]
KB:	*[laughter] And what, what kind of films would you watch on video, then?*
Turtle:	Uh, Freddie movies, Chuckie and stuff like that
KB:	*Why would you watch them on video?*
Turtle:	Dunno...cos you can get all your mates round and like have a laugh over it and stuff like that
John:	Laugh at that little ginger haired doll [laughter]
Turtle:	Umm...it's just funny,
KB:	*So how come that., that's funny then, cos I mean, that's like, supposed to be like horror, and everything?*
Turtle:	I dunno, well, it's like, people turning into stuff, it's like, dolls coming alive and

	killing you and..stuff like this..
John:	It's um, unreal..
Turtle:	Yeah
John:	You just gotta laugh at it
Turtle:	And Freddie turns into a puppet and just starts writing things on people's chests in blood and stuff
KB:	*Sounds like a great laugh*
Turtle:	Yeah! [laughter]
Mike:	I ain't ever watched a Freddie film, actually
John:	I don't think they're that good.. there's no storyline they're.. just like scary..
Turtle:	They're just funny..
John:	Yeah you just got to laugh at his face
Turtle:	Once you seen the first one, you understand them all. But you gotta see the first one to understand the rest
KB:	*Right. So what sort of film do you expect the Dredd film to be like? I mean you've said there's going to be like.. futuristic..*
Mike:	Very futuristic..
All:	Violence
Turtle:	Violent, and adventurous, sort of
John:	There's bound to be a girl in it that he ends up with
Mike:	Laser guns
John:	He always does
KB:	*And what, what kind of girl?*
Mike:	A very sexy one
John:	Slim, attractive,
Turtle:	Robotics as well, some kind of Androidy sort of thing
John:	...knows some sort of martial art, that's what usually happens..tough, good looking, sexy, slimline girl [laughter]

Turtle:	Calm down John! [laughter]		Schwarzenegger Presidential Labour Day"
KB:	*Um, and, I mean what kind of, you know, if you had to say , you know, that this film was like, this other film, I mean what, what kind of film would you say this was like, then?*	KB:	*Oh right! So what would you um, if you did go and see this film, what would you expect to, to like and dislike about it?*
Turtle:	Dunno...I think this film would be like *Demolition Man*, like his other films, cos he's got like a, he's got like a comedy around him, Sylvester Stallone, he's got his own sort of comedy that he adapts..	Turtle:	I think I'd like the violence in it
		John:	And him beating up people
		Turtle:	Yeah. And I'd like the bad side of people as well, like, the baddies and..stuff like that..
John:	Yeah...He's got his own sort of style hasn't he, he doesn't use anybody else's, like...	John:	The way they.. think up ideas and their, their evil laugh and stuff
KB:	*What do you mean, comedy?*	KB:	*Yeah*
Turtle:	Well he's got his own comedy, he's he's, funny, in the way that he is, he don't.. copy other people..	Turtle:	I think it's good, but they've got a dark side on them is good cos I like that..
John:	Yeah, no-one can say.. no-one can say, "oh, he's like Arnold Schwarzenegger," Sylvester Stallone is like Sylvester Stallone	John:	I think it's good that they always get beat, no matter what....[laughter] goodies never lose
Turtle:	Cos like, Sylvester Stallone and Arnold Schwarzenegger they just take the mickey out of each other in every film that they make	KB:	*And um...You were saying that he's um, a role model or something you, you enjoy about it. Do you think that's a, he's a good role model or a bad role model or..? Should,...should..*
KB:	*Oh right!*	Turtle:	It..it is bad in a way cos he's teaching you violence and stuff, but not many, not many people would copy him, his violence, cos not many like 15 year olds have got motorbikes and truncheons and stuff, or guns
Mike:	Yeah..that's it..in like, *Last Action Hero*		
Turtle:	Yeah!		
Mike:	Arnold Schwarzenegger...goes uh, a sort of one liner: "who d'you think I am, Sylvester Stallone?" [laughter]		
John:	Yeah, and in *Demolition Man*, there's the "Arnold	John:	M16s! But in a way it's good cos he doesn't just do violent films
		Mike:	Yeah he does good films as well...*Cliffhanger*
		Turtle/John:	Yeah
		Mike:	That was good, kind of

	thriller kind of thing	John:	I don't mind it, I, I enjoyed *Lethal Weapon 3*, it's good
KB:	*I mean do you think films should like, have a bit of a moral, or teach you something..?*	Mike:	Yeah I enjoyed all of them
		Turtle:	It's good cos they got humour in it, it's funny
John:	Not always cos it's, it's too cheap sometimes..but most..	John:	I liked *Time Cop* cos I like that sort of film, like futuristic, and like time travelling and stuff like that
Turtle:	They try and get it over like..,		
John:	Too, too hard	Mike:	That's Jean Claude Van Damme
Turtle:	Yeah	John:	Yeah that was a good film. I, I actually got into that at the Showcase..it was 18
John:	They try to throw it at you		
KB:	*How do you mean? What kind of films?*		
		Mike:	I thought *Stargate* was quite good
Turtle:	Well they like, repeat it sometimes or summat, like halfway through they repeat it again, and then right at the end..they'd repeat it again..	John:	Haven't seen that
		KB:	*So do you think that it's always..if they put a message in that makes the film, you know, a bit crap then? Is that what you're saying, that it's better without? Or..*
Mike:	They'd spoil the plot..		
KB:	*Yeah? Like what kind of things?*		
John:	Like they done in..um... *Lethal Weapon 3* was about drugs and stuff, kept repeating how, like, loads of kids had guns,	Turtle:	I dunno...if they're making it too obvious that they're putting it in there, that would make it a bit..
		John:	If they put it in sneakily..then it's good
Turtle:	And drugs..and they're dying cos of drugs..	KB:	*Yeah. And do you think a film can, I mean, you know, do you ever come out thinking oh, you know, I haven't thought of that before and that's really made me think..?*
Turtle:	And they're dying cos of drugs..		
John:	Always dying, always getting shot..stuff like that		
Turtle:	And everyone knows all that like, and they just try to keep it going		
		All:	Yeah
Mike:	Still a good film though	KB:	*What kind of films were they?*
Turtle:	Yeah, it is a good film, but, once you think about it you notice it like, going on all about drugs too much and stuff		
		Turtle:	Well it's like, if you see like, things like, if someone's got a car and they got all these buttons inside like ejector seats and stuff like that and you think "no" [laughter] that's not real is it? And you
KB:	*And that's what puts you off does it?*		
Turtle:	Dunno		
Mike:	Don't really care actually		

	think of how you could make it and stuff like that, and make money out of it, and you could make onto a car yourself. But you couldn't [laughter]	Turtle:	Yeah
KB:	*Right. And what films have made you..think about things then?*	KB:	*And what, what's your definition of a good hero then?*
Mike:	James Bond films things and stuff like that, all they gadgets he got.	John:	Sylvester Stallone! [laughter]
Turtle:	*True Lies*	Turtle:	Arnold Schwarzenegger, people like..
John:	Yeah! *True Lies* was good.	John:	Van Damme
Mike:	But it was over-exaggerated, most of it	Turtle:	Who's just built theirselves up into, like, hype, they've just hyped theirselves up all the time
John:	It was good though! It was funny!	John:	Yeah. And they're well-recognised as well.. and well-known and stuff..
Mike:	That end of the missile, or whatever [chuckles]	Turtle:	Yeah they.. get a good reputation for good films and stuff
Turtle:	The lady on the front of the plane, just holding on! [more chuckles]	KB:	*Right*
John:	When I see a film like that, I tend to think of all the special effects, and how they do it, and stuff like that	Turtle:	And you just think 'oh, I gotta see his next film'. Or her next film.
Turtle:	They just make you want to be in a film, sort of thing	KB:	*Yeah... D'you think there any female..?*
John/Mike:	Yeah	John:	Renee Rousseau
KB:	*So that's part of the uh, apart from, like the plot – I mean you said that, you know, your ideal film then would be, something with a good, decent story, something with like, a lot of violence in it, um, possibly some, sexy woman with a gun, um, what was the other thing, lots of special effects?*	KB:	*Who's she then?*
		John:	She was in *In the Line of Fire* and *Lethal Weapon 3*
		KB:	*And, and.. she's a good female hero?*
		John:	Yeah. She, she, she knows karate
		Mike:	That's her is it?
		John:	Huh?
		Mike:	That's the one who went out with that.. in *Lethal Weapon 3*.. the one who went out with..
John:	Yeah	John:	Mel Gibson
KB:	*Anything else?*	Mike:	Yeah
Turtle:	Well, action, adventure, violence, stuff like that really	John:	Yeah
		KB:	*And what makes a good female hero then?*
John:	Good hero	Turtle:	Fighter..yeah..martial arts like stuff and guns, and stuff like that
		Mike:	Strong

KB:	So much the same then really	Turtle:	People like that.. so like so that they can get it into their head like, don't do crime, and drugs.. stuff like that..
Turtle:	Yeah		
Mike:	Bit of humour with them		
KB:	Right. Who do you think, um, I mean what – sorry – do you think like the film Judge Dredd then will have a message in it, I mean like you were saying about Lethal Weapon 3...?	John:	Yeah teenagers.. and Jonah Lomu
		KB:	And who?
		John:	[laughter] Jonah Lomu
		KB:	What's that?
		John:	New Zealand Rugby player
Mike:	Yeah I think it will, it'll be..	KB:	[laughter]
John:	I think that um, uh, it'll be a really, really dirty streets, stuff like that, and the message there will be trying to get across, is like, it's gonna end up like this, if we're not careful	John:	He's solid! He's unbelievable
		KB:	Right. I'm gonna have to spell that when I type this up. Um, so mainly, sort of teenagers, you think, this film's gonna be aimed at?
KB:	Yeah	All:	Yeah
John:	Stuff like that. Loads of pollution and lots of crime	KB:	Um, what, what type of teenagers, a particular type of teenager?
Turtle:	Loads of like, people with guns on the street		
John:	Violent police officers, stuff like that.. that's probably what...		
[tape blip]	Turtle:	From 15 upwards, well, yeah, 15 upwards.. people who are like, most likely to get into drugs and stuff, just to prove they're hard like,	
Mike:	[...?...]		
Turtle:	They're like, putting over the message like, if we don't do summat about it, soon, about the crime and stuff, then the police officers are gonna get armed and start fighting back sort of thing	John:	To make a point
		Turtle:	Yeah. Just to make it look like they got a bad reputation
		KB:	So what you're saying, people'll go, who, people will go and see this film who, what just to make a point that they can get in or-?
KB:	Yep		
Turtle:	Start blowing your head off if you don't do summat right	Turtle:	Yeah, stuff like that
		KB:	Right
John:	Yeah	John:	Just to say look, I got into an 18
KB:	Right. Um, who do you think this film's gonna be aimed at then, what kind of people?		
		KB:	And does that go on then, is that like a bit of a is it, I don't know what the word is these days, cool thing to do [laughter]?
Turtle/ John:	Teenagers		

41

Turtle:	I think some of my mates would. They just go just to say oh, I got in			*said there about..being brought up in a different era, I mean, what's the difference do you think?*
John:	Yeah...to say I've watched it		John:	Like, um...
Turtle:	But I just go, go and see it		Mike:	The 50s
John:	to enjoy it..		John:	Like our time now, is, much more violent..and crime ridden..
Turtle:	cos I..want to see it			
KB:	*Right...right...so who, what type of people would enjoy it most, do you think?*		Turtle:	Our Mum, our mum grew up with..
Mike:	Boys		John:	Than the 60s or something..
KB:	*Why is that?*		Turtle:	My Mum grew up with something like um, *Copacabana*, something like that, if that were a show or something..or *South Pacific*
Mike:	Uh, it's just...one of they films, innit			
Turtle:	It's like...I dunno...something like, that's bad about it..it's got like..			
			KB:	*Yeah, yeah...*
Mike:	Violence...Loads of...beating people		Turtle:	But, we've grown up with like, *Star Wars*, stuff like that...all the star films and stuff
Turtle:	Thing is, it's in that [?]...cos they're most likely to do crime and drugs and stuff			
John:	Boys are more, more prone to, to violence as well		John:	*Kick Boxing* King! Stuff like that
KB:	*And who, who would enjoy it least then?*		Turtle:	And it's all like army films and stuff today, *Full Metal Jacket* and stuff like that
John:	Old people! [laughter]			
Turtle:	Me mum!		KB:	*Yeah*
KB:	*And why, why is that?*		Turtle:	It's like, it's got to have guns in nowadays, it's got to have something to do with guns and something to do with drugs
Turtle:	I dunno, she just likes,			
Mike:	They don't like..violence..			
Mike:	My Mum likes..Love films, sort of thing			
John:	And they grew up in a different era		John:	To sell, to sell now, people have got to die, there's got to be some scandal, something like that
Turtle:	Yeah and my Dad, he'll just watch anything, anyway, just to like talk about it to his mates like			
			Mike:	Yeah
KB:	*Yeah, right*		KB:	*Right! Um, anything else you want to add, that you can think of, that I haven't asked you?*
Turtle:	"I watched this film the other day, it was a, a young film, all the kids are talking about it..", like			
KB:	*Right. So what, what do you mean when you just*		End.	

POST-FILM INTERVIEW

KB: So when did you go and see the film, then?

Turtle: Erm, about..

James: ..On the night it came out I think, one day after

KB: Right

Turtle: Something like that, yeah

KB: And did you go together, or..

Matthew/
James: No, no, we didn't

James: We went with other friends

KB: Were they other school-friends, or...?

Turtle: No I went with me dad

KB: Right. And when did you decide to go then?

Turtle: When I heard about it.

James: I saw a small clip of it on Sky

Matthe: And that, probably just the [indistinguishable]

KB: Right. And which cinema did you go to?

Matthew: Showcase

James: Odeon

Turtle: Odeon

KB: And why, why did you go to those cinemas?

Matthew: Cos, it's a 15 you know. Did you know that, I'm sure...

KB: Yeah [laughter]

Matthew: I'm having my birthday soon

Turtle: Yeah, honest, honest!

James: Um, some of us had never been to the Showcase before, so..a lot of people say it's quite good

KB: Right. And do you normally, do you normally see films that you're not

Matthew: Er, well, well, [talking over each other, laughing] I don't go to a cinema that I like, I just see films that I really want to see.

KB: Right. And why did you really want to see Dredd?

Matthew: I studied the clips from it and it looked really good and everything

KB: Right. What about you two, why did you go to, why did you choose the Odeon?

James: It's cheap [slight laugh]

Turtle: It was the closest place cos I was on holiday and it was the only cinema we knew in town.

KB: Where were you then?

Turtle: Weymouth

KB: Oh right – very nice... Um. And is it different, I mean obviously it is quite different but is it, how different is it like when you go to the cinema say with like your parents or with friends? I mean, what kinds of things do you do that are different?

James: When you go with your friends, you can just..walk about.

KB: Is that like before and afterwards?

James: Yeah

Turtle: It's more of a laugh with your friends cos you can talk about it after, like, and take the mickey out of it if it was crap, and stuff like that.

KB: Right. Cos what kinds of things do you do then if you go out to the cinema with your friends? I mean, you know, sort of before and after the film?

Turtle: Organise all the lifts, who's picking up and who's taking. That usually takes about half hour. Then we

	wait for everyone outside the cinema, and then we goes in and gets the tickets.		KB:	*So why don't like those kind of films, then?*
Matthew:	Sometimes people want to go down around town about 11 o'clock, just to find out, like...		Matthew: KB:	Just, just boring *Right..and why do you like the Action?*
Turtle:	...like, nothing's open [laughs]		Turtle:	Cos it's always fast and it keeps coming at you quick, like.
Matthew:	Hang out [indistinguishable]		James:	[indistinguishable] and it's like late at night and it's all dark [general laughter as they enact a scene]. When you're watching a slow film you want to go to sleep, probably, more than you want to watch it.
KB:	*So what do you do, you know, if you go round town?*			
Turtle:	Get beat up [indistinguishable] get mugged by those people in the night clubs.			
KB:	*Right..um, how do you normally get to hear about a film you want to go and see?*		Matthew:	It's not boring, if I'm watching Action
			KB:	*So, so when you went to see Dredd, then, was it a kind of typical night out for you at the cinema, I mean did you do the..*
Matthew: James:	Billboards, um. Magazines, and telly and stuff		Turtle:	Yeah, we've run out of stuff to see now haven't we?..
Matthew: KB:	Just telly, really *Right..and what kind of films do you like, then, what kind of films would you really sort of want to go and see?*		Matthew: Turtle:	Yeah ..Seen everything now..and the only thing we didn't want to go and see was *Asterix* or something like that which is only in the cinema
Matthew: Turtle: KB:	Action films. *Die Hard*, that was good *Right..and what kind of films would you never go and see?*		KB: Matthew: Turtle: KB:	*Right* *Casper* Yeah..that was good *Em..what did you think, then, of the first ten minutes of Judge Dredd ? You know, the opening scenes, what did you think when you saw all that?*
Turtle:	My Girl 2 [general laughter of assent] But we went and seen that			
Matthew:	Romantic films, and stuff like that			
James:	...*Waterworld*.		Turtle:	I dunno, I thought it was
Turtle:	Which we've seen as well, which was great		Matthew: Turtle:	..Slow ..Yeah
KB:	*Yes, I remember you saying about My Girl 2*		Matthew:	It usually is, isn't it, when you see a film
Turtle:	Yes, that was great fun that was...[ironic laugh]		Turtle:	You expect it to be slow, though, cos it gets into the film. It tells all, like, the

background of it.

KB: *Right*

Matthew: It don't get too violent too early

KB: *So what was slow about it? What did you..*

Turtle: Cos they were introducing everyone, like, and everyone that they use, and stuff

KB: *So what would you have liked to have happened in the first..*

James: No, I think it was alright, cos if you've got too much action in the first bit..it doesn't tell you much about the film

KB: *And what did you think, cos, did you know about the comic before uh..?*

James: Yeah (all)

KB: *How often had you read it?*

Turtle: I gets it every week. I get the weekly one now, and I used to get the monthly one.

James: I've only read it a few times, but my friend's got a load round and he lets me borrow them

Matthew: I didn't [indistinguishable]

KB: *So, the two of you who've read the comic, what did you think of the first sort of..*

Turtle: I dunno, it was like a typical comic, really, the film..

James: Yeah..

Turtle: ..cos it's the same as the comic. The comic always got summat to do with, like, baddies and then he's got to go and get it back and then the next baddy he'd have something else and it'd keep going all the time.

KB: *Right..and what did you think of Sylvester Stallone being Judge Dredd ?*

James: I reckon he looks a lot like him, in the comic and that

Turtle: ..Yeah he does..

James: Cos in the comic he's got like a massive chin

Turtle: ..His chin and his cheeks, isn't it?

KB: *Right. And what did you think, cos, I mean, not knowing anything about it?*

Matthew: I knew stuff about him but I just didn't, like, read him...I never read, the cartoon..the magazine, like, and I thought, like the film would be based on the magazine. But like he said, the magazines are changed every time, so it's pretty new one, a different story

KB: *Right..em, what did you think of its ending, then if you can remember it?*

Turtle: Yeah, well, it's they all got caught, isn't it? It's gotta happen, ain't it, in every film? It's the same. It weren't really different. All the baddies got caught, and like jailed or killed.

James: And you see, you get half way through, and you see like who the baddies are and everything, you know by the end that they are going to be killed or caught or something like that.

Turtle: But you still go and see it cos it looks good.

KB: *Yeah.. so why do you think you watch films like that, even though you know sort of what's going to happen?*

James: Well, you kn..

Turtle: ..Something to talk about

James: ..You know it's going to be different from another, it's not going to be exactly the

Turtle: same Sometimes it's just the people that are in it, and they're going to make it good or it's going to be bad.

KB: *Right..em, what about its, I mean, obviously set in the future, and what do you think about that kind of view of the future?*

James: Well, stuff like the bikes and everything that was good, but all the lives and everything was tat [?]. I didn't like that.

KB: *And what didn't you like about that?*

Turtle: Well it was like all [indistinguishable] wasn't it and..

James: You would have thought it would be like nice where everything was like nice and everything. But it was a state really for the common people..

Matthew: It was stupid, it was only a small area, and it didn't seem to, cos there was a massive wall, wasn't there, around the outside..

Turtle/
James: ..yeah..

Turtle: like a barrier, wasn't it?

Matthew: cos one of them had to take the Long Walk..

KB: *And what about the kind of story, then? What did you think of the story that the film had?*

Matthew: Well, he got wrongly accused or something and they, like, he got cleared..

Turtle: ..He sort of got cleared and all that, and then become a cop sort of thing, get his own back on the other ones that set him up.

James: ..His brother wasn't it?

Matthew: Well, yeah, like, well, it wasn't like his true brother, really, a man-made sort of thing

KB: *Did you think it was a good story or a bad story?*

Turtle: Yeah, it was good, but it wasn't the same as the magazines, cos the magazines have always got a different like baddy or something.

James: I was going to say like, if you can remember a storyline from after a couple of months, it was quite good. If it can still make you remember..

KB: *Em..when you were watching it, did it remind you of any other kind of films or..anything?*

Turtle: Er..not really..

James: ..Just the usual..

Turtle: ..Goody wins and baddy dies and..

KB: *And do you think it will be like that in the future, kind of..?*

James: Na..doubt it..not horrible..

Turtle: ..Not in the year 2000 anyway. Might be like millions of years away. There's no way you can get flying little taxi things..

KB: *..not for a few years..when it [2000AD] started, I suppose it seemed like really far in the future, didn't it, cos you'll be, what, twenty, nineteen?*

Turtle: ..Twenty..

KB: *Em, so generally what did you think of the film? What were its sort of good and bad points, do you think?*

Turtle: I think it was like, it was good cos it had quite a lot of action in, and it was bad

cos it was slow to start and it was slow in the middle when he was getting sentenced and everything..

James: ..Yeah, it took too long..

Matthew: [Indistinguishable] cos when they crashed, you couldn't really understand why. They crashed and then the bloke said there's still some you know people missing, I can remember them saying that. And then those cannibals collected them up.

James: The thing is, why did those cannibals only pick Stallone and that other bloke if there's like three or four of them..

Turtle: ..Yeah, there's more..

James: ..Why did they only take two?

Turtle: It's always the main characters, isn't it?

KB: *So did the plot have a lot of those kind of things in, do you think that made you think well what's going on there, then?*

Matthew: It had a few bits, not a lot really.

Turtle: It was just like the bits where he was getting sentenced, and you had to listen..

James: That made it stop, the sentencing got a bit too complicated, wasn't it, showing all the gun details and everything.

KB: *I got lost, all that stuff about the Janus project and there was, I lost...em..would you see it again?*

Turtle: ..Yeah..

James: ..I'll probably go and buy the video when it comes out. I quite like that.

KB: *And why would you see it again?*

Turtle: To remember it, like.

James: I wouldn't go and watch it again in the cinema or anything, but when it comes out I'll definitely go and buy it.

KB: *Right..and why would, why would you do that? Why would not go and see it in the cinema but buy it?*

James: Cos you can have it, well, after I've watched it three or four times at the Showcase that would be like sixteen pounds and I couldn't afford it.

KB: *Right, right, yeah..*

Matthew: ..And you can have it whenever you want it, to see like, instead of going where is it in the cinema in a couple of years time.

Turtle: It's good, cos when your mates ask you for it, and you've got it, you know..

James: ..but like I think it would be boring if you watched it too many times in a couple of months, if you went and watched it..

Turtle: ..and you can exchange it with your mates for another film that they've bought, like

KB: *And do you do that, then, I mean, do you watch a lot of videos?*

All: Yeah, a lot

KB: *And do you watch them with your family, or friends, or on your own..*

Matthew: Well, I watch quite a bit with me family, but..

Turtle: ..Mostly with friends..

Matthew: ..I'd tape it if there was something really good I want to watch and I didn't want my younger brothers spoiling it I'd probably tape

47

	it and watch it next day with my friends or on my own		mind that.
KB:	Right..and what about getting videos out from shops and things?	KB:	Right, so, when did you start watching films that are around 18? [Laughter]
Matthew:	I did used to, but I got Sky now and it's on within 8-12 months..	James:	Oh..I saw a really s..., a really horr..I was watching a video...my friend come round with a video , it was really good...? was it one of the? I think it was the first *Poltergeist*, I don't know, it was really good like ghost story. And I watched it, and it really done my nerves [?], it scared me for a bit afterwards. But now I'd watch it, like, Action ones and they wouldn't scare me and I thought they were good. Apart from there, really.
Turtle:	I just rents it, from the Co-op..		
KB:	Right..and what about em we talked about this last time, didn't we? like videos that are 18 or whatever? Where would you watch those?		
Turtle:	Yeah, if me dad gets one. Cos they always say you've got to have your parents with you, so I just take me dad with me and he gets them.		
KB:	Right. And I mean do you watch loads of videos that are..	KB:	What did you say when you saw Poltergeist?
Turtle:	..If they're good, yeah..	James:	Well I was young, I was only about....[indistinguishable]
James:	..By the time I'm old enough to go and watch it, they probably won't have heard of it any more..		
		KB:	Oh right, sorry, I thought maybe. What does that mean, then, that you were scared?
KB:	Right..I mean, what do you think about that kind of that there are classifications for different films? I mean, what do you think about..	James:	Oh I was a bit scared. I mean I was having a bit nightmares afterwards, I remember that.
Matthew:	It's stupid..	KB:	And how old were you then?
James:	..No, I reckon it's alright, cos like there's really young children like eleven or twelve that's copying all the things and words and that..	James:	I was about ten I suppose. Ten, eleven.
		KB:	Right, right..and what about you?
Turtle:	..Yeah, but it'll be up to the parents, won't it, to let them go and see it?..	Matthew:	Oh..I can't remember when I..
James:	[indistinguishable]	Turtle:	It was *Freddy's Nightmare*, I think. I can't remember if it was 1 or 2, it was one of them. And my Dad got it, and he said you can watch it if you want. But if you get
Turtle:	Yeah, well, we do that		
James:	But my Dad doesn't really		

KB: nightmares don't come running here. So I just watched it, and that was it.

KB: *And how old were you then?*

Turtle: I was about eight, eight or nine.

KB: *Right...And you can't remember – too long ago? [to 3] Em. This film, then, the* Judge Dredd *film, do you think it had like a kind of message? I mean was it trying to teach us something?*

Turtle: Warning us about the future..

KB: *..Right..*

Turtle: ..It can get like this if you don't do something about it.

KB: *What kind of things do you think it was after telling us we should be doing?*

Turtle: Don't carry flamethrowers in your pocket. [Laughter] You'll get nicked by the cops.. I don't know, like.. crime's going to increase, and all the cities and stuff are going to decrease into metal and stuff like that..

James: [Indistinguishable] into a box in it and stuff like that.

Turtle: ..It's going to be like [indistinguishable] and stuff.

James: It's a bit stupid, though, weren't it? It don't know how long it's going to take, but it ain't going to be like this.

Matthew: In Dredd, like even in the daytime it was really dark in the city, but when he went outside it was really like bright and shiny.

KB: *Mmm. Em did you read any of the reviews or did you hear any you know of*

the sort of reviews of the film like on the telly..

Turtle: Not really..

KB: *..Right. Who do you think the film-makers were aiming this film at, then? Who do you think they thought was their audience?*

James: People our age..

Matthew: ..Yeah, our age..

Turtle: ..Teenagers

James: [Indistinguishable]

KB: *Right. Em, and who do you think would have enjoyed it the most..of all the people who saw it? What kind of people?*

Turtle: [Indistinguishable]

James: People who like Action, that sort of thing, like to see a lot of Action films. A bit of adventure, and that.

Turtle: I think it would have to be like the person who likes Sylvester Stallone, cos I thought it was crap. But it must have been someone who likes him, or a fan of him.

KB: *So you didn't like the film.*

Turtle: No

KB: *Why didn't you?*

Turtle: It was too slow all the way through, really.

KB: *Did you, did you both like it?*

James: [Definitely] It wasn't as good as I thought it was going to be first of all. I though it was going to be like..one of the films of the decade or something like that. Cos everyone was hyping it out.

Turtle: Yeah, with their plastic [indistinguishable]

James: I was a bit disappointed first of all, but as the film got on, I quite enjoyed it.

KB:	*So the stuff that you'd heard about it was, like, this is going to be really..*
Turtle:	..Yeah, that's like *Waterworld,* it's going to be brilliant, and then you're...falling asleep in your chair. I got told to shut up, you know what I mean. I was chatting to... [Series of exchanges among all three as they rehearsed how they got told to be quiet.]
KB:	*Em, have you come across any of the merchandise for the film, like, the stuff that you can buy.*
Turtle:	Well, there's the figures and stuff?
KB:	*Mm, yeah.*
All:	No
Turtle:	It's all *Terminator* stuff, ain't it?
James:	The thing is, they do all things like that, like bring out Terminators for young kids, but they ain't got a clue what it's about. [Indistinguishable]
Turtle:	Yeah, kids don't have a clue.
James:	And that's for a period of about 6 months, something like that, they brings out a cartoon to get em used to it.
KB:	*Right...and do you think that will happen with Dredd?*
Turtle/ Matthew:	Don't know. Suppose so.
James:	The cartoons and that, the magazines..
Matthew:	Yeah, but the magazine was out before the..
James:	Yeah but it's violent, though..
Turtle:	..the magazine is, yeah.
James:	It's like, you couldn't make it really for the under 12s,

	sort of thing.
Turtle:	I don't think the little kids would understand it anyway. It's got like big words [laughs]. Or there's like names that they use for enemies and stuff, like on the *X-Men* as well.
KB:	*Right. Em – this is my last question. If you were going to make a sort of* Judge Dredd 2, *what kind of things would you want to put in there and what kind of audience would you want to aim at, and things if you were...?*
Turtle:	..Have to make it something that was different, something that no one's done. Make a different motorbike that's faster than usual, and it can fly..
James:	..It would be the same, though, wouldn't it? It couldn't be changed.
Matthew:	All that's on the same lines as the last one, but change a lot of it. Like, the [indistinguishable]
KB:	*Right, well, what kinds of things would you keep or what kind of things would you change?*
James:	Keep the uniforms and that
Turtle:	Yeah, and the characters, you'd have to keep.
James:	..Bring in a few, like, new different bad guys
Turtle:	Yeah..I think they could have done with more bad guys in the film that were out of the magazine.
James:	Right .. cos they kept, well, the same one really, right the way through – that Rico.
End.	

50

What should be done with a transcript of this kind? It was, to our eyes, a successful interview in the sense that the boys had very willingly taken part, and seemed relaxed and comfortable with the questions and the questioner. They hold forth in their own languages, and have plenty to say (if a tad more so in the pre- than the post-film interview). There is a great deal in particular about the process of cinema-going, but it is not at all transparent how this might be relevant to understanding their relations with *Judge Dredd* – how might the ways they organise their watching of films like this shape what they take from them – this being, after all, a central question our research had set itself?

We found it difficult – not because there isn't a great deal to say about it. It was difficult because on the one hand it could be used to provide 'evidence' for almost any position you choose; a determined moral panicker could with ease point to those repeated declarations of love for 'violence', and cry danger, especially given the ease with which these under-age boys appear to get into adult-rated films – but on the other hand, others could as well point to the mass of evidence that these boys are well aware that they are watching films, and know their rules and conventions, therefore well know the difference between cinema and outside. Equally, various existing academic theories can readily find first handholds to sustain their approaches, but they seem to run out of steam very quickly. Are these 'active' or 'passive' viewers? They certainly seem to prefer activity – throwing popcorn, being a social nuisance, and so on – though these seem to be prevalent when they are bored by a film. Perhaps, then, the 'danger' is in the passivity that comes when they find a film they really enjoy?

Are there signs of 'negotiation' of, or 'resistance' to, messages (the standard media studies categories)? This seems a question without much purchase. These boys certainly negotiate a good deal: they have to negotiate their way into cinemas to see films they aren't entitled to, they have to manage parents, girl-friends and the like. But the film seems just to be enjoyed or dismissed, without intellectual effort.

Are films important to these boys? Yes, and no. Yes, by the measure of their unanimous 'Yeah!' when asked about cinema, and in the sense that they go whenever they can. Yet there is a curious stepping back in this exchange:

Mike:	I just watch anything.
KB:	*Yeah?*
Mike:	Anything suits me as long as it's good.
KB:	*So do you go to the cinema quite a lot then?*
Mike:	Not really. Can't afford it.

It's as if there is a relationship with films he knows of and would like to have, but circumstances just don't allow.

We became aware of two contradictory pulls in our thinking in response to a transcript such as this. On the one hand, we wanted to delve into all the complexities and subtleties, and to spend a great deal of time teasing out their

details and implications. On the other hand, we were acutely aware that, though valuable, this might lead us nowhere. We would know a great deal about the local specifics of these boys. What we couldn't gain through that was any sense of patterns in their responses, and of the ways in which those patterns might be of greater generality than just these boys. Yet in many ways these boys thought of themselves as part of wider patterns. They know about 'hype' as a general phenomenon, they are very aware of filmic traditions, they have an acute sense of 'boys' as a group bigger than themselves.

Our approach, then, became one of searching for features which might allow us both to give due attention to detail but also to build a basis for subsequent patterned generalisations. Accordingly, we focused on the following:

- *repetitions:* discursive features which recurred, and particularly if they recurred in different contexts, suggesting some independent force;

- *connections:* any features which appeared linked or combined, with particular attention to trying to identify the nature of the link or combination;

- *distinctions:* separations and oppositions indicated within the boys' talk, which may point to distinguishable operative categories;

- *implications:* moves that are made in the boys' talk which bring into view the implicative structures they are using, and thus the unstated (enthymematic) premises of their thinking;

- *key concepts:* any ideas expressed which appear to act as organising foci for making sense, in the boys' talk, of other particular elements;

- *modalities of talk:* any situations where the way the boys talk about something constitutes development or modification of the overt meaning;

- *puzzles:* any kinds of talk (concepts, references, explanations or even absences) which are at first sight surprising, but with the aim of identifying what in us was surprised by them.

Our tactic, then, was to see what small-scale, local schemes of explanation might be generated by the search for these. Initially tentative, they could at least provide the basis for comparisons with other interviews.

With these to hand, then, we begin in no special order to take note of some of the features of this interview, without any pretence at 'completeness' (if indeed that idea can have meaning here):

1 Certain words and phrases do get repeated, and usually in close association. The most obvious examples are the words to describe and judge films such as *Dredd*: 'violent', 'action', 'bad side of things', 'safe', 'wicked', and 'fast'. This colony of expressions is interesting in as much as it points to a possible point of view from which films may be assessed. This point of view acknowledges its grounding in a shared culture (hence the use of in-words such as 'safe'); sees the world from the sides of both good and bad; and associates these with a kind of speed and excitement. This raises the possibility that words such as 'safe' constitute a bridge between individual likes and dislikes, and culturally-grounded ways of judging. This, we would argue, is a good example of what we mean by a key concept.

2 Seeing a film appears to involve elements of performance – not just in the obvious popcorn-chucking and irritating of neighbours, but also in what you do if a film is bad. Several times, the boys claim to 'almost fall asleep' in films like *My Girl 2* or *Circle of Friends*. Yet in almost the same breath one of them tells of having to be told to shut up for talking throughout such a film: hardly snoring, more talking through! This isn't a contradiction, but it suggests that being their kind of member of a cinema audience is to play a certain role. Interestingly, though, there are non-Action films which don't produce this response. *The Lion King* can be enjoyed in another way. This raises the possibility of exploring the ways in which people such as these boys take on a certain viewing role for a film like *Dredd*.

3 'Once you've seen the first one, you understand them all. But you gotta see the first one to understand the rest.' The implication of this comment on the 'Freddy' films is interesting: it points to a knowingness on the part of the boys, which is repeated elsewhere, in the several-times-used phrase 'Usual stuff'. They not only know about films, but they seem to value knowingness – it is part of their goal to become knowing viewers. The question is: what kinds of knowledge matter to them? For other parts of their answers show that their attention to publicity is quite casual, primarily involving watching special effects and action scenes in trailers to check out their 'hype' rating. In the boys' own talk, then, there seems to be an implicative structure, linking knowing what to expect with being ready to attend to the film in a chosen and appropriate way.

4 But with this goes something which did puzzle us: a virtual disinterest in the plot of films. These could be digested, and spat out, in a single phrase: 'Just the usual. Goody wins, baddy dies'. But this isn't a criticism of a film, it is just how things are – and then it is possible to move to what counts in assessing a 'violent, Action' film: its speed. Two thoughts emerged from this, in particular: first, was the beginnings of a suspicion that film theory and analysis has been far too engrossed in ideas of narrative, and their role in implicating audiences – let us call this 'plot-centricity' – whereas 'plot' for at least these viewers might seem no more than a carrier-wave enabling them to get at the aspects of the film which interest them. And that raises the second thought, that perhaps 'watching' is the wrong word to depict their way of relating to films. Without according this the dangerous implications that some might wish to find in the idea, it would seem better to say that they want to *participate* in the film.

5 The emphasis on the pace of the film seems to supersede every other criterion. They will (just) forgive a film for having a slow opening – that may be necessary just to establish characters and situation. Thereafter, anything that causes 'slowness' is a problem, particularly if it requires you to concentrate on making sense. Something that 'made it stop' (say, for example, a scene with a lot of dialogue) in that way would damage the film greatly, in their eyes. A film is most enjoyed if it does something to you: if it makes you jump, or wince, or laugh. That raised for us a question which subsequently became crucial: what might it be possible to learn through an investigation of the vocabularies of pleasure used by film-goers?

Just as importantly, we need to see that it is the ground on which disappointment is possible. 'Pace', 'excitement' and 'being done to' seem to constitute ideals

towards which their Action-film cinema-going is directed. Films are judged for how well they live up to this desired ideal.

6 What makes them go to see a film: easy, it's 'hype!'. 'Hype' constitutes the public claim to attention by a film, but of particular kinds. They emphasise drama and excitement, promises of new-ness, and spectacular achievements from great expenditure (from money, energy, technology, stars, etc). But caveat mercator: a film had better be as good as its hype. Hype, then, seems to function as a measure of expectations, to be met on the day, or else. We might take from this an idea of readiness to view, which is in part at least fashioned by the perceived meanings of a film's publicity.

7 These boys know their cinemas, and they know their preferences among them, even if they can't always get what they would ideally like – and note again that notion of an 'ideal'. In little doses, we began to see the presence of expectations and preferments against which experiences would then be judged. The Showcase multiplex is best because in several ways they can get 'control' there: they can manage to get entry OK, it has the requisite popcorn, it has other leisure options to hand. The Odeon will 'do', but that's all. The Showcase has reclining seats you can rock, and it has sound that goes 'all round your head'. Others aren't even on the map. We raise the idea, already generated for us in the previous chapter, of a social geography of cinemas.

8 In the other direction altogether, they know what others think, and in particular worry, about films. They know the standard condemnations: 'sexism', and 'violence'. As David Buckingham has astutely shown,[11] these boys mark a distinction. On the one hand, there are their own mature responses to films (and those who know well recognise these things – Mum recognises he's growing up, and doesn't now mind him watching *Basic Instinct*). On the other, there are 'kids', young ones who probably need some protection. Not that they ever inhabited that category. Having been frightened had done them no harm – they'd seen horror films once and been scared, but after that it was no big deal. Still, the fact remains that these ways of talking about the 'risks' of film are well-known to these boys. They know their effects on what they can or can't watch – TV is worst, because the worst cut. Video next, with Dad's help. But cinema is the real thing. There is an apparent acceptance that adult power just is there, to be got round if possible. Irrelevant, but there. And they recognise the tendency to 'preachiness' in films where a 'message' gets larded on them. In short, in a complex variety of ways, a point of connection is their awareness of what we choose to call the disciplinary discourses of dangerous media.

They know about adults and their moral discourses, of course, and accept that these are going to come up in films – and they don't really mind as long as they are not 'too preachy', and as long as they don't spoil the pace of the film.

9 The boys are very aware of themselves as 'boys', but that is not something fixed and given for them. They are aware of having grown into it, as therefore a stage of life for them to pass through. They are also aware of the category 'boys' as something which they are, in a way, enticed into, with attendant risks, and attractions. They can be in other categories for some purposes, but those others are even more provisional, and certainly distant at the moment. This raises a

fascinating question: are there ways in which identifying oneself as a certain category of viewer imposes expectations as to how one should watch?

10 Stars: they know what stars are and do, they know what Stallone is, and they know in what way Stallone is different as a star to them. In fact, one of them gives an astute one-sentence summary of Stallone's star persona: 'It's good cos he always gets beat up and then just comes back and decks em'. They also value and share the in-jokes where Stallone and Schwarzenegger joust over their personae. This puts a complexity into their declarations that he is a 'role model', especially given the hint (it's no more than that) that closes their three-handed discussion of Stallone:

John: Someone to look up to, like someone.
Mike: Yeah, role model.
Turtle: Someone that's, that's powerfuller than you and thinks, "Oh I wanna be like them" so you wanna go to see it like, to, just to...
John: To style yourself in a way.
Turtle: Yeah, just to dream, that you could be like them, sort of thing.

Knowing stars, knowing stars as having personae, knowing that their films embody and play with their personae, knowing they are 'larger than life': all combine here to create a complex relationship with a core of admiration and dreams. This must make us think about relations to stars as a significant question.

11 Video carries different meanings and possibilities to cinema. Although sometimes chosen for pragmatic purposes (because cinema is expensive, or because age-classifications can debar entry), video anyway offers different pleasures. Cinema seems to be for submersion, for hopefully losing oneself in an experience. Video is for playful revisiting of that experience, in uninhibited company. The recurrent word in all their talk of video is 'laugh', in contexts where it clearly means having an intensely group relationship in group-controlled space to their chosen films. Video, in other words, carries a socially-distinctive meaning to cinema, but one which seems to link with their broader relations to film as a whole.

12 Talking about films is a normal thing for these boys, and their talk with us had some striking characteristics. There is a staccato quality to exchanges, with bursts of speech following each other at great speed, to the extent that on many occasions we hear one of them finishing a sentence for another. And they agree so widely with each other. The moments when they feel constrained to be reflective, a sense of slight awkwardness sometimes intrudes, as if this isn't what one does with film. Yet clearly films are watched to be talked about – in particular ways. In this sense, they become pieces of collective property, ownable through talk. This raised two questions for us: first, what modalities of talk might go along with different ways of relating to our film? Second, and very complicatedly, how on reflection can this be managed in interviews? This had implications for how we are perceived to (want to) talk about the film, and the relations of our expected and actual kinds of talk to theirs in the interviews. In short, we were hard-pressed to deal with the social relations of interviewing, not least in light of the public perceptions of our research as being about 'violence' and its dangers.

We hope we have shown convincingly that audiences such as the Boys' Club group pose problems, but offer great opportunities, for understanding and interpretation. While it is possible to find hints of patterns and relationships, there are also just acres of difference. Later, we return to these transcripts, to show how far in the end we were able to take their analysis (see Chapters 9 and 13).

This, then, was the outcome of our first encounter with these transcripts (of course, to some extent clarified by retrospective revisiting for this book). They constituted a set of insights into particular aspects of the boys' relations to *Dredd*, but in truth with little sense of an overall pattern (although it is worth noting that many of these points recurred in other interviews, mainly with boys, but also with some girls and some older men). Readers will no doubt find much more than these twelve, as indeed we ourselves did. Rather than pursue more of those, we've chosen to follow where we went at the time: to a comparison with other interviews. For though the particular contents might be different, other transcripts displayed equivalent patterns of conceptualisation, connection, distinction, and implication.

1 One author who very honestly tells of her difficulties is Joke Hermes. Her *Reading Women's Magazines* contains a wonderful Appendix in which she details all the difficulties of locating and gaining access to interviewees – including one sad but to us highly recognisable story of being sent on a wild goose chase to a house that did not even exist. See Joke Hermes, *Reading Women's Magazines: An Analysis of Everyday Use*, Cambridge: Polity Press 1995, Appendix 4 'The research process'.

2 A common response, in fact, was to say 'What a jammy job! Getting paid to chat to people about films all day long!' Curiously, it was hard to protest about this, without suggesting that they should worry that perhaps we were doing something more than just 'chatting'.

3 Focus groups have become the topic of a vast amount of writing, most notably by David Morgan and Richard Krueger. Their (1997) *Focus Group Kit* now runs to 752 pages, indicating how widespread is their use, including increasingly for political spin-doctoring. But very little of Morgan and Krueger's work addresses the political questions raised by the purposes and social context of such researches. See David L Morgan & Richard A Krueger, *Focus Group Kit: Vols 1-6*, London: Sage 1997.

4 Sidney Levy, cited in David L Morgan, *Focus Groups as Qualitative Research*, London: Sage 1988, p.18.

5 David L Morgan, *Focus Groups*, p.50.

6 Ien Ang, in Ellen Seiter, Hans Borchers, Gabrielle Kreutzner & Eva-Maria Warth (eds), *Remote Control: Television, Audiences, and Cultural Power*, London: Routledge 1989. This quote, p.104.

7 Barker has faced just this problem in his researches on fans of *2000AD*. See his essay 'Taking the extreme case', in Deborah Cartmell, I Q Hunter, Heidi Kaye & Imelda Whelehan (eds), *Trash Aesthetics: Popular Culture and its Audience*, London: Pluto Press 1997, pp.14-30.

8 A few exceptions. At the UKCAC session, not everyone was asked every question, since we had a rolling attendance which made it impossible to ensure that every topic was broached. The interviews with film-refusers clearly could not ask those questions which depended on knowledge of the film. And in one or two other interviews, time was limited. For instance, in two of school groups the class bell rang just before we had finished, and we had to curtail the discussions.

9 One tape, the aforementioned Science Fiction Club's, proved unhearable, because of overwhelming background noise.

10 The proportion is much larger than might at first seem the case. In a large number of cases, it became impossible or inappropriate to give out the form. In several interviews, we had too strong a sense of people doing us a kindness for us then to ask them, as well, to complete a feedback questionnaire. In some other cases, we lost contact with people whom we had hoped to interview for a second time. In all, we estimate that the real rate of return was just under 50 per cent.

11 See for instance David Buckingham, *Children Talking Television*, Brighton: Falmer Press 1993.

WHAT DO AUDIENCES DO?

W hat do our other interviews show to correspond with all the aspects we began to observe in our Boys' Club transcripts? What follow, are gleanings which seem to show just these same processes. These allow us to start thickening our descriptions of these elements. It also quickly becomes apparent that many extracts cross boundaries and deal with several of our topics at the same time. This may seem an obvious point, but it does encourage an idea that perhaps the small implicative structures we began to identify may be components in larger patterns:

Ideals

> 'The film has got a LOT to live up to, so I really hope it does well for its own sake' [Interview 2]

The Boys Club transcripts displayed ideals that centred on sensuous responses. These are repeated in many others, but by no means all. Here, another group of boys declare their 'best':

KB:	*So what else would you have in there then?*
Martin:	Lots of scary things
KB:	*Why?*
Martin:	Things that make you jump
Lee:	Yeah, those sort of things, that get your adrenalin rushing!
Johnny:	An adrenalin rush off a film!
Martin:	Do you get em?
Johnny:	Not very often no
KB:	*What kinds of films do you get that from?*
Johnny:	Uh – *Basic Instinct* [laughter/ groans]
KB:	*Because it's scary or--?*
Martin:	Um, what sort of films..?
Lee:	Horror films
Martin:	Yeah! Horror films like, when they got a brilliant story and that, and then
Lee:	It makes you jump
Martin:	And you don't know what's gonna happen next, and you feel all uptight, oh shit what's gonna happen, what's gonna happen,
Lee:	The music sort of,
Martin:	Yeah! The music starts going and
Lee:	It makes you jump
Martin:	Yeah, they sort of films, I love them. [Interview 40]

One striking thing about this extract is not simply its openly declared love of the 'adrenalin rush', but the way it is told to us – their talk becomes a virtual re-enactment of the experience, in which their comments gradually pile excitedly on top of each other.

Others would recognise the love of sensuous cinema but put it in a different context. Here is one self-acknowledged film buff glorying in the sheer magic of cinema for its own sake:

John: Films are made for cinema so the ideal place to see them is the cinema on the big screen, sat in the dark, especially today, the sound is all around you. ... I don't very often come out of the cinema disappointed, I usually enjoy a film. ... I read a review, one of the reviews of the film which Sylvester Stallone was eventually, as he has made the transition from a three-dimensional character to a two-dimensional character at last. Which I think was written down as a bit of a put-down but umm, that was a compliment to me, because if somebody had tried to put a comic strip character on the screen I thought that was exactly how it should be done, as two-dimensional. [Interview 23]

The transition in this is significant. For him, any film can be right if you know what sort it was meant to be. There is nothing amiss in enjoying two-dimensional films, because that is what some of them are, and should be. They can be contained within cinema's spread.

Others don't see it that way. For some of our interviewees, factors outside cinema exerted rights over how a film like Dredd ought to be made.

Don: Em. I liked the first twenty minutes. And after that, it turned into a bog standard Sylvester Stallone sci.fi. flick. Erm. The introduction of the ABC Warrior was quite good, but it looked like Hammerstein, everyone expected it to be more like Hammerstein and he wasn't, and that was both a relief and a disappointment. Em. Their handling of all the characters, characters with solid backgrounds, characters with long pedigrees was just thrown straight out, and they just took names from the comics and attached them to people who they had no relevance to at all. McGruder, Griffin, Silver, the lot, in their handling of the Angel Gang it was just like they were there, they were presented, they were a threat, they were wiped out, like that. And OK, maybe that's how Dredd's meant to be, but em, it wasn't what, what the characters deserved. [Interview 28]

To assert 'deserts' is to make strong external demands of the film, measures it must live up to – and didn't. To many *2000AD* readers, this mattered a lot – if the film didn't take their comic as seriously as they did, it would be an insult:

KB: *What about you, who would be your Anderson?*
Stuart: Anybody really. Since Bolland drew her first, she's always been sort of tall, with long blonde hair, so maybe to stick to the way she's always been

drawn, but no, as they could act, that would be my, my thing, to actually play the part as it's supposed to be. But I would actually put no name, I would not be bothered as long as on screen they, you know, they played Anderson as Anderson's supposed to be.

MB: *Right, right.* [Laughter of relief in the room ..]

Don: Excuse my laughing at that, but I mean, playing Anderson as Anderson's supposed to be ..

Stuart: Well yeah alright, I mean yeah, in the film you'll probably get some big-chested long blonde haired bimbo who'll just sit there, you know, in a very tight uniform showing her tits off the whole film .. [Interview 28]

But it's important to see, though, that knowing the ideal is not the same as expecting it. Indeed, one of the recurrent features of very many of our interviews was, if you like, getting ready to be disappointed. Nowhere was this stronger than among the *2000AD* readers – one of whom nicely set Dredd within a general tactic he now adopts with the cinema:

Matthew: I think there's a bit of strategy now for me, where I don't try and have too many expectations about a film, so that I won't .. and that leads me quite smoothly onto Dredd because I tactically lowered my expectations cos I had heard pretty much that it wasn't, there weren't going to be any brilliant intelligent surprises to it .. [Interview 35]

This two-sided attitude, having an ideal, knowing it won't be met, therefore tactically reducing your expectations is, we suspect, very widespread.

One of the first aspects of cinematic ideals is audiences' recognition of how much is at stake, and how much that inevitably constrains the film company:

Munro: Like, they, they need a big name to carry it off now, nowadays, films like that, you've got to have a background, especially a big name star

Gary: Especially with a big, big sort of name cartoon, a lot of people won't have read it or have heard of it, so you need Sylvester Stallone so that people go, oh, Stallone, yes, he's got some good films behind him, and go and see it

Herb: Also, I think they're trying to go out to the, the younger element again, so it's going to be, a good seller, all the youngsters are going to see it, we're talking from, I dunno what, how many young people do read *Judge Dredd*, but um, it goes up into adult, they've got such a wide audience

Munro: Depends what certificate it is, when it comes out..

Herb: Haven't they decided yet?

Munro: Um, I dunno, I think it's going to be a 15. But that'll affect it quite a lot.

KB: *So do you, have you, uh, you, you know quite a bit about the forthcoming film then, yeah, do you?*

Munro: Yeah, I've just read stuff and seen stuff about it, I mean, it's..it's supposed

to be the most expensive film ever made in this country, which, I mean, means it's got a lot riding on it, it's got a lot at stake, I mean, if it doesn't, doesn't work... [Interview 2]

This intense awareness of the risks faced by the makers then couples with their own hopes and fears:

Munro: Hopefully it's going to be exciting, but it's not gonna be predictable, like, you know, stuff like *Demolition Man*, that, he's done in the past, and that sort of stuff, is very American, very .. Stallone

Herb: There's nothing more annoying than a predictable film, I can't stand that, I really hate that. [Interview 2]

Notice the histories being drawn on – Stallone's, the comic's – and the assemblage of these into an operative category ('that sort of stuff ... very American ... very Stallone') which then grounds their own suspicions of likely disappointment.

What is also important, though, is that these categories can carry different judgements, or tactics of response. Here is one Stallone fan showing his tactic of dealing with the moment of watching:

Richard: I mean I thoroughly enjoyed the film, but I think, um, I mean I, I really have mixed feelings about it. I think as a piece of entertainment, it was very impressive. I thought it really was a very good example of a good summer popcorn movie. Plenty of action, plenty of entertainment, there was a comedy, comic relief in the film, visually I thought the film was stunning, and that's something I really couldn't fault the film for at all. So on that level, it really did live up to expectations, um, but I think if you look deeper, I was disappointed at um..in many ways, the lack of substance, which in many ways I wasn't expecting because I did, I did think they would go for a more formula type film. I think they generally had decided not to be..I think visually they were very ambitious, but they really, I don't think they did enough or as much as they could have done with the story. And also in developing the characters and that's ultimately why I was somewhat disappointed. [Interview 22]

Provided he can manage that distinction between 'entertainment' and the 'popcorn' element, and his deeper hopes of a meaningful Stallone film, he gets his due pleasure.

The notion that film-viewing is often organised around ideals is both obvious and striking. It's obvious in that we don't believe there is anyone who hasn't experienced going to the cinema and having their hopes and expectations disappointed – and disappointment is an obvious mark of the presence of an ideal. But we are arguing that to identify ideals is to identify some key organising principles in people's ways of responding to films and cinema. For they have the power to shape people's

preparations for film-viewing, their choices of cinema (or of course video), their company, their ways of watching and being involved, and their criteria for judging, categorising and using the filmic experience. Ideals, if you like, are little utopic hopes people carry round with them.[1] Where they come from, how they are created and sustained, and changed, are fascinating questions in themselves.

Social geographies of the cinema

Our Boys' Club interviewees were clear: *Judge Dredd* for them is a natural part of life at the Multiplex. For others, deciding where to see a film such as *Dredd* is a mixture of ideals with pragmatics. For many, especially for those who had waited a long time for this film, it had to be made into an 'event':

David: .. well, afternoon actually, we went on a Sunday afternoon to Leicester Square, erm, make a sort of, see it in a decent cinema not in some local flea-pit.
Graham: No, no, it was because, uh, all of us who went were either Dredd fans or Stallone fans, or just action fans...um, yeah it was, it was a bit of an event really, to go to see *Judge Dredd* at Leicester Square. [Interview 28]

Two quotes from different parts of our longest interview with groups of comic fans. The second, interestingly, acknowledges the possibility of other reasons for seeing the film. The film can readily be an 'event' for them too. What is gained by this? A sense of 'mass participation' for a start:

KB: So what does the, the science fiction and the Action films do for you then?
Mike: Um, when you're fired up and you need...um...what's the word...you just need things to be happening around you, if you see what I mean, it's the same reason that you'd go to a city centre pub instead of a country pub, you just want some noise, some of that liveliness around you. [Interview 33]

Cinemas can be appropriate or inappropriate just by virtue of their technology. One group [Interview 40] scornfully rejected a local cinema for its 'hanky' of a screen. And surround sound is now a must for many people, at least for Action films.

But other things come into play – for many people, certain cinemas are associated with particular kinds of audience:

Mike: We tend to think of films in terms of, you know, by the Watershed or Odeon, which is quite interesting.
KB: Yeah, yeah
Mike: It's a Watershed film or an Odeon film, so ...
KB: So what, what, what is that difference?
Mike: Well, I ...
Steve: Well it's commoners or people with a bit more intelligence! [Laughter] As they walk out they're all discussing the nuances and they're ... as you walk out of the Odeon, it's like, where's the pizza? You know, where's me fags?

> [Laughter] Where's the toilet? And you know, that's it, that's the mentality when you come out of an Odeon cinema, you know, and in the Watershed it's like, who's for a martini? You know, that's the difference, and it's the social groups that go, sometimes you get the Sharons and Traceys, not knocking them, but you do get that sort of like you know, 'I'm gonna go to the pub, go to the cinema, and go back to the pub' sort of thing, whereas, you know, Watershed is more like 'we have dinner, we go to the cinema, we come back for coffee'.

KB: *Yeah ... so is it a class thing, then, do you think?*

Steve: Oh definitely, definitely, very much so.

Christian: Do you go to the Showcase then?

Mike: No, nobody goes, well ...

Steve: We did! [Interview 5]

Note that this is not about the films, but about the assumed audiences of the multiplex. Here, a group of viewers acknowledge their own assumptions and prejudices – half-mockingly, given that this group of young black men was only too aware of assumptions people might carry about them! (See Chapter 11 for a full investigation of their before and after interviews.)

Cinema vs video

Video has been a major phenomenon since the mid-1980s. Surrounded by fears in the early days (whether the industry's fears of more cinema deaths, or the politicians' fears of uncontrolled viewing and of 'video nasties'), it has now become part of the settled landscape of films. What, though, does it mean to audiences? Often, it is purely a practical device. It's cheap – a more relevant factor for young audiences than is generally acknowledged (many telling us that they like video because they can see a film many times over, and share or swap with friends). And it's a way to catch up on missed films. The range of uses is stupendous, and makes any idea of generalising about the meanings of video very risky. Look at the spread in just the small sample we've boxed apart below. They indicate a span of at least the following: seeing video as substitute cinema, for which you must shrink yourself to the appropriate 'size'; a moveable feast between richly enjoying with friends, and 'just' watching with parents; using it to re-run even disliked films, to milk them for their references and other good bits; an alternative indulgence to womb-like cinema, in which you can sag and smoke; and a stage-managed participation in a 'slacker' life-style. It can also be, as in the words of some young boys, just a chance to let go:

KB: *And what kind of things do you do when you're watching videos, then, and what kind of videos?* *[Laughter]*

Anthony: You eat and drink, relax, slouch on the settee, and pig out. That's it! [Interview 29]

KB: *Are there any films that you think are video films as opposed to cinema films?*

John: Umm, well, yeah, I suppose if there is nothing that involves scenery, one where the scenery doesn't play an important part or when ... a dimension of size, if it's basically about people then yeah, I think that might come over better on video, or it would come over just as well on video. But otherwise, you have got to try and shrink yourself, you've got to try to imagine that you're smaller than the television, basically haven't you, to try and enjoy a big screen film on the telly. *2001* is an example they are showing it ...box. You've just got to try and be aware of it as a big screen, so I always insist on having all the lights out, just a small light perhaps on, when I'm watching a video at home. [Interview 23]

Rob: No, no not when I'm at home, I mean when I'm over my friend's house, Ken, we get a few drinks in, and like sit down, have a drink and watch the films then, and maybe a bit of food in, but, I mean...there isn't, I mean...Yeah, that's, that's what we do over there, but at home I just sit down with my Mum and Dad and watch it, I mean... [Interview 37]

Amanda: I think I will want to see it again, and I've got friends who've seen it a couple of times, and have been noticing all sorts of bits and pieces like graffiti in the background, and so on, so I wouldn't mind picking that out, and I think I enjoyed it enough to shell out £2.50 to rent it from the video shop. [Interview 39]

Meri: I love going to the cinema, I like the comfort of watching a video at home, being able to make myself a cup of tea and have a cigarette as cinemas are now all no smoking. Those things are nice, being able to pause it and you know have a bath and watch the rest of it in the morning if I want to but the cinema is special, umm, going in the side, it's an evening out, you're getting out of the house you're going somewhere. You are doing something, you're not just sitting round vegetating. But the actual cinema itself, it's like going into a womb. It's.. you just get.. sink into your seat and disappear for two hours, you're just lost into whatever's going on on the big screen in front of you and the video never

63

captures that. The actual size and scope of it means that you... I literally feel that I'm falling into the film ummm, and that's what I like – the total involvement with the cinema, as I say you know you can't have a cigarette and make yourself a cup of tea you're there, you're in the film, ummm, so yeah, they're very different. [Interview 50]

David: This was a really studenty, studenty period of my life, sort of second year fine art, art college in Newport and we had a patch of wasteground with a skateboard ramp built in it outside our crappy little basement flat, and we dragged the sofa and the settee out into the night and watched *Repoman* and other kind of proto-slacker movies out under the stars .. with a lot of sherry or something ..

Matthew: But that, the video thing is em, brings drugs into it cos you can smoke dope and stuff watching TV. [Interview 35]

Being a kind of viewer

Audiences are aware of each others' differences: this is patent, common, and normal. They know that not everyone likes a film, and that the grounds of judgement are likely to be different. This is easy to operate with, when you know the people personally, as here:

Philip: I went with two of my friends from work – one of them likes *Judge Dredd* and the other likes Sylvester Stallone
MB: *Oh right. And how did they respond to the film?*
Philip: Um, the fellow who likes Sylvester Stallone films thought it was brilliant, like, mad film and the one who liked *Judge Dredd* thought it was like, very disappointing, he thought like, it just cheated him half way through the film, it was a slow movie. [Interview 28]

When you don't directly know the other people, natural processes of imputation set in. Some viewers put a gloss on the reactions of others in the cinema, imputing to them reactions that make sense of their own. Here, one female science fiction and *2000AD* fan seeks support for her loathing of Fergie:

Amanda I thought visually [*Judge Dredd*] was quite good. I liked MegaCity One, and so on. They'd done a good job with that. And that ABC warrior robot was really really good. Mucking around with the plot and the continuity of the comics and so on, I'd sort of expected so it was irritating but not

unexpected, and then there are, everyone in the cinema giggled when one of the, what was it Chief Judges, says something like 'I don't want to be remembered as the man who imposed an unjust and fascist system' or something like that, and the whole cinema just sniggers 'cos they'd read the comics, um, so there's bits like that. I hated Fergie, I loathed detested and despised him. I kept hoping he'd die, and he just never did, he kept coming back and coming back, and no, I detested him. [Interview 40]

It doesn't matter whether she was right or wrong about the reasons for other people's 'sniggers'; either way, it functioned to validate her own dislike.

Another viewer, well aware of the quite wide dislike of the Fergie character, sought a rationale for his own unsullied pleasure in the film:

Richard: I thought it was great! He just comes in, stomping in and the scene with him and they're just shooting at him and stuff and he's just walking straight through because as he knows the bullets won't reach him because, everyone's cowering and stuff, cos Dredd is always in control. I suppose that's how, if there's any kind of theme to the film, it's actually about the loss of control.
MB: *Who did you go with?*
Richard: Erm, a friend of mine, a guy called Ashley at work, we thought we'd go and see it.
MB: *Do you normally go to the cinema with him, or was this a special ..?*
Richard: Erm, not particularly. Especially if it's a good Action adventure thing, then I'd probably go and see it with him, whereas if it's a bit more of a romantic stuff, I'd go with my girlfriend. *[MB laughs]* You know, she doesn't like too many explosions.
MB: *Yeah, yeah. So I mean, when you go to the cinema with Ashley, is it a kind of ritual, do you go for a pizza afterwards, what ..?*
Richard: OK, you could go for a pint first, then go and see it ... male bonding, that's the one, I suppose. It wouldn't actually mean anything to us but .. we went to see *Die Hard* recently, which was quite fun. I mean I know a lot of people – I forgot his name now – hated the guy who was the sidekick .. *[MB Fergie]* Fergie, I thought he was wonderful! He was sort like a human version of Walter the Wobot, or something. He actually, I mean, made the film what for me was like he introduced an element of humour into it, and especially the parodying Dredd theme which was very nicely done. And he was ob.., he was obviously the, the viewer, he actually was the viewer inside the film and stuff, sort of reacting to everything around him. So you virtually kind of, cos you, cos you can't empathise or either sympathise with Dredd, so you have to have some sort of edgy bloke for the viewer, I suppose .. [Interview 28]

This viewer, then, chooses his company by kind of film and then, aware of the criticisms of others towards Fergie, writes a script around the film which explains and justifies his own gleeful irreverence ('it wouldn't mean anything to us').

This means that, in effect, he was playing a role in relation to a characteristic he ascribed to the film. To many film-goers, it seems, to be an audience is to indulge some part or other of their personality. It is to play a role. That doesn't mean that it is false, in any sense. It means that it is a choice among viewing positions. Many viewers told us that they selected who they went with, according to what kind of film they planned to see. Others said they varied their preparatory and post-film activities according to the kind of film. In other cases, where only one kind of film applied, audiences knew that the film fitted a specific aspect of their personality. This is what is at the back of one wonderful exchange we encountered:

KB: *What would, what would prompt you NOT to see a film then?*
Mark: Love scenes, and soppy junk. [laughter]
Herb: What a bloke. [laughter] You blokey blokey type bloke you! [Interview 2]

What we are sensing is a scaling of extents of role-playing in parallel with degrees of importance. At one extreme, to see a film is to sit and receive. A virtually empty act, the person might as well be elsewhere, the act means so little. If asked what s/he thought of the film, the most that might be said is 'It was alright'. This disconnected way of watching therefore can have no consequences except the passing of some time. A high level of response is one in which a person plays a role such as above in relation to a film. S/he commits a part of her or himself to the film, and engages – perhaps a little, perhaps quite fully – at that level. But it is a part only of the person. Above this again, a person can knowingly commit him or herself to a viewing, wanting and expecting a certain kind of involvement. The rules of engagement are known, and the film matters for what it is expected to provide. Finally, above or to the side of this, stands that rare moment of surprise engagement where a film offers more than ever could have been expected. Once, perhaps, in some people's lifetime, a film will be encountered which changes their life. It will so embrace and overwhelm them that they see the world differently as a result. We met a few people who reported such experiences. Such people did not, could not, role-play in that moment of revelation. Here is a sample. We cannot say if it is typical, since we encountered only a very few of these. But it does have some striking characteristics:

KB: *Um, when did you first kind of get interested then in Sylvester Stallone?*
Richard: Uh, well, 1983 was the year. Uh, in the early part of that year, I went to see
 Rocky 3 for the very first time. It was shown in Birmingham, on a re-run,
 and I'd never seen any of his films before, I'd never in fact um, heard,
 really heard about him but I can remember the..some..
KB: *How old were you then?*
Richard: Uh, about fourteen-fifteen? about fifteen. Um, but the um main reason for
 seeing it, I knew the song 'Eye of the Tiger' by Survivor, so I went to see
 that, in the early part of '83.
KB: *So you went because of the song?*

Richard: Well, mainly because of the song, and I've been a big Survivor fan ever since! So that started something else! [laughter]

KB: *So bit of a big, big night out then, that one!*

Richard: That's right! But uh, a couple of nights later I went to stay with a friend, cos I used to live in Worcester, and I'd moved by that point, and um, I went back to visit, and he had just in fact had his very first video machine, and he had been renting out these films for the very first time, and he had come across a film called *First Blood*, and he said, 'you must see this film! It's an Action film, it stars Sylvester Stallone', and obviously then I said, 'Well I've seen *Rocky 3*, but um, obviously they're different films, so I saw that, and I just never, I'd never seen a film up until that point that had really excited me that much, as an Action film, I just, it just completely took me away. So we, we rewound the tape, and watched it again all the way through, and then we woke, we got up early the next morning to watch it a third time before it had to be taken back to the video shop and um, it just started from there. I mean the next day we went into the video shop and rented out *Rocky 2* and *Rocky*, and in the course of that week I'd seen probably six or seven Stallone films..I mean basically anything that was there on the shelf at the time- *Escape to Victory* – and it just started from there, then I came back to Birmingham where I was living, and I just started to collect magazines on him, started to read up about him, and it just really started from there. [Interview 22]

This need to tell the story almost becomes a re-living of its results. By surprise, it 'completely took me away' and 'it just started from there' – a long-term fascination which leads to serious fandom, to a need to know, to follow, to stay involved. Very few films – indeed, very few anythings – do this for very few people. Such moments of seizure and commitment are worthy of study in their own right. First, we have to recognise their absolute distinctness. What they are distinct from, is the more ordinary viewing which, even where there is a generic commitment, allows the playing of a partial viewing-role.

We only encountered one person who even came near claiming that *Judge Dredd* brought about a life-change, and it wasn't in the course of a proper interview. The case, however, is interesting enough to warrant telling. On one of the occasions when we leafleted a cinema queue, a middle-aged woman (slightly, we suspect, pitying us) agreed to be interviewed. Subsequently she changed her mind, but instead wrote us a long letter, telling us of her responses to the film. They are fascinating:

I was asked to go to the cinema with a few friends and as I haven't been for X amount of years, I thought it would be fun. However as my last film was *The Sound of Music*, this was a shock to the system. I didn't know what to expect, and the first 20 minutes of so I didn't really pay much attention. My first thought was, God I'm going to get bored, I don't like this kind of thing, but then suddenly I started to really look at the screen, and my interest quickened. I started to think, Could this really happen? is it so far ahead, with atom bombs and things. It led your thoughts all over the

place. I wouldn't however go again to see such a film, it would cause me to have nightmares, of what could happen, if someone pressed the wrong button in a coutnry gone mad, I like nice films like Miss Andrews in *The Sound of Music*, I guess I'm the sort of person who likes a nice tidy mind where no bad ever happens, and this film at the end of the day makes you sit up and think of all the bad things that could happen everyday, and it is not a nice thought to go to bed with. But having said that, funny thing is I enjoyed it, maybe I'm not so cut off from things after all.

We won't discuss this account here, since really to make sense of it will take the rest of this book, we would argue. Let it lie as a lovely puzzle for the time being.

Disciplinary discourses

One of the central features of contemporary British film culture is its embattled state. A month does not pass without someone belabouring as dangerous what millions would happily enjoy. It does not have to be the big political battles of *Natural Born Killers* or *Child's Play III* or *Crash*. Local papers, or parents, or teachers, or others with cultural authority can proscribe viewing, or make it seem valueless. One of the things we encountered regularly was the effects of these 'disciplinary discourses'. In this, there are few if any differences among viewers. A very large number of people are aware of being judged, if they declare their liking for certain kinds of films. This leads to paradoxical self-condemnations as self-celebrations, as here:

KB:	*So what types of teenagers or young people* [J: Yobs!] *would go and see this film?*
Lee:	People like us
Martin:	thugs
Lee:	thugs!
KB:	*What kind of people are they then?*
Lee:	People with no jobs and no money
Martin:	If you got no jobs and no money you're not going to watch a film, unless you're a car thief or summat...
KB:	*So what kind of people then?*
Martin:	Thugs! Um...people who like Action, cos that's what it is really --
Johnny:	Mindless violence! [Martin There ain't any plot] That's what it was! Mindless BLINKING violence! [Laughter]
KB:	*So it was more of an action film than...any other kind of film?*
Martin:	Yeah, but there weren't enough blowing up and stuff, nowhere near as much as they could have had.
KB:	*Right. Um, who would enjoy it most then out of the group of people that it's aimed at?*
Johnny:	People with no brains [laughter]
Martin:	People like you, John, yeah
KB:	*Why do you say that?*

Lee: Cos you must have no brains to pay any attention to it ... that's just my opinion though. [Interview 40]

Tabloid language is rained down on their own heads – the expressions 'thugs' and 'mindless violence' are straight borrows from a thousand headlines about vandalism, or mugging, or football violence. It condemns them, yet is joyously embraced at the same time. It becomes a bizarre self-definition., which sits awkwardly alongside a much more thoughtful hint at another account ('if you got no jobs and no money you're not going to watch a film, unless ...'). Certain kinds of pleasure have been so thoroughly disallowed in our culture that to enjoy them many viewers have to incorporate, sometimes with relish (as here) at other times with some self-diminution, a damning account of the very things they like.

We found what David Buckingham has previously reported, that a number of younger viewers reconcile the force of the accusation that these films are 'harmful', with their own experience that they are pleasurable and 'just films', by counting themselves as 'older' and therefore safe. The implication is that somewhere down in the Infants is a vulnerable child who might do goodness knows what. Here, a group of 11-year old boys debate this issue:

Nick: I want, I want to go and see *Judge Dredd* but it's 15 so...
KB: *Well, that's what, yes...*
Wayne: like down at Showcase, they, you can get in, I, I could buy a 15 ticket..they only want the money down there really
KB: *Yeah. Do you think that's good or bad then that they do that?*
Wayne: that's bad..well, it's good like, cos you wanna watch it, but it's like bad -say like, um, a reporter come round or something, and got someone to , uh, do it, then, uh, ...say like, um, they might get a young kid to try and buy, a ticket, and then like, they'd have, uh, a bad reputation in all the press or something
KB: *Do you think these films are like, good for people to watch, or...?*
Wayne: No. Not for like, younger people, but for older people like us
KB: *Why is that?*
Nick: Cos..they just won't get it and they'll think it's like, boring and more boring and more boring
Wayne: yes cos like, younger children, say like um, on a 15 or something, a 3 year old sets fire to his school, then like,
Nick: Bit stupid innit
Wayne: they'll go to school the next day, and like
Toby: Be scared
Wayne: Set the school on fire
Nick: Bring some matches
Wayne And set the school on fire! [Interview 8]

Their experience tells them that films that are too adult are likely to be boring to young children, because incomprehensible, but they can see that at worst such

films might be 'scary'. But the adult fears of them, that they 'cause bad behaviour', lead to this bizarre fantasy – perhaps the worst crime they can imagine – of setting the school on fire.

It may even be a form of revenge that young people, aware of adults' attitudes to their pleasures, turn the tables when they can. Consider the following extract from a group of young boys discussing the perils and delights of trying to get in to see films under age:

Gerard: I saw it on the ferry on the way back from Spain ..
MB: *.. oh did you? .. but presumably that was just chance, the fact that they happened to be showing it ..?*
Gerard: Mm, yeah, they just happened to be showing it, but the thing that shocked me was I went up to the door and there were kids up to knee height jumping up to the counter saying 'one child's ticket, please', and they didn't ask them their ages. [Laughter] And when I came round, she said adult or child ticket, and I thought ah-ah, adult just in case ... not thinking .. but I was shocked. [Interview 29]

When we began the research, we had assumed that for young boys it would be quite a 'macho' thing to get to see 18-rated films, especially at the cinema; the more a film appeared to be 'forbidden fruit', the more attractive it would be. Not so. From the evidence of our transcripts, the entire issue seems mundane, a ritual of testing systems to see if they can outwit 'authority'. If they can't, oh well, that's boring adults for you, If they can, they boast of it – but at the same time, express disapproval of the hypocrisy of adults. The recurrent fears and scares, and then the plausible avoidance tactics, provide a rich scenario to sustain young people's cynicism about adult reasonableness, at all levels.

Talking about films

Nothing is more normal than talking about films. Viewers do it all the time. But the kinds of talk they indulge in tell a lot about the manner of their involvement in those same films. Remembering how they talked about a film is still a part of its pleasure.

Simon: Before a film we just like to go there straight there, see it. But afterwards I and all my friends like to find a comfortable little pub, sit there till chucking out time, you know talk about the film, debate, argue, fight, punch-up before we all agree to disagree and then go out for a kebab. I think that's the best way, that's the best...I can't leave a film and not talk about it afterward cos I think then you've wasted a lot of what there is to be got out of a film. [Interview 51]

Another kind of use bathes the imagination in a film. For those to whom films are important, and especially where they are a source of visual fascination, the very scale of a film becomes its own dimension.

David: We usually sort of walk back out from the centre towards our neck of the woods and find a pub along the way and sit, drink and talk, talk – not just about what we've seen, but what we've seen usually seems to trigger off a nice filmic kind of conversation. We're sort of rabbiting on in the style of the film or rabbiting on, just free-associating the images that we saw in that film and relating it to all the films [...] – it sounds pretentious but it's just something that I think everybody does to some degree. You're affected by the film you've just seen, in almost a hallucinogenic manner, you sit in front of the screen, with a big brash, especially like *Judge Dredd*, I mean, everything's so big, big or it's in your face, you know, a punch in the face kind of thing that will, will affect you for a few hours afterwards. I went to see *City of Lost Children*, and we went to a pub that's just had a makeover, it's just been redeveloped and I was sitting there and all, my eyes seemed to be picking up all the colours in the pub that were prevalent on the screen, you know from just seeing it, it seemed to just turn the pub into a set from the film. [Interview 35]

What this respondent is showing is one of the ways in which the filmic experience does not stop with the credits. If a film has involved you, it carries its imaginary world with it for a while longer while its situations, its fascinations, and its pleasure-potentials are worked through. Talk is just an aspect of this working through.

To others, though, this would be far too private (and probably 'sad') use of a film. For them, the whole point of seeing a film is to pick up on 'references', the materials for appropriate in-group chat, as here:

Herb: If it's like any other Action film, you know, you just go along and say, you just sit in the pub and say, eh, what do you reckon [G Wasn't that great?] Yeah (very strong Somerset accent) 'Whaddaya reckon to this thing?' ...
Munro: And if he said, so and so, you just pick up on lines, if it's got a good script
Gary: It's the same with any film, the prime example was *Dumb and Dumber*, wasn't it
Herb: Oh yeah! [laughter, yeahs]
Gary: We'd only just got in the transit van and it's like, 'Aaaah!'
Herb: Yeah, and picking out the one liners straight away, something like that, that's sort of
Brian: That film was full of one liners though wasn't it. [Interview 2]

The idea of using films for 'one-liners', that can pass for a while into a group's argot, combines with a very particular kind of knowingness, one which emphasises being up-to-date and in touch with where your culture is going. It is quite different from the kind of appraising talk that, for instance, a fan of Sylvester Stallone would engage in. It is also distinct, though less obviously, from the way a fan of *2000AD* would hunt the film for 'references'. For the latter, far from being shareable, they would be like private gifts from film-makers to the cognoscenti –

let the mass audience have Dredd without his helmet, we at least can spot the significance of the Smiley Face on the Statue of Liberty.[2]

A question inevitably arises from this: if the kind of talk people partake of is a function of their uses of film, to understand their ways of talking to us, we would need to have some sense of their uses and purposes in our interviews. If their talk with each other was a function of their social relations with their film group, what were their social relations with us? These sticky questions returned to haunt us, at various points.

The patterns of cinema-going

What we are seeing thus far is a wealth of differences, on every aspect. We could multiply these endlessly, and indeed the task we are setting ourselves is to explore all those differences. What patterns are there among them? How might they be grouped? Are there any emergent models which could make sense of the variety of responses to Dredd, and to films and cinema in general?

What is most striking in all the above is the recognisable ordinariness of all the diversity – as indeed we should be expecting. Even so, there are some general processes at work of real importance. The first is pretty obvious, we feel – we might call this simply 'doing things for reasons'. In all aspects of the above, people are making knowing choices, and each choice is made because of an expectation that will link with something else. People choose the right kind of cinema because of their wish for the right atmosphere, or the big screen, or the right company, or the ability to get a closed tube between themselves and the screen. Our respondents may differ enormously in their uses of video, but each kind of use is motivated by a wish for a certain kind of viewing. This includes, and this is important, even those moments when people lose control – this is a chosen relationship people want to experience. What we are seeing therefore is a series of patterned choices, in which people know in advance that there is a kind of filmic experience they want. They prepare themselves appropriately. They choose the right company, the right cinema (or video set-up) for this purpose. They let themselves go in the right way. And they use the experience afterwards in a way that completes the process. 'Success' or 'failure', 'satisfaction' or 'disappointment', can't be understood except in terms of these complete processes. For some people, the film is the film is the film. For others, being able to talk with affectionate contempt afterwards can turn a crap film into a delightful evening. For others again, a film like *Dredd* obviously couldn't do what they wanted, so they scaled down their expectations – planning included tactically lowering their hopes. As we will propose to call these processes later, people's cinema-viewings are guided by practical logics. These are what we have to try to understand.

The other general process is more complicated, and less obvious; we want, therefore, to spend a little more time drawing it out. This concerns the ways in cinema-going is a social process. It is not that everyone sees this in the same way – far from it. But there are clear patternings along the following dimensions. (1) Cinema-as-social always has two elements: an awareness of ways in which film, or cinema, exists and functions externally to the individual (it has histories, it follows rules, etc); and an individual response to that awareness. (2) Involvement in cinema-as-social obeys a logic: the more dense and intensive a person's

involvement, the more s/he has to know and care about the ways cinema operates independently of the individual: its histories, its rules, etc. Conversely, the less a person is involved, the less s/he bothers with knowledge of the external functioning of film and cinema, and the less s/he bothers with orienting to these. (3) The higher their involvement, the more readily does people's talk naturally contain and express their understanding of and relations to cinema's 'externalities'.

These principles may perhaps seem very obvious and not very interesting. We ask patience of readers, as we try to show that their importance is of the first water. These principles, we maintain, hold true regardless of all differences in the particular attitudes people have to films. Because this is so, in our explanation of these below, we have not worried at this stage about who among our interviewees said each thing. The important thing, for the moment, is to show the ways in which, generally, the social is inside the individual. We offer a sample of the main ways in which sociality reveals itself in interviewees' talk:

1 Languages of constraint

One frequent concern among people was not to be seen to behaving inappropriately. The most common version of this was a worry about being 'sad'. For example:

Jason: Of course I have a rule that I won't go on my own [laughs] ..
MB: .. why's that?
Jason: I think it's particularly sad. [General laughter]
Fabian: .. you haven't got anyone to go to the cinema with ...!
Jason: Yeah I know but you're on your own, you go, I mean, you go to the cinema to share it with people. I mean, I'll watch a video on my own but I mean I just won't go to the cinema on my own. Em ... you also like share it, you know, you laugh along with everybody else, and you know if it's sad you might cry along with everybody else and .. it's, you're sharing the .. the enjoyment yourself. [Interview 34]

To go to the cinema on your own, for this individual and group, is to admit to lacking friends. Of course, it doesn't stop you – but you live with the risks, both for self-image and for other people's attitudes to you. The general laughter that follows that acknowledgement confirms – indeed reminds each other of – the group's acknowledgement of this rule. This was quite a widespread feeling. Hear it again:

Simon: I don't think I'd enjoy a film as much if I went to see it at the cinema on my own. First of all you'd be a bit self-conscious sat their on your own, you know, Mr Sad. And secondly there's no one to talk about it or share the experience afterwards. [Interview 51]

And one further time:

Alex: Ordinarily though, I wouldn't dream of going on my own. There is a big social stigma attached. It's embarrassing. Also it's more fun with other people you want to natter about it after, don't you? [Interview 49]

73

Note that this time though the same constraining judgement is clearly being referenced, the word 'sad' does not need to be present – a fact which makes it difficult to analyse such social processes by any mechanical means. 'Sad' will turn out to be a key concept for some groups, with a heavy meaning-loading. It sums up a wrong attitude to cinema-going, in which personal interest in a film over-rides the social aspects of its use. It connotes, in other words, obsessiveness – something which many avoid by self-ironising, as in this:

Sol: Um, I used to go to the cinema a lot more than I do now, uh...I, in 1993 I went 32 times, I was sad enough to actually count them! [Interview 4]

By acknowledging the obsessiveness, he saves himself from the charge – a curious version of rescue-by-confession! 'Sadness', then, looks to be a risk that has constantly to be worked around, and one way to do this is by self-conscious acceptance of its charges.

If for some people to go to the cinema alone is a confession of cultural inadequacy, for others it is no problem – rather, an opportunity:

KB: *Do you, do either of you ever go on your own to the cinema?*
David: Er I do, not very often, but I enjoy it when I do.
KB: *And how is that a kind of different experience, what's different about that?*
David: It's me looking at the film down a tube, me and the film, just us two, so a little love affair you're having with the screen, no, nothing can disrupt that and you feel you've somehow exerted some kind of extra control over the kind of thing you see. You feel like you're seeing something that you, that other people wouldn't want to see cos some people a lot of the time, a lot of the time you go and see a film that no one else has shown an interest in seeing ..
MB: *.. do you take it more personally when ? ..*
David: In fact I do, I feel like I'm cheating myself when I go and see a film that I know my friends want to see but haven't seen yet and I'm seeing by myself. It seems somehow wrong and that ...
Matthew: I find that about seeing films on my own. I haven't seen one recently on my own, but the ones that I do are far more memorable, and I think about them a lot more and it generally means, don't have a drink so you just walk out of town, you know, just have a long time, long private time to reflect on the film. [Interview 35]

Note that in this account the screen becomes a friend with whom the viewer has his/her own intense relationship ('a love affair'). In very real senses, therefore, seeing a film alone is just as much a social act as seeing it in company. Interestingly, this is seen at the same time as stolen time, for which he will have to recompense his friends. But going alone allows him something too important to jeopardise: an 'extra kind of control over the kind of thing you want to see'.

So for a good number of people being 'sad' is just not an issue at all:

Ralph: I actually went on my own, I'm quite happy to go to the cinema on my own, anyway, I do that quite a lot, I mean I do enjoy going with people cos you can talk about it afterwards, and that's, but I mean I, it was just one of those night where I fancied, I've got a nice little cinema, in Leeds, um, Hyde Park cinema, it's only about 10 minutes from where I live, and they tend to show good films, they'll either show a couple of films a night or a couple of screenings. [Interview 28]

We will need to explore later what else someone is wanting, or doing, that makes 'sadness' so irrelevant. What it does immediately raise is the question of what kind of activity 'being an audience' is. There seems to be a choice of ways of being involved, if we can judge by this 'balanced' response.

2 Awareness of film genres

People know about film genres, and they know what they mean. Again, this may at first seem obvious, but that obviousness is deceptive. Consider what is involved in these judgements: 'Bog standard Hollywood Action epic' ... 'drive-in movie type film' ... 'cerebral film' ... 'trash movies' vs 'worthy films'. These are just a few among the kinds of classification our interviewees deployed. What do they show? First, they require people to have acquired little histories – what went before, and led on to this/these? They indicate the kind of viewing activity that will be demanded of you ('cerebral film' is the clearest, but so in their own way do all the others). They mark out awareness of the possible value of a film; but this is a value placed by 'others'. A 'trash' movie is, of course, trash – but that can be just what a person likes it for. To put something in a category, also, then allows distinctions within the category: hence a 'bog standard Hollywood Action epic' demarcates this film (in fact, *Dredd*) from others which go to the limits of the category.

In fact, if we consider this last expression closely, we can see how much is condensed within it – especially if we add that this was said as a complete, self-contained answer to our question: 'What kind of a film did you think *Dredd* was going to be?'. 'Bog standard' commentates not only on the perceived quality of *Dredd*, but also the expectedness of this – which is then explained by the addition of 'Hollywood'. 'Action epic' establishes *Dredd* as coupling two, regularly associated genres of film. And the whole expression, of course, confirms the knowingness of the speaker – to be able to summarise a film in this way marks him down as competent, in a particular way: filmically and culturally aware, with a knowing cynicism.

To be able to place a film within genres is also to know something about its audiences:

Gary: Uh, yeah, I mean, it's going to be aimed at hopefully, sort of like, older *2000AD* readers.
Herb: Which are millions anyway so they know they're gonna do well from it.

Gary: Also there's people like, obviously the Stallone fans, will be wanting to go and see it, and hopefully, if the trailers are interesting enough, you'd get people who've gone to see, perhaps something like, oh I don't know, a Schwarzenegger film, and think, oh yeah, that might be quite good, or they've been to see *Batman...*

Mark: Or Sci Fi fans.

Gary: Sci Fi fans, yeah.

Munro: It'll be interesting, that.

Herb: Or anyone who just likes an ordinary, good Action film. [Interview 2]

This extract reveals people's day-to-day awareness of the differences between specialist audiences (the *2000AD* readers) and their requirements, and a 'general audience' ('anyone who just likes an ordinary, good Action film'). It doesn't actually matter that Herb is almost certainly wrong in his estimate of 'millions' of comic readers guaranteeing the film's success, since to him such audiences are fringe benefits to 'anyone who just likes' such films, which includes him and his mates.

What is also important, though, is in knowing about different audiences we declare attitudes to them – sometimes in the relatively neutral way as above, where our interviewees mainly just appreciated difference and were glad that it could help 'their' film. Often, though, concrete social judgements attached to knowledge of film genres and their audiences. A good example came in a letter we received from another person whose work situation prevented him coming to a discussion. His three-page letter included the following:

> This is going to seem mean, but works well I find. If ever I am undecided about a film and have an opportunity to see it, I describe it in the best terms I can think of to anyone of the many stupid and pointless people that my existence is cursed by being surrounded by, and if they are interested then I know it is not worth seeing, conversely, if they are not interested and decry it as boring or unusual, then it must have some potential.[3]

His cinematic self-image is built round his difference from those he judges 'stupid and pointless'. What is interesting about this example is precisely the way it shows that film-viewing can start long before someone actually reaches a cinema!

But also knowledge of film genres interweaves with expectations, with the bases for judgements of particular films, and with audiences' sense of their own power or lack of power, their sense of 'being fairly done to':

KB: *Were you, I mean, obviously you were comparing* Dredd *to the comic, but there other things that you were comparing it to when you were watching it?*

David: Yeah, yeah, I was comparing it, I was definitely comparing it to all the Stallone films. I couldn't help but do that because the man does have the screen presence. I was comparing to *Robocop*, I was comparing to *Blade Runner*. I tend, whenever I see a film, I do tend to have this kind of track somewhere in my head that files it according to the like, like-minded films that I see.

Matthew: Em, *Total Recall*, and yeah *Total Recall* in particular. That's one that's stuck
 in my mind. ... Yeah very much about people with a lot of money trying to
 create a vision of the future without a clear vision of, a clear idea about, like
 Blade Runner succeeded cos it has a very clear idea like em, all the more
 stylish ones like *2001* or *THX1138* or the kind where they've all got a much
 simpler idea, and there's such an LA hotchpotch that wasn't convincing at all,
 same, I thought, the same with *Total Recall* as well, it's just loads and loads
 of money and it's almost that you sort of feel that .. disappointed with the
 waste, cos you know there's so much work being done, and you hear stories
 about someone being, who did all the graffiti in Megacity One, and you don't
 read any of it, and there's so much because it's such a big budget and
 there's so many people on board, all these neon signs that aren't you know
 getting edited out, and that's a big thing that I've got about that and *Batman*,
 and there was one other one that all got edited to buggery .. Sort of there's
 no one recognising that this doesn't make any sense, is there no, you should
 feel more powerless and less listened to as an audience. Um, I mean I know
 it's not *Judge Dredd* but in *Batman Forever* there's an absurd bit at the end
 where a character that's at the top of this deadly well appears at the bottom
 of the deadly well on his feet, um, 10 seconds after everyone else has fallen
 down the well and landed at the bottom of it. Just layers of things that you
 like. [Interview 35]

Knowledge of film genres, then, readily connects with a sense of who makes the
films.

3 'Hollywood' as film-maker

It was very common for our interviewees to know about Hollywood – or better,
'Hollywood'. 'Hollywood' is a widely-shared mental construct which summarises a
place of tinsel and tin, glamour, money and power. It is worth noting that we found little
if any evidence of the kinds of attitudes widely found in the 1930s, in which
'Hollywood' equals 'America' equals land of magic and dreams.[4] Equally social, but
differently constituted, Hollywood was for our viewers a site of power towards which
they felt real ambivalence. On the one hand, Hollywood does things predictably, to a
pattern: 'That's Hollywood for you!', as one UKCAC interviewee put it [Interview 28].
It is also in many senses a cultural thief, taking over and transforming what is 'ours':

Philip: I think what with the futuristic background though, you know, the aim of this
 American thing, cos like, the Americans go for that kind of thing, you know,
 they go for that, but I think they were trying to make him into a, kind of, you
 know, cult character you could follow like in years to come, which they
 didn't, cos the comic's only been in America about five years, or something.
 The most they got into *Judge Dredd* was the *Batman/Judge Dredd* thing
 and I think they really tried to make it like that, for the *Batman* fans, there
 weren't *Judge Dredd* fans in America, they'd even thought they could
 rewrite the history of *Judge Dredd*. [Interview 28]

Here, 'Hollywood' dissolves into Americans, more generally. They don't understand, perhaps can't understand 'our' story. At the same time, 'Hollywood' can be understood in terms of the requirements of its global operation. Many viewers understood that for a film to succeed, it had to 'speak many languages':

Ralph: Don't you feel though, that the problem ultimately was that really it was obviously a film made by executive decision [General agreement] and there were so many layers of things – I mean that's the way Hollywood works anyway, I mean um, any film has got, so much got to be a commercial success because so much money is, is invested in it, that, it was obviously so many people had their say and pulled it this way and that, that it was going to be a shapeless mass at the end, and in fact I was just surprised that considering so many people had had their say that it wasn't so bad!! [Interview 28]

It shouldn't surprise us that while awareness of 'Hollywood' was almost universal as condition and constraint, it was a particularly potent issue with *2000AD* fans – especially when interviewed on their 'home territory' at the Comic Art Convention. What is important, is the range of assessments and judgements this could produce – from irritation and dislike, to an acceptance that 'this is just how things are':

David: .. you know, with the Judges you've got complete chaos, so it tells you what the situation is, you know. So, it's, its a different message, but it's a different audience I think. Erm. You know, Cinergi weren't making it for erm, 100,000 present day *2000AD* readers, if that's how many do read it now. You know, they're making it for a world-wide market. [Interview 28]

What is striking, and should exercise our minds a good deal, is the way 'Hollywood' here, and many times elsewhere, is seen to be incapable of delivering certain messages because of the way it operates. The 'price' of having a film-version of Dredd is having it 'Hollywood-ised'. For those with a *2000AD*-reader's prior knowledge, that means guessing that the comic will hardly survive the transformation. What to think about this? To know is not the same as to judge: responses could range from easy setting aside of the comic version ('I didn't care – I just thought it was great!') to heavy-hearted acceptance ('I tried to make a conscious effort to leave me Dredd-head outside the cinema, and go in, watch the film, enjoy it but not enjoy it, and then after I'd sort of – no, I did enjoy it – but then I could quite easily put me, I could actually rip the thing to bits, but I wanted to go and see it, I've been waiting since 1981 for a Dredd film and I wanted to enjoy it, really did want to enjoy it, and I did') to something closer to anger ('my girlfriend said you're going to bellyache all the way through the film, go and see it on your own. And she was right! I, I, I mean, it looked flash and I'm sure that to people who, em, aren't involved with Dredd, it was a decent Action movie'), even outrage:

Chico: And the worst thing is, if you take a look at the movie adaptation in the comicbook and you take a look at the uh, the ones in the local newspapers, they now got people like Carlos Ezquerra and Ron Smith doing Dredd without his helmet on! Cos they're, actually doing the proper Dredd, without his helmet on! And it's so sickening! They've screwed the comic character up completely now'. [Interview 28]

Notice that expression the 'proper' Dredd – an assertion of rights over the character, which can only come from a combination of intense knowledge of the character with a sense of belonging to his world and a commitment to his authenticity – all of them densely social processes.

4 Cinema-viewing as mass activity

If, above, we saw one viewer carving out the right to view a film alone, for many, being in the cinema is precisely important because it is a mass activity. But this also has different meanings for different people. For some, it is an occasion for soaking up the benefits of other people's responses, getting heightened responses through these:

Nick: The best thing I like there is um, when we were watching the comedy thing like Ace Ventura? They all laugh and you look behind you and there's everybody going huhuhuhuh it's just a real crack up! [Interview 8]

But for other people, cinema-going is an opportunity to affirm one's difference from the mass:

Sol: Some movies like Jurassic Park, it was good to see it at the cinema as many times as possible, cos, I, I like watching other people's reaction, and listening to other people's reactions, I like hearing people shit themselves in the scary bits! [Interview 4]

To do this, of course, he has to know the film, weigh the audience, and maintain his own 'distance' from them – all complex social processes. That, of course, is our point. Though very different from each other, each is a wholly social response to the cinema.

We must be carefully aware that cinema-going starts and stops as a process at different points. For some, cinema is an 'event' which begins in the foyer:

KB: What's, what's the kind of, why the Showcase and not the Odeon then?
Johnny: Cos they got seats you can go [rocking motion] and sway about, it's cool
Martin: I knows why I'd be there
KB: Why?
Johnny: CHICKS!
Martin: Yeah, there's loads of em!

KB: *What, hanging around in the...?*
Martin: Yeah! They just hang about in the lobby and don't go and watch a film, they're just there like, for people like us to pick em up! [Interview 40]

Fantasy or not, the 'event' of cinema begins well before the film. And the same 'irreverent' attitude continues once inside, hence the delight in the rocking seats. This 'boy-ish' commitment to messing about in the cinema is exemplified elsewhere. It is important because it is still part of the cinematic experience:

Jag: Well I like to go with a crowd, because, you know, it's much better, um, you're with your mates you can have a good laugh
Sean: You can throw popcorn at each other
Jag: Yeah! You can, yeah! You can sit at the back and go [throwing action – general laughter]
Don: I like to go on me own, I like to study the film
Jag: He's a boring fart, he is
Don: Get stuffed [Interview 3]

The (fended off) accusation of being a 'boring fart' is the equivalent for this group of being 'sad'. D is refusing to participate properly in his 'group's' ways of going to the cinema. But this time the charge is not of obsessiveness – that belongs to the repertoire of another kind of cultural group, but of being 'boring' – an epithet conveying that he plays the official game, and won't be enough of a 'lad'.

In these and many other ways, the common element is a two-sided way of responding to the whole cinematic process: on the one hand recognised sets of social aspirations, routines, predictions, shared knowledges, roles that can be played, and so on; and on the other hand individuals making their own strategic orientations to these – what hopes or commitments are too important to give up, how far to go along with the requirements of the ideal, whether it is worth the effort, what compromises might be necessary on all kinds of practical (eg, financial) grounds. To understand real audiences will involve dealing properly with both ends of this.

What does a theory of media audiences need to do?

Our task becomes one of making sense of this diversity – but a diversity in which we can now see these common features. In the next chapter, we review what we found on a revisiting of the main general theories of media/audience relationships, as these have expressed themselves in proposals for how we should research and understand audiences. As far as we were concerned, a useful theory of audiences has to offer us several things: a way of doing better than just losing ourselves in the sheer differences among people; a way of understanding the practical reasonings we found in people's cinematic choices; and a way of taking full account of this dialogue between the social and the individual, including people's uses of their small but important ideal expectations.

1 In passing, we have to say that this idea of 'cinematic utopias' is quite different from that which Richard Dyer has developed in his *Only Entertainment* (London: Routledge 1992). Dyer's is a very interesting account of 1930s musicals, in terms of their excess, and the possibilities these offer for dream-utopias. Aside from the difference that he is discussing films while we are investigating audiences, we will try to show that some audience ideal expectations can be highly disciplined and controlled, rather than excessive. We return to this issue in Chapter 13.

2 ... and we're not going to tell you here. If you don't get the point without our help, you are not the right person to know! But see Chapter 9, if you must ...

3 Chris, *Letter to the authors*, 23 August 1995.

4 On the research on this, see below Chapter 8.

THE PROBLEMS OF KNOWING AUDIENCES

> One possible conclusion to be drawn from the current impasse is that new ways of approaching the issue of televisual violence and its effects on children need to be found. ... It would seem that a constructive, open-ended dialogue between those from all the various interested disciplines is long overdue and would help to move the debate forward from its current polarised position.[1]

What is the current state of thinking about film audiences, and media audiences generally, as we write? In our opinion, it is something of a mess, but not a mess to which an easy solution can be found as hoped by the quotation above.

One of the main problems with a great deal of audience research and theory is precisely that it has been driven by two related kinds of desire: a desire for policies, and a desire for political positions. These, we will show, have not only been damaging to the conduct of research, but they are also damaging to film audiences themselves – in subtle but important ways. Take, as a small example, the report from which the above quotation is taken. It comes from part of a report launched in connection with a campaign entitled *Violence and Young Minds*, with the support of the Gulbenkian Foundation. The report is judicious and careful.[2] Unusually, it takes fully into account the challenge posed to American-style research by the findings of researchers such as David Buckingham; and it closes with the above demand, adding that 'Whatever conclusion one may reach about the influence of televised violence, it is essential that debate takes place within a context that addresses the policy implications'.

We want to undo that linkage, for several reasons. First, the pressure for policy – which almost always means the enactment of statutory or pseudo-statutory restrictions and rules – has systematically distorted how research is done. Secondly, the very terms in which this report poses its question are wholly problematic. Our research shows starkly what a meaningless category 'screen violence' is. It also shows that we cannot afford to make presumptions about the meanings and uses of either cinema or video – or lose the differences between them. Third, campaigners of these kinds do not seem able to stop and ask themselves: what are the unplanned consequences of our campaigning in this way?

Our research shows that the persistent climate of dangerousness that surrounds a wide range of films and other media materials does actual damage to the processes of film viewing. Lastly, the call for researchers from competing disciplines to come together to try to resolve their differences: in our view misses the point. The different kinds of research currently being conducted simply cannot be merged, or amalgamated, or embraced within a wider framework. The situation is analogous to that in the Middle Ages when conflicts arose over the claims about evidences of witchcraft. There was research which seemed to show that witchcraft existed, and which had powerful effects – but in the eyes of those who scorned and attacked it, that was because it was so designed that it was bound to find 'witches'.

This is the problem that a number of people have recently sought to address. The 'effects' tradition has taken for granted that it is meaningful to talk in this way of 'violence' as an abstractable category. There isn't one iota of evidence that it is possible to equate and examine alongside each other cartoon violence, action-adventure violence, news and documentary violence, historical-epic violence, and so on.

There has been far too much demand for immediate policy-relevance, and little willingness among politicians and journalists to consider how research is done, what kinds of theory and modelling of media-audience relations are being used by researchers and policy-makers. The problem seems to be that the media and popular culture are so politically salient and culturally sensitive, that it is hard to break free from what we will later call 'folk theories of the media'. These are widely-held, mythological, fear-based systems of ideas about what might be the effects of different cultural forms.[3]

This problem has a curious, inverse echo in our own field of research. Consider the interesting exchanges between James Curran, a leading historian and political economist of the media, and David Morley one of the foremost researchers of audiences within the cultural studies tradition, which have recently been brought together.[4] In an essay first published in 1992, Curran charges the cultural studies tradition with 'discovering' some truths about audiences which have in fact been long known, and dressing them up as 'new' – but in a form that veers towards the apolitical. Citing work by people such as Herzog, and Hyman and Sheatsley, from the 1940s, he argues that the complexity and social groundedness of audience responses was well known to many within the uses and gratifications tradition, and that that tradition does not deserve the dismissive criticism of having had a 'fixed' view of human needs. The thrust of his argument is that cultural studies work is infected with a 'new revisionism' which is stripping out radical questions in favour of a celebration of uncritical celebration of audience creativity.

Morley, replying, argues that Curran's history is awry. While it may indeed be true that some of these ideas had been developed before, it is not a weakness of the cultural studies tradition to have 'forgotten' them – on the contrary, he argues bullishly that but for this tradition, it wouldn't have occurred to someone like Curran to go back and look. 'Histories' are written generally in accord with the agendas of the present. Figures who are marginal in one history become central when the story is told for different purposes.

This is a very odd debate, and inasmuch as it is representative, one that reveals much about current thinking about audiences. The main problem with both sides of this argument is their treating the history of audience research as essentially an academic history. Yet the question of audiences has been almost entirely dominated by non-academic concerns: commercial, public-opinion, ideological, and directly political. Commercial research into audiences began early, in the late 1930s, as the film companies sought to quantify their chances of success with particular film titles, star combinations, and storylines. But even earlier, the Payne Commission enquiries into films' influences on the young began the long tradition of 'effects' research. This tradition does not work by accreting results. Indeed in many senses it does not develop at all. Its central question is not a research one, but a moral one: 'how much harm is done to vulnerable viewers by improper media materials?' So even when research comes up negative, the premises are not harmed, they are deferred. The response is either: not this time, or: more research is needed. Meantime, vociferous public campaigns have ensured continued funding for research based on this question; and whatever doubts some academics may have had, the predominant image of the purpose of academic audience research was to 'measure effects'.

There was a flip-side to this: the search for what are now called 'pro-social effects'. Once again, the agenda is a moral one: how much good can we do through the media? And just as the 'negative effects' tradition did not do research to test its assumptions about vulnerable audiences, so the 'positive effects' tradition did not ask difficult questions about what exactly a 'pro-social' goal is. Like other traditions of American research, it was policy-governed, and was expected to produce results. But in terms of understanding the history of audience research, they shared one assumption at least – that research into audiences is research into influence. Take one of the works cited by Curran, in his rebuke to cultural studies: Herta Herzog's study of daytime soap viewers.[5] Curran parallels this with Ien Ang's study of viewers of Dallas, and suggests that most of what Ang found, and claimed to be original in rising above the 'fixed needs' of uses and gratifications work, is already present in Herzog.

In a narrow sense Curran is right. Herzog does list a number of socially-based uses of the serials, for instance, summed up in this sentence: 'The overall formula for the help obtained from listening seems to be in terms of "how to take it".' (p.30) But what Curran leaves out, is what follows this. For the point of Herzog's study was to recruit radio serials as instruments of wartime propaganda. This is explicit both in Herzog's essay, and in the following ones by Rudolph Arnheim and Helen Kaufman. Here is Herzog's statement of this:

> [T]he argument that the primary purpose of daytime serials is entertainment rather than education does not apply here. The writers of daytime serials must live up to their obligations to which the influence of their creations, however unintended, commits them. Both the obligation and the opportunity for its successful execution seem particularly great in these times of war. The audience to daytime serials comprises a cross-section of almost half of all American women. Thus

the radio industry and the Office of War Information seem quite justified in their effort to use these programs as a vehicle for war messages. (p32)

Herzog concludes by demanding that radio fulfil its necessary role of telling its listeners where their duty lies. Thus it will become an 'even more important social instrument after the war'.

Here was research that was strongly steered by the requirements of propaganda. It sat exactly at the second pole of the American 'effects' tradition: the 'doing good' pole. Any argument over the political nature of those 'goods' was deferred, for good. It is extraordinary that Curran doesn't mention this, since he has charged the cultural studies tradition with political naivety.

On the other hand, Morley's reply is equally unconvincing. This shows in a curious exchange which follows in the two shorter essays written specially for this volume. First, Curran uses 1970s American communication sources to argue that people such as Herzog have not been seen as marginal in American communication traditions. Their work has been cited in the most standard textbooks. Morley, responding, counter-cites the standard British media textbooks of the 1970s to show how marginal considerations of audiences were. Again, at a simple level, Morley is right – Cohen and Young's (1973) *The Manufacture of News* has almost nothing to say on audiences. And early work belonging directly to the cultural studies tradition (the Occasional Papers from the Birmingham Centre, for instance) does no better. But that is because the mainstream of cultural studies had 'solved' the problem of audiences before it was ever posed. In 1974 Stuart Hall published his much-cited essay on 'encoding the television discourse' (on this see later in this chapter), and for those who accepted his account, that made active audience research almost redundant. For we 'knew' that texts interpellate their audiences, via preferred readings. And indeed Morley's own study of the *Nationwide* audience was designed precisely to furnish the proof that this is how media influences work.[6] The only defence was to be 'oppositional'. The truly remarkable thing about that study is that when it didn't work, he acknowledged it, and began a reconsideration of the Hall model. But, as we show below, after his striking self-critique, he returned to that model. And throughout the essays we're considering, whenever audience activity is named, it is still called 'decoding'.

Two of the most important theorists in our domain seem trapped in different ways but with the same outcome in a sterile encounter. We are arguing that the central problem with both British and American research traditions is that they have been 'interest-driven'. In America, the tradition follows the necessities of American politics: either undefined 'pro-social' or equally undefined 'violence'. In Britain, the main tradition saw the adoption of theories which met the ideological requirements of cultural studies' claims for its own role. Only as confidence in that role diminished did doubts about the audience emerge.

There have been three main models of media-audience relations: the uses and gratifications approach (henceforth usually the U&G approach); the encoding/decoding model; and the hermeneutic model.[7] In different ways, especially with the first two, these evolved to escape the wrong-headedness of

effects claims. The sad fact is that, to an extent more than is usually realised, they took with them chunks of the agenda and assumptions of the effects tradition (which itself is testimony to the ideological power of that tradition). For this and other reasons, we find ourselves at odds with all of them. Our objections to them are a mixture of the empirical and the theoretical. Since this book is not primarily a book about general media theory, we set out our critiques below in summary form. In a number of instances, our criticisms are not new. For space reasons, we haven't footnoted the original sources every time, and we have only stated the criticism very briefly. In other cases, we believe our criticisms are new. In these cases, we have taken a little longer, and tried, where possible, to cite at least one instance where the problem particularly shows. What we have sought to do, however, is not just to criticise the approaches in the abstract, but to find one exemplary use of the ideas which can let us see how the ideas work in practice. We have looked in each case for a strong piece of work, so that each approach can be seen at its best.

Uses and gratifications

The uses and gratifications approach was developed partly as a reaction against the perceived individualism and conceptual naivety of the 'effects' tradition. This tradition focused on the needs which the media meet, and was built around the maxim: Don't ask what the media do to people, but what people do with the media. Somewhat in abeyance in recent years, this tradition had two distinct tendencies: the American version which understood people's 'needs' in essentially psychological ways; and a British strain which, based more in sociology, looked at the social organisation and distribution of needs.

There seems no doubt that the uses and gratifications model was experienced as a liberation by many researchers. Justin Lewis for example cites Joseph Klapper's ecstatic outburst in 1963: 'Viva los uses and gratifications studies, and may their tribe increase'.[8] But as a number of critics have pointed out, it veers dangerously back toward its source in as much as it still accepts 'commonsense' accounts of what is going on in the text.

There would be little point in our rehearsing in detail what others have better and more fully done, to consider the usefulness of the uses and gratifications approach.[9] But there are some issues it raises which have not, to our knowledge, been much considered but which are particularly germane to where we have ourselves going. Consider the following definition of the model: 'Our model of the process is that of an open system in which social experience gives rise to certain needs, some of which are directed to the mass media of communication for satisfaction'.[10] This definition has the appearance of great clarity and potential for research applications. We set out our problems seriatim, and then try to illustrate them against a representative study:

1 U&G research does not conceive the possibility of needs being generated by the media themselves. It is always and only 'social experience' which generates the urges which seek satisfaction in the media. But this contradicts all we know about the importance of publicity regimes to all modern media industries.

2 U&G research never considers in any detail what might happen if needs are not gratified. In one famous study, it is true, researchers examined what happened when people were denied their daily paper by a strike.[11] But the case studied by no means covers what we are concerned with: the centrality to so many people's experience of being disappointed by the media we select. The film is not as good as the 'hype', the book is not as the cover depicts it, the article in the newspaper looks exciting/raunchy/sensational, and in fact is very ordinary, etc. U&G research by and large assumed that needs were met.

3 Because this model saw needs as generated in the generality of 'social experience', it never examined the possibility that to some people, at any rate, media contact might become a kind of experience sought in its own right. The implications for this are considerable, for they require us to explore such things as: how growing knowledge of a medium alters our use of it, our pleasures in it, and the roles that it may play in our lives. Yet we know that fascination with the media has a long history, at least back to the rise of fan publications in the 1920s. Further, 'satisfaction' may itself thus become dependent on social processes – the sharing of (the right kinds of) knowledge may become part of the meaning of the encounter, for instance, as may enjoying the experience in the right company. And even for less specialised uses of the media, before we can be gratified, we have to have sought out the right materials for purposes of gratification. But we can only do this if we have knowledge that these might fit the bill for us. That depends on the circulation of appropriate knowledge, in the right ways, to the right people – all of which in their turn modify the meanings of the encounter between medium and audience.

4 The U&G model does not seem to suppose any change happening as a result of satisfying needs. The model is essentially homeostatic: a need is generated by social processes, a media experience is sought to allay that need, and thus we return to where we were. There is no history here. Indeed, there is an irony that the model only seems to use half of its own name – 'uses' hardly get studied, in the sense of people taking hold of experiences and changing themselves, their relationships, or their surroundings as a result.

5 Most extraordinarily, from our point of view, U&G research never seems to have asked themselves what the implications might be of the fact that some audiences make greater use of the mass media. This is because their research inherited from the 'effects' tradition a view that there was something slightly disturbing about media use. 'Too much' media use signals a problem in the audience.[12] We want to introduce a new agenda of questions about the ways in which greater interest and involvement in the media alter the relations which audiences have with their chosen media.

Bearing these general criticisms in mind, let us look at an example of the approach in use.

Blumler et al's study of television gratifications

One of the most cogent examples we've encountered of the uses and gratifications approach is the research on the gratifications of television by Jay Blumler, J R

Brown and Denis McQuail.[13] Based on an eighteen month project funded by the Social Science Research Council, the final Report goes so far as to develop and offer for use a General Instrument which the authors believe could be used for researching audience gratifications from television.

Blumler et al begin from an honest acknowledgement that the U&G programme has not lived up to its ambitious claims. They criticise, for instance, the lazy and incidental assertion of 'functions' without research to back it, and also the American tradition which 'tended to feed single sentence descriptions of media functions to samples of the public for endorsement' (p3) when there had been no check as to whether these corresponded to that public's own accounts. From these criticisms they derive a principle: 'For surveys to produce valid results, they must be closely linked in conception and implementation with the language and the range of experiences of the population under study'. (p3) We agree, wholeheartedly!

Their research had three stages. First, they used the opportunity presented by the death of *The Dales*, a radio soap opera based on the life of a doctor's family, to investigate how fans viewed the programme before, and two months' after, its death. Building on the outcomes of this, they next studied the audiences of *Coronation Street* and of quiz shows. Finally they looked at the gratifications associated with watching television news, and with two television adventure shows, *The Saint* and *Callan*. At the end, they develop and propose the 'General Instrument'.

At each stage, they developed their questionnaires from a series of initial interviews with fans, so that the proffered list of gratifications arose from volunteered statements. Thereafter the key elements of their approach are, first, a meticulous development and analysis of audience responses, using (for the time) advanced statistical techniques in order to find clusters of responses which could be labelled and theorised.[14] Second, the research populations were selected to include a range of social characteristics; these were extensively recorded, and correlated with the different clusters of gratifications. All this is done with exemplary care and skill, and does result in some fascinating puzzles and insights – which are in our view made stronger by being based on this mix of qualitative and quantitative research.

For example, their study of *The Dales* revealed a strong association between following this programme, and broadly Conservative attitudes among women fans. And the core response associated with this was a response to its perceived 'family life and atmosphere'. This was the quality most missed, with the passing of the programme. They also found, surprisingly, that relatively few of the fans chose to talk about the programme with friends, commenting that 'It would be interesting to know whether anything in the typical fan's relationship to a programme like *The Dales* had tended to inhibit references to it in her contacts with friends and acquaintances' (p13). Interestingly, they found that some listeners significantly changed their views of the programme in the two months after its demise. For instance, one group defied expectations by simultaneously indicating a rise in their belief in the 'realism' of the programme, yet recording less reasons actually to like

it. Trying to make sense of this, the Report becomes nicely anecdotal, recording the response of one woman to a rumour that one character from *The Dales* might make guest appearances in *The Archers*: 'Oh, no. That wouldn't be right. They are entitled to a bit of private life now'. But the quite correct use of this quotation to illuminate this paradox raises a more general problem about the meaning of 'realism'. This is a concept Blumler et al use throughout to distinguish those who see programmes as 'true to life' from those who don't. Unfortunately, their own materials indicate that, as work within the cultural studies tradition have shown, to call something 'real' or 'unreal' is more than just recording its relation to an empirical reality.[15] This has extensive consequences, as we will show.

Their conclusion in this first part of the research is that *The Dales* 'met the needs' of older conservative women, or other women in relatively lonely and low status social positions. We will need to return to this notion of 'meeting the needs' in a moment.

The issue of 'realism' re-emerges strongly in their discussion of their *Coronation Street* research. Their discussion of this exposes their central error:

> In a different approach to the study of viewers' impressions of a programme's realism, the respondents were asked whether they agreed 'that *Coronation Street* would be more like everyday life, if the pace was a little slower and not so much was happening all the time'. Despite the affirmative bias of the wording of the question, a majority (32 of the 56 respondents who answered it) denied that greater realism would be achieved by slowing down the pace of the programme. And of the 24 individuals who agreed that *Coronation Street* was larger than life in this sense, only a minority (9) said they would like it better if it was slowed down. Thus, although some fans of such a programme recognise that it does depart from reality, at least in the sense of abstracting for attention some of its more interesting and exciting elements, most of the viewers prefer it to be constructed in that way, while (more remarkably) the majority is unwilling to admit even that such a minimal sacrifice of realism has been perpetrated. (pp29-30)

This is only 'remarkable' if 'realism' is taken to mean some simple concordance between programme and daily life. Their own evidence does not support that notion. For example, asked how they felt about a famous episode where a number of characters were involved in a coach crash, viewers repeatedly responded that it was good because it 'could happen', it 'might happen' and – very challengingly: 'It takes away the veil from people; you see them as they really are'. The 'reality' that these fans wanted was a heightened picture of their world, not a dull correspondence. But that fact undoes a series of other propositions in their research, which made it distinctively a piece of U&G research.

The problem concerns their use of the concept 'gratification'. Throughout the report, for all their critique of the American U&G tradition, 'gratification' means one and only one thing: it is a solution to a deficit in an individual which has been caused by problematic social experience. They talk of the media 'compensating' for problems, of audiences 'feeling insecure' and using the media as a result.

The difficulty is that audiences in the meantime seem to drop out of history. It is worth just asking for instance whether the 'escapist' excitement which the authors attribute as a compensatory gratification to *The Saint* is conceivable nearly thirty years on. It's hard to believe that Roger Moore's enigmatic eyebrow could still operate except ironically (a category of use, incidentally, which is virtually inconceivable on the U&G approach). But that is because audience responses are constructed by much more than putative 'needs' seeking gratification.

The concept is misleading and dangerous. Misleading, because there simply isn't space for understanding someone saying that they might like a programme or film or whatever because it is fun or funny. These are positive qualities, sought for their own sake, not because of a failing in a person's life. Dangerous, because it forecloses investigation just at the point where it should begin. Because of the focus on deficit 'needs' being 'satisfied', the model presses us to think only of gratifications, not of what is putatively part of the research programme: uses. The image we have of audiences is of people struggling from moment to moment with a little help from the media. The media have no point in themselves, and they can't be used for anything, in the sense of, perhaps, allowing people to change their situation.

To go further, we would need to undo their bald distinction between 'real' and 'unreal', and to study the kinds of relations of use that people have with different media. For that, a far more complex account of the nature of the media being used would be needed – and that, of course, is just what the cultural studies has tried to develop, through its close attention to texts. But it will also need us to undo all crude distinctions between 'fantasy' and 'reality'.

We chose this piece of research because we wanted to examine U&G research at its strongest. And our judgement is that it fails, precisely as it produces its most abstracting concepts and methodologies. Nonetheless, we want to conclude on this by remarking that it has a strength which much contemporary qualitative work – including our own – should learn from. The combination of qualitative and quantitative approaches it developed has a great deal to teach us.

Encoding/decoding: the 'Hall model'

The tradition of critical media studies, originating mainly in Britain in the 1970s introduces an emphasis on the 'texts' and their organisations of meanings which, it was argued, was missing from both the 'effects' and U&G approaches. Drawing on an increasingly sophisticated array of methods, this approach has sought to penetrate the way media texts are structured, and to explore the implications of those structurings for audience 'decodings' (central term). But partly as a reaction against what was felt to be a 'textual determinism' in the critical tradition, a new emphasis has been placed on investigating the variety of audience responses and on the ways in which real individuals and groups make their own meanings out of their encounters with media texts and forms. One expression came to summarise this approach: the 'active audience'. From this have grown a number of rather different kinds of research: first a much-criticised tendency to celebrate audiences as supreme tacticians, liberated resisters of official meanings; second, a more cautious approach which has emphasised the contexts (especially domestic) in

which viewing takes place, seeing those contexts as shaping the kinds of uses and meanings people will make; finally, there has been a partial encounter with a set of approaches developed primarily in continental Europe, which shifted the emphasis to looking at the mental communities through which audiences responded.

Stuart Hall's model was quietly announced in a small essay in 1974, and hardly developed by him thereafter.[16] The encoding/decoding model, as it came to be known, looked at television programmes – and by implication therefore all cultural products – as highly structured systems of meanings which address and involve audiences in determinable ways. A game show isn't just a collection of people and events; an action drama isn't just a gathering of incidents, 'violent' or otherwise. Each is organised at a number of distinct levels: televisually, in being stage-set, filmed, recorded and edited in distinct ways; and ideologically, in mobilising various issues and themes. The excitement lay in the possibility of a systematic study of these organising principles, which could reveal the ideological meanings and proposals incorporated into any programme, and how the programme reached out and sought to capture the attention and agreement of audiences. Here, Hall and his subsequent followers turned to draw on a range of French theorists. Beginning with Althusser's notion of 'interpellation' – that we are 'hailed' by ideologies and, at least for a moment, enter the position of responding and recognise ourselves in that role – and along the way engaging with the work of French semiotician Roland Barthes, this way of understanding audiences then drew increasingly on the work of Jacques Lacan, and other psychoanalytically-inclined theories. This approach does have the odd effect of seeing all media on an analogy with advertising: they are, as it were, selling ideological projects.

One of the main reasons why Hall's model was so attractive was surely because it seemed to solve certain perceived problems. It did represent a clear break from old 'effects' models, by emphasising the meaningfulness of texts. In the same way it surpassed the Uses and Gratifications model, because it stressed the ideological role that texts could have. It put media products firmly into a social and historical context, and invited attention to a circuit between production, texts and audiences. And at least in its later versions, where the emphasis on multiple possible meanings (polysemy) grew, it seemed to acknowledge and make sense of differences in audience responses.

Nevertheless, it is our contention that the encoding/decoding model has become a blight on contemporary audience research. This wasn't inevitable. A turning point could have been the publication of David Morley's *The Nationwide Audience* in 1980. This remarkable study took and tested Hall's model, and found it not to work. Morley had previously published, with Charlotte Brunsden, a semiotic study of the British early evening television current affairs programme *Nationwide*. Their analysis revealed it to be organised around a complex set of ideas about 'Englishness', linked to (among other things) a celebration of the 'eccentric individual' – but with a real downer on any kind of conflict. Morley's subsequent work carried the project forward, by generating a hypothesis linking Hall's model with Frank Parkin's model of class positions. Parkin had formulated three broad forms of response to ideology: dominant, negotiated and oppositional. If the

semiotic analysis was to hold, then those audiences successfully 'hailed' by the programme ought to regard its ideological positions as 'commonsense' – and thus be blind to its constructedness. On the other hand those who negotiate or resist, because their class position sets them at odds with the coded messages, should be more aware of its constructedness. Morley showed an episode of *Nationwide* to a series of different groups, from bank managers to art students to black teenagers, and analysed their responses. The outcomes were not as predicted. The fact is that the bank managers might agree with the politics of programme, but they just did not like its presentational manner. The shop stewards might dislike the programme's view of trade unions, but they would happily put up with that, because it had the right kind of friendly relaxation for early evening. The black teenagers simply didn't respond at all – they refused any engagement with the programme at any level. In a very honest reprise Morley asked himself why.

This is the only full test that the encoding/decoding model has ever had. Morley himself proposed that greater attention needed to be given to a series of factors which he had largely ignored: people's leisure patterns and how these might govern choices and pleasures; the social (and in particular gender) arrangements of the home; and the pleasures of viewing. Morley subsequently researched the role of gender and domestic relations in shaping viewing, and the social meanings of the television set and the remote control. Why then has the model survived? Morley himself has recently offered this explanation:

> I would still want to defend the model's usefulness, in so far as it avoids sliding straight from the notion of a text as having a determinate meaning (which would necessarily impose itself in the same way on all members of the audience) to an equally absurd, and opposite position, in which it is assumed that the text is completely 'open' to the reader and is merely the site upon which the reader constructs meaning.[17]

This makes it a fall-back and a rhetorical position, a device for avoiding the excesses of 'active audience' theories. Here for instance is Elizabeth Traube using it in just this way: 'To recognise the active role of audiences in constructing textual meanings is not to ignore or deny the influences exerted by texts.'[18]

The Hall model and the 'active audience' approach are actually twins – mutually necessary, but equally untenable. Below, for brevity's sake, is a summary account of the main problems we have with the model in its two parts. But in some ways we are concerned that in practice the Hall model harms actual audience researches by imposing a grid of requirements which interfere with the analysis of the actual materials gathered.

The problems with encoding/decoding

1 At the 'moment of influence', audiences cease to be social. Despite being committed to seeing texts and audiences as social, there is a paradox in the model. The 'social' operates as a protective mechanism guarding us against the influence of 'texts'. If our social experience sufficiently contradicts what a text proposes, we will resist. But the implication of that is that at the moment and point of influence, the social drops, leaving just the text and the vulnerable audience.

The image of 'influence' therefore curiously mirrors that of the 'effects' model. In more than a century of public panics about new media, there has been a recurrent pattern, which historians and analysts of such panics have become adept at recognising. First, there is a fear of corrupting influence. Then, there is an acknowledgement that most people (fortunately), and (of course) the critics themselves, are immune to the claimed damage. But finally, there is always an ill-identified group of 'vulnerables', who will lack the moral/intellectual capacities to resist the degrading blandishments of, variously, Penny Dreadfuls, Dime Novels, Cinema, Horror Comics, Horror Videos, Arcade Games, Pornography, and more recently, computer-based media. As a number of critics have in fact shown, there is in fact an unspoken link in such arguments between images of 'childhood' (innocence, vulnerability, need for paternalistic protection) and ideas of class.

There is a striking recurrence of this in the pair 'polysemy/preferred reading'. Those who 'resist' need not concern us for the moment – drawing (presumably) on cultural resources in the communities to which they belong, they have managed to subvert the intended ideological processes. But those who fail this test, the ones who do receive the 'preferred meaning', must have been in some way ill-resourced to resist. They are the vulnerable ones, the ideologically-led. Forgive them, for they know not what they do. In fact, we have, without realising it, returned very close to something like a medical model of the transmission of ideologies. Most, luckily, have enough strength in their cultural immune-systems to divert/defeat/convert the invading 'ideas'. But some do not.

2 The model is 'message-centred' in the way it sees texts as being essentially vehicles for ideological propositions. This is more than a proposition that in some way 'everything is ideological', or 'the personal is the political'. We don't disagree with that, but there are differences nonetheless: choice of foods may be ideologically inflected, but not equally so. Compare a poster for a chip shop with an advertisement for British beef urging us to defy the Common Market's fears about it. The encoding/decoding model requires us to see all media texts as essentially ideological, and all other aspects as worrying accompaniments, possibly disguises.

The force of this problem is well revealed through the discussion of 'pleasure' in Seiter et al. After (rightly) noting that we still lack an 'adequate, contextualised understanding' of media pleasure, they say:

> The issues that scholarship needs to investigate further have been summed up by Simon Frith: when popular culture critics place themselves on the side of the consumer, 'the resulting politics of pleasure cannot easily be separated, historically, from the politics of leisure, from struggles over education, time and space, cultural capital, or from the question of signifying power – who can make meanings stick?'[19]

Pleasures, then, are necessarily implicated in power-processes, and 'not inherently progressive'. Everything, but everything, is measured against this 'universal scale' of ideological significance: is it sending the 'right message'?

94

3 The model depends on an ahistorical and one-dimensional 'scale' from progressive to reactionary. This leads to a further problem with the model: its use of a dimensional model of power: from dominant, through negotiated to resistant; from progressive to reactionary. We have many difficulties with this. Firstly, it assumes we all have an agreed scale, and 'know' what counts as a 'progressive' treatment of all main social issues. It further tends to assume that 'resistance' always coincides with 'progressiveness' – a bizarre idea, frankly, in face of right wing backlashes in a hundred places.

It is also oddly ahistorical: is there no difference in what will count as 'progressive' or 'reactionary' in different historical circumstances? In her historical study of audience responses, Janet Staiger indicates the ways in which *Birth of a Nation* encountered quite different kinds of response, and indeed opposition, at different moments. Her argument is that the range of possible responses was much wider at certain moments: 'from today's perspective, even the 1880-1920s liberal mentality is scarcely a non-racist attitude'.[20] But then what counts as 'progressive' at one point will look decidedly reactionary at another.

4 The model requires the arbitrary division of texts into messages, and vehicles for persuasion. In an essay on one of Hall's most important publications, *Policing The Crisis*, Barker shows that his model requires us to identify and separate three components in a television programme (or whatever) from the coded message in itself: 'decoding devices ("work to enforce plausibility"), disguising devices ("transparency" and the "taken for granted"), and linking devices ("the communicate process consists of performative rules – rules of competence and use, or logics-in-use which seek to enforce or pre-fer one semantic domain over another and rule items in and out of their appropriate meaning sets").'[21] In another critique of the perhaps best known application of Hall's approach, Barker shows that there cannot be a consistent way to do this, with the result that such analyses lead to arbitrary distinctions between these elements.[22]

5 No actual audience has ever yet been identified which corresponds to the supposed 'preferred reading' of a text. The idea of a 'preferred reading' is only an analysts' construct. This has the irony of putting us back into the very position that many cultural studies investigators have been keen to escape: the position of the superior, knowing investigator who can see things about the text which all others are incapable of seeing. 'We' know the preferred meaning, 'they' are simply constrained or limited by it.

6 The concepts of 'meaning' and 'reading' are intrinsically confused. A series of problems circle around its central terms 'meaning' and 'reading'. As John Corner among others has argued, the model collapses the differences between quite different senses of 'meaning in a text'.[23] To understand the literal meaning, or indeed referents, of a sentence (or, in the case of a film, to know what you are seeing) is a quite different activity from developing associations around them (elaborating on the significance of the things you see and identify). And David Bordwell, among others, have pointed to the dangers of the metaphor of 'reading', seeing film (and other media) on an analogy with languages which have to be

understood.[24] As he points out, films can't produce meaningless sequences in the way that sentences can be nonsensically constructed.

Turning to the 'active audience' notion as the counterpoint to Hall's model, we meet an equivalent set of problems:

1 The model of 'activity' used is not just banal but false. Many people have pointed out that in at least some of the work of John Fiske, 'activity' automatically seems to mean 'resistance' – as though having fun with something is per se a political act. But we want to go further and say that we know of many situations where actual audiences could be said to be positively choosing passivity – but thereby making the languages of 'activity/passivity' meaningless.[25] Think of curling up with a 'bad' novel, think of letting oneself go to a film in order to 'have a good weep', think of (from our own research) deliberately choosing films which will startle, shock, scare or otherwise 'knock the pants off you'. If these do not count as examples of strategic passivity, then the image of 'activity' has become so all-encompassing as to be meaningless. As we've suspected, the 'passive' preferred reader is a non-existent vanishing point – in which case, the model's capacity to generate an account of ideology becomes simply illusory.[26]

2 The associated concept of 'polysemy' is intrinsically confused. Those who try to combine with Hall's model with the idea of 'active audiences' do so via the notion of 'polysemy'. This notion says that any text will support a range of possible reading – but not infinitely wide. If the range was infinite, then the text could be all things to all people, and would dissolve into whatever 'meanings' each individual or group makes. 'Polysemy' thus required the idea of limits. This is a hollow gesture. No one has ever identified a limit beyond which 'readings' cannot go. Further – and just as important – no one has identified an audience whose 'reading' is in some way constrained by their text. The metaphors of 'limits' are widely used, but are deeply troublesome.

3 The notion of 'polysemy' needs to allow for variations in the extent of meaning-ranges, but cannot without dissolving itself. How and why is there polysemy? Most writings which use the idea do not ask this question, simply asserting its presence. But we do need to know, since there are at least two possibilities. One – and the one which we sense to be implicit in most work in this area – sees polysemy as a function of meaning-making *per se*, a general condition of semiosis. It is striking how often, at points of asserting this idea, the work of Valentin Volosinov is cited, although (as Barker has argued at length elsewhere) it is surely a serious misreading of his ideas.[27] But the point is that the necessity of polysemy is thereby being derived from the very fact of speech and communication.

But that then creates a problem: if polysemy is a function of communication itself, how is it possible to ask if particular texts are more or less polysemic. Consider some examples: direct propaganda and purposive advertising (for example, party political speeches, and Government health warnings); consciously playful publicity (for example, the recent tradition of cigarette advertising, or the Benetton campaign); popular story-forms (for illustration, *Casualty*); and highly individualised/

'authored' forms (for example, Tarantino's recent films). A theory that cannot distinguish how much 'freedom' of interpretation each of these offers its audience, is surely banal. Yet we cannot think of one study that has sought to go beyond the simple assertion of polysemic possibilities, to examine the range in particular cases.

The couplet of encoding/decoding with polysemy is less a theory, more a warding off. It forecloses questions, on primarily political grounds. It does not allow, let alone encourage, theoretical elaboration. Despite many problems with the approach being identified before, the model has been remarkably resilient. We think this is for two reasons: first, it seems to have explanatory force; second, no other viable model, fulfilling the same conditions, seems to be available. Here we want to show that the model not only lacks explanatory force, it actually impedes research.

Liebes & Katz's *The Export of Meaning*

Liebes & Katz's *The Export of Meaning* is an important study.[28] Many people refer to it, but few discuss it in any detail.[29] The book is a detailed account of their research into the reception of the American prime time soap opera *Dallas* in different cultures. Using focus groups, they explored the meanings and responses to the programme in America (its 'home', as it were), Israel (contrasting the reactions of Kibbutz members, Russian immigrants, and Arabs), and Japan (where *Dallas* proved very unpopular, and was only screened for one season). Their starting point is the question of cultural imperialism: is there reason to believe that the mass export of American-made film and television constitutes a colonisation of the minds of receiving nations? And with what exactly would they be being colonised? This second question provides the impetus, a survey of academic opinions of the soap opera. They show how diverse academic textual readings of the series have been, and offer their own audience research as a way of testing some of the textual claims.

They do show real divergencies in the kinds of sense, importance and moral judgements that *Dallas* evokes among the different groups. The Americans, for instance, are the most 'knowing' about the business background of the programme, and let that knowledge inform their talk; but at the same time their judgements of the programme are most likely to be presented as personal responses (using 'I' as their source). The Arab groups on the other hand use 'we' the most commonly, and are also scathing about the 'American values' they see *Dallas* as containing. The Russian groups meanwhile are the most suspicious, seeing the programme as a form of American consumerist propaganda, while the Kibbutz members adopt the most playful ('ludic') approach to it. (The Japanese are different, and cause problems to Liebes and Katz, as we will see.)

What do they make of these kinds of findings? Their transcripts were subjected to a series of analytic codings, designed to draw to the surface the presence of different kinds of talk. These codings are presented quantitatively – and here a first problem arises, in our view. It is never explained why frequency should count as any kind of proof of the salience of certain reactions to a cultural group. This point has serious ramifications, so we pause to develop it.[30] Isn't there reason to suppose

that certain kinds of response, precisely because they are important to a group, would not be openly mentioned very often? Take the case of embarrassment. A group to whom issues around sexuality cause unease and awkward feelings of intrusion may feel that they have to reference their unease, but may well do so only once, and thereafter hope that a boundary-marker will be respected. The same could be the case where something is so taken for granted that it will not need to be said, where a group has only a partial language for stating its feelings or views on a topic, and where to articulate a view clearly and repetitively would be to present things with a seriousness that would be out of kilter with the shared modality of the group's talk. These are just possible instances, but we think they make a point: repetition and frequency of a kind of talk is not in itself any evidence of its significance. Indeed, it may well be exactly the opposite. There are, surely, many kinds and occasions of talk in which formulaic discussions are able to continue for long periods of time.

Without frequency to rely on, analysis is much more complicated. But that is no reason for building theories on what may be meaningless quantitative measures. And Liebes and Katz do build judgements into and out of their counts of repetition. Sometimes this is done almost unobtrusively. For instance, discussing the Japanese responses to what they seem to perceive as inconsistencies in *Dallas*, they turn repetition of response into emotional involvement; the 'Japanese are troubled by inconsistencies', they argue,[31] and go on to offer explanations in terms of unresolved tensions within Japanese culture. The sheer presence of an idea, even if repeated, is not in itself evidence of its importance.

This is important, but it is not the heart of their argument. The key to this is a distinction which runs as a thread all the way through the book, between 'referential' and 'critical' responses to the programme. 'Referential' points them to talk that links events, characters or situations with *Dallas* to 'parallels' in the world outside. Liebes and Katz do point out that not all such talk is the same, and for instance distinguish 'serious' and 'ludic' talk. 'Critical' talk on the other hand is distinguished into 'syntactic' (which addresses how *Dallas* works as a programme), 'thematic' (which deals with recurrent themes, motives or messages), and 'pragmatic' (where viewers turn their gaze on their own reactions to the programme). But 'critical' talk, they believe, always puts a distance between the viewer and the programme.

It is of course quite proper for researchers to introduce analytic categories to help organise their materials. These become problematic, though, when such categoric distinctions sustain and are sustained by a theoretical approach which is itself untested. The problems grow more intense when their research materials themselves are at odds with the categories into which they are being fitted. This is the case with Liebes and Katz – who come close to admitting it.

The theory at back of the distinction between 'critical' and 'referential' responses is, of course, the encoding/decoding approach. It is striking that the word 'decoding' occurs 45 times in the running text of the book, yet its meaning is never once explained, let alone argued for. It seems that currently this approach is so 'obvious' that it needs no further accounting. In fact, their only

case for it is their wish to avoid two 'extremes': textual determinism vs abolition of the text.[32] The encoding/decoding approach is assumed to be the only escape route. This is just the difficulty we are trying to face up to. Sometimes, of course, a word like 'decoding' can be used without evoking its full theoretical apparatus. But here, as we will show, it carries the full theoretical clobber, and actually interferes with the investigation of their own evidence. Revealingly, the word 'decoding' is hardly used at all in the central empirical chapters – it is the framing chapters at start and close in which they seek to make sense of their findings that we find it.

The key is in the opening sentence of Chapter 1: 'The study of television is the study of effect.'[33] Katz and Liebes would surely acknowledge that there are many other kinds of question to be asked about television – aesthetic, political, historical, processual, for instance – but for them the study of 'effect' is the over-arching topic. This means that, no matter where else they may go in their study, they haven't truly studied television if they don't come back to 'effect' at some point. Meaning no puns, this has effects. Let us trace some of them.

(a) It leads to a desperate and paradoxical search for a 'message' in the programme. Having begun their account by noting that *Dallas* has virtually as many 'meanings' as it has analysts, they still feel able to wonder if some groups may not 'allow the message of the producers to seep in' (p.113). Which message, and how have they identified it? In fact they haven't – but it is a postulate of the approach that such a 'preferred reading' must be identified, and so they put the idea in, without warranty.

(b) Not only this, but they then postulate that certain groups may in fact be more 'vulnerable' to this indeterminate 'message'. We found this aspect of their work offensive. They suggest the Arab groups may be prone to influence because they are 'less modernised', 'traditional' (unlike the modern, progressive kibbutzim ...). This claim is not based on anything derived from their transcripts (indeed, exactly the opposite, as we will show in a moment). Rather, it comes from a claim that the treatment of women evidences their clinging to 'traditional social organisations'; this is based on their observation that a number of the Arab groups showed discomfort at men and women watching *Dallas* together. Somehow this is read as a sign of weakness – yet exactly the same tendency to separate men and women among the Japanese is not used as the basis for any such judgement.

The point is that the judgement about vulnerability and influence is tacked onto the end – it has no bearing on their actual empirical materials. In one respect, though, it is embedded in their research strategy. Throughout the study, they have taken for granted that because their groups were assembled on the basis of 'ethnicity', what their transcripts reveal is going to be primarily an expression of that. Not only is this very arguable in itself, but the way it is used here shows that they have a very particular working definition of 'ethnicity'. To talk of groups as more or less 'modernised' is to import a highly contentious developmental view of cultures, seen as relatively self-contained and formed from inside. It also leads easily to political judgements which we do, indeed, find offensive – especially in the context of Israeli politics.

(c) Their unargued adherence to the encoding/decoding model actually makes them misread their own materials. That model, as we've seen, privileges distanced responses over close involvement, seeing the latter as a sign of weakness. The model searches for signs of 'passive' viewing, where 'active' means either withdrawn or oppositional. The difficulty is that, as they themselves are honest enough to admit, none of their groups show any passivity at all. On the contrary, they all debate vigorously. Liebes and Katz in fact amend the orthodox encoding/decoding approach when they note that, contrary to expectations, those who adopt a predominantly 'critical' approach can still be passionate about the programme, while those who make referential use of it are capable of being 'cool' and fairly detached.[34] But whatever qualifications are entered, the issue of 'effect' has to be got back to, in the end. They have to be able to say who might be 'got at':

> We cannot point which of these forms of involvement and distancing are more likely to affect viewers. While it may appear at first that ludic keying and metalinguistic framings are more resistant to influence, we are not certain that this is so. The ludic may be seductive in the sense that fantasy and subjectivity invite one to be carried away. Similarly, constructionist concerns distract attention from the ideological message. Even ideological decodings are vulnerable to influence in the sense that the decoders believe that their oppositional reading is the truth! Each community has its own defence. If we had to hypothesise which viewers are more vulnerable (in the sense of upsetting their balance), we would presume those viewers that accept the reality of the programme – those that do not challenge its hegemonic agenda – even as they argue with it.[35]

This is bizarre. Honest to their own findings, they recognise that each mode of attention to the programme makes its audiences notice some things and not others, achieve some responses and not others. But somehow, creeping round the back of their argument comes the preferred reading, the 'hegemonic agenda', the 'ideological message'. This seems to work best and only when you least expect it. It creeps up on you, even as you think you are invulnerable because you are actually arguing about the programme.

(d) So who do they think is least and most vulnerable? As we've seen, the Arabs – no matter how much they may have argued with what they perceived to be the value-schema of *Dallas*. The least influenced are the Americans. We want to reverse that argument, and say on their own evidence the Arabs are the most *perceptive* audience, while the most *deceived* groups are the Americans – and Liebes and Katz themselves. This is not a rhetorical trope on our part, it is a serious argument. Liebes and Katz survey the range of academic, textual readings of *Dallas*, and see how diverse they are. That might tempt some to abandon textual approaches altogether, to see what different audiences make of it. But they can't do that, if they want to stick to the encoding/decoding model. Also, any textual analysis that is worthwhile must contribute to understanding the sheer popularity of the series – how it managed to succeed in more than 30 countries. This explains our authors' own preference for seeing *Dallas* in terms of what they call

'primordiality' and 'seriality'. 'Primordiality', they argue, is the almost biblical tendency in the series to emphasise basic family issues of conflict, power, ownership and the role of women. Brothers compete for wealth and women; the women struggle with their fertility – thus, the 'mythic' family is enacted before us. 'Seriality', meanwhile, allows the programme to run parallel to our lives, endlessly suggesting links between their world and ours. The very fundamental nature of these, they say, can explain the almost universal success of the programme.

The only trouble is that, as they themselves say, their groups only rarely talk this way – indeed, it is primarily the Americans and the Kibbutzim who do. This is minority talk, and therefore – given their own quantitative emphasis – can hardly count. But if we invert the terms of the argument, a quite other conclusion emerges. Who says that this image of the family is so 'primordial'? This does not seem to us a 'given' at all. On the other hand, we think it is easily arguable that it has been a claim of a large proportion of American media output that the 'American experience' can be treated as the world experience. In other words, the claim to primordiality is perhaps the most important status-claim which programmes such as *Dallas* seek to make. This is not so much a direct function of their textual make-up, as of their positioning in culture. Watch American people in the media, they seem to say, and you are watching the 'basic human condition'.

Understood in this way, there is no need to have recourse to a hidden ideological message or hegemonic agenda working 'behind the backs' of viewers. There is correspondingly no reason to suppose that distanced, 'critical' viewers are less vulnerable – on the contrary, to be vulnerable is to accord a certain status to the story of *Dallas*. And that is a conscious, thought-full process. On that basis, the Arab groups are among the least vulnerable since – on the evidence that Liebes and Katz themselves give, but then ignore – they are among the most conscious of the American-ness of *Dallas*, and contest it on that basis. On the other hand, the American audiences, however 'ludic' they may be, see *Dallas* as something 'safe'. It is 'only an escape' – but then to 'escape' into something in which what one does is to play without reserve with the idea that these are ordinary human beings, and their dilemmas are the natural order of things, is precisely to make yourself vulnerable to an Americanist ideology. Katz and Liebes' study's prime importance may be as a demonstration of the way in which the encoding/decoding model actually interferes with the thorough analysis of materials.

We have given this much space to the 'Hall Model' because of its wide and often unacknowledged influence. Although we both had concerns about the adequacy of the approach before beginning this research, some of the problems only came into focus as we explored its capacity to sustain solid empirical research. We have come to the emphatic conclusion that it does not.

The hermeneutic tradition

The final approach we want to consider arises from a meeting between two traditions. In continental Europe a predominantly literary tradition developed after World War II, which studied novels in particular for the ways in which they wrote in the reader. In related ways, a tradition of formal analysis of literary texts

developed in America.[36] The 'implied' or 'inscribed reader' was discovered by close analysis of the textual properties of literary works, found not only in forms of direct address ('Reader, I married him') but also in the way stories do such things as providing clues which we have to assemble, or containing gaps which have to be thought round. The implied reader is a position which a real reader can – and indeed must – inhabit, if s/he is to understand the text. Over time, as literary analysts developed more sophisticated tools for this kind of analysis, so it became clear that the 'position' provoked by a text is enormously complicated. Indeed, if there is a politics of any kind implicit in this formalistic work, it is a celebration of complexity. To demonstrate depths of positioning in a novel is to demonstrate its quality. By contrast, as Wayne Booth illustrates, simplicity was believed to lead to complicity.[37] In America, this tradition stayed predominantly literary; in Europe, it began to spill into other media, and researchers began to ask difficult questions about the relations between inscribed and actual audiences.[38]

In the mid-1980s, these literary traditions encountered an emergent set of problems in media and cultural studies. The wide acceptance accorded to Stuart Hall's encoding/decoding model led to its most famous test, in David Morley's *Nationwide Audience* study – a test which ought, as we argued earlier, to have led to its abandonment.[39] Instead, it led to a much more blurry set of responses. Among these were various attempts to find a new balance between textual determination (in whose importance much had been invested) and audience freedom. Apart from Morley's work,[40] the work most cited and discussed as offering a new way of working has been Janice Radway's study of women readers of popular romances such as Mills & Boon. It is worth recalling that this was as much a response to the American literary tradition as it was a contribution to media studies. Radway was defending women's pleasures in cheap literature against the dismissal of both by the American literary academy.[41]

In drawing on the reader-response tradition, two concepts came to the fore: the idea of the 'interpretive community', which is held together by its 'repertoires of response'. And to the extent that researchers abandoned notions of textual determination, they made what became known as the 'ethnographic turn' – that is, trying to study and understand media uses within the on-going cultural lives of readers, viewers and listeners. In fact, it would be fair to say that a sizeable proportion of the ethnographic research done on, for instance, TV audiences has been prompted by the wholly laudable impulse just to find out what people do when they watch, and with what they watch. Let's be honest – there is a boundless joy for real researchers in just being able to go and find out things which can surprise and astonish – it is perhaps the most important element of job satisfaction! But on its own this would inevitably lead simply to a pile of information, to findings without pattern or consequence. The idea of 'interpretive community' has provided the main tool for trying to think about the meanings of that information.

There has been an extensive and important debate about the value and validity of ethnography, as a means of investigating interpretive communities. It's been pointed out, for instance, that the term derives from anthropology, where it was assumed that no ethnographic study could take less than several years – the

anthropologist became, in effect, a guest-member of the society s/he was studying. Media researchers sometimes claim 'ethnographic' status for work based on one long interview. The relations of researchers to researched have also provoked much thought. But curiously, there has been much less attention to the central concept that underpins this kind of research. In an important commentary on this concept, Kim Schrøder has shown how dangerously confused 'interpretive community' has become.[42] The meaning of 'community' shifts uneasily: sometimes it is defined in terms of socio-cultural characteristics (class, gender, ethnicity, age, etc), sometimes in terms of discursive commonalities (using the same ways of speaking, even if the 'members' have no other common characteristics), sometimes in terms of their co-presence (being together in an interview and talking to each other). This is important in itself, but becomes even more so if we ask: what exactly is added to an account of a set of responses to, say, a news item or an advertisement or a music video or a film, if we say that the respondents constituted an 'interpretive community'? What does it warrant us to ask or say about them, that isn't already evident in their talk?

What follow are a few thoughts about this. We don't claim to have anything constituting an answer. This kind of research is very important, if only at descriptive levels in painting more complex pictures of real media uses. But it contains tendencies at the theoretical level which are less acceptable to us. One of the dangers of snap-shot research is that it treats audience 'communities' as givens, when in fact they have histories; and one of the ways in which they are formed historically is through people talking to each other, and learning to share ways of talking. In this sense there is a world of difference between communities in which, whether in fact-to-face communication or by mediated means,[43] people forge links and purposes; and communities which, while they may share ways of talking, derive them from a common, distributed source. Audience research needs to be very honest about the time-boundaries within which it works, and therefore the historical questions it cannot answer. Developing questions and hypotheses about the histories – and indeed the futures – of such communities could lead to some profitable links between media/cultural studies and other disciplines which have specialised in studying social movements.

One tendency we have noticed in a number of studies in this mode is to talk of audiences as being 'limited' by their membership of particular communities. We have never seen any warranty for this talk, which takes the form of talk of 'horizons of expectations' or of 'constraints'.[44] This may be demonstrable in particular cases – some communities do for instance mock certain kinds of talk, or disallow questions or attitudes. But these are particular instances, not matched for instance by the same degree of attention to what is allowed, encouraged or achieved through membership of communities. There is also a danger that 'interpretive communities' will be graded, implicitly, as more or less constraining, in the manner of Basil Bernstein – and of course that we who can see the constraints can see beyond their 'horizons'.

One aspect of a great deal of recent work we would strongly oppose is the tendency to the dissolution of interest in people's responses to particular texts, in

favour of what Ien Ang has called 'methodological situationalism',[45] which would focus primarily on the life-circumstances under which people meet particular media. The problem is that this is simply disrespectful to the very audiences whom we claim to be listening to – many of whom show by the ways they talk about particular films, books, kinds of music etc that they care enormously about them. They want to talk about them, gossip about them, catalogue them, judge them, make histories out of them, and so on. What we as researchers need to do is to keep our eyes on the differences among people in this respect, and to ask what else changes when some people invest importance in particular media forms while others don't.

These are marginal notes to a debate which is healthily under way among many media researchers. The idea of 'interpretive community' has much mileage in it, but mainly in so far as it sheds certain in-built tendencies to tell us in advance what a 'community' is, and what it means to belong to one, or of course more than one. The debate around the most significant exemplification, Radway's *Reading The Romance*, has been wide and we do not want to add to it here. We hope that the outcomes of our own research will amount to a serious addition to this kind of work.

Concluding remarks

Inevitably we have had to give schematic accounts of these main traditions, and that carries risks of unfairness. But what shows in the best of all these three kinds of recent research is something which outruns the theoretical approaches in which they are embedded. Both uses and gratifications, encoding/decoding and hermeneutic researches at their best press us to pay close attention to how people talk about their own uses of the media, how they define their own pleasures, what meanings they see in a 'text' and what significance they attach to their encounters with it.

The problem in constructing an alternative seems to be to know what exactly we want of a 'theory of audiences'. The difficulty in answering this question may lie in that very word 'audience'. As Andrew Tudor pointed out as long ago as 1974: '"Audience" is not a satisfactory term. Even its everyday use has overtones of passivity'.[46] This point was developed more recently by Janice Radway who has pointed to the odd origins of the word, in courtly reverence required of those attending to a royal person. A king 'holds audience', and his courtiers had better pay scrupulous attention, or else. The word 'audience' came to us resonant with assumptions about power.[47] This is partly true, but 'audience' has had a long career since those early uses. Now, though there remain problems with the word, they are more to do with diversity of meanings, and unresolved conflicts between uses.

However among all the differences and disputes, and with the (boringly inevitable) exception of 'effects' research, there is one common and dramatic shift. This is the rise in attention given to how audiences themselves talk about their media uses. 'Talk' as evidence is the material of our next chapter.

1 Young Minds, *Screen Violence and Mental Health*, London: The National Association for Child and Family Mental Health 1994, p.6.

2 See, for instance, the appalling output of the Parliamentary Group Video Enquiry (summarised in Geoffrey Barlow & Alison Hill (eds), *Video Violence and Children*, London: Hodder & Stoughton 1985). The summary does not tell the story behind the research which is revealed in all its gory detail in Brian Brown's 'Exactly what we wanted', in Martin Barker (ed), *The Video Nasties*. In line of descent from these, of course, come the more recent Newson Report (Elizabeth Newson, 'Video violence and the protection of children', in *Home Affairs Committee*, 'Video violence and young offenders', House of Commons, London: HMSO 1994, pp.45-9), and the current submission to the Home Secretary (Parliamentary All-Party Committee on Family and Child Protection, *Violence, Pornography and the Media*, London: PA-PCFCP 1996). The scandalous nature of the research, and the sheer ignorance of many of the people involved about what they claim to discuss, has not at all undermined the power of these documents to inform and shape law and censorious practices.

3 The wording here is very deliberate. It has struck us recently how many arguments about 'media effects' take place in the subjunctive. 'Who knows how something might influence vulnerable viewers?' 'Can you be sure that some people might not be persuaded to X?' etc.

4 See the four parts of the exchange in James Curran, David Morley and Valerie Walkerdine (eds), *Cultural Studies and Communications*, London: Edward Arnold 1996.

5 Herta Herzog, 'What do we really know about daytime serial listeners?', in Paul F Lazarsfeld & Frank N Stanton (eds), *Radio Research 1942-1943*, New York: Duell, Sloan and Pearce 1944, pp.3-33.

6 David Morley, *The 'Nationwide' Audience: Structure and Decoding*, London: Routledge 1980.

7 There are of course other tributaries of work. In their essay on the current state of audience research, Jensen and Rosengren don't separate the 'critical' and 'active audience' modes in the way that we and many others have, but do include a 'literary' tradition of thinking about audiences. But as they themselves say, 'it is probably fair to say ... that the bulk of literary criticism still asks what the structure of literary texts may do to readers, rather than what readers may do with literature'. (Klaus Bruhn Jensen & Karl Erik Rosengren, 'Five traditions in search of the audience', *European Journal of Communication*, Vol.5, 1990, pp.207-38.) This quote, p.212.

8 Joseph Klapper, 'Mass communications research: an old road revisited', *Studies in Public Communication*, Vol.27, 1963, cited in Justin Lewis, *The Ideological Octopus: An Exploration of Television and its Audience*, London: Routledge 1991, p.14.

9 See for instance Justin Lewis, *The Ideological Octopus*, Chapter 2. See also the classic critique by Philip Elliott, 'Uses and gratifications research: a critique and a sociological alternative', in J G Blumler & E Katz (eds), *The Uses of Mass Communication: Current Perspectives on Gratifications Research*, Beverley Hills, CA: Sage 1974.

10 Denis McQuail, Jay Blumler & J R Brown, 'The television audience: a revised perspective', in Denis McQuail (ed), *The Sociology of Mass Communications*, Harmondsworth: Penguin 1972, p.144.

11 Bernard Berelson, 'What "missing" a newspaper means', in Paul F Lazarsfeld & Frank N Stanton (eds), *Communications Research*, 1948-49, New York: Harper 1949.

12 An excellent illustration of this is to be found in an essay by Rosengren et al, addressing the issue of the 'consequences of media use for media use' – what ordinary folks think of as such things as 'wanting to see the next episode', or 'liking to read another novel of the same kind'. Of this, they say:

> What we see is not only the development and conservation of a habit, but also a process of habituation, sometimes resulting in mild forms of media dependence, 'addiction'.

(Karl Erik Rosengren, Ulla Johnsson-Smagordi & Inge Sonesson, 'For better or for worse: effects studies and beyond', in Karl Erik Rosengren (ed), *Media Effects and Beyond: Culture, Socialisation and Lifestyles*, London: Routledge 1994, p.136) In fact the studies cited demonstrate nothing of the kind. 'Dependence' and 'addiction' are declarations of the authors' dislike of what they saw, then imputed as 'harm' to those they were studying. This is as clear an example as it is possible to get of the tendency for U&G research to collapse back into the 'effects' tradition.

13 Jay G Blumler, J R Brown & Denis McQuail, *The Social Origins of the Gratifications Associated with Television Viewing*, Report to the Social Science Research Council, 1970. Unfortunately not published in full, the full report of the research is available in the ESRC Archive. Our thanks to Jay Blumler for drawing this to our attention, and for making a copy of the Report available to us.

14 It must be noted, though, that there are real problems with their clusters. For instance, their 'labelling' (their term) of groups of responses reveals some markedly ideological moves. By what logic, for instance, is the response 'One can talk about it afterwards with other people' an example of 'Personal Reference', while 'It helps me to forget my worries' is part of 'Reality Exploration'?

More revealingly, what presumptions underlie their labelling of the core-response 'It's free from bad language you get so much of on TV' as 'Reinforcement of the Social Role of Women'?

15 See for instance the discussion of 'empirical' and 'emotional' realism in Ien Ang, *Watching Dallas: Soap Opera and the Melodramatic Imagination*, London: Methuen 1985.

16 Stuart Hall, 'Encoding and decoding in the television discourse', *Occasional Papers No.7*, Birmingham: Centre for Contemporary Cultural Studies 1973, reprinted in CCCS, *Culture, Media, Language*, London: Hutchinson 1987. Hall's model of a television text was more complicated than many subsequent uses or restatements of it recognised, as Barker tried to show in other writings – see Martin Barker, 'Policing The Crisis', in Martin Barker & Anne Beezer (eds), *Reading Into Cultural Studies*, London: Routledge 1993, pp. 81-100.

17 David Morley, 'Changing paradigms in audience studies', in Ellen Seiter, Hans Borchers, Gabrielle Kreutzner & Eva-Maria Warth (eds), *Remote Control: Television, Audiences, and Cultural Power*, London: Routledge 1989, pp.16-43. This quote, p.18.

18 Elizabeth G Traube, *Dreaming Identities: Class, Gender and Generation in 1980s Hollywood Movies*, Boulder: Westview Press 1992, p.5.

19 Ellen Seiter et al., 'Introduction' to their *Remote Control*, p.5. The reference is to Simon Frith, 'Hearing secret harmonies', in Colin McCabe, *High Theory, Low Culture*, New York: St Martins Press 1986, p.57.

20 Janet Staiger, *Interpreting Audiences*, p.144.

21 Martin Barker, 'Policing The Crisis', p.88.

22 See Martin Barker, *Comics*, Ch.7. The reference is to Angela McRobbie, '*Jackie*: an ideology of adolescent femininity', *Occasional Papers*, Centre for Contemporary Cultural Studies, University of Birmingham 1978.

23 John Corner, 'Meaning, genre and context: the problematics of 'public knowledge' in the new audience studies', in James Curran & Michael Gurevitch (eds), *Mass Media and Society*, London: Edward Arnold 1991, pp.267-84.

24 David Bordwell, *Narration and the Fiction Film*, London: Methuen 1985.

25 On this, see the useful chapter in Roger Silverstone's *Television and Everyday Life*. Worries about the cogency of the concept of 'activity' are older than is sometimes recognised: see for instance Mark R Levy & Sven Windahl, 'The concept of audience activity', in Karl Erik Rosengren, Lawrence A Wenner & Philip Palmgreen (eds), *Media Gratifications Research: Current Perspectives*, London: Sage 1985, pp.109-22. For a recent critique which attempts an empirical test, see Jane Roscoe, Harriette Marshall & Kate Gleeson, 'The television audience: a reconsideration of the taken-for-granted terms "active", "social" and "critical"', *European Journal of Communication*, Vol.10, No.1, 1995, pp.87-108.

26 There is a counterpoint to this. Frequently, media studies critics of the 'effects' model use the idea of 'audience activity' as the basis for dismissing the claims of the 'effects' model. Justin Lewis, for instance, writes that 'While the behaviorists' mice live in a controlled environment, most of us are unaccustomed to watching television in uniform laboratory conditions' (Justin Lewis, *The Ideological Octopus*, p.9). Implication: since we aren't controlled and don't pay much attention, we can't be influenced. Second implication, therefore: if people could be found who did pay attention, they might be influenced in just the kinds of way the behaviorists worry about. This concedes just the ground from which we refuse to budge. The 'effects' theorists have misunderstood *how* people are influenced, not just how much.

27 See Martin Barker, *Comics*, Chapter 10.

28 Tamar Liebes & Elihu Katz, *The Export of Meaning: Cross-cultural Readings of Dallas*, Cambridge: Polity Press 1993.

29 For a useful exception, see John Tomlinson, *Cultural Imperialism: a Critical Introduction*, London: Francis Pinter 1991.

30 These issues have arisen before. They constituted one of the prime grounds for a critique of a hotly-contested research report on the role of television in the miners' strike. In 1985, the Broadcasting Research Unit published a report on television's role which effectively exonerated it of systematic bias. The research on which the report was based was essentially a quantitative content analysis. Subsequent critics of this report drew attention to ways in which this distorted the news reports it supposedly analysed. See Guy Cumberbatch, John Brown & Robin McGregor, *Television and the Miners' Strike*, London: Broadcasting Research Unit 1985; Colin Sparks, 'Striking results', *Media, Culture & Society*, Vol.9, No.3, 1987, pp.369-77; Martin Barker, '*Television and the miners' strike*', Media, Culture & Society, Vol.10, No.1, 1988, pp.107-11; and Greg Philo, 'Television and

the Miners' Strike: a note on method', *Media Culture & Society*, Vol.10, No.4, 1988, pp.517-23, and his *Seeing and Believing: the Influence of Television*, London: Routledge 1990. On the broader issues of content analysis, see also, Brian Winston, 'On counting the wrong things', in M Alvarado & John O Thompson, *The Media Reader*, London: BFI.

31 Tamar Liebes & Elihu Katz, *The Export of Meaning*, p.133 (our emphasis).

32 See Tamar Liebes & Elihu Katz, *The Export of Meaning*, pp.114-5.

33 Tamar Liebes & Elihu Katz, *The Export of Meaning*, p.8.

34 In fact, at this point, Liebes and Katz come close for a moment to a major part of our approach, when they wonder whether there shouldn't be attention to both the kinds of involvement that different viewers have, and the levels of commitment or investment they make. These ideas surface several times, but are in the end buried under the dross of the requirements of the encoding/decoding model.

35 Tamar Liebes & Elihu Katz, *The Export of Meaning*, pp.153-4.

36 The following are helpful introductions to reader-response theory: Roman Selden & Peter Widdowson, *A Reader's Guide to Contemporary Literary Theory*, Hassocks: Harvester Wheatsheaf 1993, Chapter 3; Robert C Holub, *Reception Theory: A Critical Introduction*, London: Methuen 1984; and Douwe Fokkema & Elrud Ibsch, *Theories of Literature in the Twentieth Century*, London: C Hurst & Co 1995, Chapter 5.

37 Wayne C Booth, *The Rhetoric of Fiction* (Chicago: University of Chicago Press 1961) is a careful study of the ways in which stories are narrated – with implications for our 'positioning' by the stories as readers. Perhaps the key sentence is this: '[A]ny story will be unintelligible unless it includes, however subtly, the amount of telling necessary not only to make us aware of the value-system which gives it its meaning but, more importantly, to make us willing to accept that value-system, at least temporarily'. (p.112) Clearly a lot more is tied up in that notion of 'accepting the value-system' than at first appears, since Booth will allow all kinds of complexity in our relations with literary works (see his discussion of the different possible meanings of 'child abuse' in literature immediately after the above quotation). But he severely disallows popular fictions which he regards as 'giving the impression that judgement is withheld' (p.83). His archetype of this is Mickey Spillane ('for those who can stomach him at all' (p.84)), whom he regards as sneaking judgements past our eyes. Although this early study now seems simplistic when compared with the almost endless complications subsequent literary analysts have introduced into the concepts of 'implied author', 'narrator' and 'implied reader', something of the same judgementalism survives in a lot of the later work.

38 See Paul Willemen, 'Notes on subjectivity', *Screen*, Vol.19, No.1, 1978: 'There remains an unbridgeable gap between "real" readers/authors and "inscribed" ones, constructed and marked in and by the text. Real readers are subjects in history, living in social formations, rather than mere subjects of a single text. The two types of subject are not commensurate.' Thanks to Svein Østerud for this quotation, which I have taken from his essay: 'How can audience research overcome the divide between macro- and micro-analysis, between social structure and action?' (MS from the author)

39 See David Morley, *The Nationwide Audience*, London: Routledge 1980, and his subsequent self-appraisal in '*The Nationwide Audience*: a critical postscript', *Screen Education* 39, 1981, pp.3-14.

40 See his subsequent *Family Television: Cultural Power and Domestic Leisure*, London: Comedia 1986.

41 Radway, Janice, *Reading The Romance*.

42 Kim Christian Schrøder, 'Audience semiotics, interpretive communities and the "ethnographic turn" in media research', *Media Culture & Society*, Vol.16, No.2, 1994, pp.337-47.

43 *Film 98* (BBC1, 5 January 1998) had a fascinating example of such a virtual community. It interviewed the American who runs the Website 'aint-it-cool-news' which has become sufficiently successful as to be seen as influencing the success or failure of forthcoming films. It was 'credited' with having contributed to the bad performance of the 1997 *Batman Forever*, but also to the better-than-expected performance of *Titanic* (1998). The flow of information through it, and the kinds of talk it has permitted, has led to film companies not only taking close note of what it says, but even trying to feed it information or, in one case, taking legal action against it. For many practical purposes, this is a, 'interpretive community' sharing effective modes of talk.

44 The expression 'horizon of expectations' derives from the German reception theorist Hans Robert Jauss, but it has found a ready home elsewhere. It is even echoed in Shrøder's excellent essay, when he talks of communities 'imposing constraints' (Kim Christian Schrøder, 'Audience semiotics, interpretive communities and the "ethnographic turn"', p.344) on their members.

45 Ien Ang, 'Culture and communication: towards an ethnographic critique of media consumption in the transnational system', *European Journal of Communication*, Vol.5, 1991, pp.239-60.

46 Andrew Tudor, *Image and Influence: Studies in the Sociology of Film*, London: George Allen & Unwin 1974, p.74.

47 Janice Radway, 'Reception study: ethnography and the problem of dispersed audiences and nomadic subjects', *Cultural Studies*, Vol.2, No.3, 1988, pp.358-76.

5

THE PERILS AND DELIGHTS OF DISCOURSE ANALYSIS

The application to the ESRC promised that this research would analyse audience responses to *Dredd*, by using procedures derived from discourse analysis. Discourse analysis, a multi-faceted set of proposals for studying human communication, has blossomed into a specialist field in recent years. The part of it which concerned us was that which works to reveal the operation of social and cultural processes within individuals' talk and writing. Through studying how people talk or write, discourse analysts believe that they can bring into view the social assumptions, shared cultural values, and communities of response in which people are involved. More controversially, discourse analysis also makes it possible, many believe, to identify processes of persuasion, and of ideological transmission: in short, power at work in language.

Discourse analysis starts from a belief that all acts of human communication are complex structured processes. A main part of their complexity arises from the ways the social relations which surround a communicative event intersect with the specific communicative forms used. In this sense, it is closely related to the rise of textual analysis of media and popular cultural forms, in their shared recognition of complexities of structure and operation which had often to this point been ignored. But while films, news items, books, magazines, advertisements, or whatever have fairly evident boundaries and forms, discourse analysis has wanted to deal with less formally structured materials such as conversations. In practice, this distinction gets blurry, once we think of things such as political speeches, or television chat shows, or serials, or on-going news coverage. But the real messiness begins when textual analysts argue that in analysing, say, an advertisement – one of the most bounded and purposive forms of communication – they are revealing connections to images and ideas not directly present, but referenced and mobilised, in their text. Every text, therefore, is an intertext, defying its apparent boundaries. What links them became known as 'discourses'.

Even so, analysis of talk does pose problems not presented by, say, a television programme. The programme will be broadcast and available in the same form to everyone, regardless of whether an analyst is watching or listening. And our analysis won't change that. With talk, unless we manage unobtrusively to record conversations which are just going on, the researcher inevitably plays a role in shaping what people say and how they say it. In many cases, the materials

wouldn't even exist but for the researcher – the interview is the classic example of this. And talk does not fall into 'units' with anything like the ease that, say, magazines do.

The impulse to think of culture and communication as forms of 'discourse' has become very strong in recent years. Textual and discourse analysis claim to delve below the surface of their materials, to reveal non-obvious features, in particular about 'power'. How may we do this? The recent blossoming of work has produced a panoply of ideas and proposals. But because the new concentration on 'discourse' has arisen from many different sources, the field is congested with competing approaches. One solution has been not to worry too much about method and validity, just using a loose approach with the aim of offering 'insights'. But if that is all discourse analysis can achieve, it is weak.

Our starting ambition was well put for us a long time ago by Antonio Gramsci:

> If it is true that every language contains the elements of a conception of the world and of a culture, it would also be true to say that from anyone's language one can assess the greater or lesser complexity of his conception of the world.[1]

Yes, but how do we do this? And how do we know when we have done it adequately?

The sources of contemporary work on discourse

The speed and extent of the recent turn to 'discourse' is remarkable, as is evidenced by the boom in books and journals devoted to its study and development.[2] Within just a few years the idea of 'discourse' has become common language within a wide range of academic, and indeed some non-academic, writing. There has been a sense of excitement in the invention and development of a new intellectual project. But in another, more negative direction, a welter of different meanings of key terms, and a confusion of methods has characterised the field. This is in part, at least, because of the number of changes which have contributed to the growth.[3] We outline these only briefly, for reasons of space:

1 The structuralist inheritance: in the early years of this century and in a number of fields, the idea of 'structure' emerged as a main concept through which society and social processes were to be understood. Within linguistics, no one embodied this more than Ferdinand de Saussure, whose new way of thinking about language has become well-known.[4] Saussure argued that language should be understood as an 'arbitrary system of differences with no positive term'. The implication was that language is a structure which grids onto the world, and thus stamps a framework of concepts onto objects and our experience of them, onto people, relationships and indeed all things thought. This idea became the basis of a great deal of early investigation of cultural studies work on texts, but only after two changes. First, Saussure saw each 'language' as co-terminus with a culture, and therefore in a sense simply belonging to itself. Subsequent uses on his ideas wanted to be able to link forms of language with social interests, to suggest that processes of persuasion and of ideology were bound up with power relations within society. This meant

seeing the 'naturalness' of a language as a mask or illusion fostered by the interests of powerful groups; and it also meant being willing to talk about linguistic units smaller than whole 'languages'.[5]

The second shift resulted from the encounter between structuralist ideas, and developing sociolinguistics. Saussure had stressed the classificatory aspects of languages – the way they categorise. Sociolinguistics was interested much more widely in all the forms and practices of speech between people. This encounter produced, among other things, an investigation of social grammars as forms of discourse. Perhaps the earliest uses and versions of this were those which sought to show that language was structurally gendered; among these was Dale Spender's *Man-Made Language*, which sought to show that a preference for the male gender was structured into the English language at all levels, from simple vocabulary all the way up to criteria governing the 'right to speak'.[6] But in particular, the work of a group of researchers and theorists around Gunther Kress began to develop, in the 1970s, a set of ways of examining such things as Press reports, for their embedded ideological assumptions.[7] In later writings this strain of 'critical linguistics' became known as 'critical discourse analysis'.[8]

2 The 1960s and 1970s saw other developments in sociolinguistics. One, associated with the rise of ethnomethodology in sociology, was interested in the micro-processes of social interaction. Conversation Analysis, as it was dubbed, involved studies of features such as turn-taking in telephone conversations and how that contributes to the achievement of a successful communicative act – but virtually irrespective of the content of the conversation. The principle behind this was a shift away from an older orientation to language which only looked at structures of grammar or, if it looked at interactions at all, tended to make up examples rather than examining messy, real-life ones. Michael Stubbs, among others, dubbed this a new emphasis on language 'above the level of the sentence'.[9] The other insistence was that language is a form of social action. This could be demonstrated by pointing to the disjunction between the grammatical sense of a sentence, and its social import. 'Can you shut the door?' functions grammatically as a request for information, or confirmation of a capacity. But we recognise it as a polite request for a performance.

As is often the case, this starting point made space for other interests. Soon, another strand was looking in particular at forms of interaction in situations such as classrooms, and examined what effects they might have on educational achievements and forms of learning. The big change here was the new interest in the role and impact of power-relations in communication.[10] But overall, Conversation Analysts maintained their focus on the micro-processes of interaction and rule-following in talk. Some considerable rows have taken place over the question of 'power' in communications, especially in America where Conversation Analysis first developed. Its critics damned this approach for its refusal to think about the broader social contexts and inequalities of power in which speech occurred. Its defenders damned their opponents for giving up on analysis, substituting political critique instead.[11]

111

3 Meanwhile mainstream psychology saw the emergence of a school of 'rhetorical psychology'. It is interesting that this, and some other developments, all took place in connection with research on 'race' and racism. A widespread realisation of the ways in which elements of racist ideas could permeate both ordinary and scientific talk led to a number of psychologists challenging the then dominant conceptualisations of 'racism', and the associated concept of 'attitudes'.[12] If the problem of racism is a problem of (pre-rational) 'attitudes', then it focuses attention on those seen as having fixed attitudes within rigid personalities. It also exempts and excuses more 'educated' people.

The challenge to this had several parts. First, it was pointed out that the evidence for people's 'attitudes' was entirely their verbal (spoken or written) responses to interviewers' questions. But what if people's responses could be argued to be a function of the contexts of conversation, rather than an indication of some fixed, inner tendency? Second, looking at people's responses in verbal terms, rather than as symptoms of 'attitudes' hidden behind the talk, showed that those with apparently non-rigid responses shared and articulated much the same views, but in more 'acceptable' forms – they were evincing respectable racism. Third, this then pointed to the necessity of investigating what became known as 'repertoires of response', that is, shared and patterned ways of thinking and talking about a topic. Finally, in a reverse move, it was argued that mainstream psychology was itself implicated in those very repertoires of response which have underpinned racist forms of talk.

What emerged, then, was a way of thinking about talk as situationally determined and as drawing on repertoires of response.[13]

4 In the late 1960s and early 1970s academic Marxist theory underwent a series of very fast changes. Driven by a felt need to produce a viable theory of ideology which did not 'reduce' ideology to some chimera thrown up by an 'economic base', cultural researchers seized on the work of Louis Althusser. Althusser, a last-gasp Stalinist, offered a theorisation of ideology well-suited to the perceived needs of the time. His model depicted ideology and other forms of social superstructure (law, politics, and education, for example) as only 'in the last instance' explainable by reference to the movements and requirements of capitalism. But what marked them was their difference from 'science'. Science, for Althusser, was the outcome of a specialised set of theories and investigative procedures, which become possible through the historically-situated insights of Marxism.

Within a short space of time, both these steps were under fire. First, that 'in the last instance' was quickly seen as an empty move, designed to maintain the idea of class analysis, without giving it any practical explanatory role. Let it therefore be abandoned, and let us examine each level of social action in its own right. Second, the attempt to make Marxism itself a special source of knowledge was rejected – if all forms of knowledge are historically conditioned, and thus limited forms of social imaginary, then so is Marxism. Althusser, it was argued, wanted an impossible 'standpoint outside history'.

What this further led to, was either a wholesale rejection of the concept of 'ideology', since that seems to require an ability to stand outside and above the fray of politics to judge the 'interests being served', or else a narrowing of its application to special cases of direct propagation of particular interests. In place of 'ideology', then, post-Marxist thinkers began to talk of 'discourse' instead.[14]

5 In parallel with this dismissal of Marxism for supposedly claiming to have a 'grand historical narrative' came a shift from consideration of 'class' and 'exploitation', to investigation of 'gender' and 'oppression'. 'Exploitation' is a socio-economic relationship which can go on working even if we do not understand it, or have clear mental images of it. The concept of 'oppression', on the other hand, demands we look at how people get defined, labelled and represented and through those made into the objects of power. But almost as soon as this had shifted the primary target from from class to gender, that in its turn was split as other groups demanded attention to other, cross-cutting, forms of oppression: black and other ethnic groups, gays and lesbians, disabled people – all could be equivalently seen as subject to oppressive representations. And so there followed a shift towards seeing a multiplicity of overlapping and interlocking modes of representation, or 'discourses'.

6 In this same period, the work of Michel Foucault came into prominence. Foucault was another, rather different critic of Marxism (which he also understood and encountered primarily in its Stalinist forms). Foucault developed a sophisticated theorisation of social processes at whose heart was a concept of discourse. For example looking at sex and sexuality in the nineteenth century, Foucault argued that, far from being repressive, the function of this period's ways of investigating sex, classifying and medicalising different kinds of sexuality, was to produce modes of response and self-understanding consonant with these discourses. Discourses constitute their object of interest, they work to produce people in their own image. Foucault applied these ideas to medicine, to punishment regimes, to the treatment of madness, and to other ways in which a modern society 'knows' its members. His followers have applied his claims ever more widely. The Foucauldian style of argument and analysis merged frequently with psychoanalytic approaches, because of their shared interest in the ways in which people's sense of self might be 'constructed' through powerful social interactions.

Like the other post-'marxists', Foucault rejected the idea that the development of these various productive discourses could all be explained in terms of one central model, about class and capitalism. Instead, he saw a society as a swirl of overlapping but separately evolving discourses, each constituting a separate field of disciplinary (both senses of the word) knowledge. And paralleling the claims about the multiplicity of separate institutions was a claim, also shared with psychoanalytic approaches, that we all are 'non-unitary subjects'.

7 A minor strand of work has turned elsewhere. A number of theorists and researchers have looked back to the work of Valentin Volosinov, and have seen that as offering a different way of thinking about the role of language in society. Volosinov was the earliest to mount an assault on Saussure's structuralist

account of language, seeing it as leading to a 'dead' study of languages. In place of this, he offered a theory of language which emphasised its role in social struggles.[15] Volosinov only laid down the bones of an approach, and didn't even indicate how it might be applied. Only recently have a few scholars sought to apply his work.[16]

These many routes to 'discourse' happened at real speed, and untidily. Critical grammarians quickly started listening to and debating with rhetorical psychologists. Postmodern post-marxists reached for elements of sociolinguistics to develop their positions. Foucauldians introduced strong elements of psychoanalysis in their thinking, while having to respond to criticisms from feminist psychoanalysts of Foucault's inattention to gender issues. And so on. The result is a sometimes confusion of ideas about 'discourse'. Even so, perhaps the following mark out a fairly shared terrain.

Language is never 'innocent': the way people talk, write and generally communicate to each other is always socially inflected. This affects our lexicon of expressions, our semantic categories, our grammars, our available forms for talking about things, and our sources of 'legitimate' ideas.[17]

Talk always occurs within interpretive communities: in communicating with each other people draw on stocks of beliefs and ways of understanding which have developed from the activities and interests of particular groups – though actual speakers need not belong to those groups.

Language is never simply a neutral communication of information: our language-uses contain forms which structure the contents of what we say, adding many things to their meaning (status, authority, structure, possible uses, etc); they also are in themselves actions, and thus create and maintain social relations between people – talking, writing etc are among the things we do to each other.

Social researchers cannot escape talk and its social implications, to reach some non-social truth about people: no matter what researchers may wish, they will always elicit talk which is structured by the social relationships between them and the people they are trying to investigate.

A mass of work has developed under this broad banner of 'discourse'. But the different inheritances reveal themselves in the ways different people think about discourse analysis: most critically, what exactly can be established by discourse analysis? When can we validly claim that a text, or a piece of conversation, is connected to a wider 'structure of discourse'? What procedures does a valid discourse analysis need to follow, and what methodological criteria does it need to fulfil to count as valid? And though discourses are social, they are only ever discovered through individuals' talk; so how should we understand the relationship between the individual and the social?

Whatever the problems, we start from the fact that this has become an expanding and exciting field, with a range of emerging specialisations. Our work is only concerned with one aspect of the field, and what will constitute doing this well. For this purpose, therefore, by 'discourse analysis' we mean the structured investigation of people's language-uses with a view to analysing the ways in which they contain, embody, or otherwise refer to wider social processes, conceptualisations, assumptions, ways of thinking and talking. Put less formally, we are after effective ways of seeing individuals' talk as social microcosms, containing the signs and symptoms of the social relations in which they are caught up. Relating this to our specific materials, what we want to be able to understand is how people's responses to films like *Dredd* can be studied as social phenomena. A film is a body of social meanings. So is going to see it. So are people's responses. We need to listen to their talk. How can we most effectively analyse it?

An advantage in tackling this task is the wide range of significant empirical studies undertaken in the past few years, which seem to demonstrate just how productive discourse analysis can be for our kinds of purpose. Leaving aside media audience researches, the following are just a few among the impressive array: Michael Billig's many studies, including his investigations of people's relations to the Royal Family[18] and his analysis of the very particular kinds of racism expressed by Young Conservatives;[19] Rosalind Gill's account of the self-justifying talk of broadcasters about the absence of women in radio;[20] and Pete Goodwin's close analysis of legal talk, showing how court procedures invalidate certain kinds of defence.[21] The journal *Discourse & Society*, founded in 1990, contains an impressive range of empirical studies of a host of different communicative forms and situations. All these are particularly interesting to us, because they meet two conditions: they are trying to reveal aspects of people's social relations in and via the available forms of communication; and they are acutely aware of methodological questions about how we may validly make this move.

Problems in discourse analysis

This isn't the place for a full-scale inquiry into those seven contributory influences. But we have to raise some difficult issues, which we do by posing five questions:

(a) What entitles us to conclude that we have identifed a wider discourse within a communication, to 'name' it, and thus to regard that communication as an example of a wider phenomenon?

(b) When researchers talk to people, our talk is a social transaction like anybody else's. How, then, should we study and understand our own role in making the talk occur as it did?

(c) Is all talk equal? When we are analysing responses to a film, are everyone's responses equally significant?

(d) What entitles us to conclude that a specific communication, or a wider discourse, has 'power' over its receivers, and how would we determine what kind of 'power' this is?

(e) How far do the different approaches allow us to study different degrees of organisation and coherence of discourses either in individuals or in society more generally? Or are all discourses just that, fully-formed members of an undifferentiated species?

We start with the question of 'power' since that has been central to much discourse analysis. For the aim of a great deal of such work has been to expose persuasive moves and ideological premises in speech, writing and the mass media. This is equated with disclosing acts of power. Putting at its crudest, a good deal of textual and discourse work seems to work on the assumption that to find a pattern is to find a powerful pattern. It is the premise underlying this claim:

> Language organised in discourses (what some contributors here call interpretative repertoires) has an immense power to shape the way people, including psychologists, experience and behave in the world.[22]

Really – an 'immense power'? How is this known? And what kind of shaping? The authors of this are in danger of making it true by definition, that the moment we locate a discourse, or interpretative repertoire, we have *ipso facto* proven it is powerful. This seems to be the case regardless of the specific approach to discourse analysis. When Kress and Trew analysed British Leyland's work-force leaflet and the *Sunday Times'* rewriting of it, the identification of hidden but structuring patterns seems to be all the evidence we could need of the salience of the thus-uncovered ideologies.[23] When Ryan and Kellner investigated the discourses of the *Star Wars* trilogy, and saw them as implicated in 'dominant American conservative ideology', combining modern anti-Statism with rural nostalgia, their little bit of empirical evidence from an audience survey functions at best as a confirmation of what they know from their textual 'reading'.[24] But if this was accepted, there could be no basis even for asking if some discourses are more powerful than others. 'Power' would become an automatic consequence of the existence of a 'discourse' – and not on grounds of its content, but on grounds of its operation as a discourse. So even if we had evidence of people being persuaded, we should not trust their own explanation of this. For they would say they had come to believe the ideas, for example, but 'we' would have to say that it was the general persuasive form they came in that influenced them.

That's unacceptable not only on the good sense grounds that we know people often reject ideas and images preferred to them. It is also disturbing in that it can mean that analysts' claims to have discovered discursive constructs would be the only evidence we would need, and could have, for their existence. That puts far too much weight on an uncheckable analytic procedure.

The difficulty turns in part on some real slipperiness in the meaning of 'power' – and especially as regards the mass media. When people talk about the 'power' of a film, they can mean any of the following. A film might 'make people laugh, or cry, or think' as they watch it; it might 'make them worry, or dream, or have nightmares, or rethink an issue' as in the aftermath of seeing it; it might 'make them degraded, or violent, or dehumanise them' as a consequence of seeing it; it might 'embody powerful discourses about masculinity, or nationhood, or war'

which involve and restructure people's sense of self through their engagement with it. These are all claims about 'media power', but they are of quite different orders from each other. The evidential base for each is quite different. A great deal of media theory assumes a meaning to 'power', and as Ian Hutchby has put it: 'There is a tendency both in culture and social scientific discourse to conceive of power as a "big" phenomenon, operating at the largest scale within social formations'.[25] The trouble is that Hutchby uses this argument to reintroduce the Conversation Analysts' position, which effectively does away with any questions of power other than those which communicators themselves acknowledge or reference in their talk. We don't wish to go there, for reasons which Norman Fairclough has well put. In an essay reviewing the first two years of the journal *Discourse & Society*, Fairclough discerns two tendencies within discourse analysis: the first, towards linguistic analysis, by which he means the analysis of communications for their internal grammars, moves, and relations between parts – the procedures which make it work as a communicative event, in other words. The second, 'intertextual analysis', explores the ways particular communications can be seen as samples of wider repertoires.[26]

Fairclough proposes that both are necessary to a viable discourse analysis. Linguistic without intertextual analysis isolates and flattens a communication, since it cannot deal with its connections with wider processes – and this has been the problem with a great deal of conversation analysis. But intertextual analysis without grounding in close linguistic analysis easily becomes wayward, and uncontrolled. It is worryingly easy to illustrate this. Consider a not atypical essay, on Superman. Marc Kipniss discusses the episode of the 1993 'death' of Superman.[27] In his hands, this becomes an 'example' of postmodern popular culture. The story cannot possibly offer any resistance to Kipniss' account, because he does not so much analyse them, as retell them in terms of his already-known theory. So, when he tells us that 'the contest between Superman and Doomsday is often rendered in violently homoerotic terms',[28] this is not the result of an analysis of the story's rendition, but of a 'naming' of things which could as well be named in other ways (why should exo-skeletal armour automatically be a 'phallus'?). Or when he discusses DC's marketing strategy (very crudely rendered as 'quite obviously using the story ... to boost the comic's flagging sales'),[29] this is within a paragraph rendered as a 'perfect example of' an account of postmodernism as 'complicitous critique' (how exactly does maximising the moment in publicity terms mean that it 'manages to install and reinforce as much as undermine and subvert the conventions and suppositions it appears to challenge'?). The relation between evidence and theoretical claim is limp to the point of dissolution. And perhaps most worryingly to us, Kipniss' claims just do not seem testable by any regime of investigation we can imagine.

We therefore propose a rule of provisionality: by their nature, discourse or textual analyses can only result in provisional claims about the presence of discursive forms. Among the tests of these will be these: they must draw attention to clearly defined aspects of the materials; and in attaching significance to them, (a) must make clear how these were discovered within the materials, (b) will be persuasive

only to the extent that they can explain more features of the materials than other approaches, and (c) crucially, must make possible triangulations with other, independent kinds of evidence.[30] So, Kipniss' argument could be acceptable if he could demonstrate the following: that the textual features he points to are clearly 'read-able' as signifying postmodern discourses; and if he could show that it is possible to explain the presence and operation of those features in terms of a concrete history of DC Comics, or the comics' market situation, or the nature of the readership.

The limits of 'semiotics'

The problem seems to be that a good deal of discourse analytic work is mainly persuasive because of its acceptability to certain kinds of contemporary academic talk. It is not convincing by virtue of of tested evidence. Our entire research turns on making the question of the power of the film *Judge Dredd* into an empirical issue. If that can be 'named', known in advance, and in ways that do not admit testing, it isn't even worth beginning.

But this can't be seen just as an issue of amount of influence – as if we know what the influence would be if it is there at all. It must also be a question about the kind of influence. And that in turn splits into two questions: it means querying both how one determines the presence of possibly-influential discourses in *Dredd,* and how one determines the way they might influence people.

This introduces an idea which is now emerging as an important one within discourse work: the idea of 'modality'. Consider one approach which does aim to transcend the difficulties which we've posed here. Robert Hodge and Gunther Kress have been among the foremost exponents of critical discourse analysis, that branch of discourse work which initially studied the operation of social grammars. But in a more recent book, they have developed their ideas into a new way of thinking about the ideological significations of cultural materials.[31]

Social Semiotics is a defence of the value of semiotics in the face of many people being tempted to abandon it. Aware of the many criticisms that it has faced, their reformulation seeks to re-ground semiotics more securely. The first step in that is a move away from the assumptions imported from the work of Ferdinand de Saussure. Saussure, they argue, wrongly asserted the 'arbitrariness' of linguistic and cultural distinctions; he did so because he generalised a partial truth, that many word-sounds or written-forms have no connection with the concept they enunciate, to an absolute truth. Against this, Hodge and Kress argue that especially at the point where languages change, the way meanings are expressed is essential. For this can reveal the social ownership of the new word, or concept, or representation. Among their examples of this is a fascinating discussion of the history of the word 'shibboleth': originally the hebrew word for 'river', it was co-opted by the Gileadites as a basis for demarcating themselves from the conquered Ephraimites, and conducting what was effectively a form of ethnic cleansing, killing all those who could not pronounce the word properly.[32]

Here they depart from Saussure towards two other starting-points: the American pragmatic philosopher Charles Pierce and, more particularly, Valentin Volosinov.

Volosinov it was who first criticised Saussure's approach to language and, instead, stressed the part that battles over words and meanings play in social struggles. For Kress and Hodge, the most important feature of Volosinov's approach to language is his insistence on the materiality of the sign. But they take this in a direction that Volosinov did not want to go. It leads to them seeing visual representations as essentially no different than verbal accounts. This is where we depart from them.

The key is yet again an unargued notion of power, which is well caught in one sentence: 'Social control rests on control over the representation of reality which is accepted as the basis of judgement and action'.[33] To be acceptable, this requires several of the kinds of premises we wish to challenge:

(a) it continues the Saussurean tradition of seeing semiotic processes as working mainly through the operation of cultural categories, which carve up the world and at the same time 'persuade' us of their 'naturalness';

(b) it incorporates a 'jump' from our identifying a semiotic pattern, to asserting that patterns as such have a power to reproduce themselves in recipients;

(c) the category 'social control' is not transparent or obvious. Without here entering into all the arguments over this and its accomplice 'ideology', we need to note the counter-argument that social control may not rest on conviction, but on the 'pressures of dull necessity'.[34] There is a world of difference in the implications for the role of ideas and representations if acceptance of conditions is based, not on agreement, but on feelings of powerlessness.

Two test-cases: in Chapter 3 they discuss the example of a 1333 altar-piece of Mary and the angel Gabriel by Simone Martini. They are interested in particular in the way the painting depicts the relationship between Mary and Gabriel. Mary is leaning away, uncertainly, from Gabriel who is tendering a branch. They analyse the relationships through the depicted body-language and the space between them: 'we can ask: is Gabriel too close, by fourteenth century Siennese standards? And is Mary high enough – for herself, or for Gabriel?'[35] They argue that the painting contains and embodies 'two apparently opposite ideological forms', in which Mary is simultaneously venerated as mother of God and threatened with 'rape' as a woman. But this is only possible if one reads the painting as a literal commentary on male/female relations. What goes missing entirely in their account is that this is a religious painting, designed for a particular kind of use. What is lost on this account? We simply point to one curious fact: they emphasise the degree of physical proximity between Gabriel and Mary, that Gabriel is invading her sexual space – and from this are able to 'deduce' that Gabriel's raised finger and the branch he tenders are both phallic symbols. What they don't say is that Gabriel and Mary are both nearer to the edge of the painting than they are to each other. This is because each is 'contained' within an arch of the five-part altar-piece whose centre-panel is almost bare. The literalness of their reading demolishes its role and meanings *as painting*. In Chapter 7, by happenstance, an example of this kind will return.

The second test-case is a lucky one for us, since we know something about this from previous researches. In Chapter 5 Hodge and Kress develop the other most

important aspect of their approach, a theory of modality, and apply it among other things to three comics: the *Beano*, *Dr Who*, and a western *Heroes of the West*. 'Modality' is a feature of language and the media which has received scant attention to date in our field. Hodge and Kress's serious address to this is greatly welcome. Drawing on the work of Michael Halliday, they mark out two aspects of modality. The first, and more obvious, deals with the degree of confidence or certainty with which a proposition is asserted; it deals, in other words, with the 'truth' or 'reality' of a claim. Some markers of this are pretty obvious; expressions of doubt such as 'I am not sure if it is ...' or hesitancy as in 'I think it may be ...' embody modal modifications of whatever propositional content follows (for example, '... going to rain'). Their second dimension is less obvious: 'modality expresses affinity – or lack of it – of speaker with hearer via an affirmation of their affinity about the status of the mimetic system'.[36] Their argument is that this feature operates along a dimension between 'power' and 'solidarity'. 'Power' here means the assertion of authoritative knowledge over and against another person; solidarity means an appeal to shared community.

But again what is being dealt with here is still only to do with categories of information and knowledge, or 'systems of classification', to use Hodge and Kress's own phrase. It is privileging that which was always privileged within Saussure's understanding of language, but not within Volosinov's. It is as though all, or the most important thing, we do with words is to cut up the world and experience it in lumps. We disagree. Human beings do a vast array of other things with language. We ponder, hope, wonder, fear, fantasise, imagine, prepare, plan, project, play, day-dream, versify, rhyme, chant, tell stories and seduce, with words – to name just a few. These aren't reducible to variants on 'using classification systems'. But that is what Hodge and Kress ask us to do. So, in looking at the *Beano*, their understanding of it is still in terms of its 'realism' or 'un-realism'. The drawing style indicates the latter – but the 'naughty' characters are drawn more unrealistically than the good ones. This suggests that the *Beano* should be read, they say, as an 'anti-language', a textual form which is only comprehensible as an opposite of an official language. So, 'While "readers at large" are likely to judge the whole set of modality markers as signifying "lack of realism", the specific addressees of this text are equally likely to assert their affinity with the text and its affinity markers.' On this basis, they are able to conclude that 'Dennis is a realistic character for those who share many dimensions of this world, who are young, male, white and English'.[37]

This is, from our knowledge of the *Beano* and its history, simply wrong. The mistake arises from a reading off of the 'realism' of the comic from its descriptive characteristics, which is on a par with their Saussurean insistence on 'systems of classification'. The error runs right through the book. It consists of thinking that because something is represented using gender, it is a representation about gender. 'Gender' is such a sensitive category in contemporary culture that this may be hard for people to accept. Consider it, therefore, in the case of animals. In C S Lewis's Narnia novels the figure of Jesus is represented by a lion – but we do not see this as a representation about lions. Rather it is a borrowing of some associations from

there (strength and beauty) but with a careful detaching of others (hunter and meat-eater, for instance). In Art Spiegelmann's *Maus*, Germans are represented as cats, while the Jews are mice – but readers well understand that this is a device to enable certain kinds of story-telling.[38] It is interesting to run a commutation test, that is, a substitution of elements to see what else if anything is altered on the *Beano*. Suppose Dennis became Denise: what, other than the slight loss of a rhyme, would be lost? Hodge and Kress are disappointingly predictable in picking out 'male', 'white' and 'English' (though the last is just bizarre given the publisher D C Thomson is Scottish!). They could as well have picked out 'dark-haired', 'dog-owning', and 'suburban', since all are true of the descriptive characteristics of the story. There is something very wrong with an analysis which can wind up in this kind of hole!

We have explored this example in some depth because it illustrates well our general problem with their account. By defining 'modality' only in terms of 'degree of assertion of reality', they miss out the most important feature – what we will choose to call their modality of response.[39] A comic like the *Beano* doesn't just offer a form of knowledge, it offers a way of being related to and used.

Contexts and convictions

We can best explain our idea of modalities of response, by considering another strong example of discourse analysis, Michael Billig's investigation of the meaning of 'holding strong views.[40]

Billig is renewing his assault on mainstream psychology's talk of 'attitudes' as relatively fixed, internal emotional or quasi-emotional states which are 'expressed' in talk. In the mainstream account, to hold strong views is to display something approaching bigotry, or a 'rigid personality'. Against this, Billig wants to show that strength of view is a discursive construct. Using materials he gathered in course of research on the Royal Family, he examines one family where the father was seen as holding strong views. In a fascinating essay, Billig reveals a number of features of their talk. First, it is the rest of the family who categorise the father as 'holding rigid views' – and that is done by invalidating his arguments as merely a 'wish to be provocative' and 'an attempt to stir up rows'. Second, Billig shows that the father seems to navigate a space between two poles: a pole of asserting the equality of all people (and therefore hostile to the privileges of the Royals) and a pole in which he accepts the necessity of economic differences as long as they are fair, and bring benefit to everyone in the end. One of his reasons is the threat posed by his son suggesting he is a 'communist'. To fend this off, he has to retreat to a 'milder' position.[41]

On the basis of this analysis, Billig is able to renew his criticisms of 'attitude' theory. Thus far we have no dispute. But his way of formulating his own positive thesis is disappointing. He offers a contextually-driven account, summed up in these two sentences: 'In different discursive contexts people should be expected to do different things with their speech and therefore there will be a variability in their utterance from context to context', and 'There is a challenge to the assumption that the average person is an attitude-holder who carries around a

fixed, internally-consistent view from situation to situation'.[42] In other words, Billig's counter to attitude-theory is a view that ordinary people change the way they declare their views, according to context. We would ideally have to a lot to say about this. There is, for a start, his idea of an 'average person' with its presumed implication of some non-average people. But we will limit our challenge to the following.

The difficulty with this approach is that it does walk close to reducing people's 'strongly-held views' to just cases of 'being awkward in a particular context'. Where, for instance, is there space for activists who, on any topic, hold worked-out views which they wish to proselytise? They could include a determination to attack meat-eating, a wish to promote a local football team, a commitment to the virtues of a particular rock band, or a grounded belief in the necessity of a particular religion. All involve their adherents in trying to find opportunities to raise and praise their cause. Of course, wise propagandists 'hear' when it is not good to try this – or vary their tactics according to the discursive context. Billig is in danger of marginalising these people – they are 'non-average people'. That would be risky. It makes it difficult to see how anyone becomes an activist, by committing themselves to a cause. It also leaves the door open for mainstream psychologists to regain this territory, seeing such people as, precisely, rigid bigots.

Like Billig, we see talk as people 'thinking things through', rather than just enunciating attitudes. But at back of rhetorical psychology's account is a belief that, for 'average' people anyway, repertoires of response set boundaries, limit the range of responses and provide structuring contexts.[43] While this may be empirically true at certain points in history, and may apply most of the time to most people, it is still only contingently true – or we will never be able to explain how 'ordinary people' from time to time get up and make changes. We want to leave space for considering those who, by virtue of strong convictions of some kind, exert challenges and try to redefine for others how something should be thought and talked about. The interesting thing about talk about the Royal Family is that it is never purely descriptive or classificatory – Billig rightly sees that such talk depends on references to general models of society, to how things should or might be. The Royals fit more or less well into people's picture of the world – sometimes just personally, sometimes communally. Suppose the father in Billig's research had become involved with an anti-monarchist organisation. His position would surely have become more defensible and secure. Failing that, it's probably not surprising that he veers between personal conviction, compromise, and bloody-minded 'argument for argument's sake'. What he will say, then, on any particular occasion is so highly dependent on the local context – his mood when he talks, how unsure does he feel that day when challenged by other members of his family? So there is no guarantee that his talk will reliably contain the symptoms of his personal dislike of the monarchy. But all that could change, if he became convinced of the possibility of doing something about it.

Two consequences flow from this: we begin to see how difficult it is to make sense of the relations between the individual and the social, since any time real people talk, they are drawing on their already-developing pictures of their place in society,

and they are making strategic assessments of what can be said, and what is worth saying, in any context. In as much, then, as we want to discover the social within the individual, not all talk can be equal. We cannot blithely assume that each person's 'bit' will be equally revealing. And that is a real headache. For this is what we found with our interviews into the meanings of *Judge Dredd*. Yet how do we decide? What good grounds can there be for preferring one person's responses over another's?

The key we will propose later is to examine in people's talk their sense of what communications they are responding to.

A note on Michel Foucault

Michel Foucault's contribution to our ways of thinking about 'discourse' is immense, and can't be properly discussed here. A lot turns on his account of 'discourse' as assemblages of power and knowledge. To know someone psychiatrically is to investigate them as a body of symptoms, is to require them to report on their dreams, their relationships, their fantasies as symptoms; it is press them to 'know themselves' as psychiatric objects. To know someone as a 'homosexual' was to surround them with a set of defining knowledges, about 'perversity'and its causes, about its consequences and possible 'cures'. Thus 'known', homosexuals were forced to see themselves in these ways. The same can be shown, he argues, with medicine, with motherhood, with madness, with criminality. As we've already noted, this was part of Foucault's attack on 'totalising' accounts, which explain all such particular ways of knowing in terms of one 'master' account.[44]

There is a huge amount to admire and draw on in Foucault. But equally, for our purposes, there are real problems. We have already commented on the problems of discussing the 'power' of discourses, but these take on a sharp focus in relation to Foucault. The centre of our concern is his idea, first put forward in his *History of Sexuality*, that each discourse produces its own typical form of resistance:

> There is no question that the appearance in nineteenth-century psychiatry, jurisprudence, and literature of a whole series of discourses on the species and sub-species of homsexuality, inversion, pederasty, and 'psychic hermaphrodism' made possible a strong advance of social controls into this area of 'perversity'; but it also made possible the formation of a 'reverse' discourse: homosexuality began to speak in its own behalf, to demand that its legitimacy or 'naturality' be acknowledged, often in the same vocabulary, using the same categories by which it was medically disqualified.[45]

We don't want to say that this can't be true. But we want to argue that this is not the only, or characteristic, form of resistance to a discursive construction. Tactically, people in a position of virtual powerlessness may well choose to borrow the language of their powerful definers. But that, precisely, is a mark of their weakness. But the more individuals or groups feel able to make challenges to circulating discourses, the more they will refuse the categories offered. They are likely to draw on resources from other aspects of their lives, on more highly

developed accounts of themselves, and of their hopes and ambitions. The trouble is that that, if correct, undermines the core principle in Foucault's theoretical fabric, that discourses are not united by some common principle or history. What if people insist on unifying their accounts of themselves?

One more time, the question of 'power' in discourse

Once more we have to return to the issue of 'power', in association with the apparently methodological question: what are we entitled to conclude if analysis identifies a 'discursive pattern'? Here, we look at the work of the person to whom, generally, we find ourselves closest: Norman Fairclough, and in particular his *Discourse and Social Change*. Fairclough's account of previous work on discourse is very close to ours, his appraisal of others', and especially of Michel Foucault's, contributions seems to us exemplary. But there comes a decisive point where we break from him. It is signalled by a comment he makes on Louis Althusser: 'The Althusserian account of the subject overstates the ideological constitution of subjects, and correspondingly understates the capacity of subjects to act individually or collectively as agents, including engagement in critique of, and opposition to, ideological practices'.[46] What might seem a small difference, turns out to be the toe of a giant.

The implication of Fairclough's argument that Althusser 'overstates' his case is a requirement to re-balance, to build in greater space for 'agency', 'critique', and 'opposition'. But that still leaves 'discourse' and 'ideology' exactly as they were. They still involve a notion of 'positioning', that is, that if there isn't 'critique' or 'opposition', then 'discourses' and 'ideologies' are like viruses which invade the brain. But for resistance, texts get you.

In his book, Fairclough undertakes some interesting analyses of newspaper articles and advertisements, to illustrate what his developed theory of discourse can achieve. He demonstrates the presence of certain patterns. So, in light of our insistent question, what does that entitle him to conclude? This is his answer:

> What I have said so far implies that interpreters are compliant, in the sense of fitting in with the positions set up for them in texts. But not all interpreters are compliant: some are to a greater or lesser extent, and more or less explicitly, resistant. Interpreters are, of course, more than discourse subjects in particular discourse processes; they are also social subjects with particular accumulated social experiences, and with resources variously oriented to the multiple dimensions of social life, and these variables affect the ways they go about interpreting particular texts.[47]

Although stated with care, and although the latter half of the quotation seems to allow for a whole range of 'resistant' interpretations, the model Fairclough is using, we want to argue, is fundamentally wrong. It is still tied to a Saussurean way of understanding how people understand 'language'. Since this so centrally connects with our whole discussion of how audiences 'make sense of' media, we have to deal with this issue head-on.

What is wrong with this way of talking of the 'power' of discourses? Let us explain by using one of the examples commonly used in such discussions, and which Fairclough himself uses: Thatcherism. Take just one strand of Thatcherite conservatism: the promulgation of competition. What would it mean to claim that the promotion of competition was 'influential'? Stuart Hall and his co-authors of *Policing The Crisis* certainly claimed that it was influential; and Fairclough concurs. We will pass over the fact that their empirical evidence was strongly challenged in the debates over 'authoritarian populism'. But suppose they were influential – the questions still remain: what was it about them that made them influential? How were people influenced? And who exactly was most 'prone to influence'? To know, we would first have to be clear exactly what we meant by being persuaded by the 'idea of competition'. Was it, say, a particular argument such as that the National Health Service would benefit from the expansion of internal markets? Was it a general framework-assertion that 'competition will lead to a healthier economy'? Was it the encouragement of competition as a character-trait? It could, of course, be more than one of these – but the point we insist on, is that what might make these persuasive is different in each case, and therefore what might count as becoming resistant would be different in each case.

Take the first: what might persuade someone that the NHS needs more internal market? One can think of certain kinds of arguments by doctors, surveys of savings made, beds freed, drugs made cheaper: in short, masses of good or bad 'information' which might persuade. What might dissuade someone? Their experience of the effects of chaos and greed harming health care; their distrust of some of those statistics; their belief that health isn't that kind of 'good' to be dealt with by a market.

Take the second: what might persuade someone that competition is 'generally a good thing for the economy'? Since 'the economy' is an abstraction, not experiencable even in the ways in which the 'internal market of the NHS' can be, it isn't at all clear what 'believing' it amounts to. Like the car stickers that preach 'Free enterprise works ...', it is a slogan awaiting either flesh to activate it, or an end-piece to subvert it ('... for the benefit of the few').

Take the third: interestingly, the scope of the concept changes here, now potentially including non-economic activities that are competitive in other ways – sports, for example. This one, then, is not so much about persuasion as about developing kinds of people. It is not so much a matter of coming to believe in competition, as coming to be competitive.

We insist on these differences, precisely because discourse theories tend to blur them. Particularly under the influence of Foucauldian and psychoanalytic approaches, which talk of the 'construction of subjects by discourses', much writing on discourse treats persuasion almost as a process of ingestion. We are what we believe. The critical danger is that this makes us talk of people in the abstract, of unlocated individuals – who only take on social shape if and when they 'resist'.[48] What would it mean for an NHS manager to believe in the expansion of the internal market, as compared with a nurse, or a patient with or without private health insurance? We propose that this isn't just a matter of more or less likelihood

of being persuaded, or of resisting persuasion – it is a matter of what people might do with the belief. To the NHS manager, the internal market offers risks and attractions: risks because of the dangers of losing control, but the attractions of accreted power and status. It intersects directly with his or her life. To accept the discourses is to prepare to act in specific ways. To the nurse, there are likely to be several characteristics. First, this is 'management-speak'; it comes from 'them', who make life difficult for nurses. Secondly, it will be understood through its effects – no, you can't have those supplies any more, even though you had found them satisfactory – the internal market requires us to tender for the most 'cost-effective'. We could go on with examples, but it is the general point that interests us. Real people don't 'interpret' discourses, as Fairclough is saying – they understand through their mode of responding. This we take to be the meaning of Valentin Volosinov's claim that 'To understand another person's utterance means to orient oneself with respect to it, to find the proper place for it in the corresponding context. For each word of the utterance that we are in process of understanding we, as it were, lay down a set of our own answering words'.[49] A subtle difference, but a world of implications.

Concluding remarks

So far, this chapter has dealt mainly with the idea of 'discourse'. We've had to clear a lot of ground in order to see what can be achieved by using 'discourse analysis'. What we've found, is a considerable confusion over the status of this kind of work, and we've outlined some ideas which might take us further forward. What these don't tell us, is how to do discourse analysis. How do the various approaches to 'discourse' then set out procedures for doing discourse analysis? In brief, very variably.

Post-Marxist/postmodernists generally use the term very loosely, and rarely carry out anything as precise as an analysis – better a rhetorical flourish than a controlled investigation! Where they do, their work tends to borrow from other approaches which have attempted to develop a method. Foucault's heritage is hard to apply, even though he himself did write extensively about methodology in general. Part of the problem is that Foucault rarely writes about 'discourses' as such. Instead, he is interested in discursive practices. The distinction is important, since a 'discourse' emphasises the form of a piece of knowledge for itself, while 'discursive practice' emphasises how it is used in a social relationship. The problem is that Foucault is inconsistent, since in many cases people do not confront the users of a discourse directly – they meet the discourse in circulation. A 'homosexual' treated in a clinic is subject to the discursive practices of the doctors who inquire into him, classify his acts, dreams, and etc. But if he encounters the idea of 'homosexuality' through the media, or education, then it is the discourse that needs analysis. Foucault's tendency to blur the lines between those goes along with his rather mono-dimensional view of 'power', and leads rightly to the complaint that, intended or not, his ideas of discourses seem suited to Goffman's 'total institutions'.[50]

This leaves us with the two approaches of critical discourse analysis, and rhetorical psychology. But as we hope we've shown, critical discourse analysis is a problem

for us on several grounds. First, it treats the problem of discursive power as 'solved' by definition, when we want precisely to make it a question. Second, it works best on factual, even propagandistic materials, where 'modality' is least an issue. Third, almost despite itself, it tends to treat communications as 'texts', where we are interested in looking at people's responses to a text. And rhetorical psychology, at least to date, has dealt uneasily with the idea of 'contextual determination' – we've suggested that there's no reason to deny 'average people' the capacity to have strong beliefs which they carry from context to context.

Hopefully, readers have been able to see some of the ways in which a general theory of 'discourse' reveals a set of issues about how we should practise discourse analysis. The pragmatic problems are real. And the one that mainly concerns us is: when and how are we entitled to draw conclusions about the presence of social ideas and processes in an individual's thinking? The kind of discourse analysis we are interested in is that which allows an exploration of the social in relation to the individual. How can we do this? When faced with a set of transcripts, what constitutes good evidence of the presence of the social? Let us make this concrete by touching on some of the very best of recent qualitative research which uses discourse analysis: the work of people such as David Buckingham, Jackie Stacey, Annette Hill, and Joke Hermes.[51] They have brought to light many complexities in people's relations with the media, including some of the kinds we are concerned with. Buckingham, for instance, has done superb work in getting inside the various kinds of 'fear' responses that children can have to television programmes. Hill has had the courage to explore people who really enjoy ultra-violent films, and has taught us a lot about why.

But even here, something is in our view lacking. It has to do with the way analysts use segments of their interviews. Suppose an interviewee tells us, during an interview, that he really loves a film like *Dredd* because it 'takes him out of himself'. What are we entitled to do with it? One solution would be to count how often such a thing was said. A commonly proposed procedure is to use one of the recent computer packages which allow researchers to search text for the frequency of ideas, and to examine frequency of links and associations. This approach was recommended to us by a number of researchers. We want to argue against this approach. As we saw earlier with Katz and Liebes, there are good reasons for thinking that frequency is a weak ground for drawing any conclusions about the importance of an idea in a person's thinking. This problem is related to a long-standing debate in media analysis, as we saw, about quantiative content analysis.

But if not frequency, then what? If we simply choose other bits of other people's views to lay alongside this quotation, the danger is that we will without check be imposing our, analysts', perspectives onto our interviewees. Quotations may be linked when in fact they might derive from different discourses. And opportunities are lost since we are not able to explore how individuals may themselves be seeing the relations between different parts of their beliefs. There has to be a system for analysing transcripts which simultaneously does two things. It must respect the individuality of people's responses – it must take account of the degree of conviction with which people speak, their sense of what they are responding to,

and so on. Yet it cannot be enough just to explore individuals. Ordinarily, people do not have fully articulated beliefs, or utterly self-consistent bodies of ideas. We also know, apart from anything else, that individuals use concepts which they do not originate – they borrow ideas from the social sphere, to make sense of their own experience. They position themselves in relation to social practices. They acknowledge constraints and opportunities which are presented to them by their society. Finally, there is of course the problem that people themselves often acknowledge that they are not the best person to express or embody an idea – they say 'listen to X, s/he can say it better than me'. People themselves acknowledge that they are not the ideal-typical embodiments of a view or a position that they hold to. On all these grounds, therefore, it cannot be enough to stop at the individual. We must at the same time, therefore, explore all the ways in which people are responding as members of their society. This is hard. More importantly, it doesn't seem to us to have been addressed in the literature which we have met.

Readers can judge for themselves, shortly, whether they believe we have found a way through these dilemmas.

1 Antonio Gramsci, *Prison Notebooks*, London: Lawrence & Wishart 1971, p.325.

2 As recently as 1983 one leading linguist was marking off discourse analysis as an essentially theoretical interest in the 'formulation of a set of concatenation rules', based primarily on intuitions, as opposed to conversation analysis which was 'rigorously empirical' (Stephen Levinson, *Pragmatics*, Cambridge: Cambridge University Press 1983, p.286). For an excellent prospectus of what discourse analysis should try to become, see Teun van Dijk's introduction to the new journal *Discourse & Society*: 'Discourse & Society: a new journal for a new research focus', Vol.1, No.1, 1990, pp.5-16.

3 In an introductory essay to his recent edited set of Discourse Studies, Teun van Dijk lists eight major, and a number of minor, contributors: see his 'The study of discourse', in his (ed) *Discourse as Structure and Process: Discourse Studies*, Vol.1, London, Sage 1997, pp.1-34. Though his account is interesting, we've not followed it exactly because it tends to see discourse theory and analysis as only in its final stages driven by critical, non-academic concerns. Given (as we suggest shortly) the central role that impulses such as anti-racism has played in the rise of several kinds of discourse analysis, this suggests that an account of its history ought to be configured more around the questions and issues which 'discourse' was seen to resolve, than around academic fields. Another introduction which examines the sources of discourse analysis very helpfully is Norman Fairclough's *Discourse and Social Change*, Cambridge: Polity Press 1994.

4 Jonathan Culler's *Saussure* (Glasgow: Collins 1976) remains, in our view, one of the clearest introductions to Saussure's ideas.

5 One important part of this was a challenge to Saussure's assertion that signs are arbitrary. Hodge and Kress, in particular, challenge this aspect of his thinking which has the effect of making it difficult to see signs as 'belonging' to interested social forces. See Robert Hodge & Gunther Kress, *Social Semiotics*, Cambridge: Polity Press 1988, Chapter 1. On their work more generally, see later in this Chapter.

6 Dale Spender, *Man-Made Language*, London: Routledge & Kegan Paul 1980.

7 An early example of their work well exemplifies this kind of work: see G R Kress & A A Trew, 'Ideological transformation of discourse: or How the *Sunday Times* got *its* message across', *Sociological Review*, Vol.26, 1978, pp.755-76. This excellent essay unpacked the ways in which different managerial ideologies were embedded in the rewritings of a circular from British Leyland to its workforce. For a more recent example, see also Theo van Leeuwen, 'Representing social action', *Discourse & Society*, Vol.6, No.1, 1995, pp.81-106.

8 A good introductory statement of this is Gunther Kress's 'Critical discourse analysis', *Annual Review of Applied Linguistics*, Vol.11, 1990, pp.84-99.

9 Michael Stubbs, *Discourse Analysis: The Sociolinguistic Analysis of Natural Language*, Oxford: Basil Blackwell 1983. The same point is made by Teun van Dijk, in his (ed), *Discourse as Structure*

and Process: Discourse Studies, Vol.1, London: Sage 1997 ('Discourse analysts go beyond the sentence boundary' (p.7)). We find this unhelpful. Discourse analysis, in our experience, can often operate at the level of the word, or phrase, or expression – in other words irrespective of sentences, which function as grammatical vehicles. To pursue this distinction would, we think, raise much larger questions. Negatively, it would challenge the idea (discussed below) of ideological grammars, as proposed by the Critical Discourse Analysts. Positively, it would take us in the direction of the fascinating but difficult discussions of 'speech genres' raised by Mikhail Bakhtin, who draws a categorical distinction between social meanings and grammatical vehicles: see 'The problem of speech genres', in his *Speech Genres and Other Late Essays*, Austin: University of Texas Press 1986, pp.60-102.

10 See for instance J McH Sinclair & R M Coulthard, *Towards an Analysis of Discourse: the English Used by Teachers and Pupils*, Oxford: Oxford University Press 1975. For a good account and some very sharp criticisms of these approaches, see John B Thompson, *Studies in the Theory of Ideology*, Cambridge: Polity Press 1984, Chapter 3.

11 See for instance Emanuel Schlegoff's fierce restatement of the principles of Conversation Analysis in his ' Whose text? Whose context?', *Discourse & Society*, Vol.8, No.2, 1997, pp.165-88.

12 See for instance Jonathan Potter & Margaret Wetherell, *Discourse and Social Psychology: Beyond Attitudes and Behaviour* (London: Sage 1987) – one of this approach's founding texts; and Michael Billig, *Ideology and Opinions: Studies in Rhetorical Psychology* (London: Sage 1991). Many other books and articles within this approach have centred on examples of racist discourse. In related fields, see also Teun van Dijk, *Communicating Racism: Ethnic Prejudice in Thought and Talk* (London: Sage 1987); Philomena Essed, *Understanding Everyday Racism* (London: Sage 1991); and Hugh Melson, 'The discourse of the illegal immigration debate: a case-study in the politics of representation', *Discourse & Society*, Vol.8, No.2, 1997, pp.249-70.

13 Susan Condor and Charles Antaki draw attention to another significant assumption in Billig's work: 'Billig distinguishes between the contents of social thought (which he regards as historically and culturally specific) and the mechanisms of thought, which he prefers to regard as universal'. See their 'Social cognition and discourse' in Teun A van Dijk, *Discourse as Structure and Process*, p.330.

14 'One of the distinctive features of contemporary post-Marxism is the displacement of the concept of ideology by that of discourse': Trevor Purvis & Alan Hunt, 'Discourse, ideology, discourse, ideology, discourse, ideology ...', *British Journal of Sociology*, Vol.44, No.3, 1993, pp.473-99. This quote, p.490. Purvis and Hunt also constitute an attempt to retrieve a concept of 'ideology', while welcoming the general change towards 'discourse'. As an early exemplification of this drift, see also Diane Macdonell, *Theories of Discourse: an Introduction*, Oxford: Basil Blackwell 1986. Also interesting as an example of a transitional study is Frank Burton & Pat Carlen, *Official Discourse: On Discourse Analysis, Government Publications, Ideology and the State*, London: Routledge & Kegan Paul 1979. Burton and Carlen draw on another significant figure in this strain of academic Marxism, Michel Pecheux.

15 See Valentin Volosinov, *Marxism and the Philosophy of Language*, New York: Seminar Press 1973. But as Barker argued in an earlier discussion of Volosinov, a number of people have badly missed the difference in Volosinov's approach and have 'tacked him on to the end' of Saussure: see his *Comics*, Chapter 12.

16 For good examples of such an application, see Chik Collins, 'To concede or to context? Language and class struggle', in Colin Barker & Paul Kennedy (eds), *To Make Another World: Studies in Protest and Collective Action*, Aldershot: Avebury 1996, pp.69-90; and Colin Barker, 'Social confrontation in Manchester's quangoland: local protest over the proposed closure of Booth Hall Children's Hospital', *The North West Geographer*, Vol.1, 1997, pp.18-28. Some scholars seem to have arrived at the same ways of thinking without directly drawing on Volosinov; for a good example, see Stuart Tannock, 'Positioning the worker: discursive practice in a workplace literacy programme', *Discourse & Society*, Vol.8, No.1, 1997, pp.85-116.

17 Norman Fairclough, *Discourse and Social Change*, p.2 puts this well, arguing against the 'tendency to see language as transparent', and agains the 'tendency to believe that the social content of [linguistic] data can be read off without attention to the language itself'.

18 Michael Billig, *Speaking of the Royal Family*, London: Sage 1993.

19 Michael Billig, *Ideology and Opinions*, London: Sage 1991, Chapter 4.

20 Rosalind Gill, 'Justifying injustice: broadcasters' accounts of inequality in radio', in Erica Burman & Ian Parker (eds), *Discourse Analytic Research: Repertoires and Readings of Texts in Action*, London: Routledge 1993, pp.75-93.

21 Peter Goodrich, 'Attending the hearing: listening in legal settings', in Graham McGregor & R S White (eds), *Reception and Response: Hearer Creativity and the Analysis of Spoken and Written Texts*, London: Routledge 1990, pp.11-36.

22 Eric Burman & Ian Parker (eds), *Discourse Analytic Research*, p.1

23 See for instance Teun A Van Dijk, 'Principles of critical discourse analysis', *Discourse & Society*, Vol.4, No.2, 1993, pp.249-83. It is no surprise to us that some of the most persuasive of these analyses are addressed to materials like press reports, and political speeches and debates where issues of 'power' are already directly posed. But these still worry us, in as much as they carry presumptions about how and under what circumstances people might be persuaded by these messages. See below, our section on the concept of 'power' in discourse.

24 Michael Ryan & Douglas Kellner, *Camera Politica: The Politics and Ideology of Contemporary Hollywood Film* (Bloomington: Indiana University Press 1988), pp.228-36. In fact, their audiences virtually contradict their discursive analysis of the film since their survey (about which we are told almost nothing) still refused the implication that Darth Vader's Empire represented Soviet communism.

25 Ian Hutchby, 'Power in discourse: the case of arguments on a British talk radio show', *Discourse & Society*, Vol.7, No.3, 481-98. This quote, p.495.

26 Norman Fairclough, 'Discourse and text: linguistic and intertextual analysis within discourse analysis', *Discourse & Society*, Vol.3, No.2, 1992, pp.193-217.

27. Marc Kipniss, 'The death (and rebirth) of Superman', Discourse, Vol.16, No.3, 1994, pp.144-67. We are using this because its weaknesses are easily pointed to. We leave it as an open question how much else it applies to. But it does, to us, say something wider about the criteria this journal uses for 'acceptable' arguments.

28 Marc Kipniss, 'The death (and rebirth) of Superman', p.151.

29 Marc Kipniss, 'The death (and rebirth) of Superman', p.159.

30 In a fine argument, David Lee has illustrated why such a rule is necessary. Revisiting some materials in which Gunther Kress claimed to discover by analysis a clear ideological pattern, Lee shows that the pattern is much less certain than Kress asserts. To settle such an argument, it is essential that other, independently-sourced kinds of evidence could be brought to bear. See David Lee, 'Discourse: does it hang together?', *Cultural Studies*, Vol.3, No.1, 1989, pp.58-72.

31 Robert Hodge & Gunther Kress, *Social Semiotics*. We've chosen this book precisely because we admire it, share a lot of its ambitions, and believe it has made real advances in many areas.

32 Kress has developed his challenge to the idea of the arbitrariness of the sign in another excellent essay: see his 'Against arbitrariness: the social production of the sign as a foundational issue in critical discourse analysis', *Discourse & Society*, Vol.4, No.2, 1993, pp.169-92.

33 Robert Hodge & Gunther Kress, *Social Semiotics*, p.147.

34 The issue we raise here in effect goes back to the arguments over the meaning and validity of claims of 'dominant ideology', arguments that died away rather than being resolved. Abercrombie, Hill & Turner published a powerful empirical critique of what they called the 'indoctrination' version of dominant ideology, which they contrasted with another view of the ways social order is maintained which emphasises the 'dull compulsion of economic necessity'. They also argue, on the basis of a major survey of historical evidence, that the primary role of what are called 'dominant ideologies' has been to organise debates and conflicts within ruling groups, rather than to exert control over subordinate classes. See Nicholas Abercrombie, Stephen Hill & Bryan S Turner, *The Dominant Ideology Thesis*, London: George Allen & Unwin 1980, and their later (eds), *Dominant Ideologies*, London: Unwin Hyman 1990. Of course their argument was the subject of major debates, after it was published. Our worry is that in discussions of the media their powerful challenge to notions of dominant ideology, culture or representations has simply been forgotten or ignored. The issues raised by this are sufficiently important that we plan to address them in a separate essay, using as a problematic case-study Michael Ryan & Douglas Kellner's problematic *Camera Politica*.

35 Robert Hodge & Gunther Kress, *Social Semiotics*, p.54.

36 Robert Hodge & Gunther Kress, *Social Semiotics*, p.123.

37 Robert Hodge & Gunther Kress, *Social Semiotics*, p.131.

38 On this, see for instance Steve Baker, *Picturing The Beast: Animals, Identity & Representation*, Manchester: Manchester University Press 1993.

39 We are not saying good work cannot be done within the more limited definition of 'modality', simply that it will only be safe where the modality of materials is relatively unproblematic – hence,

again, the fact that the best work of this kind focuses on news and other non-fictional materials. As an example of such work directly introducing 'modal' issues, see Anne-Marie Simon-Vandenbergen, 'Image-building through modality: the case of political interviews', *Discourse & Society*, Vol.7, No.3, 1996, pp.389-416.

40 This argument appears in Billig's *Ideology and Opinions: Studies in Rhetorical Psychology*, London: Sage 1991, Chapter 8.

41 Billig takes this as an example of the general 'dilemmatic' quality of discourse. In another book, he and others argued that ordinary talk frequently displays this quality of moving and balancing between opposites. These dilemmas are the result, they argue, of historical tensions which settle to provide the dimensions within which we commonsensically judge new experiences and issues as we encounter them. See Michael Billig *et al, Ideological Dilemmas: A Social Psychology of Everyday Thinking*, London: Sage 1988.

42 Both quotes, Michael Billig, *Ideology and Opinions*, p.170.

43 In one of his most recent essays, a feisty critique of the cultural studies tradition for losing sight of 'real people' in the hunt for 'texts' and 'ideologies' (which we very largely agree with), Billig in fact repeats this very point. In the course of a sharp critique of John Hartley for the way he has used quotations from television executives, he criticises him for making 'no attempt to situate these comments in order to understand the contexts of their utterance'. Once again, this is ambiguous between requiring attention to the wider structures of ideas the executives adhere to, and requiring attention to the circumstances of their utterance. See Michael Billig, 'From codes to utterances: cultural studies, discourse and psychology', in Peter Golding & Marjorie Ferguson (eds), *Cultural Studies In Question*, London: Routledge 1997, pp.205-26. This quote, p.222.

44 Alan Sheridan's *Michel Foucault: The Will to Truth* (London: Tavistock Publications 1980) gives an excellent account of how Foucault's development of his ideas related to the situation in France around 1968.

45 Michel Foucault, *The History of Sexuality*, Vol.1, Harmondsworth: Penguin Books 1981, p.101.

46 Norman Fairclough, *Discourse and Social Change*, pp.90-1.

47 Norman Fairclough, *Discourse and Social Change*, p.136.

48 Alert readers will see, we hope, the analogy between this, and the implicit claims in encoding/decoding theory which we explored in the previous chapter.

49 Valentin Volosinov, *Marxism and the Philosophy of Language*, p.102.

50 See Erving Goffman, *Asylums*, Harmondsworth: Penguin 1961.

51 See David Buckingham's various books already cited; Jackie Stacey, *Star Gazing: Hollywood Cinema and Female Spectatorship*, London: Routledge 1993; Annette Hill, *Shocking Entertainment: Viewer Response to Violent Movies* Luton: University of Luton Press 1997. Joke Hermes, *Reading Women's Magazines*.

6 MAPPING THE PLEASURES OF A FILM

This chapter begins again. We want to start building an approach which overcomes the problems we've met, and which generates a way of investigating systematically (methodology) and understanding (theory and interpretation) our audiences. Where does one go for this? The key, we believed, lay in finding an approach which could investigate audiences' pleasures in all their differences and complexity, and still find a way of relating them to the film, and to the world which the film inhabits. But a library and database search revealed that remarkably little has been done to investigate differences in pleasures, let alone differences in their languages of expression. Just one study, introduced to us by a colleague who shall forever be blessed, seemed to do what we were seeking.[1]

Michael Baxandall is an art historian. He has among other things investigated fifteenth century Italian painting, and in particular the religious paintings of figures such as Lippi, Botticelli, Uccello, Mantegna and Donatello.[2] Baxandall argues that we won't be able to understand these paintings if we don't take account of their particular social history. He especially emphasises how the contractual relations between artists and their commissioning employer form a circuit with the uses to which paintings were put. This circuit, he argues, uses and depends on a critical vocabulary for thinking about what makes a 'good painting'.

Baxandall looks in detail at some of the surviving contracts. He shows how contracts specify exactly at what points the most expensive materials (especially golds and blues) are to be used. The best blue being derived from (expensive) powdered lapis lazuli was reserved – and required – for items such as the cloak of the Virgin. So, to own and display a painting which had these colours proved that you had a proper devotional attitude. But along with this, the contracts had a companion, and apparently paradoxical requirement: the painter had to guarantee that the work would be 'all from his own hand, and particularly the figures ...' (cited, p22). In other words, he must promise to paint all of it himself – or at least all the bits that would particularly 'count'. Those were the hands, and faces, and central figures, precisely the parts which would involve the blues and golds.

Painters, then, worked within strict requirements to ensure their works met an agreed social agenda:

> The pleasure of possession, an active piety, civic consciousness of one
> or another kind, self-commemoration and perhaps self-advertisement,

133

> the rich man's necessary virtue and pleasure of reparation, a taste for pictures: in fact the client need not analyse his own motives much because he generally worked through institutional forms – the altarpiece, the frescoed family chapel, the Madonna in the bedroom, the culture wall-furniture in the study – which implicitly rationalised his motives for him, usually in quite flattering ways, and also went towards briefing the painter on what was needed. And anyway for our purpose it is usually enough to know the obvious, that the primary purpose of the picture was for looking at: they were designed for the client and people he esteemed to look at, with a view to receiving pleasing and memorable and even profitable stimulations. (p3)

But how would potential commissioners know which artists would best meet their needs? Most surviving writings are flattering advertisements for one School or another. Baxandall turns, instead, to one of the few texts which offers disinterested commentary to find out makes a 'good painting' for these purposes. Around 1490 an agent of the Duke of Milan wrote, advising the Duke which painters to hire for a forthcoming project. But his advice is anything but transparent. He says of Botticelli that his works have a 'virile air' and the best sense of 'method' and 'proportion', of Filippino Lippi that his works are probably 'sweeter' than Botticelli's but less 'skilful', of Perugino that his are very 'angelic', and of Ghirlandaio that his have a 'good air' and that further more he is very expeditious. The Duke can choose; all are good, but there are differences.

How was the Duke to choose from these descriptions? Baxandall now begins to define what he sees as a structure of taste:

> Much of what we call 'taste' lies in this, the conformity between discriminations demanded by a painting and skills of discrimination possessed by the beholder. We enjoy our exercise of skill, and we particularly enjoy the playful exercise of skills which we use in normal life very earnestly. If a painting gives us opportunity for exercising a valued skill and rewards our virtuosity with a sense of worthwhile insights about that painting's organization, we tend to enjoy it: it is to our taste. (p34)

Consider, he says, how particular many paintings and commentaries on them are about the idea of 'proportion'. He shows how this linked with commerce's growing need for mathematical calculations (for example in gauging the contents of barrels). The paintings thus can be seen to embody as a principle of form what was required as a principle of trade. Their audience could use pleasurably the skills which they needed for the serious purposes of life. This is an element of what Baxandall calls the 'cognitive style' of Quattrocento painting.

One central organising principle of this style, of course, was religion. John of Genoa's *Catholicon*, for instance, defined three functions for religious paintings: they were to instruct the simple, since they cannot read books; to make the mystery of such things as the Incarnation more active in our imaginations; and to excite feelings of devotion. But of course it would be useless for the church to wish such

uses if it did not pass them on. And one of the remarkable pieces of evidence Baxandall adduces is from a 1454 *Garden of Prayer* for young girls:

> The better to impress the story of the Passion on your mind, and to memorise each action of it more easily, it is helpful and necessary to fix the places and people in your mind: a city, for example, which will be the city of Jerusalem – taking for this purpose a city that is well known to you. In this city find the principal places in which all the episodes of the Passion would have taken place – for instance, a palace with the supper-room where Christ had the Last Supper with the Disciples, and the house of Anne, and that of Caiaphas, with the place where Jesus was taken in the night, and the room where He was brought before Caiaphas and mocked and beaten. Also the residence of Pilate where he spoke with the Jews, and in it the room where Jesus was bound to the column. Also the site of Mount Calvary, where he was put on the Cross; and other like places
>
> And then too you must shape in your mind some people, people well–known to you, to represent for you the people involved in the Passion – the person of Jesus himself, of the Virgin, Saint Peter, Saint John the Evangelist, Saint Mary Magdalen, Anne, Caiaphas, Pilate, Judas and the others, every one of whom you will fashion in your mind.
>
> When you have done all this, putting all your imagination into it, then go into your chamber. Alone and solitary, excluding every external thought from your mind, start thinking of the beginning of the Passion, starting with how Jesus entered Jerusalem on the ass. Moving slowly from episode to episode, meditate on each one, dwelling on each single step of the story. And if at any point you feel a sensation of piety, stop: do not pass on as long as that sweet and devout sentiment lasts ... (p46)

Baxandall knows of course that one quotation does not make a view 'typical'. Instead, he sets out to show that careful attention to this helps us to resolve certain puzzles. For example: this period of painting was one in which the skills of the painters, and their repertoire of representational styles, allowed them to show uniquely different and character-full faces. Yet persistently, the best religious paintings of the time do not – they show beautiful but bland faces. According to Baxandall this very fact allowed the faces to be a *template* on which one could project images from one's own experience, as indeed young girls were advised. They could thus *activate* the paintings for themselves. This explanation also allows us to see that the paintings fall into distinct *moments* in such routes as the Passion, or the Annunciation, and that the formal repertoire of elements in each painting can *only make sense* if we assume audiences who knew how to activate them in these kinds of ways.

In the light of these, then, Baxandall returns to those puzzling comments about quality, and shows how they can now make good sense. For instance, a 'virile air' can be seen to relate to another sphere altogether, of *dance,* in which the idea of a 'manly dance' established a whole repertoire of movements, gestures, and

relationships. So, if the Duke of Milan wants a painting which can help to associate his taste with that of manly dance, he will know which painter to choose; and so on. The difference all this makes is summarised by Baxandall:

> An old picture is the record of visual activity. One has to learn to read it, just as one has to learn to read a text from a different culture, even when one knows, in a limited sense, the language: both language and pictorial representation are conventional activities. And there are various destructive uses of pictures which must be avoided. One will not approach the paintings on the philistine level of the illustrated social history, on the look out for illustrations of 'a Renaissance merchant riding to market' and so on; nor, for that matter, through facile equations between 'burgess' or 'aristocratic' milieux on the one side and 'realist' or 'idealizing' styles on the other. But approached in the proper way ... the pictures become documents as valid as any charter or parish roll. If we observe that Piero della Francesca tends to a gauged sort of painting, Fra Angelico to a preached sort of painting, and Botticelli to a danced sort of painting, we are observing something not about them but about their society. (p152)

It is not difficult at all to make this apply to our research by judicious substitutions, of 'film' for 'painting', and so on.

There are many reasons for thinking that this offers the beginnings of a new approach. Baxandall's argument shows that just because film is *visual* in its medium, does not mean that *our encounter* with it is primarily to do with a *way of seeing*. It is not the medium which determines the manner of response, but the place of that medium within a social and cultural circuit, and the tasks given to that medium in the life of that society.

Beginning from painters' contracts, he is able to show that these are much more than legal documents. Contracts establish conditions and expectations of use for the paintings' owners. Of course, while Baxandall can talk about a closed circuit between commissioning owners and artists, that certainly does not hold for contemporary mass media. Films are, if you like, a 'broken circuit', in which the film-makers know very well that every time they make a film, they are taking an enormous *risk*. A film can 'fail' in ways that a painting could not. But that very difference emphasises some things which are still the same. For one of the ways in which film-makers seek to close that circuit, is by working to create a shared vocabulary with their audience. If they can't do that, they are in as much trouble as one of Baxandall's painters who forgets to use the right Blue!

'Conformity between discriminations demanded, and the skills of discrimination possessed': this is a neat summary of a *transaction* between work of art and respondent. This seems to us to be centre of Baxandall's ideas. For this pulls to the centre of our attention the *society* in which a person's media uses are framed. It also recognises that the nature of the circuit around, say, paintings will generate a number of possible demands for discrimination. The merchant who commissions, owns and displays a painting has one set of uses and demands of it.

The priest who uses it as a basis for sermons has another. The young girl being inducted into a proper spirituality has yet another. But Baxandall's quotation from the *Garden of Flowers* tells more than this. The girl *uses* the painting in the way she is trained. She does not see characterless faces, and thus become characterless (the 'effects' model's claim). She does not bear with her a need which the painting gratifies (the U&G model's claim). She does not 'read' the painting, and through some dominant message become implicated in its preferred meaning (the Hall model's claim). Nor is there some boundary set for her (the hermeneutic model's claim). On the contrary, she has a use for the painting, as a cue to particular affective responses.

But this suggests an amendment to Baxandall's model. His own interest in the 'cognitive style' of Quattrocento painting leads him to focus on the structures of response of the *owners* and *patrons* of the art. But that quotation from the *Garden of Flowers* is not about skills of discrimination at all - it is about skills of affect, or learning how to respond with the appropriate emotions, and participating in the right way in the paintings. Remove the bias towards the cognitive, and we have the basis for a new set of questions about audience responses. How is the young girl supposed to achieve her spiritual moment? By following instructions: 'if you want to have one of those moments of spiritual bliss, then go round the church and attend to the paintings like this'. This suggests two things to us. First, emotions are not raw basic responses separable from our preparations and expectations - they are aspects of our total response to a painting, or a film, or whatever.[3] Second, it suggests that the experience of a painting does not begin when we stand in front of it, or end when we step away. It is begun by the first practical steps we take to prepare ourselves for the experience: practical steps that have to be done appropriately if we want to attain specific kinds of experience. We propose to call the organisation of these steps 'practical logics'. To explain what we mean by this: audiences don't just 'happen' upon the cinema. They choose in advance what they want to see, or sometimes only when they get there. They get there by car, bus or foot, having chosen often which cinema they prefer to go to. They have to choose on the basis of at least minimal knowledge of what is likely to be meant by a title, a poster, a star, a review or whatever.[3] They go alone or in company, and that can affect whether they go, what they see, and whether they enjoy it. These are all decisions and processes that have to be gone through. And, there are patterned connections among them. If an individual chooses to see a film on the presumption that it is of a certain kind, and may give certain kinds of pleasure, then many other things follow logically from that. If s/he chooses on another basis, quite other consequences have to be worked out. These patterns of choices, decisions and consequences are what we mean by 'practical logics'.

Suppose someone decides to go and see *Judge Dredd* because they have heard that it has excellent new special effects. What follows, by practical logic? To make it worth believing, they have to have gleaned that idea from a trustworthy source - which entails having other kinds of cultural engagement (magazines, friends, specific television reviews, or whatever) which are believed to be a 'good source'. There then has to be some sense of what special effects are good for. What is the

point of seeing them? What do you do with the experience, once you've had it? Also, special effects are something whose point is to be experienced. So, into the frame comes the issue of what the appropriate cinema is, one that will allow full and proper experience of these 'new effects' - and to deal adequately with that, our potential viewer has to have some knowledge of the *cultural geography of local cinemas*. For it may not only be a question of the right architecture, sound system etc, but also of the sense and behaviour of the rest of the audience. For it seems that the whole point of special effects is to let yourself be *overwhelmed* by them. To do that, you have to let go, in the right environment and company. And so on.

For a contrast, suppose someone chooses to go to see *Judge Dredd* because they know all their mates are going, and they don't want to be left out. What follows, again, by practical logic? If it matters to this viewer that s/he might get left out, that can only be because something will continue to go on within the group that they can't take part in, unless they have seen and attended to the film in appropriate ways. But it may also be important to be seen to be going in the right company. After all, it looks like this film is felt to be a bit of the 'cultural property' of the group. To see it in the wrong company (say, with parents) or alone (sad bastard) could diminish cultural status. So again, there are logical, practical consequences from a first decision. These are what we mean by practical logics. By extending and generalising Baxandall's examples of preparatory actions, the idea of a 'practical logic' allows us to explore the patterns in people's responses to our film.

Applying Baxandall's approach

How can we research a film and its audiences in Baxandall's way? Baxandall's own work is a highly suggestive case-study, and none the worse for that. His achievement, for our purposes, is to have managed to explore three separate elements: the principles governing the making and placing in public spaces of the paintings; the patterning of elements within the paintings; and the ways in which these provided specific kinds of opportunities for use and response. These independently knowable strands are then tested against each other, and indeed take on fuller meanings by being so tested. We couldn't understand the significance of the Lapis Lazuli Blues, or of the Rules of Proportion, or of the bland faces in the paintings, if we didn't see these as culturally-grounded *cues* to certain kinds of response. These connections are not found by some mechanical juxtaposition of painting elements, and audience uses. Instead they depend on *people's living out of cultural/conceptual connections*, and on *semantic fits* between production circumstances, painted forms, and people's uses.

The test of the strength of his conclusions is not, therefore, the *number* of people he can explain, but in showing that his account *makes sense of puzzles* and *gives concrete meaning to otherwise uninterpretable discourses*. This is because what Baxandall is drawing out is a series of cultural possibilities which are available in the abstract for all individuals in that society. But in reality not all will take up the possibility. Compare two merchants: one of whom is particularly skilled in the new commercial mathematics, and feels pride in his skills; the other leaves this side of the work to a subordinate, preferring to associate himself with an older

aristocracy. The 'proportionality' aspect of the paintings simply cannot mean as much to the latter. Or compare two girls: one of whom willingly assents to being a 'good daughter' and practises the skills of spirituality required of women; the other is a feisty resister, seeking an independent way of life. The spiritual possibilities are not going to be evenly registered or used by these two. Differences in interest, involvement and commitment will make their responses more or less revealing. But they do not weaken the significances found in the paintings. Just how we might go on to take into account those individual differences is a major issue in itself, which we defer until Chapters 8-10.

Because this is the status of his discoveries, Baxandall begins by paying attention to the *languages of involvement* which are evidenced in the exchanges between a medium and its audiences. His test is whether his answers resolve the puzzles he has discovered. In his own case, this was necessary since so little documentation has survived. But what may have been a pragmatic necessity in Baxandall's case is arguably a good working principle.

What might a general model derived from Baxandall's study look like, and how could it apply to our film *Judge Dredd* and its audiences? Many people have pointed out that one of the virtues of qualitative research is the way it can help us build models, and theories. But we want to go further, if we can, to make such models and theories *testable*. We are therefore proposing as an ideal a four-stage model of investigation, although we know that we have not here carried this through in full:[4]

A: Stage One would study *Judge Dredd* from three independent vantage points. None of these on its own could provide secure answers but, done carefully, each could generate some preliminary hypotheses. Each would need testing by triangulation with the preliminary findings of the other two. The three originating points are these:

1 AUDIENCES: What patterned ways of talking do audiences display about their ways of using and enjoying a film? What implications do those patterns have for how people must prepare for a film?[5] We propose to call these Vocabularies of Involvement and Pleasure (henceforth VIPs, for short).

2 FROM PRODUCTION IMPERATIVES TO PUBLICITY REGIMES: What is the film supposed to achieve for its makers - for short, what are its production imperatives - and how do its makers seek to ensure success? What preparatory materials have been produced and disseminated to 'train' audiences in how the film can be used? What other (warning, educational, counter-cultural) materials are circulated in response to the film, arising from what other cultural imperatives?

3 THE FILM: How do situational forces impinge on the making of the film, and with what results for the film? What forms and patterns does it embody? What features within it invite certain kinds of use?

Each of these needs independent examination, using proper methods of investigation. This is important; each must meet the methodological requirements of its domain. A proper study of the audiences must take account of the best methods available for

investigating and understanding audiences, and their talk. The study of production imperatives must draw on both the best available knowledge about film production, and take account of available theorisations of this process. And the study of the film must draw on the best validated methods for investigating filmic form. Each of these is and obviously should be open to argument and challenge.

B: Stage Two: the findings from each of these preliminary enquiries now need to be tested, by being triangulated with each other. We offer first a formal statement of how we believe this cross-testing would need to be done, and follow that with some explanatory commentary:

How can we check our preliminary hypotheses about audience responses from our understanding of production imperatives and publicity regimes, and of the film? Or in other words, if our account of audiences is right, what implications will this have for the other two, and can these be substantiated?

(a) How (far) can the processes of production and publicity be shown to support or weaken our claimed uses of the film? How (well) do they also relate to the kinds of involvement and pleasure that different audiences try for?

(b) In what ways does the film itself enable or disable particular audience expectations, and how (well) does our analysis of the film form conform with audience judgements on its effectiveness and qualities?

How can we check our preliminary hypotheses about the film from our understanding of production imperatives and publicity regimes, and of the audiences? Or in other words, if our account of the film is right, what implications will this have for the other two, and can these be substantiated?

(a) What pressures did the production imperatives place on the film, and what claims did publicity regimes make for it? What ways of attending to the film do they invite or assume? How good is the 'fit' between the film as understood by our analysis, and other kinds of public knowledge of it?

(b) Drawing on our picture of how audiences related to the film, what aspects of it thus become relevant or irrelevant? How (well) do these fit with the aspects attended to in our analysis of the film?

How can we check our preliminary hypotheses about production imperatives and publicity regimes from our understanding of the audiences, and of the film? Or in other words, if our account of production and publicity is right, what implications will this have for the other two, and can these be substantiated?

(a) What do different audiences know about production and publicity regimes? What do they do with this knowledge (eg, categorising, sharing, using)? How (far) do they take account of materials about the film that aren't part of their own preferred orientation? What do they thus reveal about the nature of all these regimes? What does this tell us about the strength and impact of different kinds of public knowledge about the film?

(b) How (well) does the film conform with what is predicted by our understanding of the production imperatives? How (far) does it display the features claimed for it in its publicity regimes?

The outcome of these should be an attempt to formulate the relationships among all three, such that our understanding of each is informed as richly as possible by the other two. The point is absolutely not to find some easy 'fit'. It is likely, rather, that there will be conflicts and difficulties between these areas. Then, the question becomes: how well can we account for the conflicts? For example, suppose (as we believe to the case) that the publicity regimes for *Judge Dredd* made impossible claims, which the film could not fulfil. We then need to ask: what are the consequences of this for the different orientations to the film, and is there evidence that those consequences were in fact realised?

Commentary

Any number of critics have noted in recent years the problems that arise from a narrow focus on one or another aspect of the media: be it texts, audiences or – less commonly, though still sometimes the case – producers. But it hasn't been so clear how to go beyond such narrowness in ways that aren't purely rhetorical. For it isn't at all clear what will count as combining the approaches.

There is without doubt a problem about textual reading performed by 'experts'. No tradition more emphatically reveals this than the psychoanalytic. The problems are well exemplified in the range of contrary readings given to particular films, for example *Alien*, or *The Piano*. *Alien* has been variously 'read' as pro- and anti-feminist,[6] while the debate about *The Piano* maps an equally large territory.[7] How are we supposed to decide between such readings? It is clear from these writings that the answer is supposed to lie within the text, and the ways in which critics discover meanings in them. But it's also clear that in doing this, psychoanalytic critics insert masked claims about the sorts of forces which *produce* their films. Classically, a vast anonymous force called 'patriarchy' does the deed, while actual makers are essentially the bearers of this incubus. At the same time, such accounts of films' meanings also contain masked claims about what the 'reader' does with the film – or, more insidiously, what the film does with the 'reader'. It would be an enterprise in itself to go through the vast array of such writings, to show how often such claims occur within psychoanalytic analyses. This is not wrong in principle. It is a problem, though, on two grounds. First, a lot of the claims are virtually untestable, since the only source for testing them is the film itself. Second, frequently psychoanalytic claims take the form of *overthrowing* the ways audiences ordinarily talk about films. Now, there is nothing wrong in analysts claiming to learn things about audiences that are not transparent to the audiences themselves – if there was, our own work would be pointless.[8] But there is a world of difference between taking audiences' own accounts and through analysing these to highlight things not perceived by them, and overthrowing their accounts of themselves to substitute others derived from a general model.

Yet the simple alternative is no less unhappy. To ignore the text in favour of the audience is an empty move. For a start we know very well that producers devote enormous energies to producing films to achieve some effects and to

avoid others (see Chapter 9 for some examples from *Judge Dredd*). We also know that audiences themselves often invest a great deal of time and emotion in arguing over the finer points of films and other media – they can *care* about every aspect of their films, intensely. Indeed, by an irony, those very audiences who are most celebrated as 'resistant' are the ones who seem to pay closest attention to the patterns of meaning in their chosen media. Fans know their materials, and they care about them. But while the 'Fiskean' celebration of audiences has been widely condemned, the solution offered has frequently been a weak assertion of a 'middle ground' – as if we would know what to do with a method which asked us to include a 'bit' of textual power and a 'bit' of audience freedom.

C: Stage Three: the next step in our 'Baxandall' model is not present in his study, perhaps because the necessary materials are simply not available. Up to this point, our approach has involved establishing the presence of publicly-distributed orientations to a film, orientations which exist prior to any individual's response, and which offer patterned ways of preparing for and responding the film. But then individuals still have to *choose* how to respond to them. One significant test of any account, therefore, has to be to look at individuals' responses, to see in what ways they signal their awareness of the available orientations. They may embrace them, they may distance themselves from them; they may adopt one wholesale, or they may combine orientations. How far can we go in understanding *individuals'* particularities and 'eccentricities', and the consequences that their choices have for them?

D: Stage Four: this step parallels Baxandall's moves to establish the *wider significance* which may be attached to particular uses of his paintings. The Duke who chooses his painters because of his preference for 'manly dance'; the merchant who displays his paintings where business associates can see them, and recognise his astuteness in his preference for well-proportioned paintings; the priest who emphasises the religiosity and moral teachings in the paintings: each is setting the paintings in relation to wider cultural contexts. Baxandall, for this, searches for *points of connectedness* between the available modes of talk about the painting, and the wider structure of the society. This is what we propose to attempt. To complete the process of investigating the cultural significance of our film, we need to be able to do the following:

- *investigate the relations between the vocabularies of involvement and pleasure, and the histories and socio-cultural characteristics of particular audiences;*
- *investigate the relations between established production imperatives and the wider operations of cultural industries;*
- *investigate the relations between the patterns and form of the film, and the wider generic and other traditions.*

These last steps takes us right to the limits of our research, but we offer one set of important if tentative findings in Chapter 12. Mostly, though, this final stage is an agenda for a further whole set of researches.[9]

Summary Table:

1 Investigation of production imperatives, film, and audiences from independent positions, to the point where we can offer preliminary hypotheses.

2 Cross-triangulation of these hypotheses, to see how far they offer a mutually-explanatory account. This will include explaining conflicts between them, and exploring their consequences.

3 Application of the resultant model to individual audience members, to test its explanatory power.

4 Exploration of wider linkages: from production imperatives to broader conditions of cultural production; from film to generic and other traditions; from our audiences to their socio-cultural positions.

Talking about Pleasures

Because we could find so little written about the languages of pleasure, we have begun by offering our own table of some ways in which pleasures might be talked about. We constructed these examples intuitively, to illustrate the sorts of pattern we would seek. Earlier, we saw in the Boys' Club respondents some ways of talking about films which emphasised the sensuousness of being 'done to', or the delights in being shocked, knocked out of their seats by the pace and rhythm of a film. Their pleasures were patterned by these, and their disappointments arose from the failure of films to meet those patterns. It also involved them putting themselves into an appropriate frame of mind, and being prepared in the right way for the hoped-for pleasures. They had to be ready to take part appropriately if they were to get the pleasures back. Pleasure thus interrelates with manner of involvement. The following list is intended to offer some examples of possible clusters of pleasure-talk and their associated practical logics. This isn't, almost certainly couldn't be, a complete list. It is simply a box of tools for thinking about the practices of pleasure.

Vocabularies of Involvement and Pleasure

1 *Physical satisfaction:* expected language would be those of *sensory gratification, plenitude,* patterned by the *process and effects of the activity.* Closely related would be *indulging or having treats:* typified by 'naughty' behaviours verging on rule-breaking, with languages of *excess, of self-indulgence,* and patterned by *preparing for special moments.* Examples could include eating, drinking and sex.

2 *Physical activity/using your body:* languages of *concentration,* and of *physical sensations,* with a strong sense of the *rhythms of physical activity.* Closely associated might be *testing/pushing yourself:* typified in hard activity, or mental exercise, with languages of *effort, challenge* and *achievement.* These have their

own distinctive pattern. Examples could include participation in sports, or dancing.

3 ***Joining a crowd:*** mass events, with a vocabulary of *community, participation, losing oneself* and a pattern imposed by the external situation, whatever it is.

Closely associated could be *sensuous participation:* typified by music, with a language of *giving yourself over, being taken over,* this time perhaps with literal rhythms. Examples could include demonstrations and being in the crowd at big events.

4 ***Joining a spectacle:*** a firework display, for instance, with languages of *enthusiasm, excitement* and *readiness,* and *participating in the spectacular,* which tend to be *punctuated* between moments of intensity and of relaxation. Closely related to the last, examples could include firework displays, or events like public ceremonies.

5 ***Being free of pressures and obligations:*** shown in languages of *release, closing down,* perhaps *letting your hair down,* with a pattern of *comfort and relaxation.* Examples could include basking, sunbathing, 'doing nowt'.

6 ***Making imaginative worlds:*** with languages of *making things make sense, being caught up in,* or *creating wholes,* with a drive towards *emergent coherence and culmination.* Examples could include following strong narratives or listening to story-tellers.

7 ***Game-playing, role-playing, trying things out:*** with languages of *experimentation, acting the 'other',* and a strong patterning by *front regions* (public performances) and *back regions* (where things are rehearsed) and *testing for control.* Examples could be certain kinds of games, or parties, or social encounters.

8 ***Letting control go:*** with languages of *being out of it, off your head,* and patterned by deliberate processes of *abandonment* and *loss of self-consciousness.* Examples could be deliberately getting drunk or high, or other ways of choosing to lose control.

9 ***Taking risks:*** with languages of *testing yourself, living on the edge,* and a pattern centred on the unpredictable, on *'being done to'.* Examples could include fairground rides, and anything else involving thrills and spills.

10 ***Rule-breaking/defiance of conventions:*** typified wherever pleasure depends on 'being in the wrong place' or 'doing the wrong thing' with languages of *opposition, being an outsider,* and built around *others' 'annoyed' responses.* Examples could include situations where official 'opponents' are thwarted.

11 ***Being in company/sharing:*** situations of intimacy, with languages of *communion* and *mutuality* and patterned by *exchange* and *merging of interests.* Examples could include meals, conversations with friends.

12 ***Making a physical or mental difference to the world:*** work, or creativity typify this, with languages of *expressiveness, purposiveness, production* or *self-production* with a patterning by the *achievement of form or order.*

Examples could include everything from gardening, to charity work, anything that involves a conscious purposeful intervention.

13 *Self/status-confirmation:* with languages of *knowingness* and *confirmation of self* or *skills,* with the pattern of a *test.* Examples could be any competitive event, or any situation where we test ourselves.

14 *Admiration and worship:* typified by responses to powerful/engaging people, with languages of *astonishment* or *hyperbole,* with a pattern of *self-diminution.* Examples could be hero-worship and certain kinds of religion.

15 *Appreciation:* typified by responses to things of known value, with languages of *recognition* and *measurement, critical distance* and *acknowledged criteria,* within *systems of judgement.* Closely related might be *setting out to learn*: typified by worthwhile reading, with a language of *valued effort, advancement* and *growth,* with a sense of *following the requirements of the supplier.* Examples could include anything consciously artistic or educational.

16 *Surprises:* typified by anything genuinely not prepared for, with languages of *being taken aback, feeling recognised,* of *making a discovery,* and essentially *patternless* in as much as it is genuinely unexpected. Examples would be unexpected presents, or experiences which unexpectedly delight, transport or transform.

This list is a researchers' artefact. It is based on a combination of hunches, perceived elements in our transcripts, and aspects of our own personal experiences. It is therefore wide open for testing and modification. But as a resource, we think it goes well beyond the generalised notions of 'gratifications' in U&G research. We offer it mainly as a basis for thinking more openly about the meaning and form of people's involvements and pleasures. One key point to consider is the difference of the last from all the rest. But for the last, all involve some kind of preparation, and therefore have a pattern of involvement which extends beyond the moments of pleasure, on which in significant ways the pleasures depend. Crudely, there are things we have to do, and to know, and to prepare for in advance if any of these pleasures are to be gained.

The pleasures of watching *Dredd*

What, then, can we identify as the main patternings of expectation and pleasures in our interviews? With due tentativeness at this stage, we believe we can identify six main patterns, each organised around a different set of key concepts. By a key concept, we mean a way of expressing a relation to the film or to the act of going to the cinema which seems to have wide and organising implications. In picking them out in the first instance, clearly, we could only propose ideas for subsequent testing. The test will be: how much explanatory power each concept has. By separating them in this way, we are not saying that they can't be joined, or mixed, although the languages are clearly distinct and provide the bases for distinct models of involvement and pleasure. Simply, dealing with them separately allows us to explore *what it would mean for someone to attach themselves completely to such an orientation.*

Language 1: the joys of being 'done to' by a film

One whole way of talking about films describes a wish to be physically affected by them: typical (wanted) experiences are 'being knocked out of my seat', 'making me jump', 'hitting me between the eyes'. This is driven by a demand for 'pace'. A bad film is a 'slow' film, that 'sends you to sleep'. A good film of this kind doesn't just keep you awake, it *shocks* you awake repeatedly. This is the basis for a genre-classification. This kind of film is an 'Action'. In one sense this is a timeless experience – enjoying a film in this fashion could happen at any time, with the right materials. But because it involves elements of *surprise* and *catching you out*, it also has a pull towards *novelty*. To enjoy a film in this way, you have to be willing to *let go* and *be done to*, and the experience is probably heightened by doing it in company.

The key to this kind of pleasure is not to intellectualise. Therefore this experience is likely to be recounted through retelling disappointments ('it was too slow', 'it didn't make me jump') or through *enthusiastic re-enactment of the event*.

Language 2: the pleasures of the spectacle

Another filmic language grows around what we might call the pleasures of the screen. It emphasises things such as the *scale* of a film, its 'spectacular' qualities, its newness, and its 'effects'. Special effects are very important to this, as something to admire and be astonished by. With a strong visual streak to it, this way of enjoying looks forward to being stunned that seems simultaneously sensuous and conceptual; a good 'effect' both makes you go 'Wow!' at how it looks, and makes you see something new in the world of the film. In many ways this language can seem similar to the first, but in one respect it is different - a good 'effect' should be relished. It is quite proper for a film to slow down for those exquisite moments.

Language 3: Dredd's deserts

Hardly surprisingly, a large number of enthusiastic volunteers for our interviews were long-serving readers of *2000AD* and fans of *'Judge Dredd'*. Not all of these, by any means, took a common line on the film, but if there was a shared language, it was one centred around 'what *Judge Dredd* is really like, and what he deserves'. Is the film adequate to him, and his story-world? This doubling is important to recognise, since Dredd fans frequently talk of their *appreciation of the 'depth'* involved in the stories – the jokey references, the irony, the satire in them. So, a good Dredd film has to have the 'dark depths' which can be noticed and stored up by aficionados, while a poor one will have been 'hollywood-ised' – made clever but superficial. This is a language of *insiders' knowing appreciation*. But it regularly associates with another. If Dredd has 'deserts', then the first of those is *to be on the big screen in the first place*. Therefore, whatever the quality of the film, a small miracle has to be acknowledged and bathed in – 'he's up there, and he's huge!'. ('The thrill of seeing it being brought to life, on the screen!' [Interview 2])

Language 4: Sylvester's measure

For a smaller but still significant number, an opposite way of talking focuses on Sly Stallone. Stallone has a distinctive persona for his fans, one which they honour and love to follow, and this provides the basis for measuring a film's success. As we saw earlier, 'it's good cos he always gets beat up and then just comes back and decks em'. This pleasure is in watching someone survive intense suffering, in the expectation that he will struggle back up and succeed against all odds. As above, this is a 'doubled' pleasure. Just seeing Stallone in a new role is itself a pleasure: to gaze at his latest embodiment, admiringly. But it is also and necessarily a watchful, appraising and proprietorial look, for 'Stallone' existed prior to this role and will continue after it. What has this film, then, done to continue and enhance his persona? Can it join the canon of 'real' Stallone movies?

Language 5: the magic of cinema

Judge Dredd is a film. For one way of considering it, that is the prime consideration. Film is about cinema, and the magic of story-telling in the dark on a giant screen. To see a new film is to touch a continuing marvel, and to have the chance to assess its contribution to cinematic history. A 'proper environment' can thus multiply the pleasures: the right technical set-up, the right kind of mass audience taking each kind of film for what it is: a kind of film. The potential pleasure of *Dredd,* then, is its new movie magic. This is once again a knowing pleasure. But pleasure is here helped by different kinds of knowledge: knowledge of the *history* of the film, its *making* and *makers.* But first, it must be *experienced* for what it is – and that means, therefore, adopting at least one of the roles above and watching by its rules.

A good example of this:

Gary: It is the scale of the thing which is one of the aspects of it ... the fact that you are there with so many other people rather than just four or five of us in front of the telly is another ... there is a community of you there really. You are one of a crowd rather than just one of your mates. ... No matter what you do in your front room, you are not going to get the atmosphere of hugeness and sound and people and space.

Paul: There's the single-mindedness of it as well, the way that everyone is focused on .. the fact that a hundred or so people .. single object.

A sense of almost *awe* is generated by the occasion, even in recall, as Paul virtually loses his words.

Language 6: the pleasures of talk and the dangers of 'sad'

One strong and present language of filmic pleasures isn't directly about films at all – it is about their *uses.* Typically, it focuses on what one can do with the experience afterwards. This is strange and striking: a good film, which meets the criteria for pleasure under this heading, isn't necessarily good-in-itself – indeed, that may be a virtual disqualification – but it is *good-for-use,* which means that it

sustains the right kinds of conversation afterwards. The emphasis is on *film as social coinage*. In a way, the 'worse' a film is, the better. There is a category 'trash' which gives licence to this kind of use – which 'worthy' films make difficult. The pleasure, then, is unembarrassed participation in one's cultural group, aided and assisted by 'quotes' from the latest 'well-junk' film. A 'good' film *belongs* in the life and argot of a local cultural group.

But there's a counterpoint to this. It's not only a pleasure, it is also virtually mandatory. You have to be ready and able to take part properly in these ways. If not, you are open to a judgement of 'sadness'. The emphasis here is on the *manner* of participation. You go, and you watch, as a group-member – never as an intense loner. The point is to have no point. It is participation as its own purpose, leading nowhere except the pub. To do otherwise is to be obsessive, a fanboy, 'sad'.

Other forms of pleasure

There are, of course, other pleasures to be had from a trip to the cinema, and to see *Judge Dredd*. Some further ones were given to us in our interviews, others which we can easily imagine were not – and the reasons why aren't hard to imagine why, either! There's going to the cinema for the time-honoured reason of 'getting to know' your boy/girl-friend, especially if private spaces are hard to find. There's going because the shopping's done, and you just can't be bothered to go home yet. There's going to forget your troubles, and the more mindless the film the better! There's going to sag off from school, or to get into a film you're not really old enough for. All these, in essence, use the cinema for non-cinematic purposes, which is fine. We neither deny nor decry them – they all, though, have the characteristic of making almost irrelevant what is on the screen.

Other pleasures don't do this so obviously. When Gary [Interview 7] tells us that 'It's the pleasures of knowing which bits to whinge about, isn't it?', he is seeking our concurrence in his enjoyment of its *failure* as a film. When Sol [Interview 4] tells us of his expected pleasure, he is *marking his 'superiority'* to the rest of the audience: 'Well, I am expecting everyone else to hate it! So consequently I think I'll probably like it more than everyone else. ... I'm expecting the fan boys to be pissed off for a start, that he takes his helmet off'. This is pleasure by means of disdain for other people's irritation. Neither of these constitutes a way of being involved in the film itself. The first handles predicted disappointment, and turns it knowingly against itself. The second gains a social pleasure out of superiority to the 'sad' lives of the fans.

The differences between pleasures such as these, and our six, we claim to be these: VIPs require an engagement, more or less intense, with the 'text' of the film. VIPs are the basis of whole viewing styles which people have to *learn,* against which individual films are then positioned, experienced and judged. All of them permit gradations. People can always vary their commitment to watching a film in a particular way – even in the course of watching it. Sometimes the response to a film will be primarily individual – and to understand it will need reference to the person's biography. But sometimes responses turn out to be highly patterned. Why, for instance, should those adopting 'Language 1' so commonly report that

the opening minutes of *Judge Dredd* were disappointing – while those in 'Language 3' all, without exception, raved about that same part? This is what interests us in these six ways of talking; they seem to amount to *social resources for joining in enthusiastically with popular films.*

In this respect, all six differ from one other response, characteristically given to us in short, dead-end sentences: 'It was OK'. 'It wasn't as bad as I'd expected'. This is a kind of pleasure – or perhaps 'relief' might be a better word. We will not be able to say more about this diffident and dismissive response until we have completed our modelling and investigation of these six emergent vocabularies of involvement and pleasure.

Samantha: It was reasonable. It was OK. I was astonished because I really didn't think I wanted to go, and when it started I remember saying to Richard I really don't know that I want to be here [laughter] .. it was a case of, yeah, I was pleasantly surprised cos I did quite enjoy it cos I don't usually go to any Stallone film.

MB: *Do you know what it was you enjoyed about it?*

Samantha: Em. .. no, I don't actually. Em .. maybe relief that it wasn't as bad as I'd feared [laughter], to be honest. Em. yeah, that really. I don't know why, particularly, just .. relief that it wasn't as bad as I was expecting it to be. [Interview 34]

A word on the researchers' plot-centricity

Something remarkable strikes immediately on viewing these six VIPs. As researchers, we were fixated on *narrative,* to the point where we thought that if interviewees couldn't retell the plot to us clearly, that proved they had not really been involved in the film![10] What we see now is the essential *irrelevance* of narrative to almost all these ways of seeking pleasure in the film. As one couple gently put it to us, as they dismissed the relevance of critics and reviewers:

Keith: Those critics go more on like, story line, er you know, plot, and all things like that, whereas people who watch the film don't go on that. They just see, look to see if it's a good film.

KB: *Right, no*

Keith: Some people do look oh, that was a good story, but it's mainly to watch the film. [Interview 19]

A 'good film' is precisely not judged by its story-line, or plot.

KB: *So what kind of things do you like then, in a film, what would make you choose..?*

John: Lots of blood

Martin: Yeah

Lee: Explosions

Martin: Good effects

John:	Dead bodies
KB:	*Anything else? Plot, anything like that?*
Martin:	We don't watch it for that! We watch it for the Action, well I do, anyway
Johnny:	Any like, films that, where you can be bothered with plots and stuff
Lee:	Yeah, the good ones
John:	Yeah, the films that need plots, that you got to listen to them.
KB:	*What about the story in it then, the ending?*
Martin:	I was watching it for the action, I didn't really get any story [Interview 40]

Consider what each of these six ways of taking pleasure implies about narrative. For those wishing to be 'done to', narrative is like a carrier-wave, similar to the role that rails play on a big dipper – necessary to carry you along, but in themselves not the point of the exercise. Only if badly designed, if they don't get you safely and unobtrusively to the heights and depths, are they even worth mentioning. For those seeking spectacle, narrative is the means by which decisive moments of technology and effects can be reached appropriately. They frame those moments, and help them intensify our experiences properly – but again, are only worth noticing in themselves when they intrude awkwardly. For Stallone fans, narrative is the means to display his achievement; it is the means to bring Stallone back to himself, in his next star-shape. For those caught up in the magic of cinema, narrative is just one of the points at which tradition and newness must coincide. The key, for this orientation, is 'genre', and whether an individual is willing to include *Dredd's* perceived genre in their 'film-frame'. And for those motivated by belonging properly to their culture-group, narrative is a structure for presenting and accentuating a collection of good talking-points, which are like the clever 'colouration' of an otherwise bare structure.[11] Only for the Dredd-fan is narrative in itself important – because their comic-reading had long emphasised the many-layered story-lines. And even then, they mean something quite different by 'depth' than almost anything that passes as contemporary film analysis.

Once we recognise that 'narrative' is essentially a means rather than a constraint,[12] and of a different sort to each audience position, we can see more clearly what it means to relate to a film like *Dredd* via each of these vocabularies of involvement and pleasure.

1 Our very real thanks to Martin Lister who pointed us in this direction. It is worth noting that one other film historian, Janet Staiger, also sees much the same potential in Baxandall's work; see her 'Mass produced photoplays: economic and signifying practices in the first years of Hollywood', in Paul Kerr (ed), *The Hollywood Film Industry: A Reader*, London, Routledge & Kegan Paul 1986, pp.97-119. We take encouragement from this, since Staiger's later work on film audiences *Interpreting Films* shares many of our concerns and develops a number of the same ideas about audiences.

2 Michael Baxandall, *Painting and Experience in Fifteenth Century Italy: A primer in the social history of pictorial style*, New York: Oxford University Press 1988 (first published 1972).

3 Pause and think about this, and think about the challenge it represents to the perennial scares about children being 'frightened' by films.

4 In Chapter 1, we argued that audience research is at a curious juncture where many fascinating researches are taking place, but are being straight-jacketed by weak theories. It is curious to look back, and see how another pair of researchers confronted a similar perceived difficulty. In 1976 Dembo and McCron ran up against the limits of the till-then-dominant uses and gratifications tradition. In an essay which pays revisiting, they argued then for a three-headed method which could 'locate the social and demographic life-circumstances', 'locate the cultural and social values

and behaviour that are important to [viewers]', and then see how these factors 'relate to purposive behaviour, in this case the use of the media'. (Richard Dembo & Robin McCron, 'Social factors in media use', in Ray Brown (ed), *Children and Television*, Basingstoke: Collier MacMillan 1976, pp.137-66) With the benefit of twenty years of intense investigations and arguments of other kinds, it is now easier to see two gaps in their model – they do not have any sophisticated analytic engines for considering the televisual texts embodying meanings; and their notion of 'social and cultural values' looks primarily a tool for moralising and evaluating. Even so, it is interesting to see that a situation similar to our own produces a related reaction.

5 There is an assumption in this which we are content to note here, though it has wide implications. The assumption is that not all responses to a film are equally patterned, and some perhaps will have few identifiable patterns at all. In Chapter 10 we do return to this important issue.

6 See, among others, Constance Penley, 'Time travel, primal scene, and the critical dystopia', and Harvey M Greenberg, 'Re-imagining the gargoyle: psychoanalytic notes on Alien', both in Constance Penley et al (eds), *Close Encounters: Film, Feminism and Science Fiction*, Minneapolis: University of Minnesota Press 1991; James Kavanagh, 'Feminism, humanism and science in *Alien*', Judith Newton, 'Feminism and anxiety in *Alien*', and Barbara Creed, '*Alien* and the monstrous feminine', all in Annette Kuhn (ed), *Alien Zone: Cultural Theory and Contemporary Science Fiction Cinema*, London: Verso 1990, and Harvey M Greenberg, 'Fembo: *Aliens'* intentions', *Journal of Popular Film and Television*, Vol.15, no.4, 1988, pp.165-71.

7 See Stella Bruzzi, 'Tempestuous petticoats: costume and desire in *The Piano*', pp.257-66; Lynda Dyson, 'The return of the repressed? Whiteness, femininity and colonialism in *The Piano*', pp.266-76; Sue Gillett, 'Lips and fingers: Jane Campion's *The Piano*', pp.277-87, all in *Screen*, Vol.36, No.3, 1995; and Suzy Gordon, '"I clipped your wing, that's all": auto-eroticism and the female spectator in *The Piano* debate', *Screen*, Vol.37, No.2, 1996, pp.193-205.

8 And it has to be said that in our experience audiences are fascinated with the idea that we might be able to offer them insights into themselves that they can't produce for themselves.

9 We want to make clear that this set of proposed procedures is not a self-serving account. We arrived at it after we had completed our primary researches, and when we grasped what we felt was ideally needed, it revealed significant limitations in the scope of our original enquiries. If we could begin again, there are some things we would do rather differently, as a result.

10 Interviewer's typical response in an early interview to respondents' not being able to recall the plot of the film at all: 'It obviously didn't mean to you, then!' Ouch.

11 Those who have followed recent academic conflicts over 'media effects' will know that one of us has been involved in some exchanges with members of the Glasgow University Media Group, about the 'safety' of so-called 'violent films'. One of the latter, Greg Philo, recently published an essay arguing that the fact that young people can recall large chunks of the dialogue from Quentin Tarantino's *Pulp Fiction* is grounds for worry. See his *Children and Film/Video Violence* (Glasgow Media Group Research Report, 1997). Philo, in our view, befuddles the issues by explaining this in terms of a loose and ungrounded concept of 'values': '*Pulp Fiction* presents money, power and style as what social life is about. Its values are intensely attractive to many children' (cited in Richard Brooks, *Observer*, 26 October 1997). Our approach offers a way of understanding to what aspect of audiences' lives such 'quoting' may connect. For further on this, see below Chapter 12.

12 Is this a new development? Recently, a number of film historians have suggested that 'classical Hollywood' has come to an end, with the new emphasis on spectacle and effects. The implication is that 'old Hollywood' was centred around (a classical) narrative form, which shaped and constrained audience responses directly. This is beyond our purview, but we draw attention, lightly, to the following (1940) response contained in Richards & Sheridan (eds), *Mass Observation at the Movies*, p.42: 'My main interest is in the acting and the personalities of the players. I don't care a hoot about the story, providing the acting is good, and the actors well cast. Bad casting annoys me extremely. I have a long list of favourites any of whom I will go a long way to see.'

7 THE SIX ORIENTATIONS TO JUDGE DREDD

What do these six patterns of involvement identified in the previous chapter have in common? How could we move beyond these descriptive accounts of them? There are in fact some telling commonalities which invite the development of a more general model:

1 Each of the six patterns points to the existence of a possible way of relating to the film which exists external to the individuals who know about and may choose that orientation. This acknowledgement of the external existence of these orientations is shown in a number of ways, as we demonstrated at the end of the last chapter.

2 Each then represents a way in which individuals can choose to orient themselves to the film. There is no reason in principle why an individual shouldn't choose to mix or combine orientations in a variety of ways. There might be practical difficulties in managing several together, but nothing stops them from trying!

3 Individuals, in choosing an orientation, can do with varying degrees of conviction or commitment, or with varying kinds of hesitation and distance.

4 But though external to the individual, once chosen, each pattern invites us to engage with the film with a complex of different parts of our personality: cognitively, in paying attention to different aspects of the film: emotionally, in caring about particular people, or kinds of events; and sensuously, in engaging with the filmic experience in particular ways.

5 All of them offer pleasures and gratifications, but each of them always offers more than just these – they offer ways of participating both in the film, and in different kinds of cultural membership.

6 Each of them has consequences for how we prepare for, participate in, find meaning in, judge quality in, relate to other participants in the film, and how we categorise, use and evaluate the resultant experiences afterwards.

Each, in sum, represents a site external to the individual, with which s/he can choose to connect. It only exists as a site in the sense that each constitutes a recognised cultural repertoire of possible responses. It is external, in the sense that each individual acknowledges it operates more widely than him or her, it inhabits a space between individuals and thus operates as a set of sharable rules and constraints, and that s/he can be judged by the criteria implicit in each. In the light of these, we propose to model these responses into coherent ideal-types, in order to try to understand what

it is that is external to any individual. It may be that no individual will ever perfectly or fully embody the models we offer below. But in acknowledging their externality, they are implicitly pointing to such models. The 'truth' of our models can be known by how far people recognise what we say as their implicit reference points, and also by how far they enable us to make sense of our interviewees' responses.

Each pattern of VIPs, then, represents a culturally-generated 'space' into which an individual can move. Or better, a SPACE. That is, a Site for the Production of Active Cinematic Experiences. We propose SPACE as a semi-technical term, whose acronymic properties nicely sum up our meaning! A SPACE is a model of a possible orientation to a film, covering at least the following aspects: reasons for going; expectations of the film; preparations; choice of cinema (or video) and company; way of participating in the film; pleasures and dislikes, surprises and disappointments; judgements; and wind-down and aftermath.

To get at these, we have modelled each of the six SPACES around their 'answers' to sixteen questions, as follows:

1 What vocabularies of involvement and pleasure typify responses within this SPACE to the filmic experience?

2 What are the ideal viewing conditions? Under what circumstances, where, and with whom should it be seen? How important are these to a proper experience of the film?

3 What defines the kind of viewer who can inhabit the SPACE? Who is it for? What characteristics are typical viewers in each orientation seen as having?

4 To be a successful inhabitor of this SPACE, what do you need to do in preparation? What kinds of knowledge are necessary for people to be able to experience the film properly? To take part successfully in the filmic experience, what does the viewer need to do to ready him/herself?

5 What should be done in preparation for the cinematic experience, and to complete or 'close' it? When does the experience start and end? What is involved before and after the actual time in the cinema that forms a significant part of the process of experiencing it?

6 What category does a film appropriate to this SPACE fall into, and how are other films different (and is that negative, positive or neutral)? What other kinds of film (or other relevant forms of culture) are separated off, and understood to require different kinds of response?

7 How is entering this SPACE demarcated from, and related to, other parts of the audience's lives? How is the experience of this film supposed to relate to other aspects of viewers' lives? What kinds of self-description are involved?

8 What is important to have in the film? What aspects of the film are important to pay attention to? What would make it a good or bad film?

9 What is unimportant or irrelevant or a nuisance in a film? What are typically seen as factors which interfere with proper participation and pleasure?

10 What expectations are had of the Dredd/Stallone nexus? What meanings of 'stars' or equivalents are involved?

11 What are the differences in meaning and expectation between cinema and video? What can each contribute to a proper involvement in the film? What are the proper conditions for using each, and with whom should each be done?

12 What relations does the SPACE propose towards the information and publicity regimes?

13 What will make the film 'new' and 'different'? How does it provide an opportunity for a novel, innovative, accumulative, additive or other kind of new filmic experience?

14 What is appropriate to talk about, after the film? How is the filmic experience recounted, re-enacted or evaluated? What social space is put between viewing the film and talking about it?

15 What wider statement about the meaning of leisure in their lives and choice of cultural memberships is made by attending to the film through this SPACE? What is film-viewing for? What role does film-viewing play within leisure-time? What other leisure-preferences is it part of, or separated from? What leisure-statements and leisure-identities are postulated in viewing the film under the right conditions?

16 In sum, what is the central criterion for assessing the film?

These were not, of course, the questions we posed to our interviewees – they are analytic queries, ways of sorting and discovering patterns and significances in our interview-materials. Although obviously they are based on our emerging sense of what might prove significant, in a sense these questions are as good as the patterns which they bring into view. Here then are our ideal-typical pen-portraits of the six main orientations to *Judge Dredd* which we began to demarcate in the previous chapter. To each, we have attached a short commentary in which we outline our answer to three questions: how strong are our grounds for each model? what are the immediate issues raised by each? and what might explain its existence?

The Action-Adventure SPACE

Summary: Anyone choosing to orient to a film via this SPACE is aiming to become involved at a very sensuous, bodily level. Via knowing and admiring the central hero, and via experiencing the events, s/he wants to take part in a roller-coaster of a film, where every moment is either be a thrill or danger, or a getting ready for the next thrill or danger.

Vocabularies of Involvement and Pleasure: These films are enjoyed for and through their pace, their rhythm, their suspense and danger. There is pleasure (thrills, excitement) in experiencing the dramas of the 'macho' charismatic hero (who is huge, awesome), whose strength and prowess is being tested. These films are 'just watched', 'just enjoyed' – you don't analyse them, you don't think about them: they begin, they do something (preferably physical) to you, they end – end of experience! There is in fact an overwhelming sense of experiencing such films in the present tense, with little sense of past or future to the process.

Ideal viewing conditions: Ideally these films should be seen at the (right kind of) cinema, as this is about spectacle: spectacular technology (car chases, weaponry)

and spectacular (fighting) bodies, and so needs to be 'seen big'. A good cinema is a multiplex, not with a 'hanky' for a screen (one interviewee's term), and with brilliant surround-sound. The films can be replayed on video, and the most exciting scenes relived, but that is second-time-round. Ideally this is a group experience, since that helps the 'letting go' into the experience. A key is that watching an 'Action' should always be uninhibited.

Who are the viewers? They're young and unsupervised. Mostly they're male, but girls and women can do it, if they're prepared to play this game. These films are about indulgence, about enjoying being unembarrassed at their uninhibited participation, and unsupervised by adult approval or peer/politically-correct approval.

To be ready to be the audience you need... not a lot. Very little needs to be done in advance, because the experience is so 'present-tense'. You need to keep a weather eye on the 'hype', which tells which films are likely to offer the right kind of experience. You need to be clear generally of what it will consist – hero, challenges, villains, stunts, climax – to appreciate it. This experience is lived, not articulated or analysed. You must, though, be ready to let yourself go, like being prepared for a roller-coaster ride at a fairground. Be ready to be 'done to'. And if the film doesn't, moan.

Before and after the cinema: There's choosing who to go with and where, and there could be some 'hanging out' with your group before and after, or going for a pint – the things you do when you're 'being in a gang'. Afterwards, more of the same, and maybe reliving bits of the film.

Other kinds of films are: 'Soppy shit', 'girls/girlfriend film', 'feel-good movies', 'films with a message', 'worthy films'. The difference is that Action films are about losing yourself, and 'being done to' (suspense, surprise, shock). Comedies can be like action, in that they are 'easy' and not to be analysed, and again, do something to you. Since other types of films don't work like this, they're an effort to watch – and as you go to the cinema to be surprised, thrilled, excited, made relaxed, made to laugh, even turned on, what you don't want are films that make *you* make an effort.

Relation to other parts of their lives: The key is release from constraints – of having to 'behave' (whether this is being polite, quiet, considerate, pc, non-macho, or whatever). This is a self-enclosed experience and, most importantly, it 'just happens'. If generally viewers feel that this is something they ought not to admit to, it can always fall into the category of 'guilty enjoyment'.

What's important in a film? Editing: it has to make you feel as if you're living it. The film has to have an overall rhythm, to be fast overall, not slow. It can have a few slow bits to set the scene, and to punctuate the good fast bits, but no more than that. And it has to have a build up, and a satisfying climax. The hero has to be properly dramatised – set against an equal but opposite villain. (To this particular SPACE it hardly matters whether the hero is male or female (viz *Alien*, for instance), providing she is adequate in this sense. The filming, the technology and the action must lift the hero out of the ordinary: cars, weaponry and explosions

should both help him or her perform spectacularly and provide exciting danger and challenges. Other characters should be there to make the hero look good, not get in the way of the action (eg, love interest).

What's not important in a film: Relationships, complex plot or dialogue which get in the way of the plot rhythm and slow the film down. Preachy messages, or anything that intrudes between the film and uninhibited participation, and being 'done to' an awful lot.

The Dredd/Stallone nexus: It isn't the star or the fictional character in themselves that matter. What matters is: do these combinations of these characters provide a new version of the action hero? Does this film do anything different from preceding versions of Action films, or Stallone movies more specifically?

Cinema vs Video: Whilst cinema is always the best, if it can be managed (reached, afforded, got into under age, or whatever), after that the key question is: where can this film be enjoyed unsupervised, where it won't matter how they behave? Video-watching can be a fun group experience, but cinema is better for effects, and if they do muck about in the cinema, they can have fun reliving that as well as the scenes in the film: all are part of 'enjoying wilfulness'.

Relations to publicity: Always ask: does it live up to the 'hype'? Is the plot as exciting in terms of rhythm as the trailers suggested? In a way, trailers are the pure essence of an action movie: speedy, fast-edited series of highlights, the high points of spectacular action scenes, with none of the slower parts, the 'dips' which join these scenes together. But the trouble is that often the trailers show all the best bits, the film itself is a bit of an anti-climax. It matters who plays the main parts: are the villains and heroes worthy (opposite yet equally dramatic) of each other? Publicity is 'consumed', as 'tasters' for the main event.

The 'newness' of the film: The formula should be recognisable – you don't want to be distracted by plot/dialogue intricacies and innovations, it's how things happen that counts more than what happens. What innovative elements are there along the way (technology, fights, etc), and how do they catch you by surprise?

Talk after the film: Definitely not analysis of the film: it's obvious, it's all there on-screen. There can be some dramatised reconstructions in the sense of playful re-renderings of best moments, or some self-ironising, if you feel the need to justify why you watch. Generally, though, you just enjoy them for what they are. An allowable kind of talk would be the kind that asks how this action film/hero compares with others (can Stallone 'do a Willis'?) but that's all.

Leisure statements and identities: To enjoy films like this is to separate yourself from the 'analysts'. These films aren't watched in order to talk about them or have opinions – those who do are either poncey academics, or misguided alarmists. In particular, for young males enjoying these films, it's about 'enjoying being your gender', and enjoying seeing it performed on screen.

The central critical criterion is: is it white-knuckle enough as a rollercoaster ride? Did it thrill us?

Commentary

Developing this model was, in retrospect, a signal breakthrough. In response to admitting our plot-centricity to ourselves, and consciously stepping away from that, we took a decision to model how people talked about 'pace' and the sensuousness of film. These led us to Michael Baxandall. There was no shortage of materials to draw on from our transcripts. This, and the Dredd-deserts model, attracted the largest proportion of interviewees' talk.

This model also alerted us to the importance of disappointment, of going to the cinema expecting and hoping for some experience that hardly arrives. For this kind of viewing, disappointment links to the importance of 'hype'. Films are enormously publicised, and popular films such as Dredd now often spend more on publicity than on the whole of production (see Chapter 10 on this). But 'hype' is more than just a term to describe publicity – it is also a way of responding to and using it. It picks out the scale of publicity, the strength of its claims, and offers to join in on those terms. But 'hype' also has a cynical tinge because by their nature hyped claims are all in superlatives. Therefore there is no paradox in this:

Chris: The film didn't live up to the hype, I don't think. It was a good film, but it just didn't live up to the hype. [Interview 29]

Because of the nature of the responses involved, people embodying this way of responding don't want to, and don't, intellectualise about films – that is dull and pretentious. Their talk, as we suggested in the previous chapter, tends to re-live the experiences, and in group-ways. So constructing this model depended on us drawing out implicit linkages and separations. For example, this extract took us neatly from admitting our own plot-prejudgement to a consideration of another kind of involvement with its own logic:

KB: *What did you think of the start of the film? Can you remember?*
Rob: That's, is that when they're in prison? Can't really remember much of it myself...Um...
KB: *Obviously wasn't very spectacular! [Laughter]*
MB: Didn't hammer itself into your head, did it!
Rob: No I didn't find it all that...good. Um Right..well, what I seen of the beginning which is, what, where Rico or someone. He escapes from the prison and he goes, I don't know what it is, I think he's trying to take revenge on *Judge Dredd* for what they done, and he escapes, and I mean, you see him flying in and then it just goes straight on to the like, street scene where they're all fighting with all the guns. [M: yes] I thought that, I mean, that was pretty, yeah the beginning looks good, I thought yeah, I'll buy this, Action straight up, it might be all the way through, and then you see *Judge Dredd* riding on the bike, and like, talks to his gun and shoots a few people! I mean, yeah, that was quite good, and then, I mean, I mean, when it got further into the film it started getting a bit slow, and things just dragged on, I almost fell asleep! [Interview 37]

To Rob, the film was something he knows is being 'sold' him, and he will take it if it lives up to its promise. If not, the dramatising 'falling asleep' kicks in. Literally, he gets the beginning quite wrong – but in 'Action' terms, he doesn't.[1]

How this SPACE might have developed is a major question which we leave until much later (see Chapter 12).

The Future-Fantastic SPACE

Summary: Anyone choosing to orient to a film via this SPACE is getting ready to respond to spectacular technologies, effects, and a blast of sensuous experiences. These have to be new, different, a demonstration of cinematic skills. The better they are integrated into the plot, and flow of the film, the better.

Vocabularies of Involvement and Pleasure: Visceral – a language of effects on the viewer (as with Action-Adventure, a film should 'do things' to a viewer, make you jump, or gasp, or etc) and of special effects. There is an emphasis on scale, both visual and aural. Almost always this is a dystopian future, involving an heroic struggle against disaster. There is also an important dimension of new-ness: each film should offer something not done before, be it great expense, an original effect, or a startling new vision.

Ideal viewing conditions: Ideally, a film with 'effects' should be seen at the most technologically advanced cinema, to get the most out of the visual and aural elements, for example, a cinema with state-of-the-art equipment. Because these films do things to you, viewing this film is best when it is a mass social experience. Part of the viewing pleasure involves the atmosphere of mass reactions to the effects. Comfortable seats, surround sound and wide screen should cocoon the viewer, to the point where it's almost as if you're there – a kind of virtual reality.

Who are the viewers? They are science fiction fans, people fascinated by technology, both *on* the screen (futuristic weaponry, for example) and *off* the screen (special effects). Viewers are those who like a film to do things to them, to keep you on the edge of your seat – most importantly, to surprise you. A Future-Fantastic film is not worth it if it hasn't given you something you've not experienced/imagined before.

To be ready to be the audience you need... to be prepared to be bowled over, to want surprise. Don't take it seriously – this kind of viewing can be anti-'expertise', unhampered by concerns about plot inconsistencies etc. This isn't a serious view of the future, it's the latest version of a spectacular dystopia. You don't view it as the future – it exists as cinema. Afterwards, we might think about more than that ...

Before and after the cinema: You need to read and take note of the hype ('it's bigger and better than ever before ... more has been spent on effects than ever before ...') and learning what to look out for (new/expensive effects scene). It helps to be ready for the special parts, if you can carry some knowledge of how they were done. Afterwards, you can recount those moments – not to analyse them but to relive the experience ('And when that spaceship crash landed on the Statue of Liberty – wow!') in knowing reconstructions.

Other kinds of films are... Plot driven: about dialogue, rather than spectacular experiences, about people and relationships, not light and noise. These other films are slow, 'difficult', they don't 'take you out of yourself'.

Relation to other parts of their lives: Future-Fantastic films are a 'self-contained fantasy' – this isn't so much about the 'real' future as it is about enjoying experiencing technological innovation and perhaps wondering what difference they could make. You don't go and see a film like this for insight into your relationships etc., or social comment, you go to see a film like this so that you can lose yourself in the wonder of a big, noisy spectacle. It might make you think: how DID they do that?! afterwards. It might even make you think: would I like it if they REALLY did that ...?

What's important in a film? Novelty is the most important element: an ideal film surprises you, gives you few clues to 'how it's done', seems to do the impossible, and is very proud of the fact! There are some key scenes of effects (which often go into slo-mo) where the plot stands still. These are the pure moments of film-as-spectacle, and are to be savoured.

What is not important? Other elements (plot, character development) can get in the way, or slow the plot down.

The Dredd/Stallone nexus: The question is: is this a spectacular and imposing hero? Does this combination succeed as novelty/surprise? It isn't necessary to know about the backgrounds of either character, but the hero can be 'placed' in comparison to other future-fantastic heroes, particularly in terms of his special powers – are they spectacular, surprising, new?

Cinema vs Video: Cinema is the best place to view these films, but the effect can be partly recreated at home with speakers, wide-screen TV. Wire your video through your home system, and approximate to cinema.

Relations to publicity: Keeping up-to-date with the spectacular innovations – you will read about new developments, the cost of a film: this alone will motivate you to go see a film, regardless of stars or plot. 'Hype' is part of the excitement.

The newness of the film: The ideal film necessarily involves novelty and surprise, this is its entire point. Money and technological advances should conspire to astound, and ought always to be better than the last astounding effect: bigger, noisier, and more 'hi-tech' (though it is possible to have some slow effects, specially generated and lovingly presented so we can almost 'see inside them'). To be new, the film should reveal an interesting new version of the existing image of dystopia – what is dystopic now, what does it catch hold of in the present to nullify in the bad future? How is it different/similar to the last?

Talk after the film: Reliving the spectacular scenes, and talking about how they did it. It could be worth comparing its version of dystopia with others, but not necessarily comparing them with the real future: you wouldn't talk so much about 'Is this what the future holds for us?' as about 'Was this cinematic version of dystopia better and more spectacular than the last? Was it the best so far?'.

Leisure statements and identities: Seeing a film isn't about seeing whether or not

you get the plot or to be challenged; seeing a film is about being surprised, being presented with a spectacular view of an exciting dystopia, so being a Future-Fantastic viewer is about being 'up-to-date' with cinema, its technologies and its visions. It is also a familiar 'easy' plot-line (human struggle vs dystopian disaster) and a good film-rhythm that allows for moments of pure effect – adopt this approach if you are the kind of person who can indulge in such pure fantastic moments.

Central criterion: A combination of rollercoaster experience, with indulgence in the pure joys of technological spectacle and speculation.

Commentary

This is less secure as a model. Although we repeatedly see traces and signs which come to make sense once the model is constructed, we did not encounter this model in a 'pure' form among our interviewees – no one displayed it as their sole orientation. Sadly, we suspect that our 'lost' interview with the Bristol Science Fiction Society might have filled out and confirmed what is elsewhere fragmentary and tantalising. Still, a large number of people delighted in talking about the pleasures of scale and visual effects of films, especially those in the general Action/science fiction genres. This became for many a very strong reason for preferring cinema to video. But one interviewee, discussing his tactic for viewing on video when he couldn't get to the cinema, revealed a great deal about the kinds of pleasure involved in this aspect of films:

KB: *Are there any films that you think are video films as opposed to cinema films?*

John: Umm, well, yeah, I suppose if there is nothing that involves scenery, one where the scenery doesn't play an important part or when ... a dimension of size, if its basically about people then yeah, I think that might come over better on video, or it would come over just as well on video. But otherwise, you have got to try and shrink yourself, you've got to try to imagine that you're smaller than the television, basically haven't you, to try and enjoy a big screen film on the telly. *2001* is an example they are showing it the box. You've just got to try and be aware of it as a big screen, so I always insist on having all the lights out, just a small light perhaps on, when I'm watching a video at home. [Interview 23]

This nicely captures the way in which a viewer prepares a mental relation to the screen – even under restricted circumstances – in order to achieve the desired pleasure.

In one sense, this is not a new experience at all. There is plenty of evidence that 'spectacular relations' to popular leisure have been available and chosen for a very long time. The work of Michael Bakhtin on carnival is easily supplemented with historians' studies of the 'world turned upside down', and by other studies of early forms of mass popular pleasure.[2] Just as significantly, recently a number of film historians have been revisiting the 'classical' model of Hollywood, suggesting that

early film viewing was centred on just these kinds of spectacular pleasure.[3]

But though although not new, it is surely undeniable that in recent years mainstream Hollywood has consciously played to these pleasures with its making and publicising of 'effects movies'.[4] What needs mentioning here is the kind of film that has in recent years typically carried these spectacular images. Among them is a core of dystopic, bleakly futuristic science fiction films. Classics in this strand are *Blade Runner* (1982), the two *Terminators* (1984, 1991), *Total Recall* (1990), the various *Robocops* (1987, 1990, 1993 and the *Alien* series (1979, 1986, 1992, 1997). There has been a wide debate about what should be made of this development, and what it indicates culturally and politically.[5] The one point we would insist on, based on Barker's earlier research on the readers of *2000AD*, is that it is inadmissible to jump from perceiving these films as bleak, to a conclusion that they make audiences bleak.

What this means in terms of pleasurable involvements for viewers is more complicated than at first appears, and we again set this aside until Chapter 12 – where we will argue that perhaps it is not surprising that this orientation tends to occur in strong association with the Action-Adventure SPACE. We make one introductory point here, since there is an apparent paradox in linking Action-Adventure and Future-Fantastic. Action-Adventure commits a viewer to speed, sensuous excitement, and 'being done to'; its main complaint is when things slow down. Future-Fantastic requires that films slow at decisive moments, to allow a devoted involvement with special effects. Although seemingly a flat contradiction, in fact these are complementary. For what the Action-Adventure orientation demands is a roller-coaster ride, in which film tugs viewers along and doesn't make overtly intellectual demands. But just a real roller-coaster, our attention can be intensified at special junctures. Imagine ... you have been chugging up the main incline on a giant fairground ride, you hit the crest and there, beckoning, is the great drop into nothingness. For a moment, all mental energies combine to magnify the thrill of impending descent! It is as if time stops ... The analogy suggests that speed is not necessarily literal, it is a way of paying attention, and in this manner nothing stops an amalgamation of the two SPACEs.

The *2000AD* - Follower SPACE

Summary: Not anyone can choose to orient to the film via this SPACE – it is reserved for those who 'own' rights in Judge Dredd by virtue of having taken part in his world for some time beforehand. The point of seeing the film, therefore, is double: hopefully, to see a huge character made as big and public as he deserves and requires; and hopefully, to see others realise his 'hugeness'.

Vocabularies of Involvement and Pleasure: The language of 'deserts': is Dredd done justice (the pun could well be self-conscious)? Has he been 'achieved' properly and adequately? Has this three-dimensional figure been appropriately done on screen? A language, therefore, of rights, ownership and possessiveness.

At the same time, a language of hopes, doubling the 'deserts' language. The *2000AD*-Followers are very aware of their own 'fannish-ness', and of the fragility

and uncertainty of the comic and its iconic figure. Therefore, along with the strong sense that Dredd ought to be better known and loved, comes a desire to see Dredd enter the mainstream, even at a cost. So, the language of rights is qualified by a second language: the language of 'cross-overs', 'arrival', 'making it to the screen' – all aspects of a hope that he can reach a new audience. That way, their future as fans is secured, their enthusiasm for the character – and perhaps his vehicle – justified. Thus they will have confirmed their right to be devotees.

These two pull against each other, and the tension between them is marked by a third language, of 'Hollywood-isation'. They're unlikely to get their own way. *2000AD* fans know that their character can't make it unsullied to the screen, and therefore a joking solution may have to be found.

Ideal viewing conditions: It is only fairly important how, when and where the film is seen. However it takes place, seeing it will be an 'event', a moment to savour when (with a probable shiver down the spine) Megacity One and Dredd first appear on the screen. Ideally see it early, as soon as possible, and in a manner that allows a concentrated 'act of devotion': 'There he is! God, he looks good/crap! The city ... wow! There's a bit from the comic ... Block-names, the smiley face on the Statue of Liberty, the street punks', etc, etc.

But again another 'doubling': also watching the 'other' audience. This can take place not only in the cinema, but via reviews, news of how the film's doing and so on. Part of this is a kind of giving permission to 'them' to watch it, along with a watchful hope that they take to it, but again, that what they get is recognisably 'Dredd', and does him – and the fans – credit.

Who are the viewers? Special people who are in the know, able to watch uninterruptedly, picking up on the sly visual references, the bits intended just for them. They are fans, people with rights because this is 'their' character.

To be ready to be the audience you need... to make a hard decision. The trouble is, they know he will have been Hollywood-ised, made 'fit' for film, blockbuster, general audiences. So, going in to see the film requires of them a conscious choice: to go in making demands, but almost expecting to be disappointed; or to 'leave their Dredd-head at the door'. The trouble is, they almost know too much! Their comics and other sources have told them much and already shown them bits and pieces; but to watch all that would be to lose all chance of being genuinely surprised – and after up to 18 years wait, that is to spoil an opportunity! So, again, a conscious choice is required – to limit contact with pre-publicity, in order to keep the sense of anticipation alive; or to read and watch it all, and then to know, to have experienced the 'Hollywood machine' at work ...

Before and after the cinema: This particular cinematic experience began many years ago – as early as 1980, perhaps. *2000AD*, like its predecessor *Action*, was always 'knowing' towards other parts of their culture, borrowing film and TV stories and settings, and 'referencing' the rest of its culture, often by knowing in-jokes. So, translation to film was always a dream. The questions circulated for years: who could/would play Dredd? How could/would the City be envisaged? What story-lines would best serve a film version? A decade of speculations,

sedimented into fan-discussions, constituted a climate of hopes and fears.

After the film, happy or disappointed, hardly matters, back to the main business. Stallone or not, Dredd is real and (hopefully) continuing. 'They' may have produced *Judge Dredd: Lawman of the Future*, key-ring purses, duvet covers and even a cake, god help us! (Dredd would have had 'em in the iso-cubes for such irreverence), but the authentic Dredd continues. A worry, of course, that the comic itself might be tarnished with a back-wash from the film.

Other kinds of films are... just completely different. 'Dredd' is its own universe, to be measured and if possible enjoyed in a way particularly appropriate to his stature.

Relation to other parts of their lives: 'Fandom' has a difficult public status, therefore the easiest thing would be to mock oneself, to circumscribe one's involvement, or to announce its 'stupidity'. On the other hand, the fans, the followers, the ones who know, have rights have known and loved, have in many senses built, this character. They have knowledge to which others aren't privy. But they also know that the non-fans have this view of fans as 'anoraks': 'sad' individuals obsessively following comic characters. Best, then, to ironise ourselves a bit – or to keep our fascinations private. The trouble is, the fans do care, they can get passionate about Dredd, especially if he is done wrong to. The ideal therefore would be for the fans to be vindicated inasmuch as Dredd-following might become 'hip'. Fight for the right to read Dredd, to scorn dead-heads, to party, and to have wilful fantasies! Therefore the followers are quite ambivalent about the modality of Dredd, and the comic. It's brilliant ... but after all it's only a comic. Don't get us wrong, we're not 'sad', but we are/have been fans of something a bit special.

What's important in a film? Dredd exists fully and three-dimensionally already. He isn't just a generic character or story-line, he is. He sets the measure that the film has to achieve to gain the hallmark of authenticity. So, within the cinema, enjoy! (That's something the fans are generally good at.) Watch the film for its Dredd-references, smile with secret joy at them. Check out which story-lines they've borrowed. See if they have 'done right' by Dredd. Forgive the bits that are just wrong (Kissing Hershey at the end? Illegal in Megacity One. Happy ending? No such thing in his world ...), as long as enough of the comic has made it into the film. But don't set your hopes too high ...

What is not important? Simply, the blockbuster-isation of Dredd, see it, junk it. It's bound to happen, but can be set aside – unless it really starts interfering ...

The Dredd/Stallone nexus: In the Dredd/Stallone nexus, it's clear. Stallone is tolerated provided some sense of the real Dredd comes through. Dredd is more real than Stallone, and sets the measure for what Stallone needs to be and to do: the voice, the posture, the characterlessness, the chin ...

Cinema vs Video: It's important to see Dredd at the cinema, for the experience of him making it to the mainstream, for that shiver of pleasure when he appears on the big screen. But once seen, if it is worth seeing again, then a video watching will do well, so it can be studied, with a fan's perspective.

Relations to publicity: The danger is knowing too much. This one has to be carefully navigated. The speculations are great, the knowledge of what has actually been done could dent the hopes too soon ...

The newness of the film: The newness of the film consists in the fact that it is a film. Film can 'realise' the drama of the City, but realisation comes expensive compared to a comic, where vast cityscapes, and swooping camerawork cost no more than simple close-ups with no background. So, it's vital to be alive to what Dredd might be in the new medium. We can hope for sequels – never mind, perhaps, that they don't get it fully right this first time, there's always the hope of another, better, more authentic version. If it works, Dredd's on the map, there can be a 'return of Dredd', 'Dredd Forever' – just like *Batman*.

Talk after the film: Talk afterwards ought to be with other fans – knowingly sharing the references, comparing, evaluating, swapping 'quotations'. Gripe about the waste of opportunities (Hollywood can never be expected to see the brilliance of the Angel Gang, for instance, and so threw them too quickly); and so on.

Leisure statements and identities: The circle closes for this SPACE. At the beginning it was depicted as balancing between three elements: rights claimed over the film and asserted on behalf of *2000AD*'s denizens; wish for it to become mainstream; awareness of the inevitability of a 'Hollywood treatment'. Add in the awareness that comic fandom carries an 'anorak' accusation over its head. In this situation, Dredd can't be all-consuming – but it is important. It has a 'call' on them. However unsure they are, this 'space' acknowledges that 'Dredd' is more than a story. It corresponds to something in our wider culture. Megacity One might be our future: Americanisation, totalitarianism, overwhelming policing. The important thing is that we aren't bleak. We know the world is, can be, might become even more, shit. That's why we party now – and we wear our Dredd T-shirts while we do so!

Central criterion: The central criteria are set at the opening: Dredd lives! beware Hollywood-isation! come on you non-Dredd-heads!

Commentary

The *2000AD* readers were among the most willing to be interviewed, perhaps because they feel they have a lot to say, perhaps because they had a sense that for once they would not be mocked and scorned for this love of their comic and its character Dredd. We therefore had a mass of materials from which to construct this model. It was also the case that among them were some of our most single-minded respondents – people unwilling to mix orientations, or to make compromises. This was by no means universally true, and the differences between the uncompromising and the uncompromising were telling.

Clearly, this SPACE can only have existed since 1977, when the comic was born. But that is not enough to explain its nature or its force. We will need to look (in Chapter 9) at the ways in which this kind of readership was nurtured by the comic. It is worth noting, however, that *2000AD*-follower respondents did couple

extensively with another of our SPACEs, below: the Culture-Belongers. This is important, since it will tell us much about the wider meanings and involvements on 'being a reader of *2000AD*'. Being a 'Dredd-head' is an honourable part of some wider areas of our culture.

Since we do not plan to explore this SPACE to any great extent later in the book, we want to note one or two things about it here. These respondents were among our most cynical – almost without exception they commented on, and usually bemoaned, 'Hollywood-isation' as a process that was going to intrude on their character. And what is more, they were acutely aware of this as a political process. This is well-captured here:

> Overall the film captured the city and its life brilliantly. It avoided any contentious issues however – such as there being no work, the Judges are there to oppress and they admit it. Also Stallone referred to 'refugees' trying to get over or through the city wall. The wall is there to keep out 'mutants' – an important difference and a sobering thought in our current society where discrimination on grounds of race, religion, health, physical appearance and so on are commonplace.[6]

What is said here highly articulately is, we believe, also behind the response that received much public mockery: the objections to the film Dredd taking off his helmet. The connection is well-made in the following:

> My first thoughts when I realised Dredd would be taking his helmet off were 'Utter sacrilege, it'll ruin the whole thing'. Thinking about it more dispassionately, that's not really the main problem. Obviously it's a big part of the JD stories, but it's not something that really matters. A bigger problem is Dredd showing emotion, that's something we can do without. I suppose the movie-makers want us to feel for Joe Dredd as a human being, but that's wrong, he's not a human being, He Is The Law. There's plenty of scope for other characters for us to feel for, that's why characters like Walter the Wobot were introduced, and Judge Anderson, altogether more human.[7]

This sense of Dredd as a Machine of Law, who has suspended his humanity, is critical to *2000AD*-followers. It is what allows, then, layers of irony and satire. This is, interestingly, the basis for these respondents being the only people who attend to the film's narrative. For serious Dredd-heads, the film was to be judged for the extent to which it had space for the knowing, layered satire of the comic. This specialised attention to the narrative was the only kind which we found.

So what is a 'Dredd-head'? It is more than a *2000AD*-lover, more than a tee-shirt wearer, more than a comic-collector. We suspect it involves a complicated willingness simultaneously to rebel against what is seen to be an achingly boring, dully repressive culture, but also to acknowledge the power of that culture. Dredd

in his comic-world polices without mercy just the kind of people who most love his comic: the street-wise punks, the loud, anarchic kids who 'fight for the right to party'. To love Dredd the fascist, then, is a complex act made possible, we suspect, by that weird period we know as 'Thatcherism'.

The Film-Follower SPACE

Summary: Only people with a commitment to cinema as medium can really inhabit this SPACE, for it requires a will to experience and then judge each film for its contribution to some aspect of 'cinematic magic'. A film is good, then, if it marks an achievement in some sense. What is allowable, of course, will depend a bit on the range of 'magics' that an individual will allow into his/her catalogue of cinema.

Vocabularies of Involvement and Pleasure: The cinema is a rather special place, with 'magical' properties and with its own traditions and languages which must be learnt and updated. So there are languages of expertise (involving directors, direction styles and techniques, actors and acting), and histories (both general and of a specific film's progress), and a sense of apprenticeship towards these. A new film contributes to the tradition and magic. This is about being 'in the know'; a language of both formal critique (film studies) and anecdote (stories of, in and around the industry). Finally, there is an overarching language of appreciation.

Ideal viewing conditions: Ideally, a film should be viewed in an appropriate setting, and there is no problem with going alone. In fact often this is preferable as it minimises distractions. To a 'serious, art-house' film follower, the Multiplex represents everything that is shallow and crass about films made to make money (versus art). If on the other hand you are interested in all film 'for film's sake', then you can celebrate the 'cinematic event' of an SFX film at the hi-tech multiplex, and equally enjoy the 'obscure' art film at the little, rundown art cinemas. There is a sense of romance about the setting, which is part of the enjoyment of the film. Other audiences are generally intruders in this setting, as they can detract from the intense relationship between the film follower and the screen. An ideal viewing setting allows concentration. A film can be watched on video to try and recapture that intensity and/or as 'catch-up' if you have has missed a film. You can become an 'expert' in discussing a particular film through repeatedly watching it. Film discussions are a large part of the pleasure involved in film viewing, and of being a 'film buff'.

Who are the viewers: Often the 'other', lay-people. As an expert, the film follower can watch a film for the audience reaction, from which s/he is separate. The audience reaction is part of the filmic experience, the film follower being a distanced viewer with 'insider' expertise. Lay-people react to a film, the film follower studies it. Part of what is studied is its very ability to cause such a reaction; you may react at first, and then watch it again to gain this distance and subsequent 'viewing expertise'.

To be ready to be the audience you need... to go knowing about it in the right way, perhaps to 'swot up', to learn about its history (how it was made, what it is

based on, who is in it, who directs, what on-set problems there were, reviews, interviews etc). This knowledge enriches viewing, as scenes can be 'read into'. On first viewing ideally the film should be absorbing, so that it can be 'lived' emotionally first. Later it can be weighed up more intellectually, via subsequent viewings, thus for example picking up intertextual references. The audience need to be able to 'place' the film and its contents in culture, and in film and cinema history. Going to see the film, then, is the high point in a continuum of this type of activity. When, where and how you go is prepared in advance.

Before and after the cinema: Talking about a film involves organising, rehearsing and displaying knowledge. A film is viewed with this in mind, the film follower begins organising and rehearsing as s/he watches, gathering responses and information from the film. An ideal film discussion involves people of similar minds, with whom you can enter into a debate/discussion. As this is a considered response, it need not happen directly afterwards. Usually if you are going to see a film there is little leisure activity (eating, drinking) immediately before or afterwards, as the film is the main event and reason for being there. It is not first and foremost a social event, but a filmic experience – unless of course you go with like-minded appreciative people, so that the post-film critique becomes part of the night out.

Other kinds of films are...: This depends on one's catholicity. Unless you are vehemently opposed to the multiplex film culture of the blockbuster, all kinds of films are interesting as part of the cinematic range and cinematic magic. Those vehemently opposed to 'commercial films' will reject anything Hollywood-ised (although old Hollywood blockbusters can be reclassified as 'classics', taking them back to when such films still 'had magic').

Relation to other parts of their lives: Film-viewing is a self-contained, serious leisure process, a vocation even, where knowledge is constantly sought, acquired, organised. There is no need to apologise for being a film follower, since it evidently deals in structured, proper knowledge. Film is culture, simpliciter.

What is important/not important: Everything is important in that it goes to make up the film: detail is important in terms of 'becoming an expert'. A film can be good in two ways: in terms of its 'place in culture' (eg: controversy, or the talked-about blockbuster) and/or it can be good in terms of how 'enriching' it is, to what extent you could develop/draw upon your acquired knowledge, to what extent that knowledge was challenged/confirmed by the film.

The Dredd/Stallone nexus: The Dredd/Stallone relationship is interesting because of Stallone's film career, his star personality and personal history, because of the film genre Stallone represents (Action) and so on. The film follower needs to learn enough (if s/he doesn't know already) to 'place' Dredd as a popular/specialist cultural form, in order to more fully appreciate the film. Dredd is also interesting, inasmuch as this is an attempt at a new cross-over from comic to film: an addition to a tradition.

Cinema vs Video: All films are ideally seen first at the (most appropriate) cinema, in order to see a film how it was intended to be shown, thus appreciating the magic

168

of the event. The film follower will collect videos, and play them over and over again, as some people play music, to get more insight into the film, to relive it, and to display one's film buffness through the collection. If like-minded friends come over, then they can enjoy cult viewing on video of films unlikely to make it to the big screen (especially controversial films/ or the 'uncut versions' which those 'in the know' will carefully collect).

Relations to Publicity: Publicity is part of the film machinery, so it is important to be aware of it. Reviews are also important as they are others' opinions about the film, but you should be discriminating about who is a good/reliable reviewer, and make up your own mind. Trailers etc can be enjoyed as part of the cinematic event but you should remain distanced from hype.

The newness of the film: A new film enables you to update your knowledge and expertise, and allows you to spot new trends, new developments in cinema and film history, and new trends in culture generally. A film therefore has a 'cutting edge' newness at best.

Talk after the film: Responses are considered, organised, rehearsed and 'displayed' in discussion with like-minded people. Film-followers will debate rather than argue, and could well have established debating 'rules' which are part of their film-viewing activities. Talk is about placing, comparing, linking, having insight.

Leisure statements and identities: Films inform and educate, and enrich knowledge; being a film follower is about aiming for status as an 'expert' in the field: an inevitably on-going process. Also inevitable here is the phrase, a 'bit of a film buff'.

Central Criterion: What new experience can I gain from this film, what can I thus learn about film generally, and cinema via this?

Commentary

As with the Future-Fantastic, we rarely found this orientation in a 'pure' form, though one interviewee in particular did provide crucial clues [Interview 23] – this was a long-standing film fan who had attended film festivals, when he was able, and still maintained a strong overall interest in cinema as a special site of pleasures. But many interviewees' responses contained elements of this model, and they stood apart as a separable interest.

Film following has a long history, with distinct canons and cantons within it. Film fandom began early, and developed its own special publications and ways of talking about films. But fandom was regarded, generally, as of very low status – fans were poor unfortunates, even if their films were, in some respects, admired and loved. It was not until the 1960s, and the rise of serious interest in popular film that this image began to change (and then, only slowly and partially). The rise of film studies as an academic domain contributed much, as did new kinds of film journalism, and a stronger sense of the history of film.[8] Without attempting a proper account of the current state of affairs, it is, we think, clear that film-fascination currently has quite negotiable boundaries. For some, it still equates

with seeking out those films which carry the 'old values' of cinema (strong and interesting central characters, powerful narratives, right solutions and feel-good overall tone), for others it can be an auteur-ish interest (fascination with particular 'high-quality' directors or actors, for instance). But now it can also be indulged in, in a totalising way, with a mobile interest in all the different kinds of film, from the most self-consciously serious to the knowingly trashy. (See below, our final Commentary in this Chapter.)

The Stallone-Follower SPACE

> *Summary: A person choosing to orient to the film via this SPACE wants to see what it adds to Stallone's career, how his 'essential personality' is given form and embodiment in the plot and presentation of this film. Stallone is the ultimate 'survivor'. does he survive this film?*

Vocabularies of Involvement and Pleasure: Stallone is a tough survivor, misunderstood, and often slated, by critics. He stands comparison, indeed must be compared, with other action heroes as to what is appropriate for Stallone? What are his strengths and weaknesses? Stallone as a star.

Ideal viewing conditions: Ideally, the premiere/preview, as the first viewing of a new Stallone film is an event: seeing it is an experience that is 'collected' along with film merchandise and Stallone memorabilia. The experience of seeing a new Stallone movie marks off another significant moment in Stallone's career and in one's involvement as a fan. On video, the film is watched to recapture/celebrate that experience and/or to gain more detailed knowledge of film – either alone or as a shared activity with like-minded others, although those not interested can be dragged along for company. First viewing: to experience the impact; subsequent viewings: to mull over and savour the film.

Who are the viewers? Stallone fans who respect him, knowing his faults and limitations, for what he embodies, and who can act as 'spokespeople' on behalf of Stallone (experts in his career history) and of other followers (he is to be appreciated because...). Those who admire his spectacular body, with envy and/or desire.

To be ready to be the audience you need... knowledge of his films, career and possibly personal life and history; knowing his strengths and weaknesses and what implications that might have. You need the ability to 'place' the film within those histories, and compare it with others. It is appropriate to have intense expectations and anticipation, combined with considered knowledge and opinion gleaned from reviews etc. Stallone fans are generally anti-reviews, as they so frequently 'misunderstand' Stallone as an actor, but hype is still important since it can be sifted through for factual information on the film and on Stallone.

Before and after the cinema: Actually seeing the film is just a high point in a continuum of preparation and expectation, gathering reviews, and sorting one's knowledge. Afterwards opinions can be rehearsed, organised, displayed for discussion. This doesn't have to be done immediately after film since Stallone followers will go on talking about each film as it is 'placed in the canon'.

Other kinds of films are...: Non-Stallone films, which are outside the corpus. Action films are on the edge of this category, as Stallone is partly understood in comparison to other action heroes. If other kinds of film are enjoyed, their enjoyment will simply be on a different basis.

Relation to other parts of their lives: Being a spokesperson for Stallone, having an expert opinion on his progress (like following a particular horse at the races). Is it appropriate for Stallone at this time, at this point in his career etc? This all constitutes serious leisure time: collecting, becoming more knowledgable, constantly 'keeping up' with Stallone, being changed by the experience of becoming a Stallone fan (retelling 'how we first met'). Being Stallone's analyst: what are his motivations, problems?

What is important in a film? Whether or not the film is an appropriate vehicle for Stallone, will help Stallone's career: does the film 'suit' him, are the elements within it 'suitable'? Does it provide opportunities for him to reveal the 'true Stallone'? What is not important are the other characters, apart from their roles as 'foil' to Stallone.

What is not important in a film? Effects are interesting in their own right, but they are add-ons.

The Stallone/Dredd nexus: Is Dredd right for Stallone – in terms both of the character and plot, and of the film's implications for Stallone's future career?

Cinema vs Video: Cinema first, for the event, then the video is 'collected' and reviewed, to relive the viewing experience, to further one's expertise, to add to the collection.

Relations to publicity: Watchful, suspicious of misunderstandings of Stallone by highbrow critics. How is Stallone coming across?

The newness of the film? The film adds to the accumulation of Stallone films, it takes his career in a new direction – ideally not downwards! – potential for new sequels, new dimensions to the public's understanding and awareness of Stallone as a star. Film viewing is a new experience to collect, new merchandise, histories, video to own.

Talk after the film: Talk at best occurs with like-minded people, who do not dismiss Stallone as do 'outsiders' who don't understand him. Talk doesn't necessarily have to happen afterwards, it can be part of a long-running debate, or generate a debate that happens long after viewing. Opinions are rehearsed etc whilst watching with these discussions in mind. Such talk is 'expert' – specific to Stallone fans, with 'insider' references. They talk in order to place film in the canon.

Leisure statements and identities: Part of a personal commitment – 'we don't want to let Stallone down' so they will view whatever he is in, even if it does not look enjoyable.

This is a self denying kind of duty, like turning up to doomed football matches with faint hope, as you have to support Stallone's stardom, and also to keep up with his career.

Central criterion: How and where is Stallone going with this?

Commentary

In many respects this model was too easy to construct. Although there were elements of Stallone-awareness in many boys' responses, we could not ignore one extraordinary interview with a man who had been, for some time, organiser of an unofficial Stallone fan network. This interview [22] was several times longer than any other (discounting our multiple interviews at the United Kingdom Comic Art Convention, which included 15 people). It has one of the lowest interviewer-indices, but that in some ways understates its unusualness. More than one page of the transcript is entirely a monologue; the interview was like a tap turned on, as though our talking to him was his first real chance ever to talk at length about his fascination.

Richard came first as part of a research-assembled group-interview [Interview 10], for which he arrived early. Kate Brooks who conducted this interview was interested by their unrecorded conversations in advance; but when the group-interview began, he became virtually silent. Sensing that something in the situation had shut him up, we decided to invite him back. The rest, as they say, is his story. Richard spoke for himself, but also for a wider constituency of fans like himself. In a sense, it wouldn't be inappropriate to say that he himself acted as an unofficial researcher and recorder of other fans' interests, and with a very tolerant attitude to differences among them. So although we did not ourselves get to interview any female fans of Stallone – a major gap, in our estimation – we can sense some of their interests through Richard's observations.

Nevertheless, we have to acknowledge that the base of information for constructing this model is narrower than we would like. But the principles at work have been found in other cases of fan-admiration, for example in a fine study of followers of Ingrid Bergman which 'found that her image only reflected a few of the roles she had played, inconsistent characterisations being written out'.[9] This commitment to the consistency of a star's career is something that warrants further investigation. Here, briefly, is a taster of Richard's 'feel' for Stallone:

Richard: With the review side of it, he [Stallone] has always received a very negative press ... He has become a very easy target ... some critics are constantly taking cheap shots at him. ... A lot of his fans, a lot of his real fans, think that he's very underrated, cos, not especially as an actor in a way, I mean I think he's got a very limited range. ... His talent, and obviously he's recognised this now, is in action films. Because, you know, he's just absolutely perfect I think in that type of role ... in the right role I still think he's the best. [Interview 22]

The Culture-Belonging SPACE

Summary: Anyone choosing to orient to the film via this SPACE is doing so because the film is perceived as potentially relevant to the ways his or her culture-group(s) conceive themselves, conduct their internal life and maintain themselves as a group. Therefore the film is significant primarily in as much as it can contribute to the person feeling 'in' in his or her group.

Vocabularies of Involvement and Pleasure: Fundamentally a self-aware, knowing language, from: up-to-the-minute, participant, very social slang, displaying confidence with the individual's status in the group, to self-conscious regulating of oneself, often referring to 'you' instead of 'I'. Continual reference to the group's criteria: either checking with a real group that what you say is OK; or calling up the imaginary group (the 'in crowd'). These are the ones implicitly referenced in the expression: 'I know it's sad but...'.

Ideal viewing conditions: A film must be viewed with other people, or at worst with others 'imaginatively present', for talking with about it afterwards. Cinemas are chosen with knowledge of what each cinema 'means' in terms of a culture statement. The cinema has to be right for both the group and the film; all are part of the cinematic experience. Viewing can be part of the event (viewing in relevant fancy dress, for example). This is also true of video watching, where setting up group viewing conditions can be all-important.

Who are the viewers? 'Idiots like us': that is, participant 'gang' humour is very much part of defining who the 'audience' is, and this is a very self-conscious process. Watching a film is part of group dynamics. But at the same time, knowing yourself also means knowing how outsiders will view you, and define you. Being a good viewer means 'entering into the game' and knowing the rules of the cinema-going experience.

To be ready to be the audience you need... generic knowledge. This gives you the appropriate cultural mapping of a film in relation to other cultural forms: fashions, music, stars etc. These are likely to be the reference points and uses in your culture. Practice in 'culture spotting' is also part of being ready: preparing to pick out elements (catch-phrases, incidents, intertextual references) to use in social interaction, to confirm your belonging and your status in your real and 'imaginary' group.

Before and after the cinema: In a way the cinematic experience never begins and ends, it's a continuous process of belonging, gathering up appropriate materials as cultural 'coinage', and making the appropriate knowing use of them. Your 'imaginary' and your real social group both affect how you choose the cinema, the time of going, how all decisions are made (who gets and doesn't get to choose the film, whether or not you'll 'look sad'). So general talk and use of references in conversation will go on not just immediately after the film but as an on-going part of group talk, for as long as the 'coinage' is valid.

Other kinds of films are...: There are films which are 'should-see' (often, 'message' films) and there are 'boring' films. Boring films don't 'give' you anything in terms of new material (catch-phrases etc). Some films are respected, such as *Schindler's List*. These will be treated differently from other films; but if possible they will still be used as a way of confirming your belonging or status. They become instead a shared, serious group event or a serious topic for discussion. The only way to see boring films is ironically, making the mockery a source of group-identification. 'Should-see' films are watched 'dutifully' or otherwise avoided as dull, and worthy: feeling like you 'should' see a film, feeling that the moral majority think seeing this film is a

worthwhile act, is a bit too much like doing what you're told – and by implication, boring. No film is ever not mapped: to take something very seriously, even a film like *Schindler's List*, can *in extremis* mean you run the risk of looking 'sad'.

Relation to other parts of their lives: There are relations of knowingness and belongingness. Films are part of the process of constantly placing and mapping culture, of ensuring belonging and status within your group, gleaned via contact with appropriate magazines, TV etc. Film has no independent status, it is entirely tied in with other social leisure activities.

What is important in a film? A good film is one that invites talk, whether serious discussion and opinions or shared catch-phrases, mappings, references, and which reinforces group dynamics by providing shared experiences or new languages for sharing (anecdotes, catch-phrases, and the like). The pleasure comes from picking up on these and then in recounting, relaying, and using elements. A 'good' film has such useful elements that can be displayed as evidence for being in the know. There are shared pleasures in passing judgement on a film. For ironic knowing outsiders, there is a distinct pleasure in the film that's 'so bad it's good', knowingly reversing the acceptable modes of film judgement.

What is not important in a film? 'Quality' by any other measure. Indeed films which aim for this criterion are likely to be the 'boring' ones which do not invite talk, hence don't count.

The Dredd/Stallone nexus: Being knowing is important again here; to know the details and history of the relationship, to 'place' exactly why and where these two characters cross: to live on the '/' between them.

Cinema vs Video: Both can and should be group, filmic events and experiences. The problem with cinema is that it isn't driven by 'cult' interests, therefore video may be necessary for shared cult video viewings. Seeing it at the cinema, while it is 'out there' in the public domain, is obviously the ideal. If a film is missed by a member of a group, it is usually acceptable to practice 'keeping up' by viewing alone on video. Videos can also be collected, and viewed to pick up more detail, and to remind yourself what was 'good' about them.

Relations to publicity: Publicity is just the normal operation of circulation in the whole of society of useable cultural knowledge. What else? It all helps to one keep up, and is definitely worth investing in. People in this group are very likely to buy magazines that tell them what's in magazines. They will read reviews by favoured, 'knowing' people. All gives useful knowledge.

The newness of the film: It's new if it adds to your 'repertoire', if it has new elements for exchange, discussion and status.

Talk after the film: Talk should be part of group viewing; you are always viewing with the 'group' in mind. Negotiating with group as to where film should be placed and/or sorting out your opinion is appropriate behaviour. Often this is explicitly done by checking and acknowledging where you are placed within the 'imaginary' ('in') group ('I know it's sad to like this but ...'). There can even be talk during a film: using the film as a backdrop for jokey group interaction. This is even more likely during video.

174

Leisure statements and identities: Film-watching is part of a process of collecting and labelling cultural forms, being a proper member of your group. Film is part of a process of 'dealing with' cultural forms in order to define yourself (in relation to your 'imaginary' group, being 'the kind of person who..', 'not a Watershed type of ...').

Central Criterion: Will this keep me in touch with things? How should I 'place' it, what shall I say about this film, and what will this say about me?

Commentary

This SPACE was acknowledged, at some level, by just about every single interviewee. Some blissfully participated in it – this was the point of the whole exercise of cinema-going. Others mixed it in with being a *2000AD*-Follower (seeing Dredd come alive is better in good company – but especially if we're expecting to be disappointed), or with Action-Adventure (it's great to hear everyone round you screaming and jumping, 'cos it makes you join in more!), and so on. Other more dedicated viewers recognised this as other people's way of watching. And the film-refusers looked on in horror at this 'culture', and despaired. The people for whom this was hardest were the dedicated Dredd-heads, who knew that no matter who they went with, they would be adjudged 'sad'.

'Sad', as we showed in Chapter 3, is a word rich in associations. It is a form of cultural juvenileness. It involves taking life, and culture, too seriously. It's being a nerd, an anorak. It's being alone. It strikes us as interesting that there is no word expressing reverse meaning: the state of being un-sad. Even to acknowledge the possibility is a sign of weakness, to be ironised away as quickly as possible. There is a proper attitude to things such as films like *Dredd*. The flip-side of 'sad' is collective knowing love of 'trash'. What is 'trash' culture? Trash culture is junk, and knows and revels in it. It delights in cocking a snook at proprieties. It is anti-official culture, and anti-politically correct culture. Trash culture is knowing about the world, but always with an ironic tone. To take part properly, you have to have 'the knowledge' – able to talk in an uptodate way, with the right expressions, the right references and the right in-jokes. Trash culture is seriously anti-serious. It is the 'visitors' response' to a culture they feel superior to, but love.[10] Properly to understand 'trash culture' is a potentially huge topic, and we won't attempt it here. But to do so will clearly involve some application of Bourdieu's ideas of taste-classes, but adjusted to give this a greater historicity. As Petersen and Kern has suggested, there is reason to believe that Bourdieu's picture of the features of 'high' culture may be changing quite radically.[11] The emergence of a 'love of trash' may be one sign of those changes.

These six SPACES cover, we believe, all the elements of orientations we have found in our transcripts. That, of course, is a claim that can only be tested by close examination and analysis of them. Table 2 summarises their main features, along with a seventh (the Film-Refuser SPACE) which we investigate in Chapter 12. Only rarely, if ever, does an individual only evince one of these model positions – but in their talk they do, over and again, show their acknowledgement of the existence of these SPACES. We certainly do not wish to say that there cannot be

Table 2: A summary of the seven SPACES,

SUMMARY OF "SPACES"	Action adventure	Future fantastic	2000AD follower	Film follower	Stallone follower	Culture-belonging	Film refusers
Vocabularies of pleasure	Pace, rhythm, danger, survival, drama	FX: their scale, their sensory pleasures	Is it appropriate/ adequate to the comic?	A contribution to the tradition, to the 'magic' of cinema	Words from his 'tough survivor' image	Sources for talk, group reference-points	Not our kind of film, disturbing
Ideal viewing conditions?	Uncontrolled, a group indulgence	A properly equipped modern cinema	ASAP, able to concentrate on the film	The right environment for each kind of film	ASAP once for experience then for evaluation	In a group, to provide 'shared experiences'	Safer kinds of cinema
Who are the viewers?	Young people, 'male', free from authority	Technology fans, who like being 'done to'	Fans, but also offering it to the 'mass audience'	Knowledgeable, apart from other viewers	Spokespeople for Stallone, different, appreciative	Non-sad people, 'idiots like us'	Worrying young uncontrolled males
To be the audience, you need...	...to know the formula, and let yourself go	...to be prepared to be bowled over	...to recognise the themes, get the references	...to weigh it up, after 'living' it	...to appreciate his strengths and weaknesses	...to know where it's 'placed' in your culture	...who knows? It's beyond our ken
Before and after the cinema...	It's and event in itself, in the present tense	Warming up, then reliving it after	An end to 18 years waiting! ...but was it worth it?	Reading up beforehand, checking your awareness of film	Preparing to place it in the Stallone canon	Talk, Talk, and more jokey talk	Be sure it is 'right' for you, friends, family etc
Other kinds of film are...	Girlie, family, comedy, etc	Plot or relationship driven (vs loose-yourself)	whatever... but just not Dredd...	All kinds are valid (unless you are an 'arthouse fan')	different: other stars, their different qualities	Worthy, serious, engrossing, proper	Enjoyable, family, real entertainment
Relation to other part of their lives	Release from 'adult' constraints	Should be a self-sufficient fantasy	Dredd is 'hip' to be his fan is special/ Superior	Film-following is a serious vocation	Stallone following is a serious vocation of advocacy	Film belongs with all other group-leisure activities	Need to protect values against danger
What's important in a film?	Should be a roller-coaster, present tense	Distance from 'ordinary' life	The references we alone can get, seeing the comic fulfilled	Detail - it enriches through recognition	Does the 'real' Stallone show through?	Its capacity to stimulate group-talk	Conflict, violence, anti-heros

and their viewing strategies (For the seventh SPACE, see Chapter 12)

What's unimportant in a film?	Relationships (they slow the plot)	Relationships (they slow the plot)	Predictable Hollywood Blockbuster cliches	Hype (we make up our own minds)	Other characters (except as foils)	Everything is relevant except what is 'boring'	Shallow effects (they distract from plot)
The Dredd/Stallone nexus	Do they make an adequate 'action hero'?	Do they make an imposing enough, new enough hero?	Is Stallone adequate to Dredd?	Testing our understanding of stars' potentials	Is Stallone adequate to Stallone's persona/ career?	Be knowing, live on the 'r'.	Both are typical crude characters/ stereotypes
Cinema vs video?	Where can they get most control?	Where is best for FX?	Cinema, to see it achieved, then video for study	Cinema for the magic, video for catching up	Cinema first for experience, then video for study	Video's for on your own (except cult re-viewing)	Cinema is nice but can be 'risky'
Relations to publicity?	Does it live up to the hype?	Evidence of being uptodate	Distrusting/ hopeful - avoiding too much contact	Publicity is just part of the machinery of films	Watchful - is Stallone coming over effectively?	Keeping in touch with what's 'in'	Publicity = news about an alien world
The 'newness' of the film	Old plot, new risk, new challenge	Novelty, celebration of technology, sense of 'futures'	Dredd makes it to the mainstream!	Renewing the magic of the screen	Each film is an opportunity for SS, and for you to follow him	Staying in tune with your culture, having opinions	Represents worrying tendency in our society
Talk after the film....	Reliving, then proving your status, later	Celebrating all that 'newness'	Was Dredd done right by?	Placing, comparing, getting insights	Later, if at all, only really with other Stallone fans	ASAP, even during the film. Jokey talk.	If seen, measure to see how bad things are getting
Leisure-statements and -identities	Performing your gender/ freedom	How much did it cost? What FX have they achieved?	To take or not to take your 'Dredd-head'	Proving your expertise in a leisure form	A duty as well as leisure; seeing even films you don't enjoy	Reassertion of group-membership / values	None - this doesn't belong to us
Central critical criterion is....	Is it white-knuckle enough?	Is it epic and bleak enough	Is this the real authentic Dredd?	What will this add to the world of films?	Where does this take Stallone?	Will this keep me 'in touch' with things?	How bad is it? How bad are things getting?

other orientations, other SPACES. In fact, the whole point is that these SPACES can, do and must change as historical conditions change. And each of these SPACES will, over time, adjust inside itself, in its particular requirements, expectations and operations.

In accordance with our own methodological prescription, we now have to test our detailed picture of these SPACES by looking at the formative histories of recent cinema in all its aspects, and at the nature of our film itself, *Judge Dredd*.

1 Arguably, Rob's response also hints at the next SPACE, with his emphasis on how the film looks, and on the kinds of novelty it offered. We will argue in Chapter 12 why this is perhaps the most important cross-over.

2 Mikhail Bakhtin, *Rabelais and his World,* Indiana Univerisity Press 1984; Christopher Hill, *The World Turned Upside Down: Radical Ideas during the English Revolution*, Harmondsworth: Penguin 1991; and Chris Jenks, *Visual Culture*, London: Routledge 1995, pp.218-37. See also Robert Stam, *Subversive Pleasures: Bakhtin, Cultural Criticism and Film*, Baltimore: Johns Hopkins University Press 1989.

3 See, for instance, Tom Gunning, 'An aesthetic of astonishment: early film and the (in)credulous spectator', in Linda Williams (ed), *Viewing Positions: Ways of Seeing Films*, Rutgers University Press 1995.

4 And with notable success: '[T]he number of science fiction or space epics have increased with the evolution of sophisticated special effects techniques. Indeed, seven of the top ten hits of the eighties were "effects" movies' (Janet Wasko, *Hollywood in the Age of Information*, Austin: University of Texas Press 1995, p.38).

5 For some of the range of views, see Max Heirich, 'Cultural breakthroughs', in Richard A Petersen, *The Production of Culture*, London: Sage 1976, pp.23-40 (who attempts a sociological explanation of bleak futurology in terms of dispersal of 1960s intellectuals); Diana Crane, *The Production of Culture: Media and the Urban Arts*, London: Sage 1992 (who investigates the shift from optimistic 1970s SF to the 1980s pessimistic version); Kaja Silverman, 'Back to the future', *Camera Obscura*, Vol.27, 1992, pp.109-32 (who develops the feminist critique of a blurring boundary between human and machine in contemporary culture); and H Bruce Franklin, 'Future imperfect', *American Film*, vol 8, No.5, 1983 (who worries about these films as 'nightmare visions').

6 This response is taken from a letter sent in by Darian (Interview 12) who had to tell us that a change in his work-situation would prevent him coming to a post-film discussion.

7 This again came in a long letter from someone whom we had recontacted from the previous research into *2000AD* audiences (Paul, *Letter to the authors*, 17 July 1995).

8 There are many accounts of the rise of academic studies of film. A useful introductory set of essays can be found in Joanne Hollows & Mark Jancovich (eds), *Approaches to Popular Film*, Manchester: Manchester University Press 1995.

9 Barry King, 'Stardom as an occupation', in Paul Kerr (ed), *The Hollywood Film Industry*, London: Routledge 1986, pp.155-84.. The reference is to James Damico, 'Ingrid from Lorraine to Stromboli', *Journal of Popular Film*, Vol.4, No.1, 1975.

10 A superb essay by Jeffrey Sconce examines the rise of a 'trash academy'. Sconce explores the conditions for this development of subject matter previously scorned as below attention, and at ways of attending to it which participate in its attitudes. See his '"Trashing" the academy: taste, excess, and an emerging politics of cinematic style', *Screen*, Vol.36, No.4, 1995, pp.371-93.

11 Richard A Petersen & Roger M Kern, 'Changing highbrow taste: from snob to omnivore', *American Sociological Review*, Vol.61, 1996, pp.900-7.

8
GLOBAL AND LOCAL HISTORIES

Before we can deal with *Judge Dredd* itself, we need to look at the forces operating generally, which surrounded and pervaded how it was made, and the contexts in which it was received. And the first thing to note is how far *Judge Dredd: the Movie* was a product of 'the new Hollywood'. This expression has been used by a number of film historians to summarise a series of developments which have transformed how films are made and distributed[1]. Many, but not all, of these changes date from the early 1970s. The releases of *Jaws* (1974) and *Star Wars* (1977) are seen as emblems of these changes. Our interest in all this is in the end in how audiences were affected. According to one kind of response, the measure we should use is simply popularity. Tino Balio, an outstanding historian of Hollywood, has fallen into just this trap. In a recent essay, he casually closes his account of the main changes with the remark that overall they have clearly been 'for the good of the punters'[2]. To work out just how wrong-headed this is, we start by listing below, with brief commentaries, the main changes.

The producers ...

Every major American film studio has changed hands in the past 25 years. That's not new in itself – between 1959-71 virtually the same had already happened. But the purposes of the take-overs were markedly different. The earlier take-overs seem to have been motivated by a combination of diversification of output, with taking on the public prestige that was seen to go with a studio. Such were the purchases of Paramount by Gulf & Western in 1966, of United Artists by Transamerica in 1967, and of Warners by Kenny National Services in 1971. The 'second wave' consolidated films as part of multinational leisure conglomerates. For example, Rupert Murdoch's News International acquired Twentieth Century Fox in 1985, Warner merged with Time in 1986, and Sony bought Columbia in 1989. From here on, films were to play their part within packages of related products. Typically, each of these companies will have interests in television production and distribution, book publishing, magazines and newspapers, music, video and video games, a software house, and at least one area of leisure hardware production.[3] This last is very important: Sony learnt the hard way from their mistake with their superior video format Betamax, which lost out to VHS because the latter was able to offer a much wider library of films. Hardware and software are being relinked.

The studios' retreat from film production created spaces for independents, whose lives have been far less secure. Sometimes genuinely independent, at other times

in fact owned subsidiaries of the majors, the Independents have any way usually depended on the majors for publicity and distribution systems. Companies such as Carolco, Morgan Creek, Castle Rock have been dubbed 'dependent independents' because of their integration into the Hollywood financial and distribution systems. Their problem has increasingly been one of capitalisation. In 1995 Carolco ceased film-making. In an editorial on the plight of the 'indies', *Screen International* opined: 'The real irony is not that Carolco has been swallowed up by a Hollywood studio, but that the fiercely independent company had unwittingly re-created the Hollywood system. Having invented Arnold Schwarzenegger and re-invented Sylvester Stallone and Sharon Stone, Carolco has propelled Hollywood's salaries and film budgets into the stratosphere. And the independent distributors – having unlocked the international markets – have now unleashed the studios against them.'[4] Simply, the scale of capital investment needed to maintain production is constantly out-stripping any other than the seven major studios.

Rise of the agents ...

'The growth of independent production also increased the importance of agents.'[5] Agents became increasingly the nexus around which film projects were developed. They put together packages of director, stars, financing, distribution arrangements, and filmic idea. Very quickly, powerful companies emerged to regularise this. First was the Music Corporation of America (MCA) who in the late 1950s expanded their operations, and began to buy into Universal Studios. Two other majors, Creative Artists Agency and International Creative Management, emerged: 'by the 1980s, Michael Ovitz, president of CAA, was being talked about as the single most influential person in Hollywood'.[6]

This has become particularly significant when associated with the rise of the Blockbuster syndrome (discussed below). There has arisen a search for the 'big concept', and all forms of popular culture are increasingly combed for the killer-concept which has the potential to transfer to the multi-media world that is now film. The case in point has to be *Teenage Mutant Ninja Turtles* (1990) which originated as a satirical underground comic, but made it big in the cinema after undergoing a series of narrative and other transmutations.

Stars ...

The break-up of the old studio system meant the end of the tied-cottage system whereby stars were effectively owned by their employers. In a fascinating essay comparing Clark Gable and Burt Lancaster, Barry King has argued that this introduced a system whereby stars had to take responsibility for their own image. He argues that this impacts on all aspects of stars' public personae, from their choice of films and even to their acting styles.[7] But while stars became far more independent after 1950, they soon became even more important to the studios. As the financial risks rose, so the companies had to ensure 'bankability', especially in their larger films. Star costs rose, as they were able to negotiate contracts for each individual film. Schatz cites as a turning point Sylvester Stallone's US $15 million paycheck in 1983 for *Rocky IV*:

Not surprisingly, the studios bemoan their dwindling profit margins due to increased talent costs while top talent demands- and often get – 'participation' deals on potential blockbusters. CAA's package for *Hook* gave Dustin Hoffman, Robin Williams, and Steven Spielberg a reported 40 per cent of the box-office take, and Jack Nicholson's escalating 15 to 20 per cent of the gross on *Batman* paid him upwards of US $50 million.[8]

But the other price of this increased dependence on artists and their agents was the terms of the contract. Films had to take account of the representational needs of the stars they recruited to make themselves bankable.[9]

Film production ...

In the 1930s, the major studios between them produced around 300 films each year, with some inevitable fluctuations according to local conditions. By the 1950s this had fallen to around 200. By the 1970s the number of annual releases had fallen again to around 120 – but the scale of investment per film had risen dramatically. It is easy to overstate the significance of this fall, since the studios after the 1950s had switched a proportion of their facilities to producing for television. But the significance in terms of ensuring a return on capital investment is still great.

One of the associated changes has been a restructuring of the kinds of film produced. In the 1930s, studios turned out roughly one 'A' film, with a budget running up towards a million dollars, for every 6 'B' films, whose budgets could be as low a US $40,000. 'B' features also took about a quarter of the time to make of an 'A' film. By the 1980s, a different division of production had emerged, with the major studios feeling pressure to produce one or two 'blockbusters' each year, whose budgets were like pockets with holes, along with a number of mid-range features, and some budget films. The problem was that they were increasingly unsure which constituted the safest investment:

> Several studio heads began to imply in 1991 that a few high-budget movies and many more lower-budget ones would become the rule, with middling budgets most likely to be cut. ... Most likely to suffer, then, would be movies with budgets in the middle range (US $25-30 million) and talent which, though expensive, was unable to guarantee profits. *Variety* quoted a senior production executive at Sony: 'No way I'm falling into the mid-range trap. It'll be big event pictures and maybe an occasional low-budget project with non-stars and first-time-out directors. Nothing in the middle'.[10]

Three things should be particularly noted here: first, the systemic planning – it is not individual films which are budgeted for, but the full year's diet; second, this is done on the back of powerful information tools, predicting what might work; but third, all this is done in an awareness of risk – though as Hillier adds, it looks like the Executive got it wrong, for the big earners that year were mid-range films such as *Silence of the Lambs*.

One paradoxical consequence is that in some ways the safest movies have become the most expensive. Björkegren cites one knowledgeable author taking the

temperature of Hollywood at the turn of this decade: "'It's less scary to make a 50-million dollar film than a 10-million dollar film. For 50 million dollars you can afford big stars and special effects and you know you'll get some money back ... With a 10-million dollar film with no stars, you run the risk of losing it all".'[11]

Merchandising and commercial opportunities ...

Janet Wasko gives a brilliant account of the rise and increasing importance of various kinds of commercial funding of films. Product placement has deepened the studios' relationships with a range of other industries, notably leisure industries such as clothing, cars and fast food. At the same time, in ways still to be fully researched, it has affected film production itself. There are many anecdotes about script revisions being occasioned by the need to give prominence to products. Product tie-ins now see big-budget films typically launched in association with other products. On some occasions there is reason to suppose that the other products benefit more than the film. Wasko gives one telling example of this: 'Although *Willow* did not materialise into the anticipated box office smash, Quaker exceeded its promotion objectives by 50 per cent'.[12] Just as important in understanding the new Hollywood is the emergence of specialist firms and publications devoted simply to servicing these relationships between the studios and other commercial companies, and the regular conducting of research to find out the most effective forms of placement and tie-ins.[13] And in recent years, these commercial links have been clearly associated with the re-emergence to prominence of product-branding, as major companies such as Coca-Cola, McDonalds, Microsoft and Intel have shifted their strategies to consolidating their 'names', above all else.[14]

Perhaps most importantly, merchandising associated with a film can now constitute the difference between financial success and failure. *Jurassic Park* released more than 1,000 merchandised items – and displayed them in the film itself, in long shots of the Park's shopping area. *Star Wars* has earned substantially more, over time, from continuing merchandising, than it has from box office returns.

Video ...

Hollywood accommodated to the rise of video very quickly. After a few years' panic that this was going to do to cinema attendance what television had mythically done, video was soon seen as a further opportunity, and indeed as an independent source of benefits.[15] The growth of the home video market was remarkable. By 1986, rental alone in Britain was worth £367 million, peaking in 1989 at £569 million. A slow decline thereafter was 'blamed' on the growth of cable and satellite, but in 1995 video began to rise again, with 194 million video rentals. Over the same period, however, video sales rose without pause, from 6 million units in 1986 to 73 million units in 1995. The value of these amounted in 1995 to £789 million.[16] As a major player, video was thoroughly established.

One important effect of the arrival of video was that cinemas no longer primarily competed among themselves, or with television as an alternative attraction. Now,

film-at-the-cinema had to be something worth seeing soon a higher price rather than waiting six months, and seeing it on the small screen. The problem for the makers is that, with a few exceptions (and Disney seems to own most of these), films do best on video that have done well at the cinema.

Hollywood and the world ...

The Hollywood Studios had long regarded European markets as important, but that importance changed over time. Few films were produced outside America, apart from necessary (and expensive) special location filming. In the late 1960s this changed for a while as tax problems in the USA combined with tax opportunities in Europe encouraged filming abroad. These advantages diminished by the mid-1970s, but the companies were alerted to seek specific opportunities abroad.

There were also shifts in balances of earnings. In the 1930s, foreign earnings were an important addition, but over 60 per cent of studio earnings typically came from inside America. By the mid-1980s in some cases foreign earnings were topping domestic returns.[17] What is new in the equation is the emergence of the Japanese market which, according to Hillier, by the 1990s was 'the biggest single national market for American movies'.[18]

The Rise of the Multiplex ...

Between 1950 and 1980 the number of cinemas in Britain declined from over 4,500 to just over 1,500, and was continuing to decline in the early 1980s. Only the arrival of the multiplex after 1985 began to turn the tide. The first to open was a 10-screen, 2,000-seater in Milton Keynes, a joint operation between Bass Leisure and American Multi-Cinema. Without question, the rise of the multiplex has transformed local patterns of cinema-going. Imported from America, this new style changed the architecture of cinemas. They were functional and modern, and their luxury consisted in carefully raked and soft seating, and heavy investment in sound technologies. Picking up on the upturn in cinema audiences after 1984, the boom in multiplex building has shifted the location of cinemas generally to much closer to the new shopping complexes, and to other leisure opportunities. The Bristol multiplex, which opened in 1994, is atypical in not being near a shopping complex, but is typical in its close association with a bowling rink, a fast-food pizza outlet, and a leisure shoe shop. Between 1984-94, the per centage of screens in Britain found in multiplexes rose from 1 per cent to 36 per cent. This wasn't just new openings, it was also the consequential closures of many older cinemas. UCI, one of the biggest multiplex builders, in eight years expanded from (1986) one site with ten screens and just over a million admissions to (1994) 24 sites with 225 screens and over 25 million admissions.[19] And the new cinemas had a completely look and offered a different experience from the old cinemas, which had been designed as 'cathedrals'[20] for films.

A less noticed phenomenon has been the effective reversing of the 1949 Paramount Decision, which forced the major studios to sell off their cinema chains. This requirement by the US Justice Department, ostensibly on anti-monopoly grounds, has never to our knowledge been fully explored or explained. It certainly provoked

wholesale changes in patterns of production and distribution, since the studios could no longer guarantee that their films would be screened as and when they chose. Generally, it loosened the link between production and distribution. But by the 1980s, as much by silent compliance as by open reversal, the studios were able to buy back into cinema ownership. Often this was through new investment in multiplexes. In 1995, for example, Time-Warner announced an investment of £140 million to build 20 new multiplexes in the UK. As Curran notes, one effect has been to squeeze independent films, as most multiplexes concentrated on the latest major releases.[21]

Audiences ...

Between 1950 to 1984, British cinema audiences fell from 1,400 million to 54 million. Only after 1984 did they show a significant rise, although by 1994 they had topped 124 million. But during the bad days box office takings had not fallen in the same way. By dint of rising admission charges, takings had actually risen from just over £100 million in 1950 to around £130 million in 1980 (not allowing for inflation). This has meant that cinema has passed much more into a 'luxury' activity – a development assisted by the emergence of video rentals from the early 1980s, which offers a cheap fall-back for many not able to afford cinema seats.

Hollywood has had to try to know its audiences better. This means, for instance, paying close attention to test screening results – even if their worth is unclear.[22] It meant paying more and closer attention to what market research generally might tell them – and one of the first findings was that audiences were diverse. Response: include elements that can attract more than audience.[23] It means paying increasing attention to time of year:

> [T]here has for some time been a strong seasonal weighting in cinema attendance. As the majors know, the peak periods fall in the Christmas and summer holidays, with the Easter break a little less busy. But if these are potentially the best weeks for the cinema, they are also the most unpredictable because they depend on the irregular audience. The difference between a good and a poor year for the cinema largely turns on the handful of big movies that attract the greater part of that irregular audience – those who go to the cinema between one and three times a year.[24]

The implications of this, if you think about it, are pretty staggering. It means that every studio has to aim to launch their required blockbuster at the same time. It means mass marketing to bring out the uncommitted viewers. It means being able to reach them despite their differences. It means acute strategies for managing and minimising risk. This is the reason for the increasing role given to marketing. Marketing is more than publicity, it is the tailoring of a film, from before the script stage, so that it can reach its targeted audience(s). Marketing took off after Paramount's success with *The Godfather* (1971). It depends on three things: first, preparing the film's concept appropriately; then, ensuring that the film embodies that concept adequately; finally, spending sufficiently to ensure that the potential audience knows full well that 'this film is for them'. The third component has since

the mid-1980s become so important that companies frequently budget and spend more on promotion than they do on the film itself.

The New Hollywood meets its audiences

What are the implications of this complicated story? And in particular, what are the implications for our picture of the audiences for a film like *Judge Dredd*? The core has to be the emergence of the 'Blockbuster' as a specific phenomenon. Blockbusters are a 'must' for the major companies. They are the ground in which they can fertilise media cross-overs, crazes and merchandising launches. They are the 'must-see' movies around which mass publicity can be organised. They are the centre of the system that is contemporary Hollywood.

The term 'blockbuster' is importantly an industry term whose use carries meanings and expectations. Films are produced to fill such a slot. In each year, some will try. The word, from its wartime origins to describe highly penetrating bombs or shells, has become diffuse and generalised, able to depict not only films but such things as powerful drugs. But its prime meaning without doubt now connects with media productions. In short order, we would characterise its associations in this Table:

BLOCKBUSTERS are ...

- events, phenomena, spectacular experiences
- released into as many cinemas as possible at launch
- multimedia events, but these circulate around a film
- designed to be 'for everyone', and universal in their appeal
- undemanding, even in some ways 'child-like'
- in competition with each other
- feel-good but at the same time cynical about themselves
- honestly 'commercial' about their wish and intention to make money
- close to a recognisable 'reality', but without any social or political implications
- not about stars – the 'effects' are the stars
- new: revisiting old ones is a quite different experience
- have some distinguishing feature, something not done or achieved before
- hyped, everywhere, 'must see' or they don't exist
- yet at the same time evanescent, and leave few traces
- set standards only to invite being overtaken
- expensive, and publicise and celebrate their costs

These are all claims. 'Blockbuster' is a status to be achieved, through self-publicity. And therein hangs the risk. The wrong amount or kind of publicity can

be harmful to a film bidding for this status. And everything about the process is designed to affect how people will know about, and watch, the film.

To go and see an intending 'blockbuster', then, is to see a film that has asked us to watch it for particular qualities, to expect particular things of it. Audiences will only manage to avoid responding to the publicity agenda if they have another already-existing set of reasons for seeing the film differently. Without that, the film puts itself in front of them with a series of demands to be seen and assessed in specified ways. Among these will be: what special qualities does it claim for itself? How is it 'different' from the tradition of blockbusters before, and from its contemporary competitors?

And of course the rise of the Blockbuster, because of its emphasis on the 'must-see' qualities of such films, is associated with two other powerfully determining processes: the drive to create 'scuttlebutt' around a film;[25] and the determination of success or failure after the first weekend of a launch.

One way in which blockbusters can ensure their 'newness' and 'event-ness' is through ever-increasing sophistication of 'effects'. *Star Wars*, again, showed the way, in all respects. Its concept is futuristic and involves a display of futuristic filmic effects. Its director then became the leading figure in the company which proceeded to continue the revolution in 'effects': Industrial Light and Magic. And the re-release of the Trilogy in 1997 allowed him to upstage himself, by digital cleaning techniques and the addition of new elements. All this was itself accompanied by a blaze of publicity, including special TV programmes on Lucas, on the development of the film, and on the general achievements of *Star Wars*. 'Effects', or FX, became one of the defining features of the kind of film the new Hollywood would produce. As Wasko summarises: 'Seven of the top ten hits of the eighties were "effects" movies'.[26]

But all these implied greater and greater risks. In the studio days, a film which performed poorly hurt, but rarely threatened, the company which made it. With the scale of investment in any new big-budget blockbuster, while a host of accountancy devices can spread risk, nonetheless a bad failure can do uncontrolled damage to a company. Yet only a small proportion of films released (many estimates say as few as one in ten)[27] actually makes a profit for its producers. The central imperative, as Nicholas Garnham argues more generally, therefore becomes the management of risk. And more than anything, the management of risk through working on that aspect of it which is most controllable: distribution and reaching the target audience.[28]

The difficulty for the producers is that, as they know much better than many of their most ardent critics, they have remarkably little control in the end over whether people will see their movies. At a critical point, control passes from even the most sophisticated marketing and publicity machine to that which they know they must try to produce, but which of necessity they can't control: scuttlebutt. In local areas, and in association with local conditions and cinematic geographies, people have to talk to each other – not wholly dissimilarly to the ways they talked to us – about what's worth seeing, where to see it, and who else to tell about it. It is to this local level that we now turn.

Understanding the decline in cinema

The story of the new Hollywood is quite well known, but overarching the entire system was that crash in cinema audiences from shortly after World War II. The magnitude of this collapse has by turns bemused investigators, occasioned hurried explanations, and stimulated some important research – research which the film industry itself has been hungry to hear about. What made cinema decline so disastrously after WWII? A number of explanations have been voiced. The most common was also the simplest: television. TV became a mass phenomenon in America by the end of the 1940s, and by the mid-1950s in Britain.

The trouble is that, despite its attractive simplicity, TV does not make a good villain. David Docherty and others make this point abundantly clear in their book *The Last Picture Show?*; using a range of statistical sources they argue that at best TV can only account for a proportion of the decline in cinema. In the same vein, they show that video arriving in the late 1970s did not, as many predicted, worsen the situation even more – in that case, in fact, the people who were most likely to go to the cinema were among the last to acquire videos, and when they did, they combined cinema-going with video-watching.

Docherty et al dub the accounts they are criticising 'technological pessimism', and instead propose an essentially sociological model: with a sardonic smile, they write that 'we demonstrate that television was framed; the real culprits were Elvis Presley, expresso coffee, the Town and Country Planning Act of 1947, and the sclerosis of the British exhibition industry'.[29] Their arguments are certainly powerful and persuasive, especially perhaps in their negative assault on naive explanations. But their model has two features to it which we want to question: first, their 'suburbanisation' thesis:

> Between 1931 and the 1970s the inner cities lost around one-third of their population while the number of people living around the edges of cities grew by around one quarter. The population which sustained the cinema in the inner cities moved out.[30]

The implication is that physical distance from cinemas became a deterrent to cinema-going. If this is true anywhere, it certainly is not true of Bristol – precisely the opposite in fact.

The second problem with their model is more tricky. It is the absence of any discussion of the kinds of films being made in the period of cinema's decline, and of any discussion of what people might have wanted from cinema. What part in people's lives did cinema play? Did that change – and did the films available change in the same way? We here sketch in a history of Bristol's cinemas, in a way which we hope will illumine just these issues. Bristol certainly mirrored national and international trends in the drastic shrinkage in the number of cinemas after the 1930s, but a close examination of this process shows it to be rather different than Docherty et al's model suggests.

Bristol's cinema history

Like many other cities, Bristol experienced an explosion of cinema-openings from 1908-1915; in all, 36 cinemas opened in this brief period. Films had been shown

long prior to this, but always in the context of other kinds of entertainment, notably the Music Hall. 'Local showmen, always on the lookout for a new attraction, were quick to appreciate the potential pulling power of the new invention.'[31] On 8 June 1896 audiences at the Tivoli were thrilled by a cornucopia of short films:

> ... a scene in a blacksmith's shop was followed a wrestling match between a man and a dog, a burlesque boxing contest, a Spanish dance, the execution of Mary Queen of Scots, the burning of Joan of Arc and, for those able to watch, a re-enactment of the first dental extraction under gas. In between Mr L A Bassett played his violin and later that week they added film of the Prince of Wales' horse Persimmon winning the Derby.[32]

Only the night before, they had had Miss Florence Merry, vocalist along with the Celtoni Brothers, a leading 'novelty show'. Seeing films soon became a major entertainment attraction. In October 1901 the Thomas Edison Show opened, with a mix of snippets, a lion-tamer and a half-hour story of a fishing trip. 140,000 people saw the show in a four week period at a time when the population of Bristol was only 300,000.

Anderson's history records 61 cinemas up to 1983. Making some small corrections to his figures in bringing them up today, the figure is now 65.[33] Perhaps the most interesting picture is gained by looking at the pattern of closures. With odd blips, we can see the following pattern. After the early explosive development, the number is stable for quite a while – though that conceals both developments, renovations and changes of ownership. The first pattern of closures corresponds to the economic downturn after World War I (allied to some shaking out of unsuitable buildings and undercapitalised local investments), and again at the end of the 1930s. Some of the closures in the early 1940s were the straightforward result of bombings; the Triangle, Clifton received a direct hit in 1940 – but by that time its owner had bought out a nearby competitor, and therefore did not bother to rebuild. Remarkably, there were

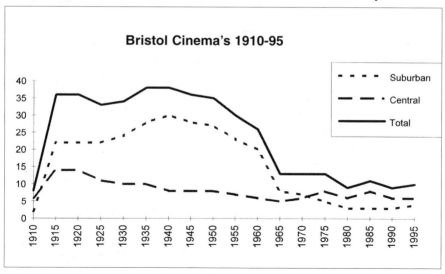

only two closures as cinemas were re-equipped for the Talkies, while six new cinemas opened in the same period. But the most remarkable feature of closures is the slough of departures between 1954-64, when Bristol lost more than half its cinemas, and with a peak of closures between 1961-3.

What the raw figures don't tell is where these closures took place. The suburbanisation thesis would predict that the city centre cinemas would be hardest hit. In fact, the opposite is the case! Of the 22 cinemas that died in the key decade, only 4 were city centre cinemas, while 18 were suburban.[34] They provide the basis for our alternative explanation. Cinemas died because for a complex of reasons people discontinued the idea of the 'family night out'. Where they did, they tended to choose to 'do it properly' by going into town – hence the disproportionate survival of city centre cinemas. This was a beginning of the process by which city centres at night became mainly the preserve of young people.

There are many complicated processes bound up in this, but these are not the task of this book. We've spent this much time on the general picture because we want to propose an alternative account of cinema-going, one which emphasises two features not sufficiently attended to in the standard model: the social geography of cinemas in a city such as Bristol; and the pattern of cinematic expectations.

Competing for audiences

The history of cinemas in Bristol is not just one of numbers, but of different forms of competition. Cinemas here inherited some intense rivalries as they arose among and from Music Hall. In the early days, competition mainly took the form of publicity stunts. For instance, in 1911 cinemas openly competed to rush film of King George V's coronation to the screening – the winner being the cinema which, having failed to fly it in because of bad weather, got it in by rail to Temple Meads with five minutes to spare. A good deal of effort also went into sustaining a sense of the spectacular. When the Premier screened *The Four Horsemen of the Apocalypse* in 1921, 'the sound effect staff entered so full-bloodedly into the job that we were deafened by the blast of indoor fireworks and almost suffocated by clouds of smoke'.[35] In the absence of a regularised system of national distribution and publicity, cinemas would mount stunts to attract their patrons. Harry Sanders, local entrepreneur and owner of the Kings Cinema, set up sponsorship for a man to walk the 120 miles from Bristol to London, to promote *Tramp, Tramp, Tramp* (1926), while for *Metropolis* (1926) he persuaded local papers to publish impressions of what Bristol might look like a hundred years on.

By the 1930s, the nature of the competition had changed. Emmanuel Harris, owner of the posh Triangle Cinema in Clifton faced new competition when the Whiteladies opened only a short distance away – a 'worthy competitor, offering the same sort of classy fare as his own, older cinema. It posed a threat he couldn't ignore. So Harris did what many a bigger company learned to do later. He tied up the product. Nine month contracts with MGM, Twentieth Century Fox, First National and Universal reserved the best films for the Triangle. There was nothing the new cinema half a mile away could do about it. Before long the two had merged into one company.' (p59) This is why Harris didn't bother to rebuild when the Triangle was bombed in 1940.

After WWII the main form of competition centred on getting hold, as soon as possible, of key money-spinning films. Cinemas could stand or fall on whether they got *The Sound of Music* (1965) on first-run. But thereafter and as audiences declined, a new kind of differentiation took place. There had always been a class system among cinemas – Bristol's Regent, Castle Street was the ultimate picture palace and the Picture House was for nobs, while the Gem and the Vestry Hall were beloved flea-pits – but to a considerable extent they would show the same films.[36] But in the 1960s, with the rise of 'auteurist' interest in film (including the newly-discovered continental traditions), so cinemas began to specialise. Arts Centres such as the Arnolfini incorporated screening spaces. A few, such as the Gaiety, would from time to time show Oldies. A new social geography of cinemas overlaid the old divisions. The arrival of multiplexes has cross-cut this to an extent. It speeded the process of subdivision in the older cinemas, and caused a small but important pricing war, with the old city centre Odeon permanently reducing its prices in order to survive. This is revealing in itself – Bristol's Showcase multiplex undoubtedly has good facilities, but it is in a difficult location badly served by local transport. But its association with a Pizza Hut, a Sports Shoe World and a Bowling Alley have made it 'the place' to go, if possible, for many young people – not least because it was a safe place.

Therefore one of the features of cinema-going now is, very evidently, a decision to be part of a certain kind of audience. People may not always be able to go where they would most like (costs, transport, times of film all can intervene), but the preferences, as we will see, play a significant role for many audiences.

Our argument is that cinema constitutes today a way of taking part in urban culture. Particular cinemas carry different meanings and expectations. For some, there is only one right cinema – because the feel of the place is right, or because of other possibilities to hand. For others, particular films demand to be seen in the 'right environment'. And in the reverse direction, people will avoid particular cinemas because they have the 'wrong' type of people, or because you just can't see a film in that sort of environment. These all constitute a complicated but powerful social geography of cinema which statistics alone cannot reveal.

Perhaps, though, the most remarkable thing about the standard models of the decline of cinema in Britain is that they have nothing to say about the films which people in their millions chose not to go and see. Docherty et al hardly mention a single film, and then only in their last chapter when talking about the pleasures of films today. It is as though once upon a time the cinema fulfilled some vital function, but then television came along and 'met the need' more efficiently. Or else, once upon a time people could be bothered to go out on a regular basis, but then it became just a bit too much bother. What they would see when they got there hardly seems to matter ... except to the people themselves. Read any of the living histories of cinema-going, and people speak loudly and with passion about their likes and dislikes. And one of the first things to show is that real audiences were immensely knowledgeable about films and their stars. They had well-formulated hopes and expectations, and likes and dislikes.

This book isn't the place to attempt a proper summary of the ways films changed between the 1930-50s, or of the ways in which these changes may have contributed to a sense of separation – that films did not speak to and for their audiences as they once had done. To be honest, the evidence does not currently exist, as far as we know. But if we assume that Bristol is not wholly different from other parts of the country, then something can be learnt tentatively from a comparison of our interviews with evidence we do have about the pleasures of cinema-going in the 1930-40s. The earlier evidence is assembled in J P Mayer's *British Cinemas and the Audiences*.[37] Mayer gathered a large number of cinema autobiographies, by advertising in the film magazine *PictureGoer*. Sixty are reproduced in full. Mayer's own commentary on them is pretty lamentable, consisting mainly in picking out one or two 'favoured' responses and a few almost random facts about them in order to substantiate a call for greater censorship. Albeit briefly, we want to look at some of the differences between the languages of pleasure and involvement in his sample, and in our own transcripts.

Some notes on cinema-going in the 1930s

Mayer's collected self-portraits must of course be read in the context of the general picture that a number of people have given of cinema-going in the 1930s. A 'phenomenon' of 'staggering statistics': '"nothing but films, films, films", was J B Priestley's complaint about the entertainment available to him in Leicester one autumn evening in 1933'.[38] This two-edged remark – it was all films, but nothing but films – gets the mix right. And of course the intellectual's slight distance and disdain was also typical, whereas for many working class people cinema was, simply, the night out.

What kind of an experience was it? From Mayer's admittedly skewed collection of 60 film autobiographies, still, some very clear themes emerge.[39] There are among his self-portraits some that are clearly disdainful, perhaps of previous pleasures. Some take an implicitly educational stance, selecting only those pictures that 'taught' them something (eg, letter 20). Cinema was 'truly glamorous then' (21). Several (eg, 28, 33, 41) use the word 'taste' as a way of distinguishing themselves from putatively indiscriminate others, or speak of not being 'moved by what appeals to the majority' (52). One or two consciously opt for British films as being 'unfaked' (37) by comparison with Hollywood, while that is dismissed by others as 'artificial, cheap' (50), and 'commercialised' (47).

But this minority group – even in Mayer's highly literate select group – is overweighed by a sheer enthusiasm for films, any films, and any American films. The predominant talk throughout is of 'favourite stars', and of moving from star to star as people grow up. Lists are given, and particular star-vehicle movies lovingly recalled. 'Film stars captured my imagination', wrote 46, typically. Others took their fascination a stage further, to imagine themselves as 'talent-spotters' (19) as viewers 'started to value the stars for their acting ability' (15). Cinema itself was a 'passion' (28), a 'chief hobby' (29), calling forth emotions of fascination, longing, excitement, stirrings of chivalry, and sheer thrill. Emotions are strong, in both males and females, though the latter let them run more uncontrolledly.

What did they do with this fascination? They imaginatively re-enacted: 'imagined myself in the role' (1); 'imitated American slang' (11); 'copied hair-styles' (eg, 13); 'took hairstyles and clothes from films' (eg, 14); 'pretended to be glamorous lovelies' (26); and 'played' at the characters and scenarios (any number of people). There is an overwhelming sense of an ideal being set up, and acknowledged (even if some remark that they didn't respond, they admit to its call). Stars 'became my ideal' (5), it was all 'something different that didn't happen to us' (27), films 'transferred me to a higher world' (34). For some, this meant that cinema became a thing-in-itself, a wonderland: a 'fairyworld' (4), a 'peep into another dream-world' (18), a 'form of fairytale' (28), or simply 'FilmLand' (11). For others, the magic had a real referent: America. 'I wanted to go abroad, especially America' (8); a 'wild desire to travel' (11); 'foreign lands look so beautiful' (12); 'intense admiration for America' (58).

That didn't require a belief that America is as it is in the movies: one at least 'wanted to visit the USA ... to see for myself' what it is really like (47). But the magnetism of America was very real to many, who otherwise felt trapped in 'monotonous suburban life' (35), or the 'sordid, everyday world' (18). Still others managed the experience by turning it into film fandom: collecting stars' photographs and clippings was very common; 'keeping a Film Book' (56); developing a 'store of movie knowledge' (1). It is remarkable to see a series of letters ending with a direct 'Thank you' to Hollywood and the film industry (44, 45, 46), which in some ways sums up the feelings people had about what 25 simply called 'enthusiasm for the screen'.

Such an 'enthusiasm', then, had several interlocked components: love of cinematicness, love of stars, love of the feel of America, and a sense of how different it all was from the rather drab world audiences inhabited. Cinema was a world, and of course a world of audiences, with which individuals could make their own personal bet. It's not difficult to see that Mayer's ways of getting his audiences' responses via *PictureGoer* would tend to draw answers where people emphasise the common elements in their viewing (although some do also talk engagingly about particular cinemas, or occasions of going). Other sources, though, correct this and reveal the ways in which the local spread of cinemas also configured people's uses of them. Local nostalgia books especially catch this aspect. Bristol's version of this captures well the communality of cinema-going, especially for children, as in this quotation:

> It was the same every week, a process of extracting a few pennies from my mother, father, or any other gullible relative with promises of work on tasks that would never be started, let alone completed, to get the money to go to the Saturday morning cinema at the Park Picture in St George. I would set out with a few friends and pick up others on the way. We laughed, skipped, and fought out way along the pavement, growing in number and speed at every street corner until finally an army of children marched into the foyer.[40]

A clear class awareness permeated even children's understanding. Another contributor contrasted going to the (cheap) Magnet in St Pauls which welcomed its young audiences with free sweets and where mass cheering was part of the event,

with going to the News Theatre in a 'posh' area of town where the programme was shorter, the proceedings more sedate and 'we felt we hadn't had our money's worth' (p28). Each town had, and has, its own configuration. The evolution of London's very different one has been well recalled in Gavin Weightman's *Bright Lights, Big City* pivoting around the West End (known to East Enders as 'the other end') which had emerged out of battles over licensing as a whole area of attractions for the wealthy, and the tourists.[41] Local history groups in many other places have, we suspect, done equivalent documenting jobs. These differences connected with the fact that generally people didn't go to see a film from beginning to end – they could arrive at any time, and often stay right round and see the programme more than once. This, is why they were ideal resorts for courting couples, provided they managed to adjust their clothing each time the lights came up.... Cinemas, in other words, became essential parts of the total social environment, and any account of film-going that doesn't include these processes has missed all that is interesting.

This aspect of the relationship with cinema did not fully change until the 1960s when film-makers began to emphasise the film as an ordered experience. It was Alfred Hitchcock, it has been recalled, who asked cinemas specifically to change the routine for his *Psycho*, so that audiences could not enter after it had begun; and made an on-screen appeal to audiences not to reveal the ending to those waiting to go in.[42] But by the time this positive new strategy emerged, audiences had deserted the cinemas in millions. What might explain the change?

We don't know the answer, because it would require a wholesale study of the history of cinema audiences, and their relations both to the event of cinema-going and to the films they were offered. One or two questions might tentatively be asked. In their study of cinema between the two World Wars, Peter Miles and Malcolm Smith single out 1940 as having a 'talismanic quality', in marking the start of a wholesale change.[43] They argue that this year saw the birth of the 'myth of the people's war', with films such as Humphrey Jennings' documentaries on life in war-time, or the fictional *Love on the Dole* (1940) 'constructing, though apparently reflecting, a new national consensus'.[44] But strangely, they couple this with saying that 'it really does not matter' how many saw films such as these. It surely does, for our purposes. The evidence, in fact, is that these films became increasingly unpopular as the war progressed. Mass Observations' studies of cinema audiences in this period reveal a sharp decline in acceptance of newsreels, and war pictures, during 1940, while most people (70 per cent) were indicating no change in their film-tastes in this period.[45] One respondent's pithy comment on the first major propaganda film of World War II, *The Lion Has Wings*, sums up an emergent paradox: 'Yes, damn clever propaganda. A real success. Lousy really.'

What we're proposing very cautiously is that perhaps World War II marked a turning-point in cinema, because people began to feel that cinema was being used to throw propaganda at them. In a sense, then, they began to feel that cinema was not 'their' space; it had been invaded by other uses and purposes. They were being 'done good to', and didn't much like it. So, even if particular films could still be enjoyable, the cinema-space in itself was no longer 'owned' in the way it had been.

There is a mile and more to go between this picture of earlier cinema-going, even if it proves correct, and our own period. This needs a social history of cinema-going, and a gathering of a mass of materials to accomplish that. We won't attempt even to walk it here.

The new meanings of cinema-going

What can we learn from these summary histories, that can inform (triangulate with) our preliminary picture of our audiences' orientations? The key is the number of ways in which the meaning of cinema-going has changed in recent years, and is still changing. Again, we offer a brief list of central points for consideration:

1 **Hollywood's new imperatives**: Hollywood is managing risk on a scale never before contemplated. That piles on the pressures to try to predict and manage audience responses. It has meant that every major film has to target a multiplicity of audiences. Yet each film has still to embody certain qualities. It has to 'make sense' to each audience. But also, a particular pressure comes from the demand that 'blockbusters' endlessly overtake each other. This builds in a multiplier into the risks taken, as each film has to demonstrate special features, new novelties, and prove it is more 'expensive' than the last. This, we suggest, will inevitably put particular strains at the point where two sets of demands meet: the demands arising from financial risk-management, and those arising from achieving a viable concept. Often, though not always, this will place the stresses between producer (as 'owner' of financial imperatives) and director (as 'owner' of the concept).

2 **The blockbuster syndrome**: to see a blockbuster is to see something that only has meaning by virtue of what it is different from (preceding films, past 'effects', comparisons of costs, scale of events, etc) and what it is related to (who's in it, what they've done before, what tradition it belongs to, etc). To see a blockbuster is also to engage in something which will be famous, or not, for its scale: what Larry Gross delightfully calls the 'BLAM' or Big Loud Action Movie.[46] It is engage in a mass event, at a local venue.

3 **The drench of publicity**: every new film that comes out, especially if it seeks to realise its intended status as 'event', blockbuster, must reach us on waves of information. What it cost, who was in it, what was new about it, what its 'look' will be. Publicity set-ups will ensure that at least one major newspaper, several magazines, a couple of television programmes and other such will feature the film and its stars, will perhaps run a comic-strip version of it, will do interviews with leading stars, will reference the film in a dozen ways (cartoons, headlines, jokey references) – long before a film gets anywhere near getting a review. These constitute the foundation on which potential audiences are invited to movie-mouth, that is, talk about the film in any way at all ... as long as they talk about it. Talk is therefore a natural and essential ingredient of modern film-going, and that curiously can even include talk with the likes of us. It also means that, as never before, it is impossible to think of an 'innocent' experience of a film, that is, one that isn't prepared for in a dozen ways. And since an essential part of that preparation is sharing in different kinds of talk, these are in principle there for people like us to research.

4 **The 'multiplex generation'**: the rise of new cinemas has changed people's expectations of a night-out, whether they personally choose to associate with it or not. Jon Ronson nicely captures some of the ambiguities in this: 'It is, of course, the gut liberal sensibility to deride the multiplex, its conveyor-belt ethic of Americana, the tacos and walls of video-screens, the cartoon architecture, the assertively joyous "movie-going experience". ... The multiplex experience is a curious blend of nostalgia for the grand old days of American drive-ins and rock 'n' roll kitsch – when movie-going was an event – and a fervent, almost imperious embracing of technology'.[47] Multiplexes are spaces for unashamed indulgence in trash, for hanging out in the foyer, for going as a group and making a choice of film when you get there – even, for splitting up and seeing different films. And other cinemas have had to compete or die.

1 Key sources for information on the new Hollywood are: Thomas Schatz, 'The new Hollywood', in Jim Collins et al (eds), *Film Theory Goes To The Movies*, New York: American Film Institute 1993, pp.8-37; Jim Hillier, *The New Hollywood*, London: Studio Vista 1993; Janet Wasko, *Hollywood in the Age of Information*; Tino Balio (ed), *Hollywood in the Age of Television*, London: Unwin Hyman 1990; Dag Björkegren, *The Culture Business: Management Strategies for the Arts-Related Business*, London: Routledge 1996; and John Izod, *Hollywood and the Box Office*, Basingstoke: Macmillan 1988.

2 Tino Balio, 'Adjusting to the new global economy', in Albert Moran, *Film Policy*, London: Routledge 1997, pp.23-38. This quote, p.35.

3 Thus the same processes of concentration of ownership have also necessarily happened in other fields. For some information on these and useful investigations of their impacts, see for instance John Feather, 'Book publishing in Britain', *Media, Culture & Society*, Vol.15, 1993, pp.167-81; Stephen Driver & Andrew Gillespie, 'Structural change in the cultural industries: British magazine publishing in the 1980s', *Media, Culture & Society*, Vol.15, 1993, pp.183-201; and Joe Moran, 'The role of multimedia conglomerates in American trade book publishing', *Media, Culture & Society*, Vol.19, 1997, pp.441-55.

4 *Screen International*, No.1034, 17 November 1995.

5 Jim Hillier, *The New Hollywood*, p.7.

6 Ibid.

7 Barry King, 'Stardom as an occupation'.

8 Thomas Schatz, 'The new Hollywood', p.131.

9 There was another aspect to stardom: this was the rise of the 'director superstar'. Exemplified by Steven Spielberg, his name alone was 'bankable' enough to virtually guarantee the success of a film. And it is interesting that Spielberg has, in a number of his films, used lesser-known actors in preference to the expensive big-name stars. This assures him less competition not only for money, but also for cumulative image.

10 Jim Hillier, *The New Hollywood*, p.30.

11 Dag Bjorkegren, *The Culture Business*, p.133.

12 Janet Wasko, *Hollywood in the Age of Information*, p.198.

13 On these, see for instance Lisa Buckingham, 'The Time ... the Placement', *Guardian*, 11 January 1997.

14 See, for instance, Betsy Morris, 'The Brand's the Thing', *Fortune*, 4 March 1996.

15 Janet Wasko explores the significance of advertising on videos, with their longer viewing periods, and their reach to audiences who by and large avoid television.

16 Source for these figures British Videogram Association, *Yearbook 1996*.

17 *Screen International*, 12 January 1996: 'Six of 1995's top 10 world-wide grossers made more money abroad than in the US, confirming the industry view that a ratio of 60:40 in favour of international holds across the board, (Ralf Ludemann, 'Foreign take outshines domestic gross in '95').

18 Jim Hillier, *The New Hollywood*, p.26.

19 *Screen International*, No.1026, 22 September 1995.

20 See for instance David Atwell, *Cathedrals of the Movies: a History of British Cinemas and their Audiences*, London: The Architectural Press 1980.

21 Nicholas Garnham, *Capitalism and Communication: Global Culture and the Economics of Information*, London: Sage 1990.

22 There is a long history to such test screenings. Leo Handel summarised their earliest uses in Hollywood in his *Hollywood Looks At Its Audiences* (Urbana: University of Illinois Press 1950). In recent years, a veil of secrecy has fallen over such practices, occasionally breached by newspaper articles. See for instance John Patterson, 'Testing, testing', *Guardian* Guide, 21 June 1997. Patterson refers to a Website maintained by Harry Knowles, 'Aint-It-Cool-News.Com' which encourages people to 'spill beans' about their experiences of such testings.

23 On this, see John Izod, *Hollywood and the Box Office*. Izod shows that as early as 1959, in *Rio Bravo*, there was a conscious decision to include stars who might reach an otherwise-untouched audience (in this case, Ricky Nelson who, a popular singer and TV actor at 19, might reach a youth audience, alongside John Wayne and Dean Martin).

24 John Izod, *Hollywood and the Box Office*, p.182.

25 This is Guild Entertainment's own term for the sort of 'spontaneous" talk they were hoping to provoke. See the discussion of Film Education's programme, '*Judge Dredd*: the marketing of a film' in chapter 9.

26 Janet Wasko, *Hollywood in the Age of Information*, p.38.

27 On this see Diana Crane, *The Production of Culture: Media and the Urban Arts*, London: Sage 1992, p.55.

28 Nicholas Garnham, *Capitalism and Communication*. Garnham's argument is of great significance, and goes far beyond what we can deal with here. In another essay we hope to apply his arguments directly to our case-study, since it illuminates so much.

29 David Docherty, David Morrison & Michael Tracey, *The Last Picture Show? Britain's Changing Film Audiences*, London: BFI 1987, p.5. Their account quickly became a touchstone for others. See for instance Lez Cooke, '"And where did you see *Star Wars*?" – Cinema-going in Britain', in Gary Day (ed), *Trivial Pursuits?*, London: Macmillan 1990, pp.200-7, who repeats their argument almost word for word (see pp.201-2).

30 David Docherty et al, *The Last Picture Show?*, pp.25-6. The same claim is casually included in Thomas Schatz's generally excellent account of the recent changes in Hollywood. Speaking of the post-World War II decline in audiences, he writes: 'The war boom had ended rather suddenly in 1947 as the economy slumped and, more importantly, as millions of couples married, settled down, and started families – many of them moving to the suburbs and away from urban centres, where movie business thrived.' (Thomas Schatz, 'The new Hollywood', p.11).

31 Charles Anderson, *A City and its Cinemas*, Bristol: Redcliffe Press 1983, p.7.

32 Charles Anderson, *A City and its Cinemas*, p.8.

33 Although broadly accurate, there are small problems with his figures because of what he includes as a 'cinema'. Anderson includes the Tivoli, which began in the 1880s as a Music Hall and was converted to a cinema in 1915. He does not include the Arnolfini, an arts centre which opened in 19.. with a large cinema space, or the Watershed Media Centre with two screens. For our purposes, we have to include these latter, for reasons which relate to what we have noted as the 'social geography' of cinemas.

34 These figures are derived from a study of Anderson's map of cinema locations. Even allowing for some arbitrariness of classification (suburbia was defined by being at least a mile from Bristol's single city centre), the figures are remarkable. What we can't say, is how particular to Bristol these may be. Certainly the suburbanisation of cinemas in Bristol began very early, encouraged by the fast growth of the city in the early twentieth century, but also promoted by a city ordinance which in 1914 forbade any new cinema to open within 500 yards of an existing one.

35 Cited in Anderson, *A City and its Cinemas*, p.46.

36 *Dream On: Bristol Writers on Cinema*, Bristol: New Words 1994 contains many interesting anecdotes of these differences.

37 J P Mayer, *British Cinemas and their Audiences*, London: Dennis Dobson 1948. This decidedly odd book is made up for the most part of letters sent to Mayer in response to 'competitions' he set up for readers of *PictureGoer*; but these are supplemented by some wonderfully selective and naïve interpretations, for which for instance he chooses one letter to make a case that films are dangerous and should be subject to further censorship.

38 Peter Stead, 'The people and the pictures. The British working class and film in the 1930s', in Nicholas Pronay & D W Spring (eds), *Propaganda and Politics in Film*, 1918-45, London: MacMillan 1982, pp.77-97. This quote, p.77. See also Jeffrey Richards, *The Age of the Dream Palace: Cinema and Society in Britain 1930-1939*, London: Routledge & Kegan Paul 1984, especially Chapter 1.

39 The sample is almost certain to be skewed by differences in people's willingness to respond to an academic's invitation to write about themselves. But *PictureGoer* was certainly at that time the largest publication of its kind. For some useful discussion of this, see Annette Kuhn, 'Cinema culture and femininity in the 1930s', in Christine Gledhill & Gillian Swanson (eds), *Nationalising Femininity: Culture, Sexuality and British Cinema in the Second World War*, Manchester: Manchester University Press 1996, pp.177-92.

40 *Dream On: Bristol Writers on Cinema*, p.20.

41 Gavin Weightman, *Bright Lights, Big City: London Entertained 1830-1950*, London: Collins & Brown 1992.

42 See Linda Williams, 'Learning to scream'.

43 Peter Miles & Malcolm Smith, *Cinema, Literature & Society: Elite and Mass Culture in Interwar Britain*, London: Croom Helm 1987, p.232.

44 Peter Miles & Malcolm Smith, *Cinema, Literature & Society*, p.247.

45 See Richards & Sheridan (eds), *Mass Observation at the Movies*: 'We have witnessed what we believe to be a pretty steady decline in the prestige, never high, of newsreels in the past year. At the end of 1939 just under two-thirds of all persons asked said they liked newsreels, and expressed sentiments distinctly favourable to them; by August, 1940, only just a quarter of those questioned held this point of view' (p.212).

46 See Larry Gross, 'Big and loud', *Sight & Sound*, August 1995, pp.6-10.

47 Jon Ronson, 'Giants of the silver screen', *Guardian*, 21 August 1995.

THE MAKING OF A FILM

The origins of Judge Dredd

'Judge Dredd' was conceived and born in 1977, amid the debris thrown up by the rows over its immediate predecessor *Action*. *Action* was a landmark British comic for at least two reasons. First, it openly ripped off a host of story-ideas from other media. So, *Jaws: the Movie* became 'Hookjaw', the film *Death Race 2000* became the strip 'Death Game 1999'; a combination of *The Professionals* (the TV series) with *Dirty Harry* and any number of hard cop or spy series became 'Dredger'. And so on.[1] The discovery that comics could feed off current media popularities cracked the publisher IPC's ossified production regimes.

The second element was *Action's* audience. Up to then, all IPC comics worked on an assumption of limited life. Launched with a blaze of publicity, they could achieve high initial sales, but would then decline steadily, hopefully to a relative plateau. Budgets were based on this, to the point that after a certain number of issues even the printing and paper quality would be reduced. *Action* bucked this assumption; after the expected fall it actually began to register a steady rise in sales – and with that came bulging postbags of fan mail. This was a new kind of audience, devotees. But by this point the publishers were in a funk over a sizeable moral crusade against the comic for its 'violence'. It closed for refurbishment (which meant loss of all its loved qualities) in September 1976.

In the midst of all this, IPC's new planning team of Pat Mills and John Wagner were busily planning their next launch. First had been *Battle* (1975), a comic which hardened characters but stayed traditional in focusing on World War II. Then had come *Action* (1976), with its pick-pocketing from other media. Now came *2000AD*, the first to be based on a prediction. IPC had spotted a film in production called *Star Wars*. Might science fiction be the coming thing? If so, that gave them three advantages. They could be ahead of the game with a launch. They could re-activate an old 'property' that some in IPC thought still had legs: 'Dan Dare', born in 1950 in *Eagle*.[2] And being science fiction could safeguard against complaints about the comic: violence in future-fictional worlds was more readily defensible.

'Judge Dredd' was born in Prog 2 (as editions were called). From the beginning, it was the most popular story in the comic, and only rarely toppled from this position. One of Dredd's key strengths was its unpredictability and continual surprises.[3] A number of features, though, characterise it. In many ways the story's central figure is not Dredd, but Megacity One. A vast cancerous growth of New York in the twenty second century, after a nuclear holocaust, the city's population of over 400

million are almost all unemployed. Nearly everyone is a potential criminal, or 'perp', of one sort or another. Yet life goes on: there are food fads, mad TV shows, fashion crazes, and so on – but all happen so bizarrely as to become sardonic comments on our own world. In a world of food shortages, there is a 'League of the Fatties' devoted to topping the one-ton weight limit. In Dredd's world, people go in for plastic surgery, but in order to make themselves ugly. TV Quiz Shows go the limits by having contestants die if they lose. Famously, the city is packed with emblems of our own time. City blocks (each a mile high) are named after people from our own time: the Jimmy Carter Block, or the Bet Lynch Block. This is science fiction as dark satire on the present.

Dredd himself is machine-like: judge, jury and executioner all in one. Humourless, living only for 'the Law', he is a grim, merciless enforcer of all laws, from the most trivial such as jay-walking. Yet that make the stories funnier, as the comic itself makes them impossibly exaggerated. We can see this in a story which became one of the bases for the film version: 'The Return of Rico'. Dredd was a genetic copy of the first Chief Judge of Megacity One, designed to produce perfect cloned Judges. But the experiment went wrong, when Dredd's 'brother', Judge Rico, went bad and was sent to on off-planet prison colony. In 1983 *2000AD* carried a single Prog story of his return, to take revenge on Dredd who had judged him. Rico confronts Dredd. He shows his horrificly modified face to Dredd (and us). But when he challenges Dredd to a duel, he is shot – his years on Titan have slowed him down. As he dies, Dredd insists on himself carrying the body to the morgue – after all, 'he ain't heavy, he's my brother'! Dredd, of course, 'doesn't know' that he is speaking the lines of the then-popular Blues Brothers song – but the comic does, and we do.

This link between bleakness and humour marked Dredd throughout, making it simultaneously brutal and funny. It also meant that the people Dredd polices could look remarkably like exaggerated versions of the comic's readers! Covers would show Dredd pointedly looking at 'us' and threatening to judge us. Young fashion-conscious perps could be found being arrested for trying to break into the comic,

or steal its logo. This subtle play with the readers made the comic a cult item by the mid-1980s.

IPC discovered they had several kinds of readers. A large group of young boys (10-15) loved the comic for its 'Action'. But these boys might only stay with the comic for 3-5 years, at best. There was a group of older fans, who loved the comic's sardonic politics. Smaller in number, this group broke the mould in carrying on reading into adulthood. The rise of American comic fandom gave *2000AD* a readership who thought the comic a sort of British Marvel. Finally, there was an 'art-school' audience, those who loved the comic for its look. These groups greyed into each other, especially while the comic managed, until the late 1980s, a balancing act between the demands of the three groups. Thereafter things started going awry, as the publishers perceived a shift in the majority towards for instance computer interests. The resultant shifts in editorial policy antagonised many older fans, who gave up their comic as 'lost'. Others clung on to the more adult elements, helped by the 1990 launch of *Judge Dredd: the Megazine*.

The comic itself, meanwhile, had become a minor pop icon. A number of pop bands had done tributes to Dredd, notably Madness, and Whitesnake. Other bands appeared on Top of the Pops wearing *2000AD* tee-shirts. Posters, original artwork, badges, and hats became quite hip. Dredd's artists became 'names' to follow, and a number were bought up by Marvel and DC in America (though Dredd himself attained only a minor following there, despite two launches of *2000AD* titles).

While other characters and stories also attracted serious following ('Slaine', for instance, or 'Strontium Dog', or 'Halo Jones'[4]), none equalled Dredd. It was this that led to the emergence of the readers' self-characterisation as 'Dredd-heads'.[5]

In many ways, also, *2000AD* sustained an interest in its own history. For example, current stories would often signal connections with incidents in earlier editions. The Titan reprints, beginning in 1981, made classic stories easily available. Prog. 1000 gave all readers a Special Collector's edition of Prog. 1. At other times, they gave away digests of characters, and story-histories. In these and many other ways, readers were regularly reminded of the history and continuities in the comic. These supported a quite special sense that this was their world.

Dredd heads for the screen

From the earliest days, there were speculations about a possible film. In 1983, IPC optioned the character to an American production company; but progress was very slow. Then in 1987 the film *Robocop* knocked back plans; the film was too close to Dredd for comfort, and indeed was partly inspired by IPC's character. In the early 1990s came the first script attempts, through the efforts of Charles Lippincott, who had cut his filmic teeth in the marketing of *Star Wars*, and producer Kevin Pressman, who had been responsible for *Wall Street*, and *Conan the Barbarian* among others.[6] But none of these scripts convinced, and no agreement was reached on which story-elements to use, until an old hand William Wisher was brought in.

From the early days, 2000AD *developed a style and a relationship with its readers that played on a dark humour and mock threats. Who is this 'punk' who might be next? What kind of power can 'Cancel New Year'?*

These uncertainties reveal a set of underlying fears in Hollywood, fears that they might make a 'fascist' film. Again and again this was a factor in their decisions. Their solution was to make Dredd more 'human': 'Charley Lippincott was one of the strongest proponents of taking Dredd seriously and giving him a more rounded character and a human personality you could identify with in conventional movie terms. But even when you say that, it's still a balancing act, because Joe Dredd certainly can't be turned into an everyman. He still has to be of mythic stature. And then you deal with, okay, "Who is Dredd?" How do you make him human without turning him into a wimp?'[7] The number of versions and revisions shows the depth of their worries. But of course to the comics' fans, the whole point was that Dredd was a humourless, emotionless bastard. The satirical elements of Dredd could not survive the transformation.

Production issues

Eventually Cinergi, one of the new independents, funded *Dredd*. Founded by Andy Vajna in 1990, Cinergi made its mark with *Tombstone* and *Die Hard: With A Vengeance*, and would live a little longer to make *Rob Roy* (1996). In 1997, they sold their assets and ceased making films. Vajna himself had been part of the earlier Carolco, which had produced Stallone's *Rambo* series, and Schwarzenegger's *Total Recall*. Cinergi was a typical independent production company of the 'new Hollywood', taking the risks that the studios were now unwilling to take, by keeping a tighter rein. As Vajna himself put it in Boxtree's book of the film: 'These are the kind of films where a producer needs to stand toe to toe with the star, with the director, with everybody on a daily basis to make sure that those budgets stay within control. That's very difficult for studios to do because there are too many layers of bureaucracy.'[8] *Dredd* did in fact over-run its budget, eventually costing US $70 million, of which a reputed US $17 million went to Stallone, with a substantial portion of the remainder going on its computer effects. The film was shot at Shepperton Studios outside London, and then underwent a long post-production digital processing, to give it its intended 'newness'.

Books such as Boxtree's 'Making Of' series are excellent at telling the story of how a film gets made, but they tend to miss out some of the more structural processes involved. It is to these that we want to turn.

Stallone as Dredd

From the earliest days, to most fans of *2000AD*, it was obvious who should play Dredd on screen: the young Clint Eastwood. His still, cold centre in films such as *Dirty Harry* seemed a virtual embodiment of Dredd. But by 1994 he was just too old. Stallone was something different. Producer Beau Marks has made a telling remark about Stallone's role in the film:

> Joel Silver told me that you can never forget who your star is, because the audience will never forget. You have to work with the natural resources the star brings with him. ... The thing that Stallone does so well, is that he gets the shit kicked out of him, then he comes back. That's his myth,

almost, ever since *Rocky*. So the presence of Stallone confirmed our sense that Dredd needed to get knocked down to his lowest point, because Sly is such a great fighter when he's coming back. It was a good plot device in the movie, but it was also very sympathetic to Stallone.[9]

This is an apt summary of Stallone's film persona. Stallone exemplifies the new breed of 1970s Action heroes. After struggling to break into the film business for a number of years, Stallone hit the big time with a story he wrote for himself, and refused to sell unless he could play the lead and collect a percentage of the box office: *Rocky*.[10] The unlikely winner, coming from the wrong side of the tracks, forced into the limelight, makes it through: a suffering loner who finds the resources from within himself to survive. This image was developed in the *Rambo* series, where Stallone came to embody the 'angry American'. Deserted by his own government, feeling that his own country had been cheated by politicians' cowardice, Stallone's Vietnam vet is so full of guilt and rage that he overturns everything in his path. This persona carried right through into Dredd, as he suffers and rages over the destruction of 'The Law' in the film.

But stars cannot have full control over their own images. Stallone had competitors, of two kinds. On the one hand a whole crop of alternative Action heroes emerged: Arnold Schwarzenegger, Jean-Claude van Damme, Dolf Lundgren, Steven Segal and Bruce Willis among others. To survive, Stallone had to be seen to be different from these. This could be done by playing up his doe-eyed, suffering, inarticulate 'self'. But that put him in comparison with another kind of actor. For Stallone began as the 'Italian Stallion'. In the early 1970s a small group of Italian-American actors emerged, led by Robert de Niro and Al Pacino. In these, ethnicity offered a version of American working class-ness – a representation which can well be seen in John Badham's *Saturday Night Fever* (1978), starring John Travolta as a dance-obsessed young man in a dysfunctional Italian-American family. It has also been reprised brilliantly in de Niro's directorial debut, *A Bronx Tale* (1993), which studied New York working class life through its ethnic communities. Stallone's early image as Rambo had borne elements of this image of class. Again, to succeed, there had to be a clear difference – but with continuities, since stars – unlike actors – cannot change their persona at will.

A problem for stars like Stallone is that they can become parodies of themselves. This seems almost an in-built tendency, for reasons connected with their need to maintain, but update, their own image (as they age, or as public interests shift). Stallone has been through several fallow periods, and has sought to redefine his filmic personality, sometimes within his next film. Consider *Tango & Cash* (1989), where he plays a suave, smart, and partnered policeman. Tango (Stallone) is facing down a truck-load of criminals. He stands and shoots it to a halt, knowing somehow that it contains cocaine. Angrily, the local cops denounce his invasion of their patch:

Cop 1: You're out of your neighbourhood, big city boy. Who the hell do you think you are?

Cop 2: He thinks he's Rambo (His mates grin and sneer)

Tango: Rambo ... is a primitive (He pulls his gun, and coolly shoots a hole in the truck, from which spills the cocaine.)[11]

This is evidence of work on the the upkeep of his image, even as he is playing his next part.[12]

Stallone's personal relationship with Dredd was difficult. Initially enthusiastic, Stallone studied the sources of the character in the comic, and seemed to see this as a possible new direction for him, after relative failures in a number of films (most notably his awful turn to comedy, in *Stop! Or My Mom Will Shoot* (1991). Stallone gave enthusiastic interviews at time of release, marvelling at the concept of 'Dredd' and praising director Danny Cannon. But even by this point, rumours were circulating of his discontent with the film's outcome. Then in a remarkable outburst in June 1995, he stormed that America needed a real *Judge Dredd* to clean up crime.[13] Not long after the film's rather weak release, he was clearly backing off from it, separating his persona from that of the film.

Intellectual Property Issues

In other respects, too, Stallone is a typical 1970s star. An early hagio-biography of Stallone linked the man and his image: 'The comparison has often been made between the fictional Rocky and the real-life Sylvester Stallone, both being cited as little men who got there because they were born triers. But perhaps, these days, the comparison would more easily be made between Rambo and Stallone for both show a rugged single-mindedness to excel in their chosen role.'[14] This is in many senses right, but the book reveals something much more telling inside its front cover, in these words:

> Sylvester Stallone is a trademark of the artist Sylvester Stallone and/or affiliates or assignees.

What this indicates is the quite central role given to intellectual property law in the maintenance and protection of a star's 'persona'.[15]

But intellectual property issues go wider than the requirements of Stallone's self-management. The history of *2000AD* is one of long bitterness over this. British comics traditionally have used work-for-hire principles, under which writers and artists did a job, were paid a flat fee, with all rights passing to the publishers. It made no difference if a writer's whole story-world was subsequently exploited, or their work reprinted, and sold in other forms. No royalties were paid, and even the original artwork belonged to the company. The same was true in America. But the rise in comic fandom in the 1960s created a pressure to change this. Artists found that they could make additional money by selling original artwork. In the early 1970s, the name of Jack Kirby, creator of a host of characters for Marvel Comics, came to epitomise the battle for 'creators' rights'. The gradual success there acted as a model for British creators, especially when early *2000AD* artists such as Brian Bolland found themselves offered American contracts on much more favourable terms. Foot by foot, moves were made towards contracts which recognised the range of contributions writers and artists made. But the one right they could not and would not get, was the right to determine the fates of characters. For if they had that, they could have demanded script-control over the film. This was not allowable.

The rules of intellectual property are embodied in a number of documents, many of them confidential. But one document does tell a good deal of the story: the 'Form Book'. The Form Book regulates under what conditions Dredd's image may be used, and what can be done with it, in part just guiding merchandisers on everything from the colours of Dredd's knee-pads, to the nature of the Dredd logo. Something of the different 'brand identities' of comic and film can be gleaned from different versions of this Form Book.

In 1990 Fleetway were only just realising the merchandising potential of Dredd. It was still struggling with creators' rights. Externally, therefore, its main concern was simply to maintain Dredd's world. The crucial section therefore addresses the do's and don'ts of using the Dredd image/logos:

1 Don't show Dredd without helmet
2 Don't show Dredd smiling
3 Don't alter colour scheme of costume
4 Don't show Dredd killing anyone
5 Don't use Dredd as a spokesperson for your company as a whole. He should be used to advertise the licensed product.
6 DO obey the guidelines in this database!![16]

This is a 'beginners' guide' for a character who does not yet have a presence beyond the fans. But by 1995, with the build-up towards the film, the requirements had changed. Glossily printed and bound in a customised folder, the Form Book now has two parts, one for the comic, the other for the film. They have almost nothing in common.

While for the comic, Megacity One is surrounded by the 'Cursed Earth radiation desert', all implications of nuclear conflict are removed from the film-half: here it is only the 'desert-scape of the Cursed Earth'. This softening of connections between Dredd's world and our own is continued, of course, in the film itself in the opening scroll: 'In the third Millennium, the world changed. Climate. Nations. All were in upheaval. Humanity itself turned as violent as the planet.' This deletes the parodic edge that the comic prided itself on. Problems of 'climate' and 'humanity' are so generalised as to feel disconnected from our times. The 'Third Millennium' has a far-distant science fiction feel to it, which 'the 22nd Century' does not.

But perhaps the more important differences lie elsewhere. The comic part is written in a self-reflexive half-mocking style, opening with the mock-instruction 'Do not attempt to proceed any further unless accompanied by an authorised representations of Copyright Promotions , etc ...'. This is accompanied by a Dredd parody of the famous Kitchener poster. The implication is that Dredd merchandising should carry some of the comic's mocking attitudes. It depicts Dredd in a witty way, studiedly aware of his woodenness: 'In character Dredd is two-dimensional and machine-like. Fifteen years in the Academy of Law, the toughest school on earth, saw to that. Dredd has no social life, no outside interests and very few feelings not linked to his devotion to the Law. Food holds no attraction for Dredd except to maintain his body in full operational condition. Music, art, film, literature (law books aside) are of no interest unless of a seditious

and bannable nature. ... Dredd never smiles. Though he is capable of a very black sense of humour, we can never be sure if he thinks his remarks are funny.'

The film section explains Dredd quite differently: 'JUDGE DREDD is a futuristic action thriller about how the toughest, most upright and respected of all the Judges saves Mega-City One from destruction'. The description of Dredd himself is different again: 'Although friendship is a concept Dredd does not recognise, he holds great affection for Fargo.' It offers an explanation of his 'stony demeanour' (from his having had to judge his brother Rico), something inconceivable to the comic. For the film, Dredd is humanised, to the point of saying: 'You said I had no feelings. No emotions. Now you know why.'

The film-section closes with an stern injunction: 'JUSTICE DEPARTMENT WARNING! STOP! This section contains vital guidelines regarding the correct usage of trademarks and copyright notices for *JUDGE DREDD* motion picture product lines, packaging and written material. Strict adherence to these rules is mandatory.'[17] The lawyers have won. Dredd here becomes a piece of private property made publicly available under terms, rather than a public cultural discourse that happens to have appeared in a particular publication.

Marketing *Dredd*

Organised by the distributors Guild Entertainment, the *Dredd* campaign began with a series of 'teaser' posters, simply showing Dredd's badge and giving the release date. Then marketing in earnest got underway, with information releases, publicity events, and the release of the main poster. Guild's intention of Guild was to blur and if possible abolish the distinction between all these kinds of 'talk' about the film: to generate 'scuttlebutt', as the Americans call it. All the following, then, are intended to add into making the film a 'talked about' production and, through that, a 'must see' event:

> The BBC's motoring programme *Top Gear* runs an item on the cars in the film, which allows Land Rover to market themselves as contemporary designers. The item – 7 minutes long – uses extensive clips from the yet-to-released film, and couples those with clearly staged shots of a whole array of the Dredd vehicles.

> Land Rover themselves tour their major dealers with the vehicles from the film, in a promotion coupling. This leads to press coverage of the film, the cars and the dealers.

> Quaker Oats do a tie-in promotion of the film, offering free stickers in packets of Sugar Puffs Cereal. The stickers feature scenes from the film. Shoe Express, 'one of Britain's fastest growing shoe outlets', ran in-store displays of Dredd 'standees' (self-standing cut-out display materials).

> Stallone makes himself available to promote the film through general TV interviews, through specific interviews for programmes such as Barry Norman's *Film '95*, and through a complete film distributed through Sky TV – for whom it constitutes cheap programme acquisition, as well as a possibly useful association of images – which celebrates the coming film.

Fleetway Editions themselves publish a substantial amount of material referencing the film, including: a special Poster Prog, whose back-cover tells of the film, yet whose image is of the comic book version of *Dredd;* free film posters given away with the new *Lawman of the Future* comic (on which see below); an 'Exclusive Film Supplement' only given away with *Judge Dredd: the Megazine*, which featured solely the contribution to the film of Chris Hall, a regular artist on the comic; ordinary editions of *2000AD* featuring 'Never-Before-Seen Movie Pix!'; and a free Sampler of *2000AD* which went out, inter alia, with the Film Education pack (from all of which, we have to say that we can't tell if it is the film's Dredd or the comic's which is being promoted).

Tower Records ran a promotional campaign building on the film/music link. In association with the film came, as standard, a *Judge Dredd* CD, an 'epic soundtrack' with music from the film plus an assemblage of tracks from bands which were seen in some way as connected with Dredd: The Cure, The The, Cocteau Twins, etc. Tower 'recreated the setting for the film at our Piccadilly store, featuring the *Judge Dredd* car, Virtual Reality sex machine,[18] artwork from the original comic book and much more ...'

A series of articles appeared in the new crop of popular film magazines, such as *Film Review, Vox, Select, Empire* and *Premiere* (each of course having to write and present it in its house-style, thus 'accommodating' Dredd to their own world), along with others such as *The Big Issue* and (slightly bizarrely, since it could not reach this medium for at least two years) *Satellite TV*. Along with these went a host of 'infotainment' previews, celebrity news and interviews, and predictions in just about every newspaper.

In more specialist publications, fans and devotees garnered and shared the kinds of information they need, to maintain their closeness to these kinds of media-world. For instance *SFX*, the (then) new science fiction magazine, gave twenty pages to giving the 'inside story' on the long struggle to bring Dredd to the screen, with (appropriately for them) an emphasis on the technologies which were involved and would be displayed. So, a two page special just on the design and look of the *Dredd* car.[19] Meanwhile, in *Cinefantastique*, a magazine devoted to cult films, the greatly-admired film journalist Alan Jones offered a 24-page on-the-set report on the film, covering everything from the 'persona' of Dredd as seen by Stallone, the animatronics and digital effects of the film, right through to our own research and what it might tell 'us' – though by this point, who the 'us' might be was beyond us.[20]

In the end – and this is exactly the point – it becomes hard to see what exactly is being promoted, and indeed what the line is between advertising, promotion, publicity, news reporting, information and reviews.

Perhaps most extraordinarily and revealingly, Film Education, a London-based company funded by the Hollywood studios, made and distributed a teaching pack for Schools and Colleges about *Judge Dredd*. In association with this pack, they distribute via BBC Education a half-hour programme which teachers are encouraged to record and use as a basis for classroom discussions of the 'marketing of a film'. The

programme is a measured and helpful discussion of the stages of a marketing campaign, how expenditure is proportioned, and what such a campaign seeks to do. The booklet for Schools issued in association not only summarises a good deal of what is in the programme, but then offers a series of classroom activities for different age groups – for example, to design a poster for the film, or a tee-shirt; or to think about the meaning of 'escapist entertainment'. The booklet ends with a call for analysis of the film itself, opening with: 'You are going to "deconstruct" Judge Dredd's appearance. This means that you will look at the way he is denoted – how he is presented to us, and the connotations that his appearance carries'.[21] So, media education about a film can be as much part of the publicity regime of that film as anything else. To get young people to 'deconstruct' Dredd is as useful for publicity as any poster on a hoarding, or promotional material on television.[22]

Where were 'the audience' in all this? Guild Entertainment were struggling to evoke as much 'talk' as possible. Since this is so hard to control, their aim was simply to maximise the amount, and not to worry too much about the content or direction. But this, we think, may have a curiously distancing effect on how people view a 'development in their own culture'. Take just one repeated slice: the number of occasions on which viewers are told that there is about to be a 'battle' between Dredd and Batman. Typical examples:

> CLASH OF THE TITANS: Every summer there's a film that takes the nation by storm. Last year everybody went *Four Weddings and a Funeral* mad, the year before dinosaurs were everywhere as the country went *Jurassic Park* crazy. This year there are two films vying for prime position in the hearts of cinema goers. Both are adaptations of cartoon superheroes and both have been created with multimillion pound budgets. *Batman* prepares to do battle with *Judge Dredd*.[23]

> A MIGHTY BATTLE: All set for war at the box office It's the battle of the superheroes! The summer's really hotting up with two new action-packed movies released today. As caped crusader Batman continues to do well at the box office, two new champions are limbering up for a share of the takings. And they don't come much tougher than *Judge Dredd* – the comic strip hero played by Sly Stallone. It's a hit in the States but can the Judge sentence *Batman Forever* to the number two slot? Hot on his heels are *Mighty Morphin Power Rangers* – high-kicking action for kids. Their TV series is a hit but does the film have enough adult appeal to give it the punch to overtake Batman? Read our head to head verdict.[24]

The questions which strike us on reading this are, first: in what way does this emphasis on the battle between films shape viewers' measurement of films? But more than that, what sort of a battle is this? Is it to see which is 'best'? Is it to see which will win a 'ratings war'? If the former, then why are we being told, since we can discover by seeing for ourselves. If the latter, then it is our decisions that will determine the outcome. Yet we are addressed as though this outcome is settled somewhere else. It is our culture, yet we observe it from afar. We are in it, yet not of it. This most peculiar form of writing has been particularly strong around summer blockbusters in the past ten or so years.

But there is something else, here. If we have to choose between them (which is what is being asked), what do we know about each? Batman comes with the built-in advantage that he has 'performed' before. He has two successful bouts behind him, and a head start in this one. Dredd is the hardly-known challenger, who therefore has to puff his (or Stallone's) muscles even harder, to get our attention – and that risks over-hyping, as we will now show.

Orchestrating the market

While such public marketing was happening, with all its confusions, other parts of the promotional activities were happening less overtly, or at least with more mediations. *Dredd* had its premiere on 30 June 1995, three weeks before its public launch. The assembled journalists got a press pack with a set of stills and promotional shots for the film, a dossier of Production Information, and a *Judge Dredd* badge. The Production Information works very hard to convey the 'mythic stature' of Dredd and his world, offering a resolution between the demands of Dredd and Stallone:

> Internationally-respected author and philosopher Joseph Campbell popularized the cult of the mythic hero, relating it to deep spiritual needs in the human psyche. Sylvester Stallone believes that movie audiences want to see the hero undergo a revelation which transforms him, makes him greater than he was before. 'As an actor,' he explains, 'my strength will always be in the man who struggles for redemption. At the end of this picture, Judge Dredd has won two victories – in the battle against the forces of evil, and the battle for his own soul'.[25]

Such philosophising sat awkwardly with the film itself, and with the genres into the film sat most comfortably, and they perhaps indicate still further spillage from that nervousness about producing a 'fascist film'.

While journalists were being offered philosophy, cinemas were being offered a Campaign Book. Local managers are an integral part of the launch of a film. They can be involved in pre-launch screenings, one to each significant area, to try to generate that 'scuttlebutt'. They can occasion competitions, foyer displays, news items, links with local merchandisers, and specialist outlets. The function of the Campaign Book is both to give necessary information (addresses for all main merchandising companies, for instance) and to mark out the image-territory of the film. The opening discourse of this Book is therefore revealing, in complicated ways:

> 'Attention all law breakers, you have fallen under martial judge control. If any resistance is offered then you punks will be subject to immediate pacification.' So speaks the voice of Dredd, so – listen up. Sylvester Stallone stars in what looks set to be this year's blockbuster in the title role of *Judge Dredd*, the personification of relentless justice in a futuristic action adventure based on the hugely popular British comic book hero. From ultimate cult icon to universal dominating superstar, Dredd is poised to crush the opposition in his grip and grind this Summer's competitors beneath his heels. ... The unique images created

by a crack hierarchy of film makers are unlike any yet seen on screen and JUDGE DREDD promises to revolutionise the future look of cinema dynamics. As Stallone himself declares 'Dredd is about the re-define the hero of the 21st century'. So like the man says, listen up because 'The future is about to be filled with Dredd'![26]

There are so very many themes at work in this: (a) a continuous shifting between Dredd as present and as future, Dredd as film and as reality; (b) a combining of promises, predictions, and hopes, as if to say 'if this doesn't happen, this won't be our fault', (c) a sense that the audience of the film is also the population of Dredd's future, (d) a series of hyperbolic claims about the film that are both vast and vague. In truth, it is hard to see what kind of film could be even relevant, let alone adequate, to claims of this scale.

The Poster

Film Education were very clear in their Schools Pack: the core of a film's publicity campaign is its poster. But as we've already tried to show, analysing publicity isn't easy. It has to begin from the very purpose of publicity, which is to prepare us and motivate us to spend the money to see the film. In this respect, a straightforward semiotic analysis of, say, the poster campaign misses the point. As Trevor Pateman argued in an important article some years ago, the fact that we identify the function of a cultural form – we know its kind, and its intended use – vitally affects the meanings it can have for us.[27] The function of publicity is to prepare us, to make available to us the cultural associations, groupings, uses and responses which would be available to us if we see the film; and alternatively, to make us feel what we will be missing if we don't go and see the film.

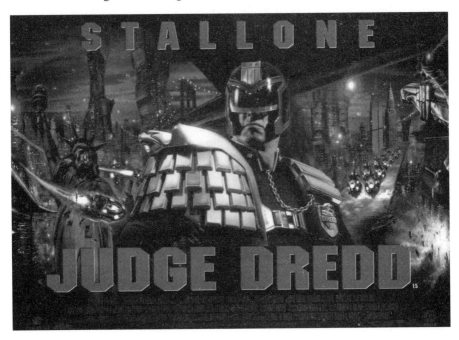

In this sense, a poster is necessarily indexical. That is, it works only in so far as what it shows and tells us points us forward and prepares us for what is to come. The meaning is not simply in the poster itself, but in what it promises. The poster is, and proposes, a triangular relationship between its content, its hints and presagings, and our capacity to read it. And that can mean that withholding information and assuming recognition can be at least as important as providing them.

With this in mind, consider the main poster for *Judge Dredd*, reproduced here in black and white only. Considering it *as publicity*, that is, in its functions as advising on possible uses and orientations, and suggesting motivations to watch, what promises might we take about the film? What claims does it seem to make about the nature and status of the film? The poster shows a large, dramatic figure, made *almost* anonymous by his helmet, 'bestriding' a city. Carrying huge shoulder emblems of power, in gold, and an evident uniform, he looks past us into the middle distance his face, cold, perhaps a grimace or sneer. On his chest a chain of office and an identifier badge tells us this is 'Dredd'. Behind, over his right shoulder, a futuristic city - but with the icon of the Statue of Liberty present, though somehow distorted. Over his left shoulder, and in a discontinuous area, a 'patrol' of identical motorbikes advances. The names 'Stallone' and 'Judge Dredd' top and tail the image in blocky, square capitals. The colours: red/flame blending into black, with small almost turquoise highlights. In the shorthand of film posters, what invitations does this propose?

1 The composition of central dramatic figure and dark environment forewarns that this will be a 'dystopian future'. America, the dire-to-come, will be policed. Though we do not see it, we know that this will be a world of conflict. It will therefore stand in line with other such bleak future-fictions.

2 The grandeur of the image, the distortions, the scale all also suggest that this will be an FX movie – one in which the visuality will be vital. The poster is 'loud' in its declarations.

3 For those who know, of course, the word 'Stallone' instantly imports a body of expectations: tough action male, survivor, with a hard battered body. The good guy, but maybe not by good means.

4 And for those who know the other words 'Judge Dredd', a different kind of expectation. This is a character and world from another medium, a comic filmed.

5 Something else is 'said' by this poster, which should not be underestimated. This is that nothing else is said. The poster presumes on our knowledge, on our ability to 'read' this composition of signs. With no indication of story-line, no direct time-coding, no sign of other characters, the posters speaks by its very minimalism.

In the light of these, we suggest that this poster makes six claims, which the film would have to vindicate to succeed with viewers. It will, it claims, be (1) an action-adventure, presenting an (American) world in which one man holds centre-stage and defies all odds to maintain order; (2) epic – a huge new world, with its own logic, coherence, look and panoply of excitements; (3) a vehicle for Stallone – his persona will be stamped large and consistently onto this stage; (4) a 'translation' of *Judge Dredd* and a realisation of his world in the medium of film, (5) a film (not

as obvious as it seems), that is, a new addition to the grand tradition of cinema magic, and finally (6) something for the knowing – those who could 'read' this poster would find it 'spoke with them' and allowed them to bring their knowledge and preferences to bear.[28]

But of course each claim had to survive testing. The film had to live up to any expectations it has thus managed to arouse.

The Judge Arrives

Judge Dredd finally opened on 21 July 1995. In Bristol it found screens at the multiplex Showcase (3 screens were devoted to *Dredd* for the first two weeks), at the city centre Odeon which had been reconstituted as a 3-screen cinema just a few years earlier, and at the north Bristol suburban Orpheus, a cinema which had been rescued by local initiatives after closing as an ABC cinema in 1993. It opened two weeks after *Batman Forever* (which found many more initial screens), and on the same day as *Power Rangers*. Curiously, and almost certainly accidentally, two films in the circuit just weeks before *Dredd* both used a catch-phrase that became associated with Stallone's Dredd: *The Madness of King George* and *First Knight*.[29] In all, it ran at Bristol cinemas for five weeks, with gradually falling attendances. The last to withdraw it was the Showcase.

So what did people get who chose to see it? There follows a cautious 'textual analysis' of the film. In the field of cultural studies, one of the first and predominant skills students are likely to learn, are those of textual analysis. A pantechnicon of books and articles have raised these skills to a high art, usable on all forms of culture. Still photographs, moving films, musical and visual forms, 'high' paintings and 'low' postcards: all formed cultural products are in principle open to 'reading' for implicit meanings. There is a tremendous attraction in these kinds of analyses. At their best, they can be exciting and illuminating, and at times surprise intensely, and with a sense of understanding our own reactions better. The question, though, is what exactly is thought to be discovered, or learnt, through such analyses? The proliferation of methods of analysis (semiotic, structural, literary, formalist, cognitive, narrative, intertextual, psychoanalytic, hermeneutic, etc) and of objects to be analysed (it's getting hard to find any kind that has not been analysed) has in our view disguised an unwillingness to answer some crucial questions, such as: what exactly can be shown (demonstrated, discovered, proved, or etc) by textual analysis? What implications are we entitled to draw from the outcomes of a textual analysis – for example, about actual audiences? Problems of this sort have inclined some people away from such analyses altogether. That is not our view.

This is a 'hot' area, and there is not the space to develop the position we adopt. We simply intrude, in order to explain broadly where we would stand, a set of distinctions suggested by David Bordwell, at the outset of his critique of psychoanalytic film-readings. Bordwell distinguishes four kinds of construction of meaning:

> 1. The perceiver may construct a concrete 'world', be it avowedly fictional or putatively real. In making sense of a narrative film, the perceiver builds up some version of the diegesis, or spatio-temporal

world, and creates an on-going story (*fabula*) occurring within it. [*Referential Meaning*] ...

2. The perceiver may move up to a level of abstraction and assign a conceptual meaning of 'point' to the fabula and diegesis s/he constructs. The film is assumed to 'speak directly. A verbal indication such as the line 'There's no place like home' at the end of the *Wizard of Oz*, or a stereotyped visual image such as the scales of Justice, could be said to furnish such cues. [*Explicit Meaning*] ...

3. The perceiver may also construct covert, symbolic, or implicit meanings. The film is now assumed to 'speak indirectly'. For example one might argue that *Psycho*'s implicit meaning is that sanity and madness cannot easily be distinguished. Units of implicit meaning are commonly called 'themes', though they may also be identified as 'problems', 'issues', or 'questions'. [*Implicit Meaning*] ...

4. In constructing meanings of types 1-3, the perceiver assumes that the film 'knows' more or less what it is doing. But the perceiver may also construct repressed or symptomatic meanings that the work divulges 'involuntarily'. Moreover such meanings are assumed to be at odds with referential, explicit, or implicit ones. Symptomatic meaning is like a disguise. Taken as individual expression, symptomatic meaning may be treated as the consequence of the artist's obsessions (for example, *Psycho* as a worked-over version of a fantasy of Hitchcock's). Taken as part of a social dynamic, it may be traced to economic, political, or ideological processes (for example, *Psycho* as concealing the male fear of women's sexuality). [*Repressed*, or *Symptomatic Meaning*][29]

Bordwell's arguments are really with the third and fourth, and we concur with his objections. We are attempting an analysis of Bordwell's first type, in that it is concerned with how readers may be able to construct a concrete world from the materials set in front of them.

Dredd: the plot and its principles

The film's plot wove together a series of elements and story-lines from different parts of Dredd's comic history: block wars, the return of Rico, cloning, Dredd's implication in a crime, a democracy movement, the Angel Gang, 1980s 'Goth' punk fashions, Judge Griffen's madness, an ABC warrior. Any knowing *2000AD* reader would be able to add more to this list. All got transmuted in the process of moving to the film.

'In the third millennium, the world changed...' The film opens with science fiction vistas reminiscent of a dozen films, at least. Returning to the city is minor 'perp' Fergie who has just completed his sentence. Hoping for a fresh start, and marvelling (with us) at the city as he is flown to his new home, he lands in the middle of a Block War – which Dredd, arrives to clean up. He's a colossus. Dredd rearrests Fergie (who offers a comedic strand throughout) for a minor offence, and sentences him to five years. The central story begins: Dredd is framed for a murder

actually committed by his genetic twin Rico. Rico, himself a former Judge who turned out bad, is helped to escape from his prison cell by Judge Griffen as part of the latter's plot to take over Megacity One. Rico, once out, recruits a decommissioned war robot to be his 'enforcer'.

At his trial Dredd is unsuccessfully defended by his female partner Judge Hershey, but because the murder weapon has 'his' genetic fingerprints, he is found guilty; he is sent to Aspen prison colony. On his way there, he re-encounters Fergie who reveals his identity, at risk of Dredd's life. But at the vital moment, the prison shuttle is shot down in the Cursed Earth desert by the Angel Gang, an outlaw group of cannibals, who just love the idea of eating Dredd! Of course Dredd escapes, but is saved in the battle with them by the arrival of Judge Fargo, his 'father', who had resigned as Chief Judge and taken the Long Walk out of the city, to save Dredd from the death penalty. Dying, he reveals the source of the conspiracy – a plot by Griffen to restart the 'Janus Project' to clone Judges, stopped when it produced not only Dredd but Rico.

Dredd returns to the city, with Fergie, breaks in through a flame-gouting vent, gathers the support of Hershey, and tracks down Rico, who has by this time disposed of his 'employer' and is planning to clone himself. In a long series of battles, Dredd, Hershey and Fergie disable the robot, and abort the cloning. Still forced to flee as an outlaw, a chase on flying motorbikes ensues, until he and Rico confront each other. Rico falls from the Statue of Liberty and dies, and Dredd is restored to his heroic position – and returns to the streets, his natural habitat, with a parting kiss from Hershey.

What makes this plot move? How are events connected, and what motivations steer it? The conspiracy is central, but the motivations for that are a bit obscure. Judge Griffen seems partly motivated by old-fashioned 'desire for power', but at times also by desperation at rising crime levels. It's never fully clear why he should be so keen to restart the Janus Project. Rico is just bad: he wants power, revenge, plus (presumably) eternal life through cloning. He is an epitome of fairytale hard-faced evil.

Dredd meantime begins the film as recognisably the steely embodiment of The Law he was in the comic, but soon reveals a different character. This is a tortured man, lonely but hiding it. Still, he's a role model to the wonder-struck Cadets whom he trains. But he has to 'learn' by the end of the film that The Law may be necessary, but it is limited and can make mistakes. The populace of the city in some ways look like the comic's population, but they are perps for different reasons. In *2000AD* block wars are the result of unemployment and urban stresses driving people crazy. In the film, people are just not 'controlled' properly; crime is the result of deviance, design or simple incompetence. In fact, after the first few minutes, the general population and the buzz of street life virtually disappear from the film, which enters the corridors of conspiracy and power instead – alleviated, meantime, by Fergie's comedy and a parade of catch-phrases (most notably, 'I knew you'd say that'...).[30]

If anything sums up the overall feel of the film, it is that 'things aren't working, and can't be trusted'. This is especially true of all the technology in the film, which

keeps going wrong! The film offers a positive orgy of hi-tech weaponry: voice-activated guns, 'Lawgiver' guns exploding in the wrong hands, the Lawmaster Mark IV motorbike mounted with cannons, and so on. But repeatedly the narrative turns on untrustworthy technology. The automatic food dispenser fails to save Fergie from detection. The voice-activated security system guarding Rico is easily overcome. Hershey's computer fails her, and Fergie can't mend it. The prison shuttle is brought down by a single gun. The DNA tests prove untrustworthy so Dredd is wrongly convicted. The Lawmaster repeatedly fails to start. The ABC warrior, supposedly a sophisticated killing machine, is brought low by pulling out a few wires, as if he is no more sophisticated than a hair-dryer. And so on. In the end, Dredd is saved not by his own power nor by technical wizardry, but because Rico's gun runs out of bullets. The clones, too, fail to materialise not because Dredd conquers them but because as the central computer tells Rico they aren't quite ready yet! Technology just lets you down.

Physical contact between people is minimal in the film, other than fighting, or rescue and protection (twice Dredd hauls Fergie to safety, for example, and Hershey pulls Dredd to safety from the edge of the Statue of Liberty). People are fundamentally isolated in their situations and motivations. But the idea of the 'family' keeps being referenced, even if only perversely. There are four 'kinds of' family images in this film. 1. The Angel Gang: though obsessively religious, these are hardly the Waltons, and rural America is not a reassuring idyll. This family represent all that is terrifying about 'serial-killer' rural America or mad 'deep south' trash.[31] 2. In Dredd's locker, curiously for a man with no emotion, is a carefully kept photograph of his family – which turns out to be a fake. Something seemingly idyllic, a happy young couple with their baby, simply doesn't exist. 3. Dredd's first fully-displayed emotion is when his 'father', Chief Justice Fargo, dies in his arms. Dredd swears revenge, Hamlet-style. 4. When the 'make believe' family of Dredd, Hershey and Fergie prepare for the final battle with Rico, something a bit odd happens. Dredd protectively forbids Fergie to come along. Fergie pleads, 'I can help! We're a team!' Hershey mediates with Dredd until Dredd relents. This is the nearest to a family scene we get in the film.

So the 'family' has become perverse, problematic at best. Rico's attempt at 'fatherhood' ('Congratulate me', he says to Griffen, as he sets off the creation of the clones, 'I'm going to be a daddy') represents paternalism gone wrong. The problem with paternal power is responsibility. More than once, there is a reference to 'playing God' (Rico tells Dredd 'we could have been gods!'; a concerned Judge says of the Janus Project 'It's not for this council to play God'). And as Fargo says as he dies, 'too much power' was in too few people's hands: 'ambition is fatal'.

This ethos spilled out of the film into surrounding publicity. Stallone, interviewed, argued: 'What America needs is one person in an influential position to literally get up there and tell the truth...our legal system isn't working ... It's corrupt... We need one powerful voice ... we need straight talk'.[32] This is a particular kind of bleak picture, of an unstable and corrupt world, peopled by the dangerously mad and the obsessively driven. Cause and effect are no longer reliable. Whose imaginative dystopia this is, is not too easy to see. It is certainly not the comic's.

Associating with the film

But of course much than a film got released. As part of the same launch, the public were also offered: a wide range of merchandising and product tie-ins; a series of other versions of the story; and a relaunch of 'Dredd' himself back into his original medium.

The merchandising was, typically, very varied. It included video and hand-held games, a variety of clothing (caps, tee-shirts, jackets, socks, pyjamas, etc), towels, duvet covers, bags, models, postcards, collectors' cards, badges, posters, wallpaper, key rings, Advent calendar chocolates and a (rumoured) cake. Tie-ins included the Sugar Puffs and Shoe Express links, plus a continuing special link with the *Daily Star*. The virtual randomness of this is significant, as we'll see.

But the attempt to relaunch Dredd himself is more telling. Fleetway, perhaps wisely, decided not to over-commit themselves. Originally they had planned a relaunch of *2000AD*, restarting at Prog 1 (see the next Chapter on this). Instead, they limited themselves to putting out a junior version, entitled *Judge Dredd: Lawman of the Future*.[33] Hoping that this might reach young people fascinated by the film, but perhaps not able to see it (since it was classified '15'), *Lawman of the Future* had to be quite sharply differentiated. Fleetway's editor accordingly put out a call to writers to offer scripts for the new publication. This offers a very concise and insightful picture of the planned new comic, by contrast with their picture of the old – and by chance, a means to measure the film. We reproduce overleaf their differentiation in full.

The first column depicts a safe, almost cosy adventure-framework. The second column depicts the cynical, knowing world of the Dredd that fans generally loved. The third (italicised) column is our addition, characterising the film in the same terms. What it shows is that *the film veers towards the junior version.*

Comparing versions of the story

The film's version of Dredd appeared in several other media. Fleetway produced an official comic book adaptation;[35] the fact that it was drawn by Dredd's original artist Carlos Ezquerra, managed to infuriate a number of *2000AD* fans when he was forced to draw Dredd without a helmet. A colour comic strip adaptation appeared over a two-month period in one newspaper Sunday Supplement.[36] Boxtree produced a novelisation written by Neal Barrett, Jr.[37] Castle Communications released an audiobook adaptation of this.[38] Most bizarrely in

Judge Dredd: Lawman of the Future

Writers' Guidelines

JD:LotF is a new comic being edited by David Bishop for Fleetway Editions. It is aimed at 7-12 year old boys, to introduce a new generation to the world of Dredd. ... It is unlikely the target audience will be able to see this film until it comes out on video, but they will be excited by it and the attendant wave of merchandise.

What follows are some general guidelines for potential writers

WHAT'S HOT	WHAT'S NOT	THE FILM'S GOT
Action/adventure	Horror/violence	*Action/adventure*
Heroic action	Anti-heroes	*Heroic action*
Fantasy hero	Realistic hero	*Fantasy hero*
Fighting evil	Fighting for himself	*Fights evil/discovers himself*
Escapism	Attainable dream	*Distant dream*
Fantasy world	Our world	*Mainly fantasy world*
Larger than life	Realistic, mundane	*Larger than life*
Originality	Homage, satire	*Homage without satire*
Simple, clear stories	Complex plots	*Simple, but messy story*
Empathy, involving	Repetitive violence	*Empathic but uninvolving*
Character detail	Details of world	*Some details of each*
Beginning, middle & end	Motiveless action	*Beginning, middle & end*
Occasional slang	Endless jargon	*Occasional jargon*
Complete stories	Segments of graphic novel	*Complete story*
Cliffhanger endings	Climaxless climaxes	*Climax after tension*
Dredd as motivated lawkeeper	Dredd as killing machine	*Dredd as increasingly motivated lawkeeper*
Dredd obvious goodie	Dredd as anti-hero	*Dredd becoming goodie*
Pictures tell story	Captions tell story	*Not applicable*
Entertainment	Lecturing, didacticism	*Entertainment + moral*
One villain per story	Nebulous, multiple foes	*Conspiracy of villains*
Clear, concise text	Shortenings, phonetics	*Length dialogue*
Impact	Obscurity	*Aimed at impact*
Communication	Cleverness	*In-the-face communication*

Continuity Guide: Forget everything you ever knew about Dredd ...[34]

our view, Boxtree also published at least two truly dreadful pamphlets telling the film's story from the perspective of Judge Hershey, accompanied by stills from the film.[39]

Taken as bare plot, these can seem very alike. Looked at as kinds of story-telling, they are markedly different from each other. A comparison of openings tells much. The film opened with a melange of classic *2000AD* covers featuring Dredd, over which appeared title and credits. These dissolve to a dark screen across which scroll, *Star Wars*-style, the opening words which are spoken to us by James Earl Jones' rich bass:

> In the third millennium, the world changed. Climate. Nations. All were in upheaval. Humanity itself turned as violent as the planet. Civilisation threatened to collapse. And then ... a solution was found. The crumbling legal system was merged with the overburdened police, creating a powerful and efficient hybrid. These new guardians of society had the power to dispense both justice and punishment. They were police, jury, and executioner, all in one. They were the Judges.

As this fades, the camera drops to reveal the silhouetted back of a cloaked, helmeted guard on a parapet looking out over dry wilderness. Engine roar announces the upsurging arrival behind the guard of a huge flying machine. It's the prison shuttle bringing prisoners who have completed their sentences back to the city. Among them is Herman Ferguson, petty criminal who sets out to his new assigned 'home'. Over several minutes we track Fergie's reactions to the mile-high cityscapes, as he is transported by air to his residential area. He is wide-eyed and hopeful that his new home will be as marvellous as its name, 'Heavenly Havens'. This impossible response – a long-time petty criminal is hardly likely to be an innocent naif who doesn't know his way round the city! – allows us a guided tour and introduction to Megacity One. When he lands, it is to find a Block War in progress, with citizens rioting and fighting each other.

The official comic adaptation opens with the scrolled words as simply a caption, and takes us straight to Fergie's arrival. No significant attempt is made to make him, or indeed any of the other characters, look like the actors who played them. The flight over the city is removed, leaving instead a scene not found in the film, in which ordinary citizens begin to hope that 'Heavenly Havens' is going to be a park for their relaxation – only to see the plans for it replaced by something rather different: 'Coming soon, the Heavenly Havens Law Enforcement Barracks, bringing security to your lives – '.[40] In the comic adaptation, it is this which sparks the Block War – a nice residue of the cynicism not allowed the film. Overall, this adaptation feels awkward, an unstable amalgam of classic and movie Dredds, typified by his response to the 'death' of Fergie (who never reappears to prove he survived his destruction of the ABC Warrior): Dredd shows he cares about Fergie as he lies 'dying', promising never to arrest him again and then seeking out Rico as though on a personal vendetta.

The novelisation shifts ground again, this time more closely tying the story into a science fiction mode. Along with a back cover which emphasises Dredd as

personal legend ('The year is 2139. *Judge Dredd* is the story of a man who is the Law, and of a deadly journey that begins when the Law, corrupted by a sinister conspiracy, turns against him for the first time'), the 'scroll' account of the origins of the Judges now becomes a 'quotation', from 'James Olmeyer III, *History of the Mega-Cities* (2191), Chapter II: "Justice", a device which recurs throughout. This conceit of using future histories to 'place' the events of a story derives from Frank Herbert's classic *Dune* series of science fiction novels – the first of which was itself the subject of a cultish (1984) film adaptation. The story dispenses with all the opening scene-setting, launching us into Fergie's battle for survival: 'Herman Ferguson ran as fast as he could ... Fergie had been running all his life. Running from his father, his brothers, from the law. From outraged victims of this scam or that. Now the streets were full of blood and he was running again'.[41] The 'feel' overall is a cross between science fiction, and hard-boiled crime novel.

The audiobook carries this further. Its cover-summary fuses the 'scroll' account with the novelisation's, now emphasising an 'environmental accident' and the emergence of 'three giant self-sufficient cities'. The tape itself opens with almost a four-minute symphonic introduction gleaned from the film score, before a dead-pan bass voice thuds in with '*Judge Dredd* – The novelisation – By Neal Barrett, Jr':

> The shuttle had gotten its cleansing spray. Nearly-faded letters on the side read 'Mega-City Judge System. Aspen Prison Shuttle Number 3'. 'Next', the Guard said. He stuck his right hand into the blinking red slot. The robot sensor whirred, then winked at him in green. "*Ferguson, Herman, ASP-niner-zero-zero-seven-six-four. Sentence served: six months, three days. Welcome back – citizen*" Thanks, Fergie said. The robot made a bleating sound, and then flipped him a blue plastic card. The card showed Fergie's face the day he'd entered prison. He was free. He didn't feel free, but he'd be damned if he'd let that hold him back. The back of the card read: 'Living assignment, Red Quad, Block Y, Heavenly Haven, Citizen Suite 666'. Poking his card in an infoslot led him to the skycab station that would take him to the Red Quad sector, some sixty miles away.
>
> The skycab set him down on a pleasant street. Couples strolled, hand in hand, Children chased each other across the lush lawn. The scene brought a smile to Fergie's face. *Man, can these frigs possibly be as dumb as they look?*

There is a relentlessly bleak quality to all this, which is redoubled by the flat hard voice of Robert Firth's urban-American rendition. Fergie is no innocent. 'We' knew from first mention that Heavenly Haven was not going to be 'heavenly', in a way that we never did in the film (or original comic, come to that). This is a hard cynic who is already planning his next con trick. This is futuristic hard-boiled fiction, without residue.

There is little point spending time on the comic strip adaptation, or *Hershey's Tale*. The comic strip acts as a minimalist memoir of the film, showing odd moments at

such speed that the plot becomes just a sequence of main events. The only thing to distinguish it is the fact that here, for the only time, Dredd actually looks like Stallone. *Hershey's Tale* is simply impoverished; we hope it failed, miserably.

It's hard to make sense of these changes. The most interesting without doubt are the novelisation and audiobook which have the virtue of finding a new site for the story, and transmogrifying it sufficiently to let it 'be its own thing'. But on the negative side, the lack of a common element is just another sign of the dispersal of the image of Dredd, with no core or centre.

We've spent some time on all these materials precisely because they tend to be ignored by most film analysts, yet they are very much part of the cinematic experience proposed by the makers.

1 For details on *Action,* including the differences made in the transition to the comic, see Barker's *Comics,* Chapters 2-3, and *Action.* See also the interesting new materials gathered in Colin M Jarman & Peter Acton, *Judge Dredd: the Mega-History*, London: Lennard Publishing 1995.

2 'Dan Dare' remained in *2000AD* for several years, but was not very popular after the early days. IPC did not read the tea-leaves. In 1984 they had one last attempt to relaunch the character, in his own comic. It failed, badly.

3 John Newsinger has contributed a useful essay on the characteristics of Dredd, in his 'The Dredd phenomenon', *Foundation* 52, Summer 1991, pp.9-16.

4 'Halo Jones' is worth particular mention, as the first significant example in an essentially male comic of a female hero. Jones becomes a mercenary in a future army, and is followed through the travails of various wars. A moving story, it helped bring its author Alan Moore to fame, although it was not at first very popular with readers.

5 There is a strong trend of self-ironisation among comic readers, who are intensely aware of the way they are pictured by outsiders. The 1990 United Kingdom Comic Art Convention in London was split between two large buildings, opposite sides of a busy road. A man was employed to stop the traffic occasionally, for safety reasons. His Stop sign read: 'Caution: fanboys crossing'.

6 On this period, see Dominic Wells, 'Dredd reckoning', *Time Out*, 13-20 November 1991. This report is interesting both for the antagonism it reveals, even at this point, between the comic's scriptwriters and the American producers; and for the way, even then, it set up Dredd in competition with Batman ('He's British, he's brutish, but can our top copper beat Batman?').

7 Jane Killick with David Chute and Charles M Lippincott, *The Making of Judge Dredd: In the Future, One Man Is The Law*, London: Boxtree 1995, p.35. This fear of 'fascism' even reared its head even into the pages of *2000AD.* Prog. 950 (28 July 1995) carried an interview with the eventual main scriptwriter on Dredd, William Wisher, well-known for his work on *Terminator:2*: '"I remember the first time I encountered it", says Bill. "I was thinking that I liked it very much, but the comic book *Judge Dredd* is basically a humourless fascist. Ultimately that is what is funny about it because it's a sort of satire parody on our own society. I thought "well, this is going to be a challenge". Taking a character like this and making him more accessible to a large audience, but without losing what was unique about him".' Diminishing his 'fascism', many readers subsequently felt, precisely lost that uniqueness.

8 Jane Killick, *The Making of Judge Dredd*, p.41.

9 Jane Killick, *The Making of Judge Dredd*, p.42.

10 There are not yet many biographies of Stallone. A useful one is Adrian Wright, *Sylvester Stallone: A Life on Film*, London: Robert Hale 1991. See also James L Neibaur, *Tough Guy: the American Movie Macho*, Jefferson, NC: McFarland & Co, pp.208-17.

11 The dangers of excessive 'readings' of a film. The original American version has 'Rambo ... is a pussy'. Because of the sexual connotations of 'pussy' in Britain, it was over-dubbed as 'primitive'. At least one learned essay on gender and cinema cites the original as evidence of a new anti-feminist masculinity in Hollywood. Does, then, the changing of the one word alter the meanings and uses of a film, we wonder?

12 See Stallone's interview, 'Why I despise the past 10 years', *Guardian*, 15 August 1997: 'In a remarkably candid interview with Trip Gabriel, Sylvester Stallone reveals how he's trying to reinvent himself'.

13 See for instance, '*Judge Dredd* to rule the world: tough guy Stallone's amazing outburst shocks Hollywood', *Sunday Mirror*, 2 July 1995, pp.12-3. 'Movie tough-guy Sylvester Stallone has stunned his Hollywood pals with an amazing right-wing outburst. The former Rocky and Rambo star wants a ruthless leader, like the fearless *Judge Dredd* in his new £50 million sci-fi movie, to clean up the world.'

14 Roger St Pierre, *Sylvester Stallone*, Romford: Anabas Look Books 1985, p.26. These are in fact the closing, summative words of the book.

15 On this, see Barry King, 'Stardom as an occupation'.

16 *Judge Dredd: the Form Book*, Fleetway Editions 1990.

17 *Judge Dredd: the Form Book*, Fleetway Editions 1995.

18 This one we don't know about. We have this sense of an 'absent centre' in our research ...!

19 Matt Bielby, L A Turner et al, *SFX*, No.2, July 1995, pp.22-41.

20 Alan Jones, *Cinefantastique*, August 1995, Vol.26, No.5, pp.16-40.

21 *Judge Dredd: Study Guide*, London: Film Education 1995, p.11. The circle closes: the booklet ends with a bibliography of further reading, which includes ... Barker's *Action: the Story of a Violent Comic* - though they do manage to mis-spell his name ...

22 We should be clear: this is in no way a plea for 'protecting children from insidious advertising, in fact, we suspect that doing exactly this was counter-productive to the film (see below, Chapter 12). What we are doing, is simply investigating the publicists' strategies, to see in what ways they are expressions of the 'new Hollywood' and what light they might throw on the films' ability to generate particular SPACES for viewing.

23 *Satellite TV*, August 1994, pp.54-5.

24 Bristol *Evening Post*, 21 July 1995., pp.24-5.

25 *Stallone: Production Notes*, London: Guild Entertainment 1995.

26 *Judge Dredd: Campaign Book*, London: Guild Entertainment 1995

27 Trevor Pateman, 'How is understanding an advertisement possible?', in Howard Davis & Paul Walton (eds), *Language, Image, Media*, Oxford: Basil Blackwell (1983), pp. 187-204. An equivalent point is made by Justin Lewis (*The Ideological Octopus*, pp.45-8), criticising those who analyse music videos whilst largely forgetting that they are produced primarily as promos!

28 We have reproduced and analysed the main British poster. American publicity was markedly different. The main newspaper advertisement sequenced three panels: 'THE GOOD' (a sneering Stallone with vest and huge gun, turned a quarter away from the viewer), 'THE BAD' (the ABC Warrior full-face to us and looking distinctly dangerous) and 'THE UGLY' (Mean Machine looking like a bull ready to charge). The images lacked background, therefore seemed to imply no world, and to be linked to no generic images. At most, it conjures up a world of weirdness, where science fiction borders on the monstrous-technical. The main American poster combined these three images, setting Stallone (without Dredd's helmet) on a large motorbike. He is riding towards us down a devastated gully, backed by clouds of smoke and firing a huge gun into the sky, looking for all the world like a latter-day cowboy riding against 'bad guys' – who are seen at the front bottom of the poster in all their smirking weirdness. The header-slogan is: 'The Thrill Ride of the Summer'. It has to be said that in as much as we can 'place' this poster at all, it is much harder to identify what genres it is promising.

29 Both these films have as a catch-phrase Dredd's own 'I Am The Law' – almost as though they were mocking it in advance of its arrival ...

29 Adapted from David Bordwell, *Making Meaning*, Chapter 1.

30 *2000AD* readers were offered a series of references and cues which only they were likely to get. For example, the 'smiley face' on the Statue of Liberty cued the popular 'Chopper' story of a rebel skateboarding grafitti artist who was 'judged' by Dredd.

31 There is a long history to these images of "white trash", as John Hartigan has showed ('Unpopular culture: the case of 'white trash', *Cultural Studies*, Vol.11, No.2, 1997, pp.316-43). What may need exploring is the difference between American representations of their own southern poor, as here; and the recycling of those images in Britain, as in the original *2000AD* picture of the Angel Gang.

32 Alan Jones, *Cinefantastique*.

33 In the event, this new junior comic flopped badly, and lasted only a few months.

34 Ian Purdie (Editor, *Judge Dredd: Lawman of the Future*), 'Submission Guidelines', London: Fleetway Editions 1995.

35 *Judge Dredd: the Official Movie Adaptation*, written by Andrew Helfer, artwork by Carlos Ezquerra, London: Fleetway Editions 1995.

36 *News of the World*, 'Sunday Magazine', July/September 1995. Script by John Wagner, artwork by Ron Smith.

37 *Judge Dredd*, Novel by Neal Barrett Jr, based on the screenplay by William Wisher and Steven E deSouza, London: Boxtree 1995.

38 *Judge Dredd*, Based on the novelisation by Neal Barrett, Jr., abridged by Edward Seago and read by Robert Firth, Castle Communications 1995.

39 *Judge Dredd: Hershey's Story*, and *Judge Dredd: Ferguson's Story*, both by Richard Mead, London: Boxtree 1995.

40 That this difference is the result of late editing changes to the film is confirmed by the shooting script included in *The Art of Judge Dredd: the Movie* (London: Boxtree 1995) which, having presumably been produced to the same time-scale, also keeps these elements.

41 Neal Barrett, Jr, *Judge Dredd*, p.3.

10 WHO CARES ABOUT DREDD?

These, then, were the formative histories that created Dredd and put him into the public arena in July 1995. And we can see the form that it took – not just as a film, but as a concatenation of cultural products offered to all of us. The film did not do well. Having cost over US $70 million, its box office returns were not good enough. While *Batman Forever*, released just a week before Dredd, launched on over 800 screens in Britain, Dredd managed only 292.[1] Distributors knew after the first week that they had problems – Dredd ranked fifth in viewing figures, behind *Apollo 13*, *Pocahontas*, *Batman*, and *Power Rangers*. Overall, box office takings grossed US $78 million world-wide, with US $34 million in the US – but set against that has to be the US $20 advertising spend in the US alone, and of course that the gross figure is split between cinemas, distributors and Cinergi. In one or two countries – notably Japan – Dredd performed well; in others, very badly.[2] By September, the film was dropping out of the top 30 across the world. Released for video rental on 18 December, Dredd did better than might have been expected, but not enough to recover the main losses. This poor performance, along with two other 1995 box office misses, *The Scarlet Letter* and *Nixon*, plunged Cinergi into trouble – despite having one smash hit in the same year, *Die Hard With A Vengeance*. After protracted negotiations with various companies, in April 1997 they announced liquidation of the business over a six month period. Disney acquired their back catalogue in return for cancellation of US $38 million production advances.

Why did Dredd perform so badly? That is not a question we could possibly answer in full with our kind of research. A number of extraneous factors were at work. Not only was there the specific competition with *Batman Forever*, there was the sheer fact that 1995 saw a sharp increase in the number of major film releases (from 130 in 1994 to 153 in 1995). This had the effect of 'reducing the average take by about US $5.5 million to US $32 million per release'[3] – but of course the takings were not averaged! At the same time, overall audiences fell in the UK for the first time in a decade. By mid-1995, they were predicted to fall by 119 million, but in fact fell to 110 million. But the time-scale of film production can't cope with such shifts.

Dredd's achieved 'persona'

Still, there are things that our account now suggests about the failure. First, consider what image of itself the film managed to generate.

Judge Dredd never in fact managed to generate a clear image of itself, despite – or even because of – all its publicity. Such images can take make many effective

forms. Consider, for instance, *Superman*, which managed to become a regular reference point for American politicians, even if often in joking manner. Consider Stallone's *Rocky* and *Rambo* films – even if the latter produced associations with Hungerford massacre (though there was in fact no link), it still contributed a clear aura to the films and the character. Consider *Independence Day*, with its memorable image of the exploding White House. Each established the distinctive presence for itself we discussed in the last chapter.

In Dredd's earliest days, his public persona was largely set from outside. Prog 1 of *2000AD* was launched to a watchful, suspicious Press. John Ezard in *The Guardian* contributed a long estimating article which tackled the emergent comic from the point of view of the then current worries about 'stereotyping'.[4] More traditional objections surface from time to time. For instance, in 1980 Sean Dunne in the Irish *Sunday Press* bemoaned *2000AD*'s 'whirlwind of sexism, violence and little fun', illustrating his article with a cover showing Dredd in a pose which would become iconic in the film. Standing between two giant city blocks, he orders: 'These blocks are under arrest!'[5] The humour of this passed Dunne by. But these complaints were minor, of course, compared to the rows that had hit *2000AD*s immediate precursor *Action* in 1976, and which had caused its suspension and bowdlerisation, and subsequent death.[6] The use of science fiction seems to have put a zone of relative safety round the comic, exempting it from the worst fears of critics.

But by the mid-1980s other forces were at work. By now, the idea of teaching 'popular culture' in schools was at least being considered. The balance between that and the customary dismissiveness is nicely captured in one report in the (again Irish) *Sunday Tribune*: 'Suddenly comics are becoming respectable, and *Judge Dredd* has even made it into the school curriculum', wrote Ciaran Carty ... under the inevitable headline 'AAARRGGH!'.[7] But another evident reason for a shift in Dredd's image was the emergence of a music fandom which appropriated him as a symbol. As fandom strengthened on both sides of the Atlantic, early Dredd artists like Brian Bolland made their way to the States, there to make big names and big money. Comics began to 'grow up', until – with something of a Press chorus – the arrival of the 'Graphic Novel' was declared. Suddenly comics, including *2000AD*, carried an aura of chic.[8] Add finally the rising number of journalists with backgrounds in fandom, and there should have been real potential for a 'Dredd explosion'.

Instead, the film was greeted with a loose baggage of references with no visible centre. The *Daily Star* (which had run a newspaper strip version of Dredd for some time) gave over their entire front page to a (dreadfully drawn) cartoon of John Major as Dredd, to ironise his temporarily hard style towards his Cabinet colleagues.[9] *The Guardian* casually used Dredd as a base for mocking the American rightwing judge Justice Scalia; what's interesting is that they use the name without explanation, yet the story bears no obvious relevance to Dredd as film or as character.[10] Only the next day the *Daily Mirror* again referenced the name on their front page, in their lead article about a judge accused of sexually assaulting a woman police officer: 'Judge (every woman should) Dread', they

blazoned, repeating the reference in their two-page inside article – again, without any apparent need to explain the inappropriate pun. The strange thing is that six months earlier there had been a slightly more relevant use, in a *Guardian* headline to an article about millennium thinking: 'The Dredd of *2000AD*';[11] this does capture something of the ambivalence about the future that comic and character embody. And an understanding of Dredd as purely right wing would return a year later, when *The Guardian* illustrated a major article on petty crime with a large photograph of Stallone as Dredd, captioned 'Zero tolerance ... as epitomised by cartoon and film hero *Judge Dredd*'.[12] But during the time of the film's greatest presence, Dredd was simply an all-purpose reference, perhaps best illustrated by the cover of the Broadcasting Union's journal *Stage, Screen & Radio*. The cover is dominated by one of the film's main images of Dredd, yet the only possible link to contents is a bald declaration of intent on the BBC's Transmission sell-off that 'We will prevent it'.[13] This is a completely hollow association, indicating that *Judge Dredd* had become an empty 'catch-all', not linked to the comic's or film's meanings.

Sadly, the nearest anyone comes, that we have found, to an identifiable image-in-use of Dredd is a passing reference in a painful essay on the lessons of the Hillsborough football disaster. It is of human beings reduced to being machines. A policeman summarising both the reactions of his colleagues to seeing all the deaths, and also the ease with which their subsequent suffering has been dismissed, digests his feelings: 'We're human beings. If we weren't, there'd be a *Judge Dredd* kind of society'.[14] Within two years, the film is being dismissed. When *Loaded* decided to celebrate *Judge Dredd*'s twentieth anniversary in 1997, the movie was curtly dismissed as 'the rubbish film version' from the character had now recovered – though what it had recovered to, was not perhaps the original. The cover showed a scowling Dredd holding an armful of half-naked woman who winks at us. And inside, the emphasis is strongly on a new 'adult' streak emerging in the comic. Dredd meets lad-culture. Beat it, perps.[15]

Judge Dredd and ideas of 'America'

More complexly, it seems to us that our film almost certainly tripped over itself in its handling of the image of 'America'. There is a long tradition in Hollywood of images of other countries, including Britain. For a long time, 'Englishness' was a double-edged representation in Hollywood films: on the one hand, culture and quality and history (the succession of 'costume dramas' and Shakespeare adaptations doing well at the American box office attests to this); on the other hand, English as villains (exemplified most recently by the succession of parts played by Jeremy Irons). But this has always situated Britishness or Englishness as a difference from American-ness. There was always, therefore, an in-built problem in having Hollywood handle a story generated out of British representations of America.

The history of British representations of 'America' has been quite well-researched.[16] The outlines are clear: the idea of 'America' has long been a centre of fascination and an image of glamour and excitement for many ordinary people

– who can at the same time see in it many frightening things, perhaps portents of what might come to Britain. America has been simultaneously a land of riches and untold opportunities, of Hollywood and celebrities, but also a land of urban waste, crime and violence. America is modernity and futurity, both attractive and repulsive. As we saw earlier, in the 1930s it was to many people known almost entirely through films, but television and travel among other things have changed that. America's more overt world political role has problematised its image for many more people, especially after Vietnam, Watergate and many other conflicts. Yet it remains, it seems, a place where futures are forged – and that has a fascination. And of course Hollywood is well versed in representing America as the place where history takes place. It was inconceivable that the aliens of *Independence Day* should choose anywhere but America to focus their landing.

The trouble with Dredd was that this was a particularly cynical outsider's image. *Judge Dredd*'s America of the future was more than the site of a series of bizarre 'predictions': quiz shows in which the contestants are killed, body-sculpturing to make yourself ugly, new forms of insanity to match the crazy urban environment. It was the really possible future as authoritarian, told by the likes of Dredd but seen through by the disaffected as a lie. This was brilliantly seen in one full-length comic story, the story of a young girl called 'America' because her father, an immigrant to the US, wanted to celebrate his 'freedom'. But his freedom became her torment as she is led through despair and desperation to work as an outsider, a 'terrorist'. Finally she is cynically killed by the Judges – who appear as terrifying symbols of oppression and fear.[17] This layering of ironies spilling over into satire, suspicion and rejection couldn't be accommodated by Cinergi's Hollywood machine, even while they smelt and were attracted by the raw power in the world of Dredd.[18]

Understanding merchandising

One measure of the success of the film has to be its merchandising: not so much through the global figures on profit and loss, which anyway are almost impossible to obtain, but through the kinds that succeeded and failed. We don't have full information on the outcomes of merchandising *Judge Dredd*, but some indices can be established which sit awkwardly with the dominant story which talks too glibly of cynical selling of cheap, useless accompaniments to credulous children or obsessive fans.[19] Without question, merchandising *in toto* is a sizeable part of the balance sheet of modern popular film, and can't be ignored. But its operation is complicated.

First, time-scales require that licences have to be pre-sold a long time before anything of a film can be seen. This is fine in the case of an established repertoire: a sequel, a well-known theme, a fixed character any of which can be reasonably known to potential licensees. Not so Dredd, who came to the screen from the insulated world of comics. For more than two decades comics have been squeezed for space within high street newsagents as sales have fallen and the number of other magazines has steadily risen. A growing proportion of comics have been sold through specialist comic shops, whose numbers have grown in Britain from 3 in

1970 to over 300 in 1990 – but which have been sharply reduced by a crisis in the comics business since then. Selling merchandising licences for *Judge Dredd*, therefore, involved risk-taking based on calculated guesses. Typically, Fleetway worked through a professional licensing company, Copyright Promotions Agency.[20] Many companies took up provisional licences, doing preparatory design and prototype work which were then abandoned when it was announced that the film would be rated '15'. A series of more child-oriented product lines, such as moulded soaps, were dropped.[21] The overall weak performance of licensed materials was confirmed by the film's relative low ratings. But that is not the end of the story.

Some products did well. Acclaim Entertainment were well satisfied with the performance of their platform game version of Dredd. That, of course, entered a market with its own dynamics, now seen as the fastest growing of all areas of media and leisure activity. It is a 'knowing' market. The game would benefit from the novelty of association with the film,[22] while being simultaneously fitted within the 'beat-'em-up' tradition (the term used to describe games built around central figures who are constantly assailed by enemies who have to be knocked down and destroyed), and discussed, reviewed and evaluated within the publications devoted to electronic games. Not all merchandising is equal, in this respect. A duvet cover or an advent calendar don't enter the social world in the same fashion as a hand-held game. Some products depend totally on chance sales through their association with the idea of the film. Others just carry the imprimatur of the film into a sector that has a life of its own. A *Judge Dredd* cake, or watch, has to be spotted as someone's birthday approaches and is likely to be used to memorialise the occasion of seeing a favourite film. A tee-shirt is more likely to be bought through a specialist outlet, where it will associate with an on-going life of the characters – but can also turn up on the racks of market stalls (though sometimes as illegal rip-offs). A novelisation or audiobook of the film will join the ranks of cult extensions of stories, as will a book on the art of *Judge Dredd*, or a model of Mean Machine. Paradoxically, the more the opportunities for generic location, and for measurement against like materials, the greater the chance for a product to gain a life of its own and to become 'its own thing'.

Merchandising is a risk business, with many complications. A film's classification and its subsequent performance are not the only ones. There are also complexities such as late editing decisions. Famously, *Star Wars* saw changes which altered or even eliminated characters late on, which affected toy versions of them.[23] In smaller ways, the same happened with Dredd. The official comic book adaptation – perhaps the most directly dependent product – contains scenes not found in the film. Oddly, had there been enough of these, and had rumour of this spread, the adaptation could have become the equivalent of a 'director's cut' and sold well on that basis.

Who produces the merchandising, then? Some of course is produced by well-established major companies. In a few cases, these have grown up specifically by capturing the main markets for licensed materials. In Britain, the classic case of this has to be Boxtree who dominate the market for books on 'The Making of...',

and who operate almost entirely around licensed concepts. Other major enterprises such as Mattel Toys (now the largest toy manufacturer in the world) have licensing divisions. By and large, these companies work precisely in the safest areas of merchandising. But a good deal of licensed production is carried by small, hopeful companies. These are the ones which carry the highest levels of risk, and depend most on the performance of the particular film. Socks, sweets, school bags, pyjamas carrying a logo or a character's picture are the most dependent on chance associations, encounters and whim-purchase – and of course on time of year, with Christmas as obvious prime period. What we're trying to convey is that merchandising is built out of a nexus of local and specific judgements and risk-calculations which make cynical decisions doubtful.

With Dredd, licensees had the added complication of two options: 'Option One was to take out a licence featuring the imagery of the character in the comic. This became known as the Classic licence. Option Two was to take out a licence featuring the imagery of the characters in the movie (the Movie licence)'.[24] Most companies opted for the classic imagery. Mattel, a major player, were clear: why should they use Stallone, they asked? He's never sold a single toy for us! The main movie-related materials were clothing, posters, and some model kits, along with books about the making of the film. Quaker Oats' Sugar Puffs promotional cards used film stills, as did Collectors' Edge trading cards. Acclaim's game simply mixed the two. But what seems to have determined success or failure was the capacity to create film-independent reasons for purchase. One company operating in the competitive toiletries field told us of their disappointment not just at the film's performance but at the inappropriateness of the link: 'it soon became clear that the film was actually aimed at an older age group and so, speaking for ourselves, there was evidently a mismatch with our product and target audience compared to that of the film. Consequently our product was quite unsuccessful and was withdrawn before launch.'[25] Other companies selling specifically youth-oriented goods told us that they had sold items like caps, mugs and jackets virtually as they had expected.

General geographies can flatten local contours. With Dredd, perhaps the most interesting was Fleetway's own sense of the possibilities of relaunching the original comic book and character via the film. With sales slipping perilously during the 1990s, hard thinking went into the opportunities the film might offer. But the company was nervous, not sure at all what benefits might accrue from the film. Something of this can be sensed from the way the comic began 'warning' readers what, and what not, to expect of the film some two months before it appeared.[26] Apart from hyping the film at the point of its release,[27] caution prevailed. Plans had been laid for a full-scale relaunch of *2000AD*, beginning again at No.1 so that new readers could feel they were in at its beginning, rather than having to do a huge amount of catching-up. A full mock-up was prepared months ahead, with extensive cross-referrals to the film. These plans were abandoned as doubts grew. Instead the comic tried to treat the film as an extension of itself ('The movie hero of '95 is here!') but emphasised its own tradition by continuing its sequence of editions and offering readers a potted history of the authentic Dredd.

Slightly pointedly, Progs 950-2 (July/August 1995) contained a new re-telling of the original 'Rico' story that the film had commandeered and massively altered. And Prog. 953 advised its readers: 'Tharg suggests that you think of "movie" Dredd as a version of our Dredd'; given time-scales of production, this had to have been written almost before the film was released in Britain!

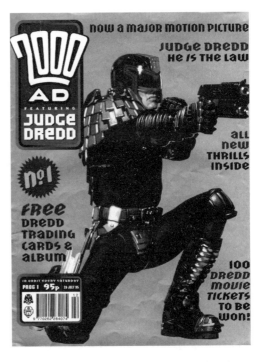

What can we learn from this? Clearly, generally, merchandising operations suffered from the film's poor box office returns. Those parts that spoke into or close to other fairly organised leisure worlds (game-worlds, street clothes cultures, *2000AD* fan following) did reasonably well. It was the general run of associated merchandise that suffered, when *Judge Dredd* failed to become a phenomenon in its own right. These re-emphasise the importance of understanding the ways in which people commit themselves to a cultural phenomenon from certain relatively fixed positions. What does it mean to care about the film, its character, its world, its associations?

The implications of failure

Let us summarise, from the three angles, where our argument has taken us:

The film ... was made under a set of contradictory demands, which results in a highly compromised form. It is as a result cluttered with incomplete materials, and underdeveloped possibilities. Though different from its source in *2000AD*, it has not achieved another coherent form. Within itself, it obeys a 'law of unreliability' which doesn't let anything be what it seems to be. Among the range of possible meanings of Dredd, it veers towards the 'childish' end.

The publicity regimes ... are full of shapeless and virtually impossible promises, amounting to a little bit for everyone. The poster offers the clearest image, seeming to balance the multiple possible audiences. The film is set up by commentators in competition with other films, in particular *Batman Forever*, and has to survive against them. To do this, it has to make great claims, because the other films come with already-established promise.

The audiences' VIPs ... are multiple, as Hollywood assumed. They come with expectations, with an awareness of the right conditions for enjoying the film properly, and what it has to do to satisfy them. All of our six ideal expectations

are marked with the 'scars' of past encounters between Hollywood and local cultures.

What we see here is a series of conflicts: impossible expectations, demands not fulfilled, compromises struck, and so on. In short, all the signs of uncomfortable and not wholly successful operations and responses. All these surround the film with stresses, and audiences have to make decisions in response. They have to decide not only whether to go and see the film *Judge Dredd*, but with what hopes and expectations. They may want something quite particular out of the film, but they may already know very well that they have very little chance of getting it. This brings into the calculation another whole dimension of audience activity which has become central to our understanding, but which has been very largely ignored: the dimension of 'investment'.

What do we intend by this idea, and what are its implications? The concept of 'investment' is our tool for depicting and making sense of a dimension of film viewing, and perhaps of every kind of cultural involvement, that has gone either unconsidered or taken for granted up to now. Put at its simplest, it addresses the sum of the differences made by how much people care about their participation or involvement in a leisure activity.

The 'Low Investors'

Imagine a person who goes to the cinema under any of the following circumstances. Because it is Friday, and they can't bear staying in. Because they have finished the shopping early, and they don't want to go home yet. Because a friend really wants to go, and they can't be bothered to say no. Because they vaguely recall a poster, or an article, or just the film's title, and they decide to drop in to 'see what it is like'. Because it is the holidays, and the kids want to go; it saves squabbles at home, but the youngsters can't go on their own. These circumstances vary from each other, but they have in common a very low level of committed interest in the experience of being in the cinema, or seeing a particular film.

It is impossible to quantify what proportion of the audience for any film, let alone *Judge Dredd*, see it with such a low level of commitment. Indeed, because it is not some quantitative scale, it may not even make sense to ask that question. But there are certain distinctive markers of this kind of cinema-goer. First, these people are very hard for researchers to catch. This is for a combination of very interesting reasons. Such 'low investors' just can't be bothered, in the main. The film meant nothing to them, so why should they bother talking about it – particularly to University researchers, whose motives for asking look a bit dodgy? If they can be caught, and got to talk, another problem kicks in: they doubt they have anything worth saying. These people feel that they paid very little attention to the film; it is mystifying that anyone should want to talk about it at any length. It went on in front of their eyes, as it were, and they have little recall of it, because there was no particular reason to have any. They see their experiences and judgements as quite simply irrelevant to any kind of knowledge of the film and its audiences. They are not an 'audience', they only watched it!

In the course of our research, we did meet a number of people who fitted this description of a 'low investor'. They cropped up, almost accidentally, in our focus groups. Several were the partners of people who did want to see it, and happened to be in on our interview process as well. One had had a broken leg, and had been given no choice by the friend who was looking after him, about what he would do with his evening. Some were obliging friends and colleagues. One pair signed up to be interviewed, we strongly suspect, because they wanted to 'see Martin Barker' whom they had heard about and perhaps seen on the television; they were unlucky – that focus group was conducted by Kate Brooks!

The key marker of these kinds of respondents was that they had very little to say, and that what they had to say was always vague. Typical phrases were that the film 'wasn't too bad', or 'wasn't as bad as I thought it might be', or 'was OK, really'. If we pressed them as to what they meant by these judgements, if we tried in any way to get at the operative criteria behind these judgements, we met a blank wall. There simply was no interest in talking about these judgements, and this did not matter to them in the least. There just was nothing more to say, that is all.

Another kind of inability to talk could exist (though we've not met it). Imagine a culturally inexperienced person, perhaps young, going to see a new kind of film; s/he is excited at the thought. But suppose that s/he has no experience of this kind of film, and only knows that this is something new and different, beyond his or her current experience. The film may excite or disappoint, but it is likely that s/he will not have instantly available a set of ways for talking about the experience. Is this the same? We are arguing that it is quite distinct. What such a child is feeling is a generalised excitement at seeing something new. This is induction into a cultural form known to others. It almost certainly has all the character of a 'treat', an 'outing', and that is likely to provide the first languages of response.

Think about the differences between low investment and this other kind of difficulty with talking, and it may help to bring to the fore what is involved in the idea of 'investment'.

The 'High Investors'

At the other extreme from the low investor, our research shows, stands, not a single figure, but a series of very distinct positions. This is important. Low investment is characterised more than anything by absence. It is an absence of caring about the film, an absence of any kind of close of involvement, an absence of particular reasons for being present, and an absence of any prior active knowledges guiding and organising the responses to the film. At the point where these absences starts to be filled, there emerge some quite distinct contents: contents deriving from and referring to our SPACES.

Imagine, then, a person who goes to the cinema for any of the following reasons. The 'hype' for the film was enormous, and promised it would give us some outrageous new effects... Stallone, he's great – well, not a great actor, but such a screen presence, this is his latest, got to see it... All our friends have been talking about this film, we've been told we mustn't miss it; we're all going for a pint afterwards to talk about it... At last, after 18 years of waiting, here is *Judge Dredd* about to appear on the big screen

where he has always belonged... In ways quite different from each other, each of these reasons for going is mobilising particular grounds for response.

One implication is a challenge to the currently popular idea of 'the active audience'. The idea of 'audience activity' has become a commonplace in writings about audiences within cultural and media studies, but to be truthful, it seems primarily to operate as a defence mechanism. Its prime function is to fend off the still-powerful challenge of the 'effects' model. If audiences are 'active' in their response to films, or television, or whatever, then the grounds for claims that they may be hypodermically invaded by 'messages', 'images' or 'effects' of the medium are undermined. But however much we agree in opposing the banalities of effects theory, we want to argue that the idea of the 'active audience' is not the way to do it. Indeed it gets in the way of the construction of a workable theory of audiences of any kind. Recently, Roger Silverstone has challenged the usefulness of this concept, and suggested that it be abandoned.[28] We resist this because we want to break up the idea, to suggest that we need to talk instead of kinds and degrees of activity – along a series of separating spectra from generalised low investment to particulate forms of high investment (see Diagram 1). This means decoupling the idea of 'activity' and 'passivity' from any implications about degrees of influence. As an example, we've already shown there is one orientation to *Judge Dredd* in which the audience *aims* to become utterly passive and consumed by the film – and then step out the end and return to the rest of their lives. They are influenced, no question, and in precisely the way they have chosen to be. They submit to the film, in order to judge its effectiveness later.

High investment is different generally from low investment in the main following ways:

- High investment involves having a lot to say about the film, and it is generally part of committed audiences' mode of investment that they want to talk about it, and do that talking in particular ways. In other words, talk is a natural part of their mode of investment, and therefore takes forms appropriate to their mode of investing.[29]

- High investment involves aiming to control relevant aspects of the cinematic experience. This therefore involves claiming rights: that in some way the film, or the act of seeing it, belongs to them. This claim is made on behalf of a culture-group. To carry through these claims to control and ownership, high investors will forward-plan and prepare themselves appropriately for the experience.

- High investment involves having an elaborated language for talking about the film, and developing criteria for judging how far it meets the requirements of high investors. Such people gather the knowledges they need to prepare themselves. They navigate round others that could interfere with their being able to arrive at their own judgements, gain all possible satisfaction from the experience, and successfully be their specific kind of audience.

- High investment requires awareness generally of being a certain kind of audience; high investors will be protective of this, and aware of the differences between themselves and other kinds of audience. Often, in the act of viewing

the film, they carry with them an awareness of other kinds of viewers, who can be 'present' either in flesh or imaginatively. They will respond to this presence in ways that are consonant with their own claims to own and control the filmic experience.

- For high investment, the cinematic experience never begins or ends with the start and finish of the film itself. This is a complicated process, entailing much more than just finding out about a film before seeing it, and thinking about it afterwards. It is a process of preparing oneself appropriately for the experience, and of placing a film appropriately into mental/cultural catalogues afterwards.

- In the same vein, for high investors a film is never a thing-in-itself: it belongs in a series or sequence of similar experiences, and takes its meaning and value from being related to others in the sequence.

- For high investment, a successful viewing of a film will bring intense experiences, and the ways these are prepared for and re-experienced afterwards are necessary to the intensity of the experience.

But as we have already indicated, high investors are differentiated. It is possible to come to the same film with quite different requirements, hopes, fears and expectations of it. In the case of Dredd, we believe we have located six, which we set out in Chapter Seven. Each, as we've seen, is constructed around its own ideal expectations. Linked with our concept of investment, we propose to call the resultant energetic pursuit of a SPACE its DRIVE, or a Desired Regulative Ideal Viewing Experience.

When people engage with a film with a high level of investment, they do so on their own behalf but also as the expression of a group or cultural position with which they are associating themselves. But this in practice is often qualified by their awareness of other possible cultural uses and responses to the film. For the higher the investment, and the stronger the DRIVE, the greater also the knowledge and cultural awareness that accompanies these. This is one reason why we rarely find a pure form of any of the forms of investment. The more normal mode is for real, actual audiences to combine different orientations, striking compromises and maintaining elements of several. This is not at all incompatible with showing relative adherence to each, or in other words making a partial investment in more than one approach. We aim to show that audiences who do this, cannot simply mix at will. Each combination brings with it complexities, since each of the available investment-positions carries its own logic of action – and they are not automatically compatible with each other.

Take two common examples: we've argued that the Action-Adventure orientation emphasises experiencing the film in the present tense, living alongside the events of the film as they happen, and resisting narrative complexity. It also couples, in its pure form, with only being interested in publicity in as much as it generates excitement and expectation through 'hype', and then talking about the film afterwards in a manner that re-enacts and thus helps people to re-experience it. But some other orientations emphasise having a knowing relation to the film, for example boning up on reviews in advance in order to be able, while watching the

film, to catch hold of references, and then be ready to talk about the film afterwards in measured, 'literate' ways. We hope it is clear that these don't readily combine; yet some people did combine them. This is possible through a celebration of 'cine-magic'. A person who wants to 'let go' into the Action-Adventure mode of watching does so by saying to him/herself, in effect: first-time viewing is for just being entranced by the marvels of the cinema. Or as one such person put it to us: 'I like to see it on my own a second time, so that you can look at it again. ... I think you need to see it a couple of times, especially a visual film like that because there's so much going on'. [Interview 22] Or again: 'That's what I like – the total involvment with the cinema ... I'm going to try not to be too critical of it'. [Interview 50]

On the other hand, consider how an Action-Adventure orientation, as we have outlined it, might combine with a Culture-Belonging Orientation. In the latter, the keynote is the gathering of cultural materials to enable its adherents to remain up-to-date. So, films should be known about through relevant sources (for instance, style magazines, youth TV programmes, etc). And the outcome is the borrowing of appropriate materials (often one-liners, shared and shareable references, and so on) that will constitute post-film talk. The distance between these is essentially the difference between losing oneself in the film, and staying culturally-aware. Despite formal differences, this can be managed by the insertion of layers of irony, and through straightforward split-discourse. Recall the people who laughed at their own involvements in such films – who watches them? 'Idiots like us' [Interview 2]

By 'investment', then, we refer to all those aspects of audiences' relations to film that relate to how and why a film matters to them. Low investors are characterised by lack and absence. Far from celebrating them, as a good deal of recent cultural theorising has done, we see them as self-disempowered – at least in this sector of their lives. High investment in film associates with raised levels of preparation and planning for response and use, with claims of rights and ownership over the experience, with developed forms of language for discussion and elaborated criteria of judgement, with the presence of means to retain and store the cinematic experience in relevant ways, and with high levels of knowing awareness of the difference (and often tensions) between the chosen orientation and other current orientations. Although this clearly is not a quantitative scale in any simple sense, there clearly will be intermediate positions. The point on the 'scale' which we are particularly concerned with, is the point at which people start taking into account the existence of possible ideal expectations. Their whole way of managing the cinematic experience shows their awareness that there could be an ideal, and they could pursue it; but for reasons which can be explored, they have chosen not to. We call such positions 'bargaining' positions, because they involve various kinds of retreat from a DRIVE.[30] It may be (among many possibilities) sheer unwillingness to make the effort, it may be an acceptance of the impossibility of getting the ideal, it may be in deference to others around the person, it may be because other interests are also being pursued. But unlike sheer low investment, which doesn't care or care to know much about the film, bargained positions do know, but choose not to DRIVE for a SPACE.

The distinction between high and low investment is to us now such a fundamental one that we have been astonished that we can find effectively no literature on it at all. It is not that the word is not used. The earliest example we have found of such use comes from the mid-1930s. Talking of the early history of the BBC's Listener Research Department, Robert Silvey discusses the adoption of a strategy of recruiting volunteers for their research. This was on the assumption that the only essential difference between volunteers and non-volunteers will be their keenness. This is pictured as a pyramid, with a small number of willing people at the apex:

> The hypothesis which we are seeking to explain is based on the not unreasonable assumption that listeners who volunteer to take part, without payment, in listener research work, will tend to be drawn from the apex of the pyramid. That is to say, the average volunteer will be more interested in radio that the average member of the listening public. Here we come to the heart of the matter. Our hypothesis is that the difference between the apex and the base is not one of quality but of degree, that the reactions of keen listeners are not fundamentally different in kind from those of casual listeners, but are of a more intense character; that though they are keen listeners, clearer as to their own likes and dislikes, those likes and dislikes are, on the average, the same as those which casual listeners feel in a much fainter degree.[31]

We hope it is clear why we think this a serious error. Since that time, apart from important work done in the fields of psychology and marketing research, which have shown that willingness to take part is an important dimension in itself, we cannot find any direct address to this issue within media studies. The only studies that appears to address it are the crop of recent investigations of 'fans'.[32] There isn't the space here for a proper review of the significance of such studies, but we want to note our main concerns about them, even while accepting fully their very real importance.

The first problem we would point to, is that a great deal of this research has been premised on a hunt for the primeval fan. This is especially true of Jenkins', and of Bacon-Smith's, research; in each case they have placed special importance on an 'inner sanctum' of fans who virtually shut themselves off, and carry out a highly specialised set of fan activities out of sight and touch of the rest of fandom, let alone the rest of the world. This couples with an almost uncritical celebration of this as a female community.[33]

Beyond these somewhat problematic cases, it does not seem to have occurred to other audience researchers or theorists that such a distinction needs to be drawn and explored. We believe that there may be two key reasons for this absence. The first is the continuing presence, at back of a lot of thinking about audiences, which equates commitment with vulnerability. The involved audience is the trapped audience. But the distant audience (that is, the one that 'knows the difference between fact and fiction, know it is 'only a film') is the safe audience. That equation runs the gamut, unquestioned, of 'effects' arguments and research. It is also, as we believe we showed in Chapter Four, very much alive in some otherwise critical models, for instance, both the Use and Gratifications Approach, and the Encoding/Decoding Model.

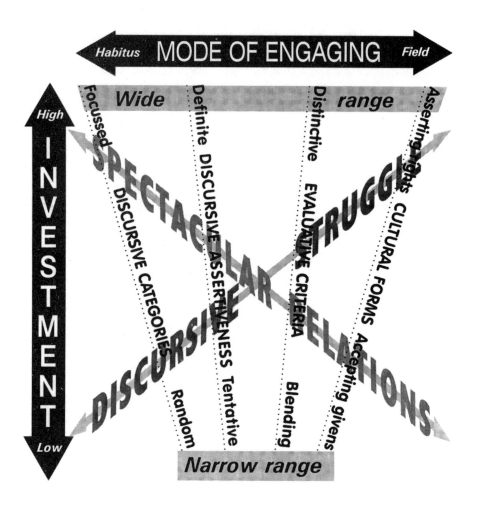

Diagram 1: This summarises our understanding of the implications of two variables for how audiences respond to a film such as Judge Dredd. *Put simply, low investment produces largely undeveloped responses. The higher the investment, the more specific and articulated each individual's response is. Those whose investment in* Dredd *is primarily through its cinematic qualities tend to emphasise effects, scale, 'action', in short, the spectacular, and as a result enjoy their passivity in the face of the movie. Those whose investment is via themes and ideas in* Dredd *are more likely to claim ownership and assert cultural rights over the movie. The words 'habitus' and 'field' are intended to suggest connections with Pierre Bourdieu's research into cultural taste systems.*

The second reason has to do with the current dominance of theories of 'postmodernism', with the associated talks of 'fragmented identities'. Jane Flax, in an essay which broadly celebrates this kind of thinking, points out that the recent upsurge of audience research has been inspired in part by a belief in the 'instability of ideological processes', especially where the media are concerned. And one reason, she proposes, why the media cannot have a singular ideological 'grip' is because, as postmodernist arguments propose, there has been a challenge to the 'cherished Enlightenment belief in the existence of a stable, coherent self'.[34] One of us has had occasion to argue in another place that this critique is bogus, since there never was an 'Enlightenment belief' of the kind claimed.[35] This is clearly the start of a much larger argument, some of which turns on whether the very terms 'identity' and 'subjectivity' relate to useful, coherent concepts. This is yet another road we can't travel here. All we want to argue at this point is that the concept of 'investment' may turn out to be a 'scandal to postmodernism', because it postulates that individuals may choose to construct themselves as having coherent, committed positions and attitudes. The fact that the difference has hardly been addressed, except in the insular field of field of fan studies, may have much to do with the regressive influence of postmodernist theorising.

If our findings are right, the concept of investment is crucial since it conditions every other aspect of the process of choosing, preparing for, experiencing, recalling and incorporating a film. It is a key concept for investigating how any individual will relate to a film. But individuals who do invest strongly may in their turn have decisive influences on those around them. For investment is preparation for doing all kinds of things with the experiences sought.

Not all kinds of investment are the same. Diagram 1 opposite summarises how we best understand some of the key differences. A great deal is indicated here, in short hand. Perhaps the most significant is the claim that there are two generally distinct kinds of investment, associated on the one hand with primary interests in spectacular relations with a film, and on the other with forms of talk about a film. Some of the implications of this are dealt with in a separate essay.[36] For reasons of space, we only say here that we see parallels between what we are saying, and what Pierre Bourdieu has said about class tastes. But with this difference: whereas Bourdieu emphasises the pressures of 'necessity' on working class taste preferences, we have found in these uses of film a celebration of excess.[37] Some of the implications of this are addressed in Chapter 12.

1 This small number – substantially smaller, in fact, than any of its main rivals -may be in part a function of Dredd's weak launch performance in America, where it opened at more than 2,000 screens. In the fortnight between, multiplexes could simply reduce the number of screens devoted to it, without removing it altogether.
2 It is worth noting one detail, though. *Screen International* noted that Dredd had the best opening weekend gross of any Stallone movie.
3 *Screen International*, No.1039, 5 January 1996.
4 John Ezard, 'Cold war takes a comic turn', *Guardian*, 21 February 1977.
5 Sean Dunne, 'Biff! Bam! Phew!, *Sunday Press*, 7 July 1980.
6 On this, see Martin Barker's *Action*.

7 Ciaran Carty, 'AAARRGGH!', *Sunday Tribune*, 15 September 1985. This should, though, be balanced by noting Dan Corby's simple dislike expressed in the *Observer* a month earlier ('Drop dedd, you pathetic scum', 21 September 1986). Remarking on Dredd's 'unparalleled ugliness', he discussed the 'distinctly sinister flavour' of Eighties idols.

8 On the illusory arrival of the Graphic Novel in the 1980s, see Roger Sabin's excellent *Adult Comics: an Introduction*, London: Routledge 1991.

9 'Who says he's got no balls?', *Daily Record*, 23 June 1995.

10 '*Judge Dredd* feels the chill', *Guardian*, 23 July 1995.

11 *Guardian*, 7 January 1995.

12 Vivek Chaudury & Martin Walker, 'The petty crime war', *Guardian*, 21 November 1996.

13 *Stage, Screen & Radio*: Journal of the Broadcasting Entertainment Cinematograph & Theatre Union, December 1995/January 1996.

14 Melanie McFadyean, 'It's not the blood money, a part of me died that day', *Guardian*, 4 January 1996.

15 See 'I am the Law, and this is my Breakfast', *Loaded*, April 1997.

16 See for instance Duncan Webster, *Looka Yonder! The Imaginary America of Popular Culture*, London: Routledge 1988; Dominic Strinati, 'The taste of America: Americanisation and popular culture in Britain', in Dominic Strinati & Stephen Wagg (eds), *Come On Down! Popular Media Culture in Postwar Britain*, London: Routledge 1992, pp.46-81; and Philip Davies (ed), *Representing and Imagining America*, Keele: University of Keele Press 1996.

17 John Wagner & Colin MacNeil, *America*, London: Fleetway Editions 1991.

18 We should remind ourselves that such things are not inevitable. Only two years after Dredd hurt itself with these compromises, Paul Verhoeven's *Starship Troopers* (1997) made open play with the controversy that had greeted Robert Heinlein's original novel of that name, and unashamedly dealt with 'fascist' themes. See on this Paul M Sammon, *The Making of Starship Troopers*, London: Little, Brown & Co 1997. That, though, just raises other questions as to why Hollywood should find itself debating these issues at this time.

19 Fleetway Comics helped with a list of all the main companies eventually holding merchandising licences. We wrote to all these, and to a number of others whom we heard had taken up options, with a short questionnaire. Only ten per cent replied, but these told us of the situation with some other licensees. In addition, it became clear that some other companies had closed operations in the meantime.

20 Jane Garner of CPA was interviewed at length for an article on the licensing of *Judge Dredd* which also listed the main kinds of licensed merchandising: see Pete Taylor, 'Licensed to make a killing', *Model & Collectors' Mart*, August 1995, pp.116-9. The list includes phone cards and trading cards, caps, jackets, sweatshirts, jogging trowsers, pyjamas, socks and tee-shirts, a variety of model kits, prints and posters, lunchboxes, flasks, tumblers, bags, rucksacks, cassette bags and wallets, wallpaper, watches, soap and bubble bath, flannels, pillowcases and duvet covers, sweets, chocolate sticks, and spugs (a kind of bottle cap that then features in a game). Since the film, Egmont Fleetway have parted company with CPA, setting up their own licensing operation.

21 One company which released children's backpacks under licence replied to our questionnaire that they have originally 'hoped to do playsuits as well'! This bespeaks a real lack of communication between CPA and potential licensees. Their other comments are also revealing: 'We hoped he would be seen as a hero', but in the event 'he did not appear to have an image at all'.

22 Revealingly, the company's response to our questionnaire asserted its market leadership in high quality videogames, and talked of the film as an 'opportunity'. They are fully aware of the separate dynamics of their market, and merely, as it were, borrowed and 'quoted' Dredd within their own world of operations.

23 On this, see Stephen J Stansweet, *Star Wars: From Concept to Screen to Collectible*, San Francisco: Chronicle Books 1992. *Star Wars* is the classic case of successful merchandising, and therefore a very dangerous mental precedent. There is no equivalent to match the range or length of life of merchandising, but it is a constant reminder of possibilities.

24 Steve MacManus, Managing Editor Egmont Fleetway Ltd, Letter to the authors, 14 November 1997. This is the origin of the two style-sheets discussed in the previous chapter.

25 Confidential letter to the authors from Managing Director of British toiletries company, 11 November 1997. The reference to it being a failure before launch tells us something else – a product such as this is dependent not only on the decisions of the producing company but also on their ability to persuade distributors and retailers to adopt the product line. Another company, reporting turnover 'significantly below projections and anticipations', locked onto the

distinction between comic and film: 'Stallone was appalling as Dredd. The film was poor; production/direction weak. The cult image built up in *2000AD* comic over 20 years was destroyed.'

26 Prog. 940 (15 May 1995) carried an editorial warning by Tharg, the 'alien editor' of *2000AD*: 'Avid Earthlet filmgoers may spot a few minor changes to Dredd and his world for the movie version. The reason? Believe it or not, there are a few unfortunates out there who are not yet familiar with Mega-City One and its environs. Look at it this way – Squaxx dek Thargo [*2000AD*'s mock-expression for friends of Tharg] have had the benefit of eighteen years of Dredd's world within the pages of *2000AD*. Ordinary mortals will only have a couple of hours to become familiar with the Big Meg and all it contains. Thus, the changes are mainly simplifications.'

27 One Prog selected a rare favourable US review of the film as its grounds for urging readers to see the film, and see it again.

28 See Roger Silverstone, *Television and Everyday Life*, Chapter 6: 'On the audience'.

29 That does not mean, of course, that they automatically want to talk to us!

30 For a long time we used the term 'negotiate' for this. But this has become so sullied with loose and unhelpful meanings because of its adoption within the encoding/decoding framework that we have now consciously avoided it. As one of us has commented before, those who use the term 'negotiate' as a virtual synonym for 'resistance' have clearly forgotten, if they ever knew, what goes on in management/trade union bargaining.

31 Robert J E Silvey, 'Radio audience research in Great Britain', in Paul F Lazarsfeld & Frank N Stanton (eds), *Radio Research 1942-42*, New York: Duell, Sloan and Pearce 1944, p.155.

32 There is now a considerable literature on fans. The following in our view are the most important studies: Lisa A Lewis (ed), *The Adoring Audience: Fan Culture and Popular Media*, London: Routledge 1992; Camille Bacon-Smith, *Enterprising Women*; Henry Jenkins, *Textual Poachers*, London: Routledge 1993; John Tulloch & Henry Jenkins, *Science Fiction Audiences: Watching Doctor Who and Star Trek*, London: Routledge 1996.

33 This is less true of Bacon-Smith, who does explore some of the disabling qualities of this closed community for its women participants. On Jenkins, see Martin Barker's review-article on his *Textual Poachers* ('The Bill Clinton fan syndrome', in *Media Culture & Society*, Vol.15, No.4, 1993, pp.669-74), and of Tulloch & Jenkins' *Science Fiction Audiences* (*Media Culture & Society*, Vol.18, No.2, 1996, pp.364-7).

34 Jane Flax, 'Postmodernism and gender relations in feminist theory', *Signs*, vol.12, No.4, 1987. These quotes, p.624.

35 See Barker, *Comics*, Chapter 10.

36 See our 'On looking into Bourdieu's black box'.

37 Pierre Bourdieu, *Distinction: A Social Critique of Judgements of Taste*, London: Routledge & Kegan Paul 1984. See especially Chapters 5-6, where Bourdieu distinguishes the distanced upper class taste structures (which he despises) from the participatory working class structures with which he sympathises. But his account of the latter claims that 'necessity imposes a taste for necessity' (p.284), implying that working class leisure and taste preferences are dominated by immediacy and usefulness. Our evidence challenges the inevitability of this.

Table 3: Distribution of all interviewees

1 Zoe [1] – Casual	35 Richard [11, 16] – *2000AD*, **Belonging**
2 Fran [2] – Casual	36 Paul [11, 16] – *2000AD*, **Belonging**
3 Brian [2] – *Belonging*	37 Dave [12] – **Film, 2000AD**
4 Gary [2] – *Belonging, Future, Stallone*	38 Darian [12] – **Future, Film, 2000AD**
5 Herb [2] – *Belonging, 2000AD, Action*	39 Craig [12] – **Film, Future, 2000AD, Stallone**
6 Mark [2] – *Belonging, 2000AD*	40 Les [13] – **2000AD**, *Future*
7 Munro [2] – *Belonging,* **2000AD**	41 Jimmy [13, 21] – **Action, Future, 2000AD**
8 Dan [3] – **Action, Future, Film**	42 Angus [14, 27] – *Future,* **2000AD, Action**
9 Sean [3] – *Action,* **2000AD**	43 Hannah [15] – Casual
10 Jag [3] – *Action, Stallone*	44 Tamara [15] – Casual, **Action**
11 Sol [4, 36] – *Belonging,* **2000AD, Film**	45 Sarah [15] – Casual
12 Martin [4,36] – *Belonging,* **2000AD, Film**	46 Angela [15] – Casual
13 Caroline [4,36] – *2000AD,* **Belonging**	47 Rachel [15] – Casual, **Action**
14 Mike [5, 42] – **Film**	48 Nick [18] – **2000AD, Future**
15 Christian [5] – Casual, *Film*	49 Duncan [18] – *2000AD,* **Future**
16 Steve [5,42] – **2000AD, Film**	50 Kirsty [19] – *Action, Film,* **Future**
17 John [6] – *Action,* **Future, Stallone**	51 Keith [19] – *Action, Film*
18 Mike [6] – *Action,* **Stallone**	52 Nick [20] – *2000AD, Future*
19 Turtle [6,38] – *Action, 2000AD, Stallone*	53 Ian [20] – **2000AD**, *Film*
20 Paul [7,41] – *2000AD,* **Future,** *Stallone*	54 Martyn [21] – **2000AD, Action**, *Stallone*
21 Gareth [7,41] – **2000AD**	55 Paul [21] – **Action, 2000AD**
22 Denzil [7] – *2000AD,* **Belonging, Future,** *Stallone*	56 John [23] – *Film, 2000AD, Future, Stallone*
23 Toby [8] – *Action*	57 Simon [24] – *Film, Future*
24 Jonathon [8] – *Action*	58 David [24] – **Film**
25 Wayne [8] – *Action*	59 Bob [25] – **Film, 2000AD**
26 Jon [8] – *Action, Stallone*	60 Jeff [25] – **2000AD, Film**
27 Nick [8] – *Action, Stallone*	61 Alison [26] – Casual
28 Stuart [8] – *Action, Stallone*	62 Teresa [26] – Casual
29 Jason [10, 17] – **Film, 2000AD**	63 Stuart [28] – **2000AD**
30 Stephen [10, 25] – **2000AD**, *Film*	64 Rachel [28] – Casual, **Action**
31 Squid [10, 17] – **2000AD**, *Action, Future*	65 David [28] – **2000AD, Stallone**
32 Richard [10, 22] – *Stallone, 2000AD, Film*	66 Don [28] – *2000AD, Action*
33 Jeff [11, 16] – **2000AD, Belonging**	67 Lawrence [28] – **2000AD**, *Action*
34 Maggie [11, 16] – **Action, Belonging**, *Future, Stallone*	68 Richard [28] – *Belonging,* **Action, Stallone**

The prime purpose of this Table is to indicate how firmly based each of our models may be. Square-bracketed numbers indicate interviews (hence some – 18 in all – have more than one). An asterisk (*) indicates that a person previously took part in Martin Barker's research into *2000AD* readers. Relation to SPACES is indicated as follows: ***Bold/Italics*** = high investment; **Bold** = bargained investment; *Italics* = awareness evidenced of a SPACE not adopted, but that may be taken up by others. Normal type = low investment/casual viewing. Primary orientation is given first, in all cases.

... by SPACE and DRIVE

69 Elaine [28*] – *2000AD*	103 James [38] – *Action, Future*
70 Ben [28] – *2000AD*	104 Matthew [38] – *Action*
71 Chico [28] – **Action**	105 Amanda [9, 39*] – **2000AD, Future**
72 Graham [28] – *2000AD, Stallone*	106 Johnny [40] – *Action*
73 Sean [28] – **2000AD**	107 Lee [40] – *Action*
74 Sarah [28] – Casual	108 Martin [40] – **Action, Film**
75 Owen [28] – *2000AD*	109 Toby [43] – *Refuser*
76 Phillip [28] – *2000AD*	110 Peter [43] – *Refuser*, **Film,** *Future*
77 Ralph [28] – **2000AD**	111 John [43] – **Film, Refuser,** *Future*
78 Joe [29] – *Action*	112 Arthur [44] – *Refuser*
79 Chris [29] – *Action,* **Future**	113 Bob [44] – *Refuser*
80 Gerard [29] – *Action, Future,* **2000AD**	114 Gareth [44] – *Refuser*
81 Anthony [29] – *Action, Future*	115 Jim [44] – *Refuser*
82 Veronica [30] – Casual, **Film,** *Action*	116 Charles [44] – *Refuser*
83 Oliver [30] – Casual, **Belonging**	117 Gywn [44] – *Refuser*
84 Roger [30] – Casual, **Action**	118 Roger [44] – **Refuser, Future**
85 Steve [30] – Casual, **Future,** *Action*	119 Karen [45] – **Refuser**
86 Kate [31] – Casual, *Action, Future*	120 Zoe [45] – **Refuser**
87 Paul [31] – Casual, **Action,** *2000AD*	121 Sarah [45] – **Refuser,** *Action*
88 David [31] – **Action, Stallone**	122 Sue [45] – **Refuser**
89 Colleen [31] – Casual, *Action*	123 Tara [45] – **Refuser**
90 Johnny [32] – Casual, **2000AD**	124 Karen [46] – **Film**
91 Mike [32] – Casual	125 Jim [46] – *Refuser,* **Film**
92 Jenny [32] – **Action**	126 Linda [46] – **Film, Refuser**
93 Andrew [32] – Casual	127 Sue [46] – **Refuser**
94 Mike [33] – Casual	128 Diane [46] – **Refuser**
95 Fabian [34] – **2000AD, Belonging**	129 Mary [47] – *Refuser, Future*
96 Richard [34] – *Belonging*	130 Hugh [47] – *Refuser*
97 Samantha [34] – Casual	131 John [48] – *Refuser*
98 Jason [34] – **Belonging**	132 Janet [48] – *Refuser*
99 Patrick [34] – **Belonging**	133 Alex [49*] – **Belonging, 2000AD**
100 Matthew [35] – **Film, 2000AD**	134 Meri [50*] – *2000AD*
101 David [35] – **Film, 2000AD**	135 Simon [51*] – *2000AD*
102 Rob [37] – *Action,* **Future,** *Stallone, 2000AD*	136 Ian [52] – **2000AD**

The Table reveals the following proportions of each orientation within our population; **Action Adventure:** *22*, **16**, 9; **Future-Fantastic:** *5,* **14**, 11; *2000AD*-**Follower:** **14, 36,** 6; **Stallone-Follower:** *4*, **6**, 10; **Film-Follower:** *4*, **21**, 4; **Culture-Belonging:** *9*, **11**, 0; **Film-Refuser:** *13*, **10**, 0. There were also 24 Casual Viewers.

11
UNDERSTANDING A 'BARGAINED RESPONSE'

How should we approach the task of analysing individual transcripts? We have been critical of other approaches on the grounds of either a lack of rigour, or because of a virtually mechanical search for ideological components. What are we proposing instead? Is it possible to conduct a systematic, checkable analysis of our transcripts such that others can evaluate our methods, the strength and reliability of our evidence, and our conclusions? Our solution is a seven-step procedure. (1) The first step is simply a reminder of the nature of the group, the interview and how it took place, and some bare empirical information about its length and pattern. Then the fun begins, as we ask, first: why did people to talk to us?

It is perfectly normal for people to talk about films, but they normally do this within settings they choose, and with people they know. To be willing to talk to university researchers is itself a large step. But to know what kind of step it is, we need to know their conception of us. It has become clear that we filled a number of quite different ones for different people. For some, we were an opportunity to talk about something which they had longed to talk about for a long time; not only that, but because we were researchers, we had to take them seriously. That was an opportunity too good to be missed. For others, we were 'university researchers' and that aligned us with the potential 'charge' that they might be 'violent fans'. In that case they had to decide how to respond to such possible accusations. For others again, and especially those we knew in some other context, there could be a sense of shared community which meant that talk would tend to include us, appeal to us, assume shared knowledge with us, and so on. These are just three different ways in which the social relations of the interviews could affect the kinds of talk we elicited.

In each interview, people had to negotiate with their image of us. We had a status, we had apparent knowledge, even expertise, we stood in a possible official position, and so on. These, we believe, do not so much determine what people say to us as how they say it. We found no evidence that people felt they had to agree with some position that they thought we were taking; and our question-schedule was designed to thwart any tendency towards this. But that does not diminish the impact of our role as researchers. In fact it expands it. We cannot know in advance of examining a transcript what role or status we were given. But because people had agreed to talk to us, they had to work out a view as to why we wanted to talk

to them. What was the point of the interview? Where were the questions leading? Even, what might we do with their answers (an important issue for our school groups, for instance)?

So (2), the second step in analysis therefore had to be to develop a picture of each group/individual's way of responding to us (drawing out their sense of our status, knowledge, and rights) and their sense of the purposes of our research (what is thought about film audiences, what they might be contributing to this, and what about themselves might be put at risk, or might be advantaged, by doing so). The symptoms of this prove to be diverse, and there isn't a finished check-list which could be mechanically applied. The sorts of discursive elements we need to pay attention to include: the occasions when we are addressed directly as 'you', and what is there assumed about us, or as 'we', with assumptions of common interests; all and any ways in which shared knowledge or attitudes to a topic are assumed; moments when 'others' are marked off, and by their difference define supposed similarities between us and interviewees; and occasions when, by the manner of their answer, interviewees show that they are responding both to the content of a question and to the status of the questioner.

Thereafter, the analysis must follow the general logic of our research. (3) We need next to look for symptoms of their acknowledgement of SPACEs, using as evidence the kinds of discursive markers with which we developed our VIPs. (4) But since we are dealing with individuals now, we need to examine how far these are elaborated: how strongly present are any SPACEs within their talk, and how far are they self-consciously stated? (5) In parallel with this, though, we need also to examine people's routine knowledge and expectations; people don't just have ideal expectations, they also have practical arrangements, and local geographies, to guide them. (6) With these hopefully fleshed out, it becomes possible to see, for each individual or group, how they manage the relationships among these: how strongly committed are they to following one orientation, taking into account practical arrangements, local geographies and so on? How do they deal for example with disappointment, or difficulties?

The final step, then, is to consider, in light of all these, (7) what they have to say about our film *Judge Dredd*? What are their judgements on that, and how does our picture of their orientations and commitments, their relationship to SPACEs and DRIVEs, throw light on those judgements?

'You always live in the hope that it will get better than get worse'

This is the point at which we have to try to deal with individuals and all the messiness of their responses. The difficulty is that dealing with mess takes a great deal of space, therefore we had to choose an illustrative example, since a survey is at this point irrelevant. The responses of one group to films in general, and to *Judge Dredd* in particular, proved especially complicated, and therefore offered a good test-case of the effectiveness of our approach to understanding 'bargained positions'. This chapter therefore offers a full account of two interviews, before and after seeing our film.[1]

1 *The nature of the group*

This was a naturally-occurring group, recruited through personal contact and prior knowledge of one member. The pre-film interview involved three black men in the twenties, Steve, Michael and Christian; for the post-film group, only two returned. The third had been the least participant by a long way in the first interview. A simple count of conversational 'starts' revealed the following:

Steve	131
Michael	109
Christian	40

Christian's interventions were also generally shorter. The reasons were complex. English was not his first language. But also, as Christian declared, he rarely goes to the cinema, using it sometimes as an alternative to getting cold in the winter! If this is taken at face value, lesser participation is almost inevitable on our approach, since it suggests a low level of investment in cinema as a site of activities.

Steve and Michael are long-standing friends, who are well used to discussing films. Steve says of Michael: 'Michael tends to open up my mind to a lot of things, so ...' This implied history of discussions about film, and sharing of evaluations proves important, as we will see.

The interviews were both conducted by Kate Brooks, and took place at Michael's flat.

2 *Relations to interviewers*

What signs are there in the interviews of their sense of us as interviewers, the status accorded, and the point of the research?

The most striking thing is the presence of banter, signalled by the amount of laughter. The transcripts record 65 moments of disruption of the flow of conversation by laughter. These take characteristic forms:

(a) the use of banter to indicate ironic or cynical readings of the film. For instance:

Steve: I like more fantasy stuff myself ... I'm a bit ... you know ...
KB: *Like what?*
Steve: In, in, up in the clouds, so you know, I like something that's more, you know, not [..], I don't like, like, real life films, you know ... bleeding hearts ... well, I like bleeding hearts but when it's been shot through! [Laughter]

We will show that it is significant that while clearly lubricating the flow of responses, this degrades a serious point into cynicism and virtual self-mockery.

Successful inputs of this kind tend to confirm the status of the joke-maker as knowledgeable, and appropriately independent. It is interesting that on one or two occasions, when the discussion had taken a more serious turn, attempted banter failed to elicit a response.

(b) the use of laughter to record and continue the existing relations among the group. For instance, in response to Kate's asking how they agree on films worth seeing, Steve says:

Steve: ... um, I'm not like, a hardened bastard to say 'I'm not going to go and see it' I mean, you know, Michael tends to open my mind to a lot of things so ... I'm quite open about, going to see it, but I'll just sit there in a strop anyway! [Laughter]

KB: *And sulk!*

Steve: I'll get my money's worth!

(c) the use of laughter which is inclusive of the researcher, in her position as a woman. For instance, talking in the pre-interview about stereotyped heroes in films:

Mike: Sometimes it's like really patriotic as well, you know, like masculine power and nationalism and he's going to .. I mean, I wouldn't be surprised if, you know, criminals have like, foreign accents or, sort of, you know, latin american or arab and, you know, at the end of the day it is him in search of revenge cos they kill – I don't know about *Judge Dredd* or whatever it is but um, you know, fighting for his nation or his identity or whatever it's just really ... you know, the huge white hero, which is, you know ..

KB: *Yeah .. with his girl*

Mike: Half-dressed! [Laughter]

This is interesting in that it moves from an awareness of 'black issues' about film, to including Kate in a community with them, via an appeal to a 'parallel' awareness of sexism. Yet at other times, they (and Steve in particular) are willing to invoke a more stereotypical male response to 'women getting their kit off on screen'. The community is there, but made for the occasion.

Michael responds to Kate in ways that make less use of laughter. For instance, talking of films' ways of offering images of the future, he makes an interesting shift:

Mike: In a way it shows the dangers of modern technology, you know, the danger of being too advanced.

KB: *Yeah*

Mike: You know, you need to kill people in order to move on, to progress ... it's sort of despairing, you know, when you see in the future and everybody's still oppressed, and everybody's ... you know, women are still wearing short skirts and they still, you know, have to show a bit of breast to get in a film, you know, get a life ...

This couples with a wider set of ways in which the interviewees, but especially Michael, assume shared knowledge and orientations. There is a high frequency of

'you know', addressed by Michael to Kate. For instance:

KB: *What do you mean the Ritzy's mentality?*
Mike: You know!

This simply calls on her to 'know' something that must surely be obvious to her. More complexly, the same kind of appeal to shared knowledge occurs in this:

Mike: And it's like, you know, and also like I found it really ... I mean, look, the Law as, as such quite stupid like the guy who was kidding in the um, food machine, the fact that he was gonna go back to jail, because he, and he goes 'you had an option', and I was thinking, you know, to the average person it'd be like 'Oh how stupid, you didn't have an option', but yes, 'You had an option, you could have died', and I'm thinking (audible shrug). You know, sort of like, somebody ... it's like a Western film, it's like John Wayne, taking the law into his own hands, like blowing up the car, that was, wasn't parked properly, it's the same thing like, you know, I AM THE LAW, it's like, yeah, so what? You know what I mean?
KB: *Yes, yes.*

There is a high degree of dependence in this exchange on shared knowledge, references, and modes of understanding, which reveal a relatively secure sense of who Kate is, and how she can be expected to respond.

In sum, then, the primary sign of our role and status in relation to the interview is not (as in some of our interviews) as either 'university researchers' or as 'possible judges of dubious audiences'. Instead, it is Kate's presence as a woman, and as an intelligent person with claims of knowledge, that seems to govern their interactions with us. There is not a problem in talking about film, since they do that all the time, anyway. The task is to talk in ways that will include Kate appropriately. Her status as woman had two distinct aspects to it: on the one hand, it provided a parallel, to which they could on occasion appeal, to their own experience of being black. On the other hand, as young men, they could engage in mildly sexualised banter, displaying elements of their masculinity. We will watch the influence of these relationships on the evolution of discussions as we explore under our other headings.

3 Symptoms of SPACEs

Our analysis leads us to conclude that the three participants have significantly different conceptions of the ideal viewing SPACE. How they handle these disagreements will turn out to be very important. Let us enumerate the symptoms and elements first:

STEVE: contributes the most on this. Repeatedly in both interviews, he names his preferred films as 'fantasy' as opposed to 'real-life'. But the meaning of this is far from transparent. On an early occasion of use, he hints at its range of referents: it includes science fiction, horror, and mediaeval. Later references specify *Alien* and

The Colour Purple. It is hard to see any evident textual connections. Instead, it turns out that Steve's ideal is built around being able to watch in a certain way. Hear how he expands on the idea of 'fantasy':

Steve: I don't like real-life stories, I've got enough problems of me own! [Laughter] I don't need to see, to pay £4 to see somebody else's rectifying them, aaah. I just want something that's you know, a bit, out of the norm, unbelievable sort of thing, you can sit there and go, you know, you can switch your mind off as well ... you know, I don't want somebody to remind me that you know, I'm breaking up with somebody, I don't want someone to remind that I got financial troubles, you know, I just want to know ('dreamy' voice) 'One day I'll be a starship captain'. [Laughter]

This kind of phrasing recurs frequently: 'You tend to, like, lose yourself.' Talking of seeing *Alien* repeatedly, the meaning is expanded:

Steve: You choose something that yeah, maybe you like a bitchy line, or like, the special effects, or ... you like the outfits people are wearing, and think, I must see that again and take notes! You know, things like that generally, you know, things like that, maybe it brought up a feeling in you, you think
Mike: Or it's really good
Steve: It usually never happens
KB: *What kind of feeling?*
Steve: Euphoria? is that the word? You think, ooh, just like in *Aliens*, I think, that's the only film I saw about 3 times at the cinema especially when she came our from that cargo thing she goes 'get away from me you bitch', I was like YEAH!

Sometimes Steve can't stop ironising himself, but even so the qualities he seeks show through:

Steve: You superimpose yourself, you know, you as an individual as opposed to a black person or a person of colour and you just think, you know, I AM WONDERWOMAN! [Laughter] And things like that, you know, you claim as your own, and think, oh, I'm going to navigate the galaxy, meet aliens or an alien's gonna come down and meet me in my backyard, or I'm gonna be killing something, I'm going to be killing a chicken or something! [Laughter]
KB: *Interesting stream of consciousness! [Laughter]*
Steve: You just gotta ... try and be ... you know, pull it apart, and reconstruct it as you as a person of colour or you as an individual would like to see a superhero portrayed in your terms ...

What seems to be central to Steve's criterion for a successful viewing experience is one in which, somehow, he can cease for now to view as a black man. That

means for him not having to make decisions, or choices (he counterposes his own response to *Schindler's List* to people's with a 'social conscience': 'I don't want to sit there and think I've got to do something'). Steve can't divorce himself from his colour-awareness, but some films – 'fantasy' ones – allow him to manage it comfortably, without having to make wider decisions or commitments. What kinds of film might allow this? We will see the answer to this later.

It is worth noting that Steve's prime ideal filmic experience has two minor keys: the first, when cinema becomes therapy. Talking of people who go to the cinema on their own, Steve had a response which was also a tale to tell. People who go on their own are typically 'desperate people! I mean most people, most people, I mean when I usually go on my own I'm in a state of some, like, personal trauma, and I go and like uuuuhhhh and shove my face in popcorn and come out and feel part of the world again.' This is quite different from his main preferred mode of viewing, for here he is losing himself in a cinema, not losing himself in a film.

The second, and perhaps more significant (since the first is self-insulating and is finished with as soon as it can be), establishes his superiority. It also gives the first real ground for his relations with friends. It comes from spotting errors in films:

Steve: I try to look for continuity mistakes myself. [General: yeah!] I love looking for them, but that's the beauty of video, cos you can like, you notice them so much more, especially like in *Crow*, like he was having a drink and he, and it's filled up to about you know an inch, and suddenly, the next shot, it's three inches taller! I'm thinking, when did he pour that? It's just like, real strange, and you just like notice these things and like, different clothing or something that's moved off the set, stuff like that

KB: So why is that pleasurable then and not irritating?

Steve: Because you think to yourself, they're not perfect. You expect them to know, you know, to know what's happening and you know, have their shit together.

Mike: For the budgets they have, you know, 17 million for a film you expect them to be -

Steve: at least to get it right.

The pleasure of being cleverer than the ones who had all the money is important to him – but it is different from, and perhaps incompatible with the pleasures of fantasy, losing yourself in that certain kind of film that permits you to.

CHRISTIAN: Inevitably we have less clues to go on here, because of his smaller participation, and absence from the second interview. Nonetheless, it is clear that he broadly disagrees with Steve. In fact, Christian explicitly distances himself from Steve's judgement, introducing *Schindler's List* as his example:

Chris: Hmmm, no, I think um, I like to see like, contrary to him, to Steve, I like to see, I go to see real life film a lot actually.

KB:	*Oh right.*
Chris:	Yes. Because I think, like, I can relate to this film about ... what's happening to me in my real life ... my life ... So I think [laughs] for me actually it's a good thing, a real life film, in one way, because [..] about Italy in the Second World War, about Hitler ...
Mike:	Oh, *Schindler's List*!
Chris:	Yeah, I want to see that, it looks really good, really like
Mike:	I haven't seen that
KB:	*Yeah, yes*
Chris:	You gotta see what happened in the past, and you can compare it to a lot of things

What is revealing is both his separation from his friend Steve, but also the fact that this is notional – he may think thus, but he hasn't actually seen the film. This is because he is at best a follower in regard to film ('My friends, if they go to see a film – "ah, this film's really good, go to see it", so I will go' – yet he rarely does).

The negotiations between the three of them around *Schindler's List* are brief but intense, and revealing:

Steve:	I think people with a social conscience will be going to see that
Mike:	What, *Schindler's List*?
Steve:	as opposed to myself as ... I don't want to sit there and think, 'I've got to do something ...'
Chris:	You don't have to sit there to do something! [Too many voices]
Steve:	I think you should come out thinking – this cannot happen again!
Mike:	I mean it's what you want, I mean if you wanna sit back and relax ...
Chris:	It does happen today! Even today it happens, things like that, I mean like I mean, for different people in the world, I mean, it was not the same, that's why you have to see it.

For Christian, it seems, to see the film is itself almost a form of action, a 'witness' to the events – the exact opposite of what Steve wanted.

Quite separately, Christian likes tension in a film. Brought into the discussion by Kate on what he would hope *Judge Dredd* might be like, he managed to insert one sentence on this: 'I say that I like, like the suspense in these films, the suspense ... they just get like, your emotions you know ... so what is going to happen next?'

These are all the clues we get to his ideal cinematic experience, and given other signs of his low involvement, this is not surprising.

MICHAEL is different again. If the key word for Steve is 'fantasy', while Christian does not evidence one, for Michael it is 'futuristic'. Responding to Kate's invitation to say what redeeming features he might hope to see in *Judge Dredd*, he sums them thus:

252

Mike: Just, just the futuristic aspect of it all, thinking like, you know, will we ever, you know, the space ships and the laser guns, and whatever, survival for food and those sort of issues, which are quite interesting, the way they deal with it, you know, cos you think, oh there'll be no food by the Year Whatever so, it's those sort of interesting concepts.

The word 'futuristic' recurs three more times in Michael's talk.

But this is far from his only ideal. Alongside this comes a will to knowingness which has several aspects. First, responding to Kate's question about how they decide to see films, with a tone somewhere between self-surprise and apology, Michael notes his liking for Barry Norman:

Mike: Yeah, yeah ... I mean it all depends, cos like strangely enough I listen to sort of, film critics, I listen to what like Barry Norman has to say, and sometimes based on that I probably decide to go and see a film.

There is an element of 'film buff' in him that likes to know, and indeed to have the right kind of knowledge, about films. The choice of Barry Norman, though, links with something else − his deep and repeated dislike of 'hype'. This isn't just to be avoided because it may let you down, but because it leads to the wrong kind of viewing. What Michael seeks is a measured response to films:

Mike: If a film's had a lot of publicity, I wait till everybody else has seen it, before I go and see it, you know what I mean? It's like, what was that one, with the ... was it *Dracula*?
Steve: Yeah.
Mike: It was *Dracula*, and then *Frankenstein*, I waited till the very very end, and I, I still haven't seen *Dracula* yet, I saw *Frankenstein* at the very very end

KB: *How come then? Why did you want till the ...*
Mike: It's the hype! Cos of the hype. Makes you think it's gonna be such a good film, and your expectations are like, up there, and then you see it and you think, you know, what was the hype about?

Instead of hype, Michael wants the space for a measured style of watching, 'so I can sort of sit back and not have everybody hassle me, just watch it'. The hassling is as much in his head (to do with 'imaginary audiences') as it is directly the result of other people present.

What would he do as part of a measured viewing of a film? To the amusement of the others (who didn't seem to know this one), Michael told of his deep and abiding love of *Grease 1*, which he claimed to have seen fourteen times in all, seven at the cinema, seven on video:

Mike: It's interesting cos the first time I saw it, I said, well, fine, I got the plot. The second time, the lyrics. Then I started looking for other things, you know, sort of uh, not the main characters, the sort of side characters, and how their dilemmas were not, you know, [..] in a sloppy way. So every time I saw it I saw something different, and I concentrated on a different character, who was not in the limelight. You know, like Rizzo's problems which were not really tackled. They didn't tackle the fact that you know, she was pregnant, well she thought she was pregnant and stuff like that, you know. Each time I see a film I sort of look for something completely different, or you sort of, you listen to what they're saying ...

It seems that the ideal behind this is a combination of three things: a film buff interest in how films work, along with elements of an almost literary critical fascination with character and plot, plus a delight in following the unpredictable, the minor key or character, the fringe interest.

One point of difficulty in identifying Michael's ideal viewing experience is his interest in the interviews in identifying and discussing possible 'messages' in films. In this he was quite rare among all our interviewees. It first arose in context of his avowed dislike of 'black films', personified by Spike Lee's *Jungle Fever*. He had avoided *The Colour Purple*, fearing it would be another 'black film':

Mike: And when I saw it I thought oh! I was really wrong, you know. I thought it was another sort of Spike Lee, sort of – which is – I mean, I'm not – I don't really like him as a, as a director or whatever he is. He's got some good films, some of his films are just so, stereotypical at the same time – you know what I mean? They're very positive, but the messages are negative. Remember *Jungle Fever*? The message was, mixed race relationships don't work, they won't work out, because there are so many differences. And I thought ooh, that was really negative. But then I know, he's a separatist so ... I think of who he is and what he's trying to show ...

This is to make 'negativity' into a hostile criterion, a barrier to enjoyment. Later in the same section of the interview, Michael returned to this issue, discussing *Mrs Doubtfire*:

Mike: I thought that was really negative, the message was so negative about divorce and everything, it was really weird, you know, couples should stay together ...

KB: *and men make better women than women*

Mike: Yeah, which was, you know, amazing – you know, if a man tries really hard he can be A Man, the whole concept, and the message about divorce is just really dodgy, so I think, most films have a message one way or another but I don't think we, as Steve said, we don't really see the message, we walk out and we don't really ... you know, it could be anything, and we just

thought oh that was a really nice film, and we go home, we saw a nice film, you know what I mean? I don't think they set out to give a message.

Michael is quite torn about whether and when to pay attention to 'messages', but it's clear that he does find it interesting when he finds them – a bit of the 'cultural critic' comes to the fore, given that opportunity – but it combines with a strong feeling of negativity. In other words, he is most likely to become aware of 'messages' when a film feels 'negative' to him, and then he will feel the need to address this. This explains, it seems to us, the real ambivalence he displays over 'messages' – along with a considerable and unusual willingness to play the game of looking for them.

Steven, Christian and Michael, then, have sharply differing ideal viewing hopes. Steve's central notion of 'fantasy' leads him to value films in which he can lose himself; Christian, though without much conviction or commitment, wants film to link with the rest of his life; while Michael combines film following with elements of the culture-critic, and a less clear notion of 'measured watching'.

4 How elaborated are their conceptions of SPACEs?

The place to start in answering this question is with a striking passage near the end of the second interview:

KB: So what kinds of things had you read about it or heard about it from other people?

Mike: Can't remember, oh some people said oh it's all right ...

Steve: Seemed to me most people were harping on about the sets, and the, the true to comic sort of like, representations like the cars all built up or what have you, and that was about it really, nothing was actually talked about the film, it was all about like, getting an exclusive picture of Stallone, or anybody or anything to do with the set and that was about it really. Whereas with *Batman* it was about *Batman* and [..] I forget!

KB: And you had, did you speak to people who'd been to see it before you?

Mike: Yeah, a lot – somebody said oh yeah, it's all right you know, 2 hours, or whatever, it's alright ... it's not bad and other people said oh we enjoyed it, if you just sit there and you've never read the comic you might just enjoy it. You know if you like, if you like sort of Action films then you might just like that one, cos a lot of people said oh it's OK, you know, bearable.

Steve: I just felt obliged to see it really (self-deprecating chuckle) I thought oh well, I should have to go and see it

KB: Why?

Steve: Well, you just, you know, there are some films that, you know, take your interest cos a lot of people say they're going to see it and you get sort of reviews and things and you think, oh I should go and see it for myself and make up my own mind, and um, I just thought ... hmmmmm

Mike: Publicity again ...

Steve: (Small sad voice) I wish I'd stayed home ...

Mike: ... when the publicity appears, you, you feel obliged, you might as well go and see it and [..]

Steve: The thing about budgets as well, it gets in your mind, 'wow, they must have spent X Y and Zee on special effects!' I want to go and see, you know, what X Y and Zee was spent on. And then you think, oh god, it must be just like, getting the extras in really.

This passage is remarkable because of its summary inclusion of four of our 'spaces', each one noticed but subtly kept at a distance – most noticeably the last. This is a striking confirmation of our sense that higher investors, and those who take a 'knowing' attitude to the film, will be more aware in many ways of other possible orientations than their own. But here, our interviewees almost participate in each of four – though not quite. This is also their tendency towards their own preferred viewing positions.

Steve, first: Steve, of course, tends to ironise almost everything. But even when he doesn't, he places a clear distance between himself and 'spaces' he knows about, and comments on. This is particularly true with regard to the *2000AD* follower space. Steve has been a reader of the comic, and associates with it in curious ways. One of these is outside the scope of this analysis, though we need to note it. In both pre- and post-film interviews, Steve returns several times to the issue of Dredd's face. Somehow he is convinced, and attaches some importance to his belief, that the reason Dredd in the comic never removes his helmet is because his face is 'mangled'. One of his criticisms of Stallone is precisely that he can't meet this condition. We offer no account of this, except to note its strangeness.

But being a former reader of the comic, he 'knows' how fans will feel about it: 'I don't think it will be Judge Dredd-y enough for, like, hardcore fans, to be honest'. This holds them somewhat at bay, a distancing which recurs when, three times within a minute, he emphasised that he uses the word 'religiously' to characterise relations with the comic. The repeated word does several jobs. It admits the existence of such a possible relationship, but in divorcing himself from it, characterises it as an effortful, perhaps obsessive position. To be 'religious' is to emotionally devoted; and this he will not be.

In fact, in the key passage where he uses the term, this distancing couples with another judgement which confirms his weaker position:

Steve: Really, but obviously, he had to show his face as much as possible, 'case we forgot who he was ... it wasn't as, obviously I appreciate that because of what the medium is you can't be true to the comic, because you know, you can get away with some things in the illustrations you can't in real life, but it didn't stick to it as religiously as it could've.

This mild concession about what will be required if the comic is to become a film, is not the same as the committed Dredd-fans who asserted rights over the character. They saw the transformation not as an inevitable function of the change of medium, but as an unwelcome outcome of 'Hollywood-isation', the result of power and ownership.

A very different signal of Steve's relation to his own ideal viewing position comes when he literally runs out of words. At the end of a long exchange between Kate and Michael focused on the latter's recognition of some of the extras in the film, the discussion shifted to the significance of Stallone in the film. Michael called Stallone's acting 'dreary':

Steve: I think he took himself way too seriously in terms of, it wasn't Judge Dredd it was Stallone, it was, he had no, um ... what's the word? What's the word? It's ...

Mike: talent?

Steve: Well apart from no talent! You just knew it wasn't Judge Dredd you just knew it was Stallone all the way, and not because it was Stallone, it was the way he conducted himself, and just the way everything focused on him as opposed to other characters. There was no, like, subplots with anybody else, and if there was it was very loose [long pause] ... it was crap really!

It is risky to reach conclusions from absences; but here Steve's struggle to say what he means links with other things. Devoted *2000AD* followers knew that Dredd was a machine while the living being was the city, Megacity One. Dredd is machine-like because he only exists to serve. He keeps his helmet on, not because he is disfigured but because in a sense there is no face underneath. The drama of Megacity One belongs with the 400 million other citizens. Steve is unable to articulate this probably because he has never had reason to say these things before. Yet he half-knows that there is such a position to be articulated.

The strongest mark of Steve's reserved position about the possibilities of ideal viewing is in his use of the concept of 'fantasy'. This word, available to many widely-differing attitudes to film, belongs to the vocabulary of folk theories of the media. It 'excuses' rather than explains or enlightens. Steve's light-handed use of it confirms this. It is almost entirely defined by what it isn't. Fantasy isn't real-life, and it doesn't make demands. It has all the signs of being a vague possibility, rather than a definite goal. One indication of its 'incomplete' nature particularly hit us as analysts. Using his concept of fantasy, we tried to predict what his judgement of the film of *Judge Dredd* would be. It wasn't possible to, precisely because it is only partly articulated. Only when, as we will see, he 'completed the circle' for himself were we able to see the full but very tentative meaning he gave to the idea of 'fantasy'.

Michael, with his different ideal viewing experience, nonetheless positions himself similarly. His fundamental relationship to films is one of distrust, particularly of the hype that accompanies films. He also deeply distrusts the motives of those who make films, and this connects with his suspicion about the 'messages' he perceives in them. Immediately following his 'inclusion' of Kate by offering to share her expected distaste of the exploitation of women's bodies in films, Michael – along with Steve – explores the very dystopic elements that in other contexts he has declared he likes:

KB: *... do you think that'll be the message of* Dredd*? I mean do you think it will have a kind of ..?*

Mike: I think if it doesn't, you know, it'll be too different from everything else, and it might not be a success ... I think whoever's making the film would not run risks

Steve: You've also got to have that aspect of hope along, somewhere along the line, that's what usually happens at the end of the film, or you get the impression at the end of the film that, you know, he knows the system is bad, he know society's bad, and he's the shining light

Mike: and you must keep fighting cos one day

Steve: one day you'll know, we'll all be free

Mike: maybe not you but your kids and your kids' kids ... it's the same thing, do you know what I mean, so yes, everything is really bad, but somebody somewhere is gonna do some good – not the Conservative Party BUT! [Laughter]

His own capacity to be persuaded to feel hope here becomes a ground for renewed cynicism. Interestingly, it also bring together Steve and Michael. Their expression of this view becomes a two-hander, a shared and almost rehearsed dialogue.

Neither Steve nor Michael, then, have a highly articulated account of their ideal viewing situation. It is there, but is only vaguely hinted at. It is a possibility, but one surrounded by doubt and scepticism.

5 What routine knowledge and expectations guide their viewing?

For both Michael and Steve, seeing films is a common or garden activity. As Michael puts it: 'I usually go either with Steve or with other friends, cos we go to the cinema quite a lot, yeah, if we have a free evening we sort of go to the cinema'. This isn't highly committed viewing, it is a regular ritual outing, in the absence of other things to do. The thing that guides this routine is their expectation that films are 'predictable'. This provided their expectations for *Judge Dredd*:

Mike: *Cliffhanger*, I saw that, yeah, sort of, you know ... I think he's trying to get out of the Rambo thing but it's .. all his films are still, Rambo, you know what I mean? [general agreement] *Cliffhanger* he could have still been Rambo in it, you look at him and you think: Rambo!

This knowingness recurs many times, about plot and about characters. How do they choose a film? Michael: 'Depending on who is in it, I mean, you know the plot, and who's in it, cos, if it's the same thing over and over, you know, Schwarzenegger type, then'. It is also about audiences. It is the general ground of their shared cynicism, leading Michael to say for them both that they go to 'have a good laugh at something really trivial'.

Part of the pleasure is their delight in classifying other cinema-goers, as we saw in the quotation from them in Chapter 3. A few moments after that, Michael had returned to this same topic:

Mike: It's really funny if you're standing outside the, uh, multiplex, the one in, um, the Showcase, and you sort of look at people and try and guess which films they're gonna go and watch ... cos we did that at the Odeon once and that's really funny, cos we were there too early, we sort of hanging about: 'Oh they're gonna watch that, they're gonna watch that' based on the way they were talking and sort of .. general ..

In particular they liked to predict what groups of young males will be going to see. But there remains, at least for Michael, a sense that he can be surprised – and would even like to be. In between the above two responses came a discussion of one film which did surprise him:

Mike: I mean it was like when most people saw *Philadelphia*, it was a complete different concept even though a lot of people say 'it's not' ... I didn't think it would be an audience success, you know what I mean? If we count that film as such, cos you would think 'mmm' I mean the vast majority will not go for it, and they did, which is quite interesting and it was ... you know, I thought it was a breakthrough, you know, I'm not saying, educating the masses, cos that's a, you know, I don't believe in that, but um, it's you know, an interesting concept, that a film about AIDS, something like that, can really go to the public and they actually liked it. And it's not, you know, it's not a mainstream film, I would say it was a Watershed ...[2]

Here was a film that lifted out of the ordinary. It transcended its category, and perhaps 'did some good' on something Michael cares about. But the interesting thing is that nowhere here or elsewhere does Michael suggest that he personally particularly enjoyed *Philadelphia*. It was just a phenomenon which challenged his audience categories.

Michael and Steve find other cinema audiences a problem. When you want to be serious, they are noisy and laugh. When you want to laugh uninhibitedly, you can't. However they manage it, they remain intensely aware of the rest of the audience.

In sum, then, their routine engagement with film is to go regularly, accompanied by routine knowledges of films, their characters, their plots and their audiences. For these reasons, film-going is mainly just 'something to do' – with just the possibility of a surprise, something more, if they are lucky.

6 How do they bargain with their ideal and routine expectations?

Steve and Michael differ about the ideal viewing experience. They have different uses and preferences among cinema and video. They don't always like the same films. But one thing unites them, more than anything else: their consciousness of being black men. And its recurrent role in their film-going is as the cynical back-out of hopes and expectations. Repeatedly in the course of the interviews, the issue of the treatment of

black people in films provides a 'fall-back'. Having set out their wishes, hopes or higher expectations, they step back into a weary acknowledgement of what they think will actually happen. Here are typical examples:

KB: *Um, so what would you assume you would like, and, or dislike about a film like this? Is there any, like, redeeming features, or, would you ... you know?*

Mike: Futuristic ... space ...

Steve: Special effects .. you know, the fantasy aspect .. you'd probably like you'd see most of like, the dregs of the world being ... black! [Laughter] As he walks through the street in his shining armour he'll have like all the tramps and stuff like that just happen to be black bums, you know, or Irish bums, or Scottish bums [laughter] you know like drug barons always being black, hispanic or what have you ... but I mean, that's par for the course ... that's the kind of films he has to thrive on, Stallone, what's what people go and see ... I mean, even if the villain is black, I mean, [..] gave as good as he got but in the end ... he was crucified! You know, and even the black villain was being manipulated by the white men at the end of the day in *Demolition Man*.

This is a sad predictability. They 'know' what will happen in all such films, and that knowledge impedes the possibility of pleasure in films they might otherwise let go in.

Again, in the long discussion of the role of 'messages' in films, there is a distinct turning point when the role of 'blackness' re-enters:

Mike: ... even *Superman*. I think even *Superman*'s got a message.

Steve: In what respect?

Mike: Well it you think about *Superman*, you think, ohh, you know, he saves the world, he's American, the American flag, Americans fighting for, you know, whatever, it's very, it's very American in that sense

Steve: He ain't American, he's Krypton [Laughter] He's an alien! He's a foreign illegal alien in America! And they don't deport him! [laughter]

Mike: You know what I mean?! It's always, you think of it: the world, the American flag, and him on top of the world, Americans on top of the world, America being the world.

Steve: You think if he was a black guy! [laughter]

Mike: Couldn't have been a black guy! He would have been a criminal!

Steve: Originally *Ghostbusters* was gonna be four black guys, and because they thought it wouldn't be commercially successful, that's why it was one black guy.

Mike: I mean in *Lethal Weapon*, why can't it be just a black police officer, it has to be two, Mel Gibson plus whatever, and I think like, that's an interesting concept – there are no black heroes, as, supercriminals – ah, not supercriminals – heroes.

Steve: The thing with supercriminals is they don't get away with it, if they're black, they always get caught.

A little later they return to Superman, and their cynical commentary becomes even more grounded when Michael adds: 'But, it's really funny because if I think, if Superman was black, and he flew into somebody's house, everyone would grab their stuff!' There is no question but that the filmic world would be so decisively punctured by this, that they know it couldn't work.

At the very end of the pre-film interview, they were asked if there was anything they wanted to add, outside our schedule of questions. As the interview was about to close, it caught fire again:

KB: *Is there anything else you would like to add that I haven't asked you ...? I don't know what, but is there ...? Right, I'll leave it there ...*

Steve: Hello Mum [loud laughter] ... It would be nice to see a more popular black film, I don't know how, I don't know what sort of ingredients or formulas is gonna be needed to create this popular black film but I would like to see a popular black film, in the same par, doesn't matter what, you know, fantasy or whatever, not necessarily pure black but at least the lead characters being black without white support. That would be fine, that would be fine, but I'm not sure how that would be brought about, how it would be financed etc etc and who should be the person to do it.

The conversation which followed moved between commenting on films and television programmes which did not achieve their aim, and speculations about how *Judge Dredd* might turn out in this respect. More than anything, their talk betrayed a wistful cynicism, a sense that they knew they were asking the impossible – and weren't at all sure what such a thing would look like, anyway. They dislike preachy 'black films', Michael in particular inveighing against Spike Lee ('He's got some good films, some of his films are just so, stereotypical at the same time – you know what I mean?'); they also reject the 'nice' version offered by the *Cosby Show* (Steve: 'like two of them being professionals and such high professionals and having five kids – I mean come off it! and have that figure!'). But there is a yearning for an unnameable alternative in which 'it would be nice to take, you know, see what would happen if they just did like an ordinary film about ordinary black folk that you know, just get along ...' whereas at present 'it's like, we have no feeling unless we've got crack up our veins!' (Steve).

Their way of handling this disappointed sense of impossibility is to view despite themselves. At the extreme, they will go to a cinema which they almost dislike ...

Steve: I don't tend to like cinema audiences anyway, cos they tend to laugh at things you don't wanna laugh at and you know, you get the person eating crisps behind your back

KB: *Yeah, snogging in the front*

Steve: That's right, and you know, you know, you feel obliged to join in with the crowd if they find it funny, and you know?

... and simply turn it into an occasion for laughter. The movie can then be good *by vertue of* being very, very bad:

KB: *If you didn't like it then, did you not, why did you stay to the end of films you don't like?*
Steve: Cos I paid good money! [laughter] You know, you always live in hope that it will get better than get worse.
Mike: I'd never walk out of a film I don't think I would. Well, there was only one I wanted to walk out of: was that *To Wong Foo*, well, we did walk out, it was SO bad, it was just, all we did, it just made us laugh, and you just you know, I think we were spoiling it for everybody else but! We had a good laugh taking the mickey out of all the characters, I think, just walking out is a bit, d'you know what I mean, what's the point of walking out?

There isn't a point in walking out if your expectations have been low to start with. Instead, you use a viewing stratagem to turn it into something half-pleasurable by virtue of being mocked. We will see in a moment how this strategy was adopted towards *Judge Dredd*, and with what consequences.

Michael in fact redescribed this occasion in the second interview, with an interestingly different emphasis:

Mike: It's like *To Wong Foo*, now come on, if I'd seen *To Wong Foo* on my own I would have switched it off and taken the video back, but we went like a large group of us and a friend of mine, she was just cracking up! Absolutely .. and I was thinking why and she goes 'it's so bad!' and the laugh – it was so corny, 'you're not a queen, you're a drag princess' and stuff like that, and my friend, she was cracking up! She was like THIS IS SO RUBBISH! [laughter] And the people behind her were sort of like, cracking up! So in a way, it's sort of like, you know, it was so bad, we ended up – were you there?
Steve: I .. no
Mike: Oh you weren't there. We ended up talking to the people in front of us ..
KB: *While the film was on?*
Mike: Yeah! And all ended up laughing at the .. one bit, the guy in front of us, he was with his girlfriend, and she just sort of stood up and started cracking jokes!

There is a stronger sense here that at a certain point a choice was made to turn ironic viewer: a choice made possible by a dynamic interaction with other people

in the audience. Pleasurable on this occasion, it is of course the opposite of Michael's ideal for film viewing!

Michael adds to this general repertoire a specific capacity to inhabit the margins of a film – to take up a consciously perverse 'reading position' which finds pleasure in something whose whole point is that it has no real connection with the main thrust of a film. Again, we will see this in action on *Judge Dredd*.

But there is another aspect to their bargaining of ideal and routine expectations, another aspect of their current cynicism. Steve reveals it in a monologic pronouncement in the pre-interview in which it becomes very unclear whether he is talking about himself or other people:

KB: *So .. do you think there is room for films with a message as opposed to films that are escapism, I suppose what I'm trying to get at, is what would be your definition of a film with a message and an escapist film?*

Steve: Anything that makes you think, basically, that you go to do something about it, but at least, the next time I see a situation like this or something like that arises, I will take stock and really deconstruct what's going on .. you know, to find from my own point of view what political, what political stand I take on that subject. And I mean, the escapist side of it is [day-dreamy voice] 'I don't need drugs!' you know! [laughter] I think messages are incredibly subtle these days and it goes over a lot of people's heads what you're talking about, to the point of offence, um, I mean, like, a couple of years ago, ten or fifteen years ago, the audience were much more intelligent I think, because it wasn't, there wasn't such a video culture. You went to the cinema, and you – because it was one of the few entertainments about at the time, you were much more engrossed in what was going on, than nowadays because you got so much visual imagery going around, you just let everything flow over you and you just take little bits but not really understand what you're taking, it's like, oh, that slightly interests me, oh this slightly interests me.

Steve returns to this theme when he talks of ours being a 'throwaway culture' so even purely filmic responses are lacking:

Steve: It's like *Dracula*, everyone was supposed to go Gothic and like, nothing happened!

KB: *Yeah, yeah! Cos on like, Richard and Judy and things there were like, gothic make-up and stuff*

Steve: It just doesn't happen cos I think, you know, nobody's that interested in films, they just want to see it, and walk away, that's it. Nobody wants to live a fantasy of being Dracula, no one wants a stake through their heart!

We have a strong sense here that Steve is talking about himself and is regretting his own declining capacity to be involved, via a response imputed to other

people. The fact that he uses his own 'ideal' term 'fantasy' suggests a boundary marking. He will control his own use of fantasy, and limit its application for himself – via a half-scornful account of 'people's' failures to become deeply involved in films.

In sum: Steve and Michael manage the relationship between ideal and routine expectations by falling back into scepticism or even cynicism. The predominant aspect of this refers to a black consciousness: an awareness that this cinema is not for them. But that can turned to pleasure by becoming a knowing superiority. These responses, however, have to be carefully managed in order that they can deliver any kind of pleasure.

7 How, in the light of these, do they assess Judge Dredd?

Key judgements and expressions: 'It wasn't its own thing', not 'original', it didn't 'fulfil the fantasy'.

Steve and Michael did not like the film, but they did in some ways enjoy it. Michael in fact went to see it twice:

Mike: Well I've seen it twice which is even worse! [laughter]
KB: *Why, why did you see it twice?*
Mike: Oh, cos some friends wanted to go so I want again, and cos I'm know, I had to drive them there [laughter] so I went back to it, and cos the Showcase has got really good sound, sort of, if you're gonna watch an action film then the Showcase is THE place to go cos of the sound.

Like many others, the first few minutes created high hopes:

Steve: you think, oh this is going to be quite impressive, and you settle down and think right, this is going to be shit hot, I'm, I'm going to enjoy this and as it goes on, things, you know, you think, hang on, this is not quite right!

And it 'fizzles out', and becomes (crucial phrase) 'just another post end-of-the-world sort of film if you see what I mean' (Michael). This is a knowing comparison to a known formula. They had a series of criticisms of the film: its picture of poverty was too 'glossy' (Steve); its filmic technique was all wrong:

Mike: And some of the shots, some of the shots were quite funny cos, do you remember, we were laughing cos he walks like a robot, his arms and the back of his neck (imitates robot-walking noises). It's quite funny, he's like you know [..]
KB: *And he's always in the front of the shot so everyone could stand behind him, you know, slightly crouched!*
Steve: Yeah!

Mike: And the way the camera kept focusing on Arms, Arms, Buttocks, Arms! [laughter]

The film became a series of discontinuous fragments for them. It dissolved into a series of references to other films. Steve captured this in a series of adjectival references – *Judge Dredd* became 'Star Warsy', 'Darth Vadery', 'Hannibal Lectery', while 'Literally everything, literally everything reminded me of *Bladerunner*! Literally!'. Michael added his own angle on this:

Mike: It's like a Western film, it's like John Wayne, taking the law into his own hands, like blowing up the car, that was .. wasn't parked properly, it's the same thing you know, I AM THE LAW, it's like, yeah, so what? You know what I mean?
KB: *Yes, yes.*
Mike: I kept thinking of Westerns, like, John Wayne, and I kept thinking of Rambo, and maybe cos it's Stallone at the end of the day, but I just kept thinking, yeah it's him, he's not acting, it's just him, the way he talks, like if you see him at an interview you see his mouth, it's the same ...

The film dissolved into elements, and was responded to as elements. Twice, Michael drops out of a continuous discussion to say, first 'Interesting special effects', then 'Special effects were alright'. They are marked off as passing thoughts, disconnected from the rest.

It was in fact out of these 'elements' and their joyous criticisms of them that a further clarification of their ideal viewing expectations emerged. Repeatedly, in recalling his responses, Steve used an interesting form of words. Closing his response to the glossiness of the poverty, he says: 'and you're thinking, oh please!' Speaking of Dredd' sidekicks, he says: 'they didn't have that much of a place .. it's so strange cos it's like, 'why are you here?'' Speaking at greater length of the film's use of the idea of cloning as an explanation for Dredd's situation:

Steve: It was interesting about the clone bit, that he was a clone and he wasn't actually born of a mother and father sort of thing, and um, it was nice the way that sort of developed, but it wasn't as sinister as it could've been. Cos it seemed to, it just seemed to tie the ends together, it didn't to seem to like, go through the flow, you didn't like, well why weren't there a few others that were done like him, I mean fair enough it did stop with him but, surely they would've developed it a but further on and it didn't develop till the end bit where you know, it was his actual brother doing it as opposed to anyone else doing it and you think well, naaa.

A complex rule about plot consistency and elaboration is being enunciated – whose breach results in him withdrawing. It is a failure of nerve, and of hope, that pulls

Steve back out of the film into 'Naaa', 'Oh god', 'oh please', and several other phrases of dismissal. The judgement that ties these together is given shortly after in his summary statement: 'it wasn't its own film'. Steve virtually repeats these words shortly after: 'It's like, none of it's, you know, its own film'.

What this means is contained in all those smaller judgements. *Judge Dredd* is sufficiently incoherent as a film that it does not hold together inside itself. It therefore is not an appropriate vehicle for 'fantasy' – and that word returns for Steve. Michael contributes another measuring word, which Steve accepts: 'original'. Six times in a short space they assess the film for its 'originality', moving across and aligning the separate meanings the word can have, in order to concretise their criticisms of Dredd. 'Original' can mean 'source' (as in *2000AD* containing the original of *Judge Dredd*), but it can also mean 'classic', 'authentic', and 'new and unique'. Their uses of the word collect virtually all these connotations, to make their judgement of the film.

Steve enunciates his ultimate judgement on the film in a (for him) quite monologic passage. After comparing *Dredd* unfavourably to *Batman*, he continues:

Steve: It should either have gone opposite or stayed close to it.
KB: *What were you expecting it to be like then? Did it confirm your ...*
Steve: I expected it to fulfil the fantasy. I expected it to um, you know, when I go to see a film I expect it to completely engross me as a fantasy film, you know. It didn't at all, I was just picking and picking faults. And that's not what a film should be all about, and it shouldn't entertain me in that way without thinking 'oh, I can find out what's wrong with this, what's wrong with that, or this lot's not working' and it shouldn't be like that. I should be like this, my eyes are hurting cos like, I've not blinked for like an hour and a half! And I walk out like, [dreamy voice] 'wow! I'm converted! I wanna be *Judge Dredd* when it comes to my time' do you know what I mean – and there was none of that at all – it just didn't .. and you know, it didn't want, make me feel to go and see it again just for it's something, it's one scene, not like *Aliens* or something like that where most people go back for that, like, when she says 'Get away from me, you bitch', you know [laughter] you know, there's nothing at all in the film where you think, right, you know, that's something that really got me going and I want to see it again ...

This is Steve's most fervent statement of both his DRIVE position and of his critique and disappointment at Dredd's failure. Michael expresses the same criticism but with a different force. For him the film became stupid, and therefore capable of being funny through its failure. Describing his second viewing when he went with people who were seeing it for the first time, he said:

Mike: That was the funniest bit for me, and as I waited for that bit I just had to sit there quietly cos you can't say anything cos [..] but you know, you get to

see other stuff and you can concentrate on other bits, and it was just as naff. You know, his persona, the whole, the acting was very much – maybe it was you know the purpose of the film that he was very very square, very very, you know, his movements were not flexible at all, even his, his acting was like [wooden acting noises]. I just found it really funny, I – you know – I just laughed through it, its, you know, over the top acting, over the top movements, you know, the the the, when the plane crashed, and they were trapped in this cave, I thought they were gonna, you know, he's gonna, they were gonna hurt him or something but no! He just escaped and killed everybody and that was that!

The fact that Michael is more willing to ironise and enjoy through mockery doesn't blunt his criticism – for him, too, the film doesn't live up to its own claims. It won't follow through the logic of its own premises. It won't be its own original thing.

Michael in fact gets his enjoyment both through becoming a superior spectator, and through occupying deliberately perverse marginal positions: at least two, in fact. First, he revelled in recognising some of the 'extras' who appeared in the film. It allowed him, while watching, to veer off into thinking about the paradox that this film, which is so American, was in fact filmed in London (thus enabling his friends to appear in the street scenes). Second, he grabbed at the moments of the bizarre and outrageous in the film, for their own sake. So, he took a perverse pleasure in the scene in which the two central women characters fight:

Mike: The bit where the two women were fighting: remember that bit? [...] The two women were fighting, it was hilarious cos [...] in a way, in a way they weren't like, fighting like stereotypical women, you know what I mean, it was like, they were like punching each other, which was quite interesting to see, cos they weren't dragging, they didn't pull each other's hair! [...] It was quite good [chuckles].

(Square brackets here indicate failed attempts by Steve and Kate to interrupt or take over the conversation – Michael in fact rode over their attempts until he had finished his point.)

Since the film failed to provide an original fantasy, both men accepted 'defeat' and couldn't be bothered even to see if there might be a 'message' in it, for all their previous interest in this possibility:

Mike: I don't think it was intended to have a message.
Steve: And if it was, it was definitely lost, cos you were so busy like stripping it to pieces and just not giving a toss about any of the characters or what they had to say that, um, the film was, completely ... you really didn't want to take notice, you just thought, where's the [..], where's the entertainment I came to see?

The final irony in their critique of *Judge Dredd* comes right at the end of the interview, after they've gone off into a fast-paced exchange of speculations on who would be appropriate to play Judge Anderson in a possible future *Judge Dredd II*:

KB: *Anything else that you wish to add?*

Steve: There were no black characters! Not that I can remember, no, not at all, we were hoping there were! Maybe in the criminal element .. well..

Mike: [laughs] There must have been!

KB: *I don't think there was really, was there? Maybe they were in another city.*

Steve: Killing each other!

Mike: All been repatriated! [Laughter] Doing their own films, a black *Judge Dredd*!

KB: *There's a black Judge in the comic.*

Mike: He was on holiday.

And so they end by falling back on an expression of their black response to films – one which is so disappointed at the whole experience that they would even have accepted black men as criminals!

Summarising the 'bargain'

We see Michael's and Steve's responses as clear cases of 'bargains'. There are experiences they would ideally like from films, but they are pretty sure they won't get them. So they go, anticipating disappointment, with prepared fall-back positions. In fact, we can broadly distinguish four kinds of responses: committed responses, in which viewers make demands, assert rights, claim ownership and feel that this piece of culture is 'theirs', in some important way; bargained responses, in which people realise their relative powerlessness, or that legitimate demands may intervene; aware responses, where people acknowledge other viewer-positions as relevant, but don't want to adopt them; and casual responses, where without commitment and with little drawing on wider knowledges, a film is 'watched'. Our Table 2 sorts all our respondents under these four headings. This shows something striking. For many viewers, high investment or commitment is readily associated with awareness of other positions, but it is less likely to be mixed. Bargained responses, on the other hand, lend themselves to mixing modes of attention. Mixing happens in two distinct modes. Some people definitely combine orientations. Others code-switch between them. It's not difficult to think why commitment should be more unidirectional. To claim rights over a film, to commit oneself to a way of responding is more likely to be single-minded than cautious minimising of expectations. (See Diagram 2 for an overall assessment of this.)

Bargained responses are qualified. Partly, it is possible to discover these through looking for modal qualifiers: hesitating, tentative, unwilling, cautious, uncertain, deferring, distancing, ironising, wishing and disclaiming comments, for instance. But often, they are to be found through their explicit reference to ideals and limitations, as in the following:

KB: *You were a bit of a long term fan is that right? [Denzil Yes] I mean what was, how did you feel, then, as you saw, like –*

Denzil: Saw Dredd come alive! [*KB Mmm*] In the form of Mr Stallone! Um, I was happy, um, like I said there was, you know, one or two little things about the costume irked, but then knowing that his voice wasn't the voice that I imagined Dredd to have [*KB Right*] So you gotta give, um .. allowances. [Interview 41]

Denzil 'imagined' Dredd's voice out of the comic, and carried that imagination with him. But he 'makes allowances'. He acknowledges, even adheres in a way, to the *2000AD* SPACE. But he bargains with it. Why? We began to develop the concept of 'modalities of use' for just this purpose. Modality judgements alone are just some of the symptoms of a response such as this. It is the extent to which Denzil admits Dredd into the context of the rest of his life, and the strength and force with which he does this, which will explain why he chooses to bargain, rather than commit himself, to his version of Dredd. Now contrast that with an investor with a high DRIVE:

Nick: The first couple of minutes when you've got Hershey and the bike turns up and you just see a pair of boots, a shiver went down my spine thinking I've been reading this comic for 19 years and finally the film is here! It was a really good moment. Then it panned up to Stallone's head,, um, but, just that first moment when Dredd appeared, it was very powerful, amazing. There were various moments though where I'd be thinking, Oh my God this wouldn't happen in the comic! That's not Dredd's voice! [Interview 20]

The contrast is so striking – for Nick, the voice just isn't 'Dredd's', and that matters. Of course, Dredd did not 'have' a voice until the film – but that is irrelevant, for Nick has fashioned Dredd into a three-dimensional persona from the pages of the comic. Stallone is just not right, unforgiveably. In this difference, we can see the lineaments of investment, and what changes come with it. In the next chapter, we pursue this idea as far as we are able, at this time.

Closing the circle

Because Martin Barker knew one member of this group, Michael, as a student, we took the opportunity to ask if he would be willing to read this analysis, and comment on it. He did, and also discussed it with Steve. It seemed an opportunity that researchers rarely take, and could provide both a test of our account, and perhaps further insights.[3] What we have put in above is the unedited version of what we gave to Michael, who was then interviewed again, to record his comments.

Michael corrected us on just one point: we had concluded that he and Steve would 'accept' black men in criminal roles for the sake of just seeing them on screen. Michael challenged this, saying that they had come to expect this, and could live

with it, but that didn't imply acceptance. Beyond this correction, which we fully accept, both the form and content of Michael's long (15 pages, with a low proportion of interviewer input) response to our analysis overwhelmingly confirmed our conclusions. The most striking feature is one recurrent word: 'interesting'. Said 36 times in all, Michael used it to mark out not only his thinking about our analysis, but also his further thoughts on the topics. The word tells of a self-reflective attitude, slightly distanced from and observing his own reactions. He reviews his position as a man and as a black man, and finds it fascinating in its complexity. Again and again, he confirms and amplifies the ambivalences we found, typified in these two extracts:

Mike: It's like yesterday I was saying to you before I went to see *The Crow*, and the main evil character as such was black, and it was quite interesting because when he came out I thought because of his voice and everything else, his deep voice, I thought, he's a criminal [*MB laughs*], and he's a criminal and he will die at the end. And I think it's because you sort of know that he's got to die at the end and from that moment on I knew, you sort of figure out the format of a film, ah he's the black criminal, and the white guy, he's going to come in, he's going to kill him.

MB: *I see what you mean, the word 'accepted' is wrong there, it implies your complicity with it and you don't want, you might put up with it but you wouldn't accept it.*

Mike: I think it's just, it doesn't undermine my enjoyment of the film because I can enjoy the film regardless, but it's sort of bringing to the forefront the fact that we know that's going to happen

Mike: Yeah, I said to Steve um, cos I highlighted some bits for him to look at, and he goes and he said [shakes his head]. Yes but you've got to think about it. And I said to him if a black person is killed in a film, do you find it strange? and then he says depending on why, if he's a black person he's a criminal, he says oh then he must be killed, he will be killed because the system needs him to be killed. And then he says but why can't there, and then he says to me I would like to see a film one day, where there's a black character on his own doing everything. And I said do you want that film, I said to him do you want that film to be within a black commun., within a black environment, he goes No. And I said do you want it to be in a solely white, he goes, It could be solely white or mixed. So I think it's got to do, I think for him it might be to do with success. A black person succeeding – I don't know if I should use the words 'in spite of' because that would sound like a liability, that would mean black was a liability ..

MB: *.. or, in the face of ..*

Mike: .. in the face of being black, succeeding within, you know, like a black president succeeding, you know, someone being elected cos they're the president, cos they're black. And I don't know if that would give him pleasure. [Phone interruption] I highlighted this bit for him: it says 'What

seems to be central to Steve's criteria for a successful viewing experience is one in which somehow he can cease for now to view as a black man'. And I asked him about that, and said 'Do you, you know, does enjoying the film mean that you don't think of yourself?' And then he says, but sometimes, he said to me, I see myself as a character but I don't .. How do you think of race, and he says, I do but I don't.

The ambivalences here declared are exactly of a piece with those we found in the earlier interviews. They are also best made sense of by seeing them as marking their distance from some presumed external positions, which are noted but held at a distance. Michael's final responses deserve much more attention than we dare give them here. But we feel they confirm the force of our main conclusions. And in doing so, they indicate the usefulness of two other things: the framework which looks at people's orientations in terms of ideal SPACES and DRIVES, in relation to which individuals then bargain their position; and, following from that, the methodological strategy we've followed to analyse individual transcripts.

What we see, then, is that these black men are very aware of the available orientations for watching and enjoying a film such as *Dredd,* and of the local cinema arrangements that go with these. But their own socio-cultural position debars them from entering into any of these full-bloodedly. This strain produces a set of middle opportunities – bargained positions – which they are prepared to try out (most notably concretised in Steve's demand that a film be 'its own thing'). 'Viewing bargains' do not rule out disappointment, but it does mean that 'bargaining' audiences are more ready to live with disappointment.

Most important, though, is the way this directs our attention to the encounter between a person's socio-cultural position, and the available SPACES. In this case, a strong awareness of representation of 'blackness' seems to drive their willingness to participate, and their bases for 'bargaining'. In this sense, they have become a specialist group, a good example of an unwillingness to let go within a film. But what of those who do go for total immersion? Cultural studies recently has privileged 'negotiating' audiences under the banner of 'resistance', on a presumption (which we have rejected) that distance equals retention of critical capacities, while immersion equals vulnerability. Dispose of that, and we can explore what happens when a filmic SPACE coincides strongly with a socio-cultural position.

The most ready and enthusiastic participatory groups seem to arise from a combination of two orientations: the Action-Adventure, and Future-Fantastic SPACES. This is also just the position which our Boys' Club respondents reveal. What might we learn about the social implications of this genre of films if we return – now armed with a detailed method of analysis – to those transcripts we puzzled over in Chapter 2?

1 These transcripts are available via the Web site of the Faculty of Humanities, School of Cultural Studies at UWE, so that readers can assess for themselves how effectively and fully our approach

has worked to bring out the orientations of the people in this group. Also available there is a transcript of our follow-up interview with one of the participants, on which see the end of this Chapter. See our URL: http://www.uwe.ac.uk/facults/hum/cultural/staff/dredd.htm

2 Here more than anywhere Michael uses 'You know'. We suspect that it is because he knows that here Kate can claim expertise – she teaches and researches on film. To talk to her about this kind of film requires him to acknowledge this.

3 The only examples we can think of where researchers have taken their analyses back to their sources, to ask for their comments, are William Whyte, 'Street corner society', in F Heidensohn, *Women and Crime*, Basingstoke: MacMillan 1985, and Paul Willis, *Learning to Labour: How Working Class Kids Get Working Class Jobs*, London: Gower 1977.

4 These ambivalences interestingly parallel those found by Herman Gray, who suggests that black people watching television tend to be divided between demanding 'realism' – an accurate mirror of the world as it is, and wishing for 'empathy' – which may depend on seeing a world depicted unrealistically. See his *Watching Race*, Minneapolis: University of Minnesota Press 1995. See especially pp.82-3.

12 JUDGING FUTURES

We can now return at last to the Boys Club transcripts, last met in Chapter 2. What can now be understood from their responses that earlier gave us problems? We can now see that the boys are in fact combining two SPACES: the Action-Adventure, and the Future-Fantastic. They do so with a considerable degree of DRIVE, but within an acceptance that their chances of getting exactly what they'd like are slight – there are too many restrictions, controls and routine barriers between them and their goal of uninhibited participation. Let us now examine in these in detail, using the same investigative method as before, with just this difference: because of the many ways in which their responses can be seen as 'typical', in the sense that their responses are shaped by an awareness of external opportunities and constraints that many others display, we have interspersed for comparison some parallel elements from other interviews.

1 Nature of the Groups

These were naturally occurring groups. Although the personnel in the two interviews are not identical, it's clear that this hardly makes any difference, as what they present we might call a 'cohort' response. They may disagree from time to time in particular judgements, but the founding criteria don't vary. And they hardly speak as individuals, but as representatives of their kind of response. Hence the frequency of expressions like 'When you go ...', and 'What you do ...'. They are describing a shared response-pattern they know about, and happily enter into.

In the first (pre-) interview, one boy, John, sets the pace. He marks himself as the most experienced, and to an extent the others are aiming to become like him. He is the one who most easily gets access to '18s', and is allowed to stay out late. His mother, he says, has 'realised' that he is now more grown up, and so is well able to watch *Basic Instinct*. But interestingly the boys are surprisingly unjudgemental about each other, accepting that at the moment one or other might still find a particular film 'scary'.

2 Relations to the interviewer

The interviewer is clearly an outsider to their cultural group, but there are no signs that this has put them on the defensive. There are few defensive qualifiers, like 'it's sad but ...', or 'I know it's junk but ...'. The exceptions are, first, when they discuss the difference between boys' and girls' films. John begins, pauses, then has to re-begin his contribution: 'it's ... not being sexist, it's a girl's film, it is, it's a film like

that'. This surely carries his acknowledgement that the interviewer is female. What is interesting, is that a little later her status gradually shifts to being that of 'adult', when the issue of 'violence' is debated. First, Turtle allows that some girls also like Action films ('violent stuff') – and indeed, John's fantasy girl turns out to embody Action characteristics ('knows Martial art, tough, good looking, sexy, slimline'. Turtle: 'Calm down, John!'). Then in a judgement that reeks of 'adult' balanced judiciousness, Turtle gestures towards the public agenda about the wrongness of filmic violence, but effectively neutralises and fends it off: 'It .. it is bad in a way 'cos he's teaching you violence and stuff, but not many, not many people would copy him, his violence, cos not many 15 year olds have got motorbikes and truncheons and stuff, or guns.' But in taking our question in that way, the interviewers' status momentarily switches to that of representative of 'public concerns'.

Perhaps because it is something quite regularly encouraged by the Club, the boys seem used to the idea of talking about their interests. Apart from the opening of the post-interview, which became briefly stilted, they don't hesitate to parade their responses, their knowledges, and even to use and then kindly explain bits of their group-argot. Why not? They are in their own territory, both physically (the Club venue) and culturally (these are their films). The occasional bravado and machismo in front of a female interviewer was almost certainly restrained by the fact that the Club's organiser, though not present, would return at the end. In the meantime, they felt safe to talk about 'safe' culture!

3 Symptoms of SPACEs

John states, and the interviewer has to ask him to repeat it, that a good film is 'safe'. This is their slang for 'good', 'brilliant'. It is also important that it is slang. A 'safe' film is one that naturally enters their cultural array; to recognise it as such is to confirm your status as part of their group. In choosing to see a 'safe' film, therefore, you aren't venturing into new or unknown territory – you are going for an expected experience. You will know when a film is safe, by the 'hype' that accompanies it.

A good film, for these boys, has several components. First and most importantly, it must do something to you. 'Pace', as we saw, is everything. They will just about accept a slow start, since a film must establish its characters and scenario. But thereafter plot complexities, confusing elements, anything that moves you back from absorption, is bad. By contrast, bad ('soppy') films 'send you to sleep'. The point, though, is not just pace: it is that the pace constantly hits you with new experiences. This is why a cinema like the Showcase is the ideal place for a film: you get 'Surround Sound all round your head'. And the experiences will be intensified by the reactions of everyone around you, jumping, screaming, laughing. Best, of course, is if your mates are with you, and you can be a 'lad'. Worst is where your viewing is disciplined – and this is a moral and social matter simultaneously. There is also always the fear of doing this wrong: remember (from Chapter 3) the boy's nightmare of his mother's hankie. This terror of the inappropriate adult is widely felt: 'If you're with your parents and you see

someone from school, and they're in a big group and you're with your MUM AND DAD, then obviously they're going to say something like "don't bring your mum and dad in here"!' [Interview 15] Our point is that this reveals itself as a concern for appropriate behaviour in a space they feel is theirs.

Along with these qualities goes the hero: in this case, Stallone. Stallone suits his films, and that is important. They know the differences between Stallone, Schwarzenegger, and Van Damme. What differentiates the first is that 'It's good cos he always gets beat up and then just comes back and decks 'em ... that's pretty good!' (they know the *Rocky* films, and one at least has collected them). Stallone also has his own style and humour, and the boys are grounded sufficiently in this tradition to have caught onto the conscious by-plays about each other within Stallone's and Schwarzenegger's films. The hero offers them several things: a promise of completion – no matter how bad the odds, the hero will make it. They can 'want to be like' the hero – and that means going to see the film in order to be able to 'style yourself in a way'. 'Yeah, just to dream, that could be like them, sort of thing'.

All this is the primal stuff of the Action-Adventure SPACE, but there is more. There is also a fascination with the technologies of the future. Their fascination with this veers between some highly particular desires (for the big motorbikes, for instance), and a more generalised interest in the 'bad side of everything':

John: I like watching futuristic films cos you sees people's ideas of the future, weapons and .. stuff.

Turtle: And you get ideas .. of like what it's gonna be and you think, 'well, can't wait till it gets to like that year', sort of thing

This sense that the technology is simultaneously of the present and of the future is the pith of the Future-Fantastic SPACE. The boys' attitudes to it are highly ambivalent. As film, it is exciting, and being in tune with it is part of becoming adult – but not so adult that they become like their parents who grew up in different times. These films, crucially, are of their times even as they are also about the future as perceived from these times (something 'we've grown up with'). But they also know, more cynically, that filmic violence is also part of marketing strategies:

Turtle: It's like, it's got to have guns in nowadays, it's got to have something to do with guns and something to do with drugs

John: To sell, to sell now, people have got to die, there's got to be some scandal, something like that.

As possible reality, their reactions are even more ambivalent. In the post-interview, there is a sharp split. The film was 'warning us about our future' (neatly crumpled into 'don't carry flame-throwers in your pocket'!), but this

vision didn't convince: 'I don't know how long it's going to take, but it ain't going to be like this'. That tension between present technology and future vision remains:

James: Stuff like the bikes and everything was good, but all the lives and everything was tat. I didn't like that. ... You would have thought it would be like nice where everything was like nice and everything. But it was a state really for the common people.

4 How elaborated are these conceptions of SPACEs?

The boys are quite self-conscious about what they expect and want from a film. They also know that this is viewed in various ways as a problem: because they are under-age; because films of this kind are frequently seen as 'a problem'; because, in some senses, they even agree that they are a problem – not for them, though, for younger children.[1] They reject 'them' moralising to them, or at least they reject it if the morals are 'thrown at you'. Films become too like school, if the film-makers do that. A message put in 'sneakily' can be heard or ignored, but at least it doesn't disrupt the flow of the filmic experience. On this, the answer becomes detached and almost vacant: 'dunno .. don't really care, actually .. don't mind it'.

They know what they want, and they recognise that the things that they want are of their time, and of the world they are growing into. It is part of their coming adulthood to have been through the right kinds of filmic experience, and to have absorbed the knowledge of them into their lives and thinking about the future. All this sets them apart from those who, boringly, block their rights to these things ...

5 What routine knowledge and expectations guide their viewing?

Boys like this know their way around their world well. They know which cinemas are best – not just for sound, and rocking seats, but for the entire experience of popcorn, foyer, girls, pizza, sports shoe shop et al. They also know which cinema they are likely to get into, despite their age. Their attitudes to this are interesting. We had expected a combination of disgruntlement at being debarred, with bravado at managing it. In fact, they and others like them display a quite different combination: of bored acceptance of adult restrictions, with an almost moral judgement on those who don't enforce the rules. Each boy has an anecdote to tell about getting to see '18s', and how 'officialdom' can be dealt with, be this box office or parents. The typical phrasing is 'You can just ...', indicating the ordinariness of the problem. In another interview: 'Like down at the Showcase, you can get in, I could buy an 18 ticket, they only want your money'. [Interview 8]

The film industry is very much a 'they'. 'They' make exciting films, but 'they' also put messages in them, which 'we' try to ignore. These boys are eager to be 'happy consumers' of what 'they' produce – but of course lack the resources to go as often

as they'd like (Michael: Any film suits me as long as it's good. *KB: Do you go to the cinema quite a lot then?* Michael: Not really, can't afford it).

They also know their films, and their formulae. Of *Fortress*, John tells a minimal plot, and adds: 'Usual stuff'. The 'usualness' is not the plot, but the kind of film it is:

Michael: It's gotta happen, ain't it, in every film? It's the same. It weren't really different. All the baddies got caught, and like jailed or killed.

James: And you see, you get half way through, and you see like who the baddies are and everything, and you know by the end that they are going to be killed or caught or something like that.

Michael: But you still go and see it cos it looks good.
'Looking good', the display of technology and effects, rescues the 'usual stuff'.

Action films, the Showcase, the hype: these are all their territory, but they routinely know that they can't get into what is theirs. Instead, they live in a world with risks in it, of which 'getting beat up' down by the (cheaper) Odeon is a typical example.

6 How do they bargain with their ideal and routine expectations?

The striking thing about their bargaining between what they would like, and what they can get, is their handling of the issue of 'violence'. The words are there to summarise whatever it is that excites them – but the words are not their words. 'Mindless violence' is the phrasing of a tabloid headline, or a politician's comment on 'hooligans' or a 'gratuitous film'. There is a curious way in which these boys are possessed by a way of thinking about themselves that is not their own. Who will most enjoy *Judge Dredd*? 'Boys ... because it's just one of those films ... boys are more prone to violence'. That's how things are. We're boys, so we suppose ... They seem to accept a certain definition of themselves, and its classification of their desired experience as a potential problem, without letting that undermine their wish for it. This is a peculiar response, and we will return to it later in this chapter.

7 How, in the light of these, do they assess Judge Dredd?

From all this, their judgements on *Dredd* are virtually predictable. It was good inasmuch as it had 'quite a lot of action' in it, but the plot was 'slow'. They'll rewatch it to 'remember' it, but there was nothing special here to reinvest in. They can trade it with mates if they have it on video. The striking thing is how little there is to say about the film once the experience is over. There is an imbalance between preparing to see it, revelling in the hype, and hoping for something special; and afterwards, when that intense 'present tense' experience is over. Really, there is nothing worth saying, except to pass on and be ready for the next one.

But a number of issues are left unresolved by this. (1) This transcript takes us to a boundary, which we need to explore: a boundary which may reveal some very important things about the role of films in the lives of young working class boys like this. What we want to say about this is tentative because our evidence is slight, but too important not to try out. (2) Then there is the issue of 'violence', and the boys' acceptance of a self-definition which sees them as a problem: this takes us in a direction we have not so far gone, to examine the hierarchy of acceptability of SPACES.

Is there a 'class orientation' to Action films?

A number of researchers have emphasised the usefulness of qualitative research as the basis for theory-building.[2] Because of the uncontrolled complexity of the materials gathered, qualitative research lends itself to puzzle-setting, and to generating hypotheses. While agreeing in general with this, we are suggesting that has become self-limiting; in our research, we have tried to move to testing hypotheses, and to validating empirical claims. But now we arrive at the boundaries of our data, and have to become more tentative. These boys, as we've seen, combine two SPACES: Action-Adventure, and Future Fantastic. In this, they seem to be typical of a large number of our young, male, working class respondents. What does it mean to combine these two orientation? What does it contribute to their lives? Action-Adventure fore-fronts the present-tense sensory experience of cinema, along with marvelling at the qualities of the hero and what s/he faces and overcomes.[3] Future-Fantastic, in apparent contrast, works along a fault-line between the spectacular experience of technologies of effects in the present, and the same features as glimpses into possible, but mainly bleak, futures. And the 'new Hollywood' has produced a long sequence of such films, as one of its central genres. We offer an account which is honestly part-speculative. Yet, like Baxandall's account of his paintings and their viewers, it makes sense of a lot that is otherwise just puzzling. Like Baxandall again, to build our account we have to draw on several sources.

To understand what we are doing here, consider the following extracts from our transcripts.

Jag:	I reckon the difference is, Kate, you need fantasy films, because, I mean, I'm a bit of a dreamer myself, but um, I like fantasy films because, they sort of take you into another place, you know, you can feel that, you know, it can happen some, you know, in the future. Or whatever, and that's the reason I like them
KB:	*What about you?*
Dan:	I think with films like science fiction genres, like, you got the present films of, um, like, *Die Hard* or something like that, which are in the present, but science fiction and fantasy, are somewhere in the future, and its, um...I think at the start of *Demolition Man* it starts off in like

1997 which is about, 2 years, from now, and it's amazing to think what, could happen, in two years. [Interview 3]

KB: *What did you think of it as a kind of vision of the future, this film?*
Chris: It was pretty accurate really.
Anthony: I don't think I'd want to live if that was the future. Everyone's running around either taking drugs being shot ..
Gerard: .. or shooting somebody else
Anthony: .. or shooting somebody else, it's just ..
MB: So I mean do you ever think about that when you're watching a film like that? You know, this is showing a world that I wouldn't want to be in, but I'm still enjoying it?
Anthony: Sometimes you're sat there, and you're imagining yourself in that place, and in that situation, and you sort of sit there and you watch it on the screen and you think, oh cool, wouldn't like to be in their shoes, and you sort of sit there and think about it and you think, nah: no way would I like to be there.
KB: *So why do you think you enjoy these kinds of films then?*
Gerard: Cos of the effects ..
Others: .. yeah ..
Chris: I came out of some films feeling queasy, thinking if that happened, if I had to live there .. like *Alien,* that is one film I am ... I can watch it, and enjoy it, I can't finish watching it, I think.
Anthony: No way! [Interview 29]

Gary: You got a city with something like 800 billion people in it, and none of them have got jobs you know,
Herb: Yeah, it would be really nice if they could get, um.. all walks of life in there? In the future, you know you got the vagrants, you got people homeless, this that and the other, what would it be, how, I'd love to see how they portray it, in, X amount of years' time, in this film, that'd be interesting, because, you've got them all, haven't you-
Gary: I mean if you stick to the comic, you haven't really got that, sort of thing, they're all just like street gangs, aren't they there's no ...
Herb: Yeah, I, I'm, thinking that, if you look at the pictures though you always -there's always some scum, somewhere. [Interview 2]

KB: *So what sort of things do you expect there to be in it..?*
John: Violence
Turtle: Violence, yeah
John: Bashing people over the head with a big stick thing..like, truncheon
Mike: Yeah his truncheon thingy
John: There's loads of posters up where he's got this big, like...
Turtle: And I like, I think I like stuff like bad side of everything, is pretty good,

	all the baddies and stuff
John:	I like watching futuristic films cos you sees peoples' ideas of the future, weapons and..stuff..
Turtle:	And you get ideas..of like what it's gonna be and you think, "well, can't wait till it gets to like that year, sort of thing"
John:	Like Back to the *Future 2*. I...I..
Mike:	That weren't really violent though was it
John:	Yeah, but that still gave you a pretty good idea of the future I thought
KB:	*Right..em, what about its, I mean, obviously set in the future, and what do you think about that kind of view of the future?*
John:	Well, stuff like the bikes and everything that was good, but all the lives and everything was tat. I didn't like that.
KB:	*And what didn't you like about that?*
Mike:	Well it was like all horrible, wasn't it and..
John:	You would have thought it would be like nice where everything was like nice and everything. But it was a state really for the common people. [Interview 6]

KB:	*What about the city?*
Martin:	A dump ... [Pause]
KB:	*I mean were there any parts of it that made you kind of think, I wonder if it'll be like that in the future or?*
Johnny:	Yeah the first bit, when they fire across the street
Lee:	The riots, yeah..
KB:	*Why did it make you think that?*
Lee:	Cos that's what it's gonna get like
Johnny:	Cos it's getting like that innit!
Lee:	With all the guns and that, so, it probably will be like that
KB:	*What do you think then about the idea of having these kind of, Judge people who are Judges and Executioners and, all in one?*
Martin:	Cos just say, if I was a policeman, and I didn't like someone, then I could just go up to them and go, like, turn up and charge up to them and that and say "I don't like you so you'll be killed" That's ridiculous, so..
KB:	*Do you think that will happen?*
Martin:	Dunno... [Pause]
Johnny:	Yeah
Martin:	[Laughs] You reckon it'll happen?
KB	*Why do you think it'll happen?*
Johnny	Cos the police will get bored of locking people up so they'll just go round shooting people instead
KB	*Does it worry you then, what's going to happen in the future?*
Johnny	No, I'll be dead by then. [Interview 40]

Something of real importance is showing here. To see just how important, think about the range of responses there could be to our question: what do you think of the kind of future shown in *Judge Dredd*? People could have said – and indeed in other interviews did say – any of the following: (a) it's unrealistic – the world's just not going to change in these kinds of ways; (b) it wasn't very cleverly designed – all we ever saw was street-gangs, hardly representative; (c) we've seen it before, in loads of similar films; (d) we didn't think of it as 'future' – Megacity One looked vaguely medieval, for a start; (e) it wasn't anything like the way we saw it in the comic; (f) it's impractical – people will still live in ordinary terraced houses, not mile-high blocks; (g) the science of it is ludicrous.

What matters to us is that in each of these alternative responses, it isn't just the conception of the future which changes, but our relation to it via the film. We want to argue that for viewers like these boys, films like *Dredd* are looked to, to give them glimpses of a possible future.

The meanings of 'special effects'

One of the most fascinating features of the boys' talk, to us, was their attitude to special effects in their chosen movies.[4] There's no doubt that, for many people eager to see *Judge Dredd*, one motive was to 'what its effects were like'. There are number of good histories of special effects, and especially of the recent rise of computer-generated effects.[5] The histories do show the strong connections between these developments and the new dark science fiction of directors such as James Cameron (whose *Terminator II* is still regarded by many fans as a by-word for great effects). But what 'effects' mean, and how we should weigh their importance, are other matters.

Conventional wisdom on the topic offers a shot-and-reverse, as it were. The 'shot' is yet another version of the standard panics about vulnerable viewers: might not people 'lose the ability to distinguish between fantasy and reality'? Might this not be especially true with the new digital media, especially video games (because they involve us, interactively) and virtual reality (because of its claims to achieve seamlessness? The 'reverse' effectively holds the same vision while negating the judgement. It celebrates the 'freedom from dull reality' in cyber-experiences, and awaits with delight the dis-bodying that this might allow. This, it is argued, might particularly benefit women who can divest themselves of gender-restrictions and gain the powers of technology. The majority of commentators veer to mid-points between these, doubting on the one hand that people are as taken-in as the panickers suggest, and on the other hand wondering if computers offer all that much 'freedom' as the cyber-enthusiasts hope, not least because so many people can't get access.

It seems to us that these conventional poles of debate miss the main question, on this occasion because they are dependent on a vision of technological teleology: or in other words, the vision they offer is of an inevitable trend towards 'more and more realism' and the 'disappearance of the real into the virtual', with humans being towed along behind, for good or ill. We want to start elsewhere, because special effects cinema seems to us to have its own features which don't disappear

just because other things become available. The key to special effects, we want to argue, lies in its name: they are special, in that they 'stand out' from the rest; and they both are and have effects. This doubling is what we want to pursue. Don Slater gives a nice account of it:

> Two simultaneous senses of wonder are invoked: wonder at the experience of being transported to a fully realised unreal world; and wonder at the (incomprehensible, hidden) technology which makes it all possible.[6]

What should we make of this doubled attention?

One approach has been suggested by Steven Neale. Neale also starts from the 'division of belief' which accompanies special effects, that the 'spectators knows that the effects are indeed just effects'.[7] But he follows the psychoanalytic film theorist Christian Metz in suggesting that this knowledge is 'repressed'. This allows him to suggest that 'effects' cinema is an exemplar of fetishism: that is, symbols and representations taken as substitutes for the real thing.[8] Films such as *Star Wars* function to trap the viewer within the spectacle of cinema by working to 'engage the scopic drive and afford its subjects the pleasures of looking'.[9] 'Looking', of course, is a deeply compromised activity in psychoanalytic film theory.

Neale's argument turns on a slide in the meaning of the word 'convincing'. He is right to say that effects seek to 'convince' us, but that doesn't tell us much. Take as an example the famous 'effect' in *Terminator 2*, where the murderous android is frozen, and shatters into fragments, but then reassembles itself as its temperature rises. Neale's argument about the repression of awareness that these are in fact 'effects' will only hold if we are 'convinced' in all the following ways: (a) we look at it and find it believable for purposes of the film – this is to say no more than that it contributes appropriately to the film, in this case emphasising the scale of the problems the heroes face, to defeat the android; (b) we find it 'special', in the sense that in its own right it has cinematic force – it convinces us to give it special heed; (c) it conveys that conviction to the film as a whole, making us believe that the entire filmic experience was 'special', and (d) having done all the preceding, it reaches into a series of primal (Oedipal) anxieties in us, and offers an easing or a temporary resolution of them, if we can 'forget' that this is a fiction and convince ourselves that these 'effects' are more than just constructed. The problem clearly comes between (a-c) and (d); and this last is only at all persuasive if one believes, on quite other grounds, in the existence of these primal Oedipal anxieties and in their power. The 'effects' themselves cannot prove or disprove that thesis. Within the closed system of psychoanalytic thinking there is a logic in Neale's conclusion – but on no other possible ground.

It's remarkable how strong 'othering' is within this kind of thinking. Others have their awareness of effects repressed. They have not been found, their names are not known, but they must be there. We will return to this in our final Chapter.

Don Slater's approach seems to us to have more 'travel'. Slater traces the history of effects to the rise of spectacular amusements in the seventeenth and eighteenth

century. Travelling performers put on shows of visual surprises, using concealed technologies of light. These formed the backdrop to the invention and rise of photography itself. Slater argues that such 'magic shows' gained their motive force from the decline of belief in the supernatural, and the rising emphasis on science, experimental proof and 'trusting your eyes'. Here were science and technology, the epitomes of the modern consciousness, making 'natural magic'. 'Wonder' did not die, it transferred itself to the natural world. This seems to us a real advance on Neale's lop-sided view, for it emphasises that such effects get their power from the relationship between what we see and what we believe. If we see 'incredible images' on the screen, they interest us because they are simultaneously there and therefore in some sense credible, and incredible. But the weakness with Slater's approach is his dissolution of all this into aspects of 'modernity' and modern forms of consciousness. While it is almost certainly true that in the eighteenth and nineteenth centuries sectors of the middle class were fascinated with science and the scientific consciousness for its own sake, there is no reason at all to suppose that this was of posing the relations between the two halves of the doubled attention will apply to everyone.[10] To our mind, Albert La Valley expresses the relationship more helpfully. Writing about 'traditions of trickery' in science fiction films, he comments that 'science fiction and fantasy films hover between being about the world their special effects imply – i.e. about future technology and its extensions – and about special effects and the wizardry of the movies themselves'.[11] It is just this balancing-act which seemed to be present in the responses of our young boys.

Doubled attention and the meaning of 'effects'

What are 'special effects', and what does it mean to experience them? In some senses, 'effects' are easy to define. They are moments of heightened drama in the cinema which draw attention to themselves. When in any number of horror films a hand shoots out and grabs a character we've been 'accompanying' down the darkened corridor, we can say 'wow, that was a disturbing effect'. When in *Terminator II* (1991), the android transmutes in front of the camera into the policeman, we watch the cleverness. When in *Independence Day* (1996) the White House is hit by the aliens' beam and explodes, we admire the visual achievement. But already in this simple definition a number of things are contained which need elaboration.

In one sense, it could be said that the whole of cinema is one century long special effect. The moment we pass beyond pointing a camera and microphone at a space and recording whatever passes in front of them, construction of effects is taking place. Lighting, camera focus, distance, angle and movement, sound layers, editing, pacing: all act as organisers and intensifiers of meaning, hence make 'effects'. But this isn't what we generally mean by 'effects' which – curiously – is largely limited to pro-scenic events. We have another category, trick photography, for manipulation of our ways of being shown events in surprising ways. The shower scene in *Psycho* (1960) is made powerful by a mix of sharp camera angles, and rhythmic editing. We haven't come across this being

called 'special effects'. But of course the distinction is entirely arbitrary. When Fay Wray is seized by King Kong and carried in his hand up the Empire State Building, there are of course the pro-scenic events; but they are made possible by cinematographic manipulations. This is far more true today than it was in the 1930s. Computer-generated cinema allows filming to be done in an unlimited series of layers which are then superimposed. High speed filming with models with added computer effects made possible the White House's demolition, so that it was both a startling visual experience in front of the camera and a piece of trick photography.

In another way, too, special effects can't be the whole of cinema. Effects are only meaningful by virtue of being set against another measure in a film. This is why cartoons are not usually called 'effects' movies. And *Toy Story* (1996), with all its wonderful visual inventiveness, doesn't usually qualify for the title 'effects movie'.[12] A more tricky example is *Who Framed Roger Rabbit?* (1988) which was praised for its effects, yet in many ways seems an 'exercise in the art'. Mainly it just plays with the difference between the 'real' world and the cartoon.[13] What is needed is a contrast between the humanly ordinary, and the extraordinary, into the space between which a large 'what if?' can move and play. To understand how this can work, we need to reflect on the difference between experiencing an effect, and experiencing it as an effect.

Imagine a child watching the dinosaurs in *Jurassic Park*. This is a very early cinematic experience for her, and she does not yet have a notion of 'effects'. She hasn't heard about Industrial Light & Magic, or the computer generation and insertion of images. What can she see? As the brontosaurus lifts its head and calls soulfully across the Park and the children watch and listen, she can marvel at the miracle with them. She can ask: where are they? Are they really as big as that? Can I get to see them too?

Now insert a concept of 'effects' into her consciousness: what changes? It isn't just that she knows they aren't 'real', and nothing stops her marvelling at them as she did 'before'. What changes is that in seeing the dinosaurs as an 'effect' she now has to do two things at the same time. To watch something as an effect is to have two simultaneous aspects to our awareness: we experience the image, and we experience as a constructed image. What matters is the relation between these two aspects.

Consider frightening films, be they horror or other kinds. There is a strong body of evidence that everyone, adults and children, police their viewing, and try to maintain a line between what is enjoyably scary and what crosses the line into unacceptably frightening.[14] What are they doing, then, when they watch a film which uses effects to generate scariness? It seems that in watching horror, for instance, we frequently manage the experience by insisting on the separation of experiencing and experiencing-as effects. If we can do this, there is always a place to retreat to, saying to ourselves 'They made that scary, by doing that'. We are frightened, or disturbed, or jumpy, or startled. But that experience can be, sometimes but not always, made manageable, even pleasurable by the doubled attention of knowing that this is an effect of an 'effect'. If we can't maintain that distinction, the pleasure goes. We are simply scared. In the genres of horror, then,

there is generally a pretty strict separation between experiencing and experiencing-as effects, and the monitoring of the border.[15] It is of course possible to specialise in one half of the double attention. This is what horror fans in effect do. Mark Kermode has given an account of the ways in which fans attend to the nuances of films such as *The Evil Dead*, exploring their nature as effects to the point where their horrificness is something which can be weighed and evaluated.[16]

Contrast that with films which we might call 'magic', by which we mean films with a strong fantasy strand to them. Often close to fairy-tales, these deal in mythological themes, and in line with that often show small people or creatures struggling to achieve. Films such as *Willow* (1988) and *The Dark Crystal* (1982) epitomise this sort of story. But there are 'adult' versions as well, and it is arguable that a good deal of the Lucas/Spielberg school of film-making operates at this level. We would argue that here the relations between the two parts of the double attention to effects are quite different. It is more likely to be a wishing it was or wishing it wasn't like this. To enjoy *ET* (1982) is to bathe in a pool of effects which invite us to 'believe', to wish away the boundary between experiencing and experiencing-as.

This is necessarily speculative in some respects. It is clear to us that 'effects' must require the doubled attention we have described, since it is part of the very meaning of the term. The speculative elements are exactly how they work in particular genres of film, and of course how people learn to operate in those different genres. That research waits to be done, as far as we know. What matters to us here, is that our film was born in an era in which an entire cinema of effects has been developed. It is now common for films to be promoted for the novelty of their 'effects'. We are regularly encouraged to go and see films to see the 'new effects' in them. The techniques and the companies that produce them are themselves widely publicised. And although such techniques are to be found in many kinds of films, their core, perhaps, is science fiction. What relation is proffered here, between experiencing and experiencing-as effects?

The error, we think, lies in asking whether people 'know' that effects are 'effects'. Beyond the very youngest child, there is no doubt that they do. The question has to be: to what strategies of use do they put that knowledge? The key here is that a relationship is posed between what is within the film, and some part or parts of the viewer's life. This is the heart of the fraught area about films. It is also one of the weakest in terms of thinking and theorisation, usually posed in the crudest terms as the 'dangers of copying' or 'losing the distinction between fantasy and reality'. We have proposed another way of thinking about this: Modality of Response. To develop further the meaning of this, we draw in part on Hodge and Tripp's excellent research into children's use of cartoons.

The media and the making of imaginations

In the early 1980s, two Australian researchers carried out a study of young children's uses of cartoons, using a 'scary' cartoon *Fangface* as their focus. The book of their research, *Children and Television,* developed a way of understanding the role of media in learning which surpasses most of what has since been done.[17]

The book covers a wide range, a good deal of which is not relevant to our argument.

Hodge and Tripp want to change the agenda about the role of cartoons in children's lives. They show how blocked and unhelpful are the standard concerns about 'violence', and about their 'impact on education'. They are interested in the ways children may learn through cartoons – that is, in the process of learning to make sense of cartoons, their characters and their stories, what skills are children learning and practising? The idea which they offer, and which we want to borrow and develop in our research, is the idea of 'modality judgements'. Modality judgements, as we've already seen, are judgements about the status and reality of the things that are being discussed. A quotation from their research best explains how this works. Natalie, aged 6, has been asked to say what she thinks about the 'reality' of various figures, some fictional, some not. Hodge and Tripp show that Natalie makes some sharp switches in judgement. Comparing her friend Kym with the cartoon characters Tom & Jerry, she says: 'Both are as real as each other ... Kym's here and she's real and, Tom and Jerry. Oh, Tom's a cat and we've got cats here, and Jerry's mouse and we've got lots of rats here.' It is irrelevant to her at this point that Tom and Jerry are cartoon characters. A little later she compares Mr Ed the talking horse (judged 'real') with the mythic Monkey ('unreal'): 'Mr Ed is realler. Like, Monkey's just in Japan. They've just made him. Someone's dressed up as him and Mr Ed's a horse'. But in the next test, Monkey was judged 'real' while Tom and Jerry became 'unreal': 'Like Monkey's dressed up and Tom and Jerry are just a photo of people dressed up'.[18]

Hodge and Tripp show that from a very young age children make sophisticated distinctions about what is 'real' or not, but that as they get older they develop greater consistency in making these modal judgements. There are several points in here which are well worth extraction. First is that the standard bogey-fear that some people might 'lose the distinction between reality and fantasy' is not only idiotic – a person who did would be effectively autistic – but it also prevents us seeing a simple but crucial truth: there isn't *a* relation between fantasy and reality. There are multiple kinds of imagining that people do, and the more fully human and adult they become, the wider the possibilities and complexities of such imaginings. This is why Hodge and Tripp end with this striking conclusion:

> Modality decisively affects interpretations and responses, so it cannot be ignored in any account of the media. ... No television product has a fixed modality value which will apply for all classes of viewer. Television products range between two extremes, but none is totally real (for most viewers) and none is totally unreal (again, for most viewers). The definition of reality is so important ideologically that it becomes the site of ideological struggles rather than an automatic yardstick that can be simply applied to any instance. ... Children's modality systems are similar in principle Young children do distinguish between fantasy and reality, but they do not know what is needed to distinguish with the precision and subtlety assumed for adult television. ... *Paradoxically, it follows that children do in fact need a diet rich in explicit fantasy – including cartoons – in order to develop a confident and discriminating modality system.*[19]

The ability to make modal judgements is only learnt by practising with materials which make that demand of us.

But of course how children first and fully learn how to make 'reality'-distinctions is not the end of the matter. For as adults, we also make connections: that is, in a hundred ways, we rehearse the complex connections between forms of the imaginary, and our pictures of and plans for reality. Sometimes these are almost perversely complicated. For instance, what is going on when fans of soap operas write in to their favourite characters, send them presents for their (fictional) weddings, mourn characters who have died, and so on? What is happening when people insistently deny that President Kennedy, or their favourite star has died? One investigator in particular has thrown light on this: Elizabeth Bird in her study of tabloid newspapers, *For Enquiring Minds*. Bird's research on the audiences for supermarket tabloids revealed rich complexities in the ways readers believed in stories about UFOs, or Elvis Presley still being alive: 'In fact, some readers seem to enjoy reading tabloids as if they are true, playing with definitions of reality, wondering if it could be so. Said this twenty-eight-year-old woman: "A lot of people claim it is a lot of bull. But I find it very interesting Sometimes it seems so real and sometimes I don't know what to think." (letter 27). A Virginia man wrote: "I think everybody needs, you know, a sense of laughter, it's so zany and stuff.... You know that there's no such thing, but in a sense you wish that there was, you know" (interview 9).'[20]

Perhaps most pertinent and challenging are the claims that are used about the dangers of pornography. One argument regularly used here is that regular users of it are in danger of coming to believe that women they meet, despite appearances, are really like the women they see in pornography: eager for sex with anyone, only waiting to be 'turned on' by a man. This is for sure the most powerful of these arguments, but only in so far as it reveals something which substantiates our general approach. The problem which such cases reveal is the problem of the absence of real knowledge about women, and their sexual responses.[21] This fits, then, with the evidence in Bill Thompson's *Soft Core* of a close relationship between sexual repressedness and conservatism, and responsiveness to pornography.[22]

The problem lies in the thin-ness of this notion of belief. Consider the following list of possible beliefs:

* a bus is due at 9.30am;
* the Bible teaches that women are by nature suited to looking after children;
* the theory of evolution proves that women are by nature suited to looking after children;
* we could all live together in peace;
* global warming has put the future of the planet in the balance;
* President Kennedy is alive, and has been hidden away by secret government agencies.

The obvious point to note is that these beliefs are not all of the same kind. The first example is of a belief which is open to ready correction. Simply, if the world/bus

company do not collude with the belief, it will be impossible to sustain it. The second and third are important because they reveal something vital about beliefs: it is not enough just to know what is believed, but how and on what basis it is believed. The second is only open to disproof by the citing of textual 'authorities' – but these will be weighed in approved ways by authoritative people. The third is effectively a deduction from certain ways of thinking about evolutionary processes. The fourth has in most instances the status of a hope, a wish. Arguments in favour of it will be to show that it could happen. The fifth is, perhaps, the outcome of a combination of some difficult scientific experiments, with hard thinking about their implications. The last is a component in a generalised conspiracy theory, which searches relentlessly for scraps of possible evidence to sustain a generally distrustful approach to all authority.

These differences reveal the varieties of status beliefs can have. The situation becomes even more complicated if we consider the variety of ways in which people use their imaginations. A parallel list of kinds of imagining could include:

- imagining a different colour-scheme for a house;
- imagining what we would do if we won the Lottery;
- imagining a world without cars;
- imagining that we can form a local drama group;
- imagining what happened to a character after the end of a story.

The wonderful thing about imagination is precisely the range of things we can do with it, and the ways in which people transform (even sometimes very small part of) their lives by imagining a change or a difference. This is important – if it were possible to insist, as the standard 'scare' mode of argument does, that people respect and maintain a clear line between fantasy and reality, they would lose the power to imagine transformations. If children had to draw a hard and distinct line between 'fantasy' and 'reality', we would be trying to deny them the space to use their imaginations to conceive the future of their own lives, to imagine and dream about their relations to other people, and so on. It insists on the facticity of the given world, and only allows changes based on authoritative 'knowledge'.

In practice, it is quite impossible to prevent people using their imaginations, thank goodness. But what we are able to do, is to make them embarrassed and awkward about admitting to using it, by labelling it as 'fantasy', as something low-grade etc. And our society does routinely distinguish and insist of treating differently 'imagination' (which is arty, cultured, law-governed, productive, worthwhile) and 'fantasy' (low, pointless, undirected, shapeless, foolish and self-indulgent). In opposition to these imposed categorisations, we propose an investigation, like Hodge and Tripp's, of the ways in which different media invite and propose particular modalities of response. We haven't conducted this investigation, even on our own materials, but we can see the shape of such an enquiry emerging at the limits of what we have done. But even to begin upon it, we will have to dismiss the attitude which we commonly find in both academic and common sense commentaries on films, which sees them in effect as 'propaganda to the unconscious', documentaries of the inner mind. This attitude misses all that is interesting and important about our power to imagine.

Modality of Response: a formal definition

So, the concept of 'modality of response' is our proposed tool for depicting and making sense of all the ways in which people's use of the a film is related to other aspects of their on-going lives. 'Related to' includes being sharply separated from, being treated as trivial and marginal, feeding into on-going valued activities of various kinds and of differing degrees of centrality; it also includes being at some tension and abrasion with other parts of a person's life. Accordingly, we offer our last acronym, deliberately designed to 'name' this package in a way that points to its links with ordinary meanings. We wish to explore the operation of people's filmic MORALS, by which we refer to their Modalities Of Response: Allocation, Linkage and Segmentation. This is intended to catch hold of the ways in which different people, located in specific historical, social and personal circumstances, take up and use in relation to other parts of their lives the imaginative scenarios proffered to them by films, or any other media for that matter.

To identify people's MORALS is to work at the very limits of our research. This is research waiting to be done, and wanting serious consideration of how it can best be done. We are only aware that in a number of ways our materials have pulled us to the limit, and showed us something beyond. In what follows, we examine one – arguably, the main and most important – such structure of MORALS, as we see it emerging from the combination of Action-Adventure and Future-Fantastic SPACEs among our interviewees.

Utopias of sensuous excess

> The Chiliast expects a union with the immediate present. Hence he is not preoccupied in his daily life with optimistic hopes for a future or romantic reminiscences. His attitude is characterised by a tense expectation. He is not actually concerned with the millennium that is to come; what is important for him is that it happened here and now, and that it arose from mundane existence, as a sudden swing over into another kind of existence. The promise of the future ... is merely a point of orientation, something external to the ordinary course of events from where he is on the lookout ready to take the leap.[23]

In his *Ideology and Utopia*, the sociologist Karl Mannheim explored, among other things, the different main forms of utopian consciousness and the historical conditions that had produced them. The part that concerns us, because of a fascinating parallelism with our materials, is his discussion of the 'orgiastic chiliasm' of the Anabaptists. The Chiliastic mentality arose in the post-medieval period, argues Mannheim, as a prime way in which the 'oppressed strata of society' began to move beyond 'fatalistic acceptance of events as they are', and to drive for participation in the political process. What Chiliasm offered was a way of living and experiencing in the present the marks and qualities of a 'transformed world'.

Mannheim delineates some of the qualities of Chiliasm. There is an emphasis on 'sensual experience' and on the heightened meanings (in their case 'spirituality')

of such experiences. They are orgiastic, and see that the completion of sensuality is, as it were, a gateway to that other world which is sought. 'The only true, perhaps the only direct, identifying characteristic of Chiliastic experience is absolute presentness.'[24] One intriguing suggestion of Mannheim's is that to understand Chiliasm, we need to 'distinguish Chiliasm itself from the images, symbols and forms in which the Chiliastic mind thought'.[25] These particular images and forms will have their own history, but the impulse to use them in a particular way is an object to be studied in and for itself.

It's not hard to see the parallels with the ways in which our Boys' Club respondents, among others, live their films. They too stress the sensuousness of cinema, and its orgiastic excess. And they combine this with an eager search for 'effects' which for them act as a juncture between present and future. While effects are to be 'drunk' and loved as spectacular achievements in the here and now, they are simultaneously cracks into another world: their future. Of course, different boys will take and live this doubled attention with different degrees of attention and conviction; but to us it is a positive, important and political aspect of their engagement with these films which has so far gone entirely unnoticed.

Or perhaps not so. Mannheim also remarks that his 'extreme form of utopian mentality' has occasioned resistance: 'Even the opponents of this extreme form of mentality oriented themselves, though unwittingly and unconsciously, with reference to it. The utopian vision aroused a contrary vision. The Chiliastic optimism of the revolutionaries ultimately gave birth to the formation of the conservative attitude of resignation and to the realistic attitude in politics'.[26] The circumstances are of course widely different, but the relationship is similar. As Chiliasm was attacked, suppressed and misrepresented as 'irrational', 'dangerous' and 'heretical', so delight in 'violent' films is feared, condemned, and misrepresented.

There are major differences to note between the two forms. Chiliasm took its imagery from religious enthusiasm. Our films take their images from technology and politics, and exaggerate and fantasise on these to conceive a world which bears the marks and traumas of our own. Chiliasm constructed its celebrations as gateways to a world wholly removed from this mundane, corrupt world. Our boys know well that this filmic world is related to their own; they know that this is a world constructed for them by 'Hollywood'. Their sensuous participation is, if you like, an enthusiastic refusal from within.

To understand their participation in this way is not to romanticise their love of film as some kind of political opposition. It is simply to consider the particular ways in which their love of Action films is embroidered into the rest of their lives, and to see in it the incipient signs of an awareness of disjunctions: between present and future, between the celebration and the dread of the impact of technology in and on their lives; between heroic rescue of the world and the oppressiveness of 'heroes'; between the wealth that is possible, that is put daily on display in front of them, and the actual lot of 'the common people'.[27] And that, paradoxically, means that the other world which can be glimpsed is not pretty. It is not the 'peaceful, other' world of the hippies.[28] It can only operate as a utopia by

simultaneously celebrating and excoriating the dumb brutalities of new technologies, their business lords and their oppressive systems.[29]

We are in the borderlands of our research. There are hints and indications in our research materials pointing in these directions. They suggest that the popularity of Action films is connected in precise ways with their historical 'moment'. In Britain and, in related ways, in many other industrialised countries, the 1980-90s saw a down-turn in working class activity, and a rise of various kinds of right-wing populism. But a class does not disappear just because its members lack confidence for a time. Instead, their group-awareness goes underground, and comes out in strange forms. Action films, we suggest, are one of those. And if the 1980s had this political flavour, its films also bore the marks. William Palmer's remarkable social history of eighties films explores the remarkable closeness of many films to politics in this period. His book is generally a study of the ways in which these films re-imagined 'America' at the same time as sometimes actually having political effects. Alongside considering films dealing with white supremacism, farming crises, the post-Vietnam experience and the moves towards Glasnost, among others, Palmer has this to say: 'Perhaps the best example of this self-reflexive consciousness in both the social history and the film history can be found in a cluster of futuristic films, all of which turn on the premise that in order for the future to exist and continue, the past must be understood and even revised. In *The Terminator* (1984), *Star Trek IV* (1986), *Back To The Future* (1985), and *Peggy Sue Got Married* (1986), time travellers consistently found the answers to the human and political puzzles of the future written in the critical act of reinterpreting and even reshaping past history.'[30] If this is right, it must trigger another round of questions: what circuits of production allowed Hollywood to produce such a sequence of films able to play this role? what does this suggest about the ways ideas and narratives of 'America' are today operating as resources for critical political imaginings?

Disciplinary discourses revisited

This is not, of course, the mainstream view of such boys, and their uses of Action films. That poses the films, and them, as a 'problem'. And they know it, as we have seen. Indeed, a wide range of our interviewees spontaneously acknowledged their awareness of 'being judged' by this view of them. We gave some typical examples in Chapter 3. Revisit them, and consider what they have in common with the following:

> It does tend to give people the impression of your mentality, where you're coming from, if you go to see a film. If you think about it, sort of like, the young kids go to see like, all the violent films and like, all the street fighter films, as you get older you try and see like more toned down, more intelligent thinking behind it, when you get older, it's just anything that's cheap and cheerful really! [Interview 42]

The common thread running through these reflections is an awareness of being judged. How it is handled varies: some with irony, some with conscious distancing, some with mock-embrace. But however it is done, this discourse of the 'violent film,

violent fan' superimposes itself on the viewing practices of all these viewers, and in different ways disciplines their use of their chosen films. And perhaps the key way it does this, is by denying them an alternative language which could make sense of their own enjoyment – in subtle but important ways, the current strength and prevalence of the 'effects' discourse is to make itself come true by debarring self-conscious use of the orientations implicit in the SPACEs we have outlined.

What then does this 'effects' discourse do for those who believe it? In this research, we took the unusual step of including groups of people who, for various reasons, refused to go and see the film. We interviewed seven such groups in all: two groups of young girls; some members of a Men's Group; a group of secondary school teachers; a group of Old Age Pensioners; and two groups of religiously-involved couples. All for one reason or another declined to see the film – and many turned out to share much the same view of those who did choose to see it. Using these as our base, we offer the outlines of a Film-Refuser SPACE, developed in exactly the same way as all the others:[31]

The Film-Refusers SPACE

Vocabularies of pleasure: There is no pleasure at all, and none is imaginable, except in *perverse* and *dangerous* forms. This is not our sort of thing at all. Pleasure is found in all things opposite to this (home vs 'public'; classic vs 'modern'; past vs 'future'; Englishness vs 'America'; people/relationships vs *soulless* 'technology'; romance and emotions vs danger and 'violence', etc). Cinemas are not the magical places, the palaces they used to be – generally, this culture is not for us. Audiences are divided into 'them' (usually young males, Multiplex-goers, viewers of violence) and 'us' (the minority, the concerned, parents, females, older generation who have been crowded out).

Ideal viewing conditions: For us somewhere *'safe'*: the small local cinema, the old-fashioned flea-pit, or videos at home. Not the multiplex, which is dangerous and modern, and for 'them'.

Who are the viewers? 'Them': young people, most worryingly young males, who enjoy horror and mindless violence, and so make the public domain a violent place.

To be ready to be the audience you need... This is almost impossible in principle to answer. We don't know or understand 'them', in fact *in extremis* we don't *want* to understand them. 'They' have a tendency to want to be more shocked and titillated than last time, or a tendency to watch it and then act it out. We like to be entertained, not 'shocked', whereas 'they' are looking for (cheap) thrills, and each time these *thrills get worse* – a worrying trend.

Before and after the cinema: If we go at all, we go there and come straight back as we don't want to be bothered with the hype (which is aimed at 'them' not us). We want to see the film and the film alone.

Other kinds of film are: About *positive* things in life: love and/or families, *worthy* classic films which will educate. These could be adaptations of classic literature, and would *enrich* one's understanding of the text. Other films are for family viewing, will *entertain, inform* or *educate,* not frighten, disturb or incite anti-social behaviour.

Relation to other parts of their lives: (*For us*) It all reinforces our opinions about what is important, doesn't challenge or frighten; it reaffirms our beliefs in proper values. (*For them*) It is all noise, effects, violence and sex: cheap thrills which affect them and their behaviour, and which we find frightening.

What's important in a film? (*For us*) It shouldn't disturb, unless that is in order to educate. Entertainment can be allowable, even important, provided that a film has a good moral to it. (*For them*) It does something; it's shallow and false emotions; plot isn't important to them, which we think is wrong and shallow.

The Dredd/Stallone nexus: They are typical *crude* and bewildering characters with *little depth*: Stallone as Dredd isn't a dashing, inspiring, morally-sound role model, nor is he intelligent or interesting, or 'realistic'.

Cinema vs video: When the cinema seems a dangerous and alien place, videos mean you can watch films at home as part of a special night in, or to catch up with 'should-see' films. Video and TV can be the only place you can re-experience 'proper' films from the past and home can be the safe place for girls to be themselves (watching a soppy movie, lots of food, chocolate, sleeping over, away from the scorn and dangers of boys). The cinema is still an 'event', but nowadays there are problems attached to going.

Relations to publicity: These simply are not relevant or important to us – indeed, there is some pleasure in just not knowing. It's an *alien* world that we read about, or hear about from younger people (children/pupils etc) which we know we ought to know about, but we don't want to know!

The newness of a film: An individual film is just a *symptom*. For us, the next step in a downward spiral, as we become more 'Americanised' – what new, cheap thrill is now available? What is the next thing to shock? How much farther away are we from the standards we believe in?

Talk after the film: In our films, we may discuss the characters. This can be done in lots of ways: academically: how are they like/not like the book?; or anecdotally: wasn't that sad, wasn't that baby sweet, and that man horrible? If it's 'their' films we are watching, we are 'on watch' for dangers: how does it represent current trends in society, how has it shocked us, what are its dangers, would we let kids see it? Young girls, mind you, might qualify these with: weren't we lucky to get in and see a film we're legally too young to view – but isn't it awful/ wrong that we can, etc?

Leisure statements and identities: We watch films for education, entertainment and escapism, after a hard day. Films should be beautiful, art, pleasurable, informative, or make us cry; they shouldn't be shocking, shallow and frightening. 'They' watch films for 'cheap thrills'. We are guardians of *standards* and the majority who have become the 'minority': films aren't made for us any more. We like films that comment on life; they like films that are stupid, crass, *unreal*.

Central criterion is: How bad is this latest one? How much further down the path to 'Americanised rubbish' have we gone? How much is it a 'boys' film'?

Practices of dislike

Let us try to show how this anti-SPACE operates in practice. First we must see that this is an orientation that arouses strong feelings. At the very start of our interview with retired businessmen, we met a speech head-on which encapsulated so much of the SPACE:

Gwyn: Yes I don't like modern films, I dislike them intensely, and what I dislike most of all I think is the fact that most films that one sees now are American films, I hate the American culture. I dislike intensely and am very worried about the effect the American culture has on young people in this country today via television and videos and of course films. I think they're having a dreadful effect. I also dislike intensely and I'm sure everybody's going to agree with me here the amount of violence, gratuitous violence of films, the amount of gratuitous sex and the swearing that goes on. None of these in my view have any entertainment value at all, and you, you'll talk to producers or the producers of films will tell you that they're are only trying to mirror what's happening in real life, well I'm sorry but I don't want...if I want to be entertained I don't want to have a mirror of real life I want to be entertained..I like to read a book and I don't want it to be true to life, I want it to have, well perhaps a happy ending. [Interview 44]

This honed speech was clearly 'rehearsed', and had a ready vocabulary of criticisms to draw on: 'of course it is a hidden persuader, very much so. And the content of programmes is a hidden persuader as well, this is why I despair so much about the American culture, being forced straight on to ourselves'.[32] This is important in as much as these critics want to do more than just dislike these films – they want to declare them 'bad for others'. The idea of a 'hidden persuader' appeals back to Vance Packard and simultaneously suggests how the 'harm' is done. It marked us as interviewers as potentially hostile to their case ('I'm sorry but' ...), and appealed to others' agreement, and largely got it (though one member of the group was allowed to opt out, and except himself, because of his personal liking for science fiction films). It acted as a summary, and sought to set a tone. It established key oppositions: 'entertainment' vs 'gratuitous violence, sex and swearing'. What exactly makes something 'gratuitous' remains unclear. Knowing little of *Judge Dredd* in a way made it easier:

KB: *Have you heard much about the* Judge Dredd *film? To kind of move onto that..do you know anything about the film?*
Arthur: I saw an advertisement in the paper..It's a man with a...I don't know..!
Bob: And you get the reviews that comes through and I take on look at it and see Victor Stallone is in it, or somebody else whose name escapes me at the moment, and I don't even bother to read the review, cos I know I'm not going to watch it, I know I'm not going to see it so I, I don't bother to read the review

MB: *Can we in fact go round each of you in turn and ask you whether you heard it – you say you saw one of the posters in the newspaper..?*

Arthur: And I thought "*Judge Dredd*", and my immediate thought was, is that to do with dreadlocks? These things..I know it's spelt differently. No, like Bob, I turned over

MB: *So you saw one of the reviews and thought that isn't for me*

Arthur: Exactly, exactly. [Interview 44]

Their mistakes ('Victor' Stallone, for instance) almost strengthen their justification – they are definitely looking from outside, and know that this is not for them. But of course, it wasn't only not for them, it shouldn't be for anyone. This is managed by presenting their own tastes in such a way as to make impossible other people reasonably liking them. In effect they picture the films they dislike as composites of everything unimaginably bad. Thus, distinguishing acceptable from unacceptable 'violence', one of them combines elements seen, heard of and rumoured:

Bob: I think in answer to your question, there's just this fear of this violence, and uh, you know, when they used to shoot them, which they did in gangster films, he just clutched his chest like this and fell to the ground. Now, he doesn't clutch his vest he opens it, and shows you a great big hole with all sorts of things happening to it and insects coming out of it and well no, not for me. [Interview 44]

'American culture' was a dominating theme of this interview, and played a powerful role as source of modern problems – though with an occasional ironic counterpoint. Later, another member of this group acknowledged for a moment:

Arthur: My father who died in 1938 at the age of 50, said damn this low down American culture – this is 1938 he's talking about- this low down American culture which is seeping down into this country will be the ruination of this country. Cos, I used to break into occasionally 'OK, You dirty rat' [laughter] And he totally abhorred it! He said it, you know, it will bring this country to ruins! [Interview 44]

But this 'moment' of realisation does nothing to challenge the certainty of the contemporary condemnation of 'America'.

One way in which this is managed is via a notion of 'reality'. The first extract reveals a need to fend off the defence that these films show things as they 'really are' – that isn't what they want, and it certainly isn't necessary. Interestingly, the same move also appeared in another interview with a couple with religious grounds for disliking these films:

John: If I'm going to enter into a serious debate, em on issues that have moral value, religious implications, then I would want to do my homework, and I would want to argue the case on a, a more intellectual, reasoned basis. I mean, the arguments that we're putting are sort of gut feeling-type arguments, I mean they're real, but they wouldn't hold up in, in a court or a debate which is within some moral or religious framework, if you know what I mean. Well, I wouldn't enter into arguments on these bases because this is just sort of feelings and opinions. Now you take, for instance, and I'll put my hand up and I'll be counted against films with strong sexual em activity in it which is unrelated to love, erm, and I mean, yeah you watch a film and OK people are making love and so on, when it seems that they are making love because they love each other, then OK there's a reality in that, there's something good, and that's morally acceptable. Em, but where you move out of that, and OK I put my hand up and I'll be counted against that sort of thing, as well as you know gratuitous violence, erm, you know, or .. well you say, that sort of violence does happen, OK so it happens but you don't have to put it on the television screen.[33] [Interview 48]

Here 'reality' is counterposed to 'OK so it happens'. Yet the same man enjoyed James Bond films, and felt that they are more 'real'. 'Reality', then, is not a descriptive criterion at all; it is a moral version of or selection from the world: edited highlights vs emphasised lowlights as it were. What is also interesting here, is that this is seen as a way of developing the case intellectually, as opposed to mere 'gut reaction', which will justify dislike but not a defensible public critique of films.

In practice, their avoidance of these films is a bit negotiable. It shifts from explicit refusal of 'gratuitous violence' to practicalities of parking, to unease about being in town centres late at night, with singular ease: 'Again it's the old arguments on sex and violence ... but also the fact that we're not very keen on going out ... besides to go into town now is not a very jolly experience late at night'[Interview 44]. But even that can be negotiated if one of their grandchildren might want to see it – at that point, they would set aside other issues, and take them if asked.

Who are the audiences for these films, then? The retirement group's account shifted between a sense of people being corrupted by films, and a generalised despair at an already-corrupt world: 'You got whole loads of morons running around now stuffing themselves with drugs and goodness knows what and I think it's all a part of this culture, they call it, I despair, quite honestly' [Interview 44]. The teachers' group had an equivalent shift, from first identifying a 'typical boy' around whom they could humorously agree (*KB Who would you see the film aimed at?* Jim: Mick Samuels Linda: [laughter] Yeah – middle teenagers! *KB What did you say, sorry?* [general chuckles] Linda: Mick Samuels, Mick is one of our boys [Interview 46]). But this humorous shared recognition couldn't mask a gulf among them. While one teacher, of Media Studies, wanted to make clear her refusal of copy-catting' arguments and her understanding of the genuine pleasures boys might get from Action films, our question about what viewers might enjoy brought an explosion from another:

Jim:	I refuse to answer a question like that, because I do not wish to know what goes on in the minds .. [general laughter] .. this is a totally serious, a totally serious comment.
KB:	*OK*
Jim:	I do not want to know what goes on in the minds of some of the children I have to stand in front of. And I ..I, I'm utterly terrified at the prospect sometimes if I take it seriously so I revert to humour and escapism. I'm sorry to hog it, you struck, to go in first, you struck a nerve there. [Interview 46]

This is significant for the way it shows that such reactions do not need grounding in religion, or in a nervousness deriving from age-differences. This was sheer cultural alien-ness.

One member of the retired group wanted to guard against our judging them naive, or ill-experienced in these things:

Arthur:	Martin, in case you think we live this cloistered life we're all ex-service people, so I mean, we know the score, we haven't lived this cloistered existence. [Various For heaven's sake no!]
Gwyn:	And just going back to gratuitous violence, I should be immune to it because I was a police surgeon for many many years, and I dealt with, personally, about a dozen murders, and I've examined the corpses, and they're not sanitised, believe me. And I'm completely inured to blood and guts and brains on the ceiling and on the floor, it was part of my bread and butter job. But I don't want to see it on the film, on the screen, terrible!
Arthur:	It's not entertainment
Bob:	No, hear hear! [Interview 44]

Again, the implicit judgement is that they know all about 'real reality', but that is not what the screen is for – it is for 'entertainment'. The very fact that they are experienced people is what qualifies them to assess these films not just as distasteful to them as individuals, but also as 'terrible', and 'not entertainment'. The implication is that if it isn't 'entertainment', it is bad.[34]

Disallowed commitments

This powerful view about the 'dangers' of Action and other kinds of popular movies is of course widely shared. We have no gripe with people choosing for themselves not to see any kind of film. But this view does more. It condemns, usually sight unseen, what it doesn't like, and with that condemns the people who do like such films. It even celebrates its own ignorance of the films, and of the viewers. What we would want to stress is that our interviewees were mild. In many ways, they wanted to avoid the extremities which are to be found in, for instance, our national newspapers and in a good number of politicians. Indeed, just as the

six pleasure-forms we've uncovered occupy a social SPACE to which individuals orient themselves, so this one is generated and distributed from elsewhere. The sources of that have been explored in other places. Here, we only repeat their conclusions: that the core of the attack on popular films is fear-management, a broadcast shout of 'Danger!' that deliberately blankets and silences questioning responses; that every attempt to justify 'fears about dangerous media' has collapsed on proper attention but, like witch-hunters of old, that never stopped anyone; that haters of popular media claim a mantle of 'science' for what in fact is a political project, to control and direct the pleasures of the dispossessed.

As this book draws towards its close, we want to say something about the fact that this is virtually the first piece of research of its kind. It is appalling, an unqualified scandal, that for so many years the film-refusers have been able to follow a scorched-earth policy, using rhetorical flame-throwers on anyone who dared to question their moral advances. Yet until now, no one has had the common decency to ask the views and explore the understandings of the film-users themselves.

Instead, what we have found – as our earlier quotations showed – is a situation in which those who enjoy these films have to mock themselves, diminishing their own pleasures and interests, and doubting their own intellects – because those with 'moral clout' have decided that 'they' are the problem. We would do the opposite: we gladly encourage people to enjoy to the full their moments of imagination, since that is still what marks us as human.

1 See, again, David Buckingham's important work on these discourses within young people, in his *Children Talking Television,* and *Moving Images.*

2 See for instance Annette Hill, *Shocking Entertainment* University of Luton Press 1997.

3 We say 's/he' even though the great majority are male. It does not seem to make much difference to such viewers where the hero is female, as in for example *Alien.*

4 Although it is by no means clear from our interviews, we sense that for our interviewees enjoying a film for its 'effects' is not centrally about enjoying those bits that are self-evidently 'generated as effects'. Rather, it seems to be an orientation to the whole film, an expectation of a way of participating in the complete experience. This is important, as we aim to show. But because we did not appreciate the significance of this aspect until the stage of transcript-analysis, we did not explore this matter further with our respondents.

5 See for instance Philip Hayward & Tana Wollen (eds), *Future Visions: New Technologies of the Screen,* London: BFI 1993. See in particular Robin Baker's essay 'Computer technology and special effects in contemporary cinema', pp.31-45.

6 Don Slater, 'Photography and modern vision', in Chris Jenks, *Visual Culture,* London: Routledge 1995, pp.218-37. Slater is here discussing Daguerre's other (non-photographic) life as a theatre designer, when he developed a series of illusions with the diorama. Slater does show that in later times the technology did not need to remain 'hidden' and 'incomprehensible'.

7 Steven Neale, 'Hollywood strikes back: special effects in recent American cinema', *Screen,* Vol.21, No.3, 1980, pp.101-5. This quote, p.105.

8 Later and elsewhere, Neale goes so far as to suggest that special effects science fiction cinema is an example of 'reinscribing of the law of the cinematic institution' (an expression used by psychoanalytic theorists to suggest that cinema as a medium constitutes a 'trap' for the unconscious) and that science fiction may by its very nature be particularly prone to this. See also his *Genre,* London: BFI 1980, Chapter 2.

9 Neale, 'Hollywood strikes back', p.105.

10 Slater does, it is true, say at one point: 'There is no one relation between science, spectacle and magic' (p.229), but all his versions of that relationship still revolve around 'problems of knowledge'. We believe that is an unnecessary limitation.

11 Albert J LaValley, 'Traditions of trickery: the role of special effects in the science fiction film', in George Slusser & Eric S Rabkin (eds), *Shadows of the Magic Lamp: Fantasy and Science Fiction in Film*, Carbondale: Southern Illinois University Press 1985. This quote, p.144. LaValley immediately precedes this sentence with the words 'unlike other films'. We think that is in danger of losing the distinction between recognising the particular way science fiction invites us to relate experiencing and experiencing-as, and denying that effects in other genres work on that distinction at all.

12 Our thanks to Judith Barker for this point and the illustrative example.

13 Arguably a related problem lay at the back of the Arnold Schwarzenegger film *Last Action Hero* (1993) with its rather heavy moralising about 'not forgetting the difference between fantasy and reality' – problems which led it to be regarded as a failure, despite its technically good effects and despite also a relatively good box office performance. Even so, it was widely seen as a bit patronising to its audience.

14 See for instance David Buckingham, *Moving Images*, and Annette Hill, *Shocking Entertainment*.

15 There is a link, we believe, between what we are saying here and Robin Wood's insightful comment that horror films have only lovers and haters. Very few people are neutral towards them. (See his 'Return of the repressed', *Film Comment*, Vol.14, No.4, 1978, pp.25-32.) We suspect that this has to do with the management of risk involved in maintaining that uneasy relationship between experiencing and experiencing-as.

16 Mark Kermode, 'I was a teenage horror fan: or, "How I learned to stop worrying and love Linda Blair"', in Martin Barker & Julian Petley (eds), *Ill Effects: The Media Violence Debate* London: Routledge 1997. pp.57-66. For a review of fan magazines which makes many related points, see David Sanjek, 'Fans' notes: the horror film fanzine', *Literature/Film Quarterly*, Vol.18, no.3, 1990, pp.150-60. There are clear elements of the same conclusion in Noel Carroll's *The Philosophy of Horror, or, Paradoxes of the Heart*, New York: Routledge 1990.

17 Robert Hodge & David Tripp, *Children and Television: a Semiotic Approach*, Cambridge: Polity Press 1986.

18 Hodge & Tripp, *Children and Television*, p.124.

19 Hodge & Tripp, *Children and Television*, p.130. Our emphases.

20 S Elizabeth Bird, *For Enquiring Minds: A Cultural Study of Supermarket Tabloids*, Knoxville: University of Tennessee Press 1992, p.122.

21 This does not mean, unfortunately, that the addition of 'formal knowledge of sex' in schools or elsewhere will resolve this away. For the problem is rather a lack of *believable* knowledge which can connect in significant ways with other things the person believes, or cares about. On a related issue, see our discussion of Media Education in the final Chapter.

22 Bill Thompson, *Soft Core: Campaigns against Pornography in Britain and America*, London: Cassell 1994.

23 Karl Mannheim, *Ideology and Utopia*, London: Routledge & Kegan Paul 1960 (first published 1936), p.195.

24 Mannheim, *Ideology and Utopia*, p.193.

25 Mannheim, *Ideology and Utopia*, p.193.

26 Mannheim, *Ideology and Utopia*, p.191-2.

27 This phrase, from James, is suggestive. It reminds us of an older, almost lost discourse, typified in the work of the Cole and Postgate, among others, who documented and commentated in sentimental, labour-aristocratic style on working class life. It's as if, with the current low ebb of working class politics, James has to reach back and hear an echo of an old way of speaking, to place his perception of this future. See G D H Cole & Raymond Postgate, *The Common People 1746-1946*, London: Methuen 1949.

28 On the hippies, see Stuart Hall, 'The hippies: an American moment', *Occasional Paper No.16*, Birmingham: Centre for Contemporary Cultural Studies 1968.

29 Another whole tradition of work within cultural studies might seem relevant here. Many have recently turned to Mikhail Bakhtin's account of 'carnival' to think about the importance of bodily and sensuous excess. There are certainly a number of relevant connections to be made with this work. The differences we would point to are, first, Bakhtin's own pessimism, his belief that carnivalesque excess as a force for social resistance has long been on the decline. John Docker responds interestingly to Bakhtin's 'gloomy assessment ... of the diminished force of carnival and the carnivalesque... I would argue that carnivalesque as a cultural mode still strongly influences twentieth century mass culture, in Hollywood film, popular literary genres, television, music: a culture that in its exuberance, range, excess, internationalism, and irrepressible vigour and

inventiveness perhaps represents another summit in the history of popular culture, comparable to that of early modern Europe'. (John Docker, *Postmodernism and Popular Culture: A Cultural History*, London: Routledge 1995, p.185) The trouble with this more optimistic reading, it seems to us, is that it is too promiscuous (pardon the near-punning word) in enthusiastically recording a history of all kinds of excesses; orgiastic behaviour per se does not contain our fork between present and future, or we would have to count the orgy of crying over Diana's death as something wonderful. The difficulty here is precisely Mannheim's point that the forms of such social behaviour can have a history independent of the impulse. What Mannheim stresses is the social/mental impulse which surfaces in particular situations. We are arguing that Action films contain one means to just this impulse.

30 William S Palmer, *Films of the Eighties: A Social History* (Carbondale: Southern Illinois University Press 1983), p.13.

31 A caveat: Film-Refusers need distinguishing, but with care, from Film-Ignorers. The latter are people who simply find the film alien to them, but don't connect their own dismissal to (as we argue here) the construction of the idea of a dangerous 'Other' who do like such films. We found this response among a number of young girls. But interestingly, this could slide over with some ease into either Casual viewing, or even into an attraction to an Action-Adventure involvement. We aim to explore Film-Ignoring in a separate essay.

32 On this use of standardised languages of criticism, including the connection with fears of 'America', see Ien Ang, *Watching Dallas*.

33 We can't forebear noting that this couple's conception of gratuitous sex in films was particularly mobile, since they discussed with ease their late-night watching of one film: *Basic Instinct...*

34 On this and other 'folk theories of the media', see Chapter 13.

13

WHAT IS TO BE DONE
(BUT PROBABLY WON'T BE)

> Throughout this book – as throughout most film studies – the audience has been conspicuous by its absence. In talking of manipulation ..., consumption ..., ideological work ..., subversion ..., identification ..., reading ..., placing ..., and elsewhere, a concept of the audience is clearly crucial, and yet in every case I have had to gesture towards this gap in our knowledge and then proceed as if it were merely a gap. But how one conceptualises the audience – and the empirical adequacy of one's conceptualisations – is fundamental to every assumption one can make about how stars, and films, work.[1]

The reason for this closing chapter is simple: this book is going to be published. Foolish or not, we want it to have an influence, not just on students' work in our field (purely academic influence) but on how people think about, understand, debate and do things about films. In publishing evidence and argument about the audiences of a kind of very popular film, our words join concourse with a babble, no, a babel of other very loud voices. The loudest are just about the most stupid. The most published are the least trustworthy. This is simply because they are driven primarily by motives of control of that which the speakers and writers fear but do not understand. Undertaking this research project was very like walking down a long corridor lined with refracting mirrors. Each mirror – our metaphor for some current way of thinking about films in general, or Action films in particular, or how films 'affect' people, etc – tempted us to turn corners. Several times we did, and made mistakes, and had to try to rectify them. We don't rule out the possibility that we took some wrong turns without noticing. But our goal was to walk a straight line and stay true to listening to our audiences, and learning from them – however uncomfortable the answers we thus got. The more we researched and analysed, the more we became aware that a key problem in all work on audiences is that everybody thinks they know what the issues are, before they begin.

Take the quotation from Richard Dyer with which we've mast-headed this chapter. It's a wise and honest admission of a problem. But how has saying it affected Richard Dyer's own practices as a film analyst? We can't see that it has, at all. This is especially germane to us in one of his most recent books. In his *Only*

Entertainment, Dyer offers two essays on this important concept. The opener is a thoughtful discussion of the meanings of calling something 'entertaining'.[2] It is deliberately self-limiting, 'only' entertainment. Entertainment is by definition non-serious – to want to be entertained is to resist any demands for the 'educational', the 'worthy'. It is also in another direction, we would add, a claim of 'harmlessness'. To say of a film that it is 'just a piece of entertainment' is to resist a moral challenge to it. Dyer's essay is very valuable, in particular for the way he shows that the idea of 'entertainment' isn't just a critics' term, but one that governs how, for instance, programme makers and broadcasters understand their job. They have to work at being 'just entertaining', and it is hard. And, we add again, fans of troubled media often have to work at defending their preferences as 'just entertainment'. But if we look at Dyer's very next essay, we see something different begin to happen. Discussing 1930s Musicals as 'entertainments', he sees them as playing off their problematic narratives (which often involve political themes about wealth and poverty, and the unequal positions of men and women) against the sumptuousness of their song and dance numbers. Thus: 'many of the contradictions developed in these films are overridingly bought off'.[3] Where? How? With what consequences? It is as if this buying off happens 'over there' in the film, but it is only worth saying because of the unspoken implication that what was 'over there' has the potential to come 'over here', and affect us – or, better, 'them'. 'They' are an audience who, by being diverted, might be converted, subverted or perverted.

We admire Richard Dyer's work enormously. But the fact is that repeatedly even he shows the gross power of what we are calling 'folk theories of the media'. What are these?

Folk theories of the media

At any time in our society, a set of ideas, and associated ways of talking, are circulating which provide the immediate resource for saying why films matter, what we should think about them, and what they are for. They do a job of providing categories into which we can pop things we like or don't like, around which we can voice doubts and fears, or pleasures that we can't easily put into words. But they aren't innocent, these folk theories of the media.

Take 'escape'. It's one of those words that just invites a pre-fix: 'it's just escapism', 'all it is is only a piece of escapist fantasy' (second folk-theoretical term). Discursively, 'escape' and 'escapism' operate defensively – they fend off possible objections. But if we were to take them literally, as potentially insightful concepts, we would have to ask: escape from what? towards what? Are people's lives so bad that they need to escape? And if we ask that, we can smell the research project in the making: measure the relationship between degrees of misery and preferences for 'escapist' materials. But of course by and large no one bothers with such a research project, since by its nature a folk-theoretical concept is so obvious as to need no research. And if a piece of research came to the conclusion that, actually, no such relationship exists, and perhaps the concept is a useless one for understanding films and their audiences, then our bet is that most people would do

one of two things. Either they would nod, say 'Ah! Interesting ...!, and then within minutes be talking about 'escape' again; or – more strongly – would say 'That's silly. Everyone knows that people use films just to escape'. Herein lies our problem.

There are quite a number of folk-theoretical terms currently circulating. Some are old favourites: 'escapism', 'fantasy', 'a bit of fun' all operate to circumscribe and protect. 'Violence', 'gratuitous', 'pointless' and 'harm' go the other way. Our 'favourite' is 'gratuitous'. Just what is meant by calling sex or violence in a film (the most common target) 'gratuitous'? The literal implication is that it is put in for its own sake, and has no function other than to be 'titillating' or 'disturbing' or 'appealing to the baser feelings of the audience' (all these being more good grist to the folk-theoretic mill). But the implication is also therefore that some kinds of audiences – the ones 'over there', not us – are vulnerable to this because it is 'gratuitous'. Instead of saying 'Oh look, that was pointless, wasn't it?' and turning against it, they think they see a point in it – they enjoy it and thus are 'hooked' by it, and thus harmed. 'Violent' films contain 'messages', they 'teach' people that violence does no harm or is the answer to everything. The fact that the viewers might say 'there are no messages, we have been taught nothing' is not so much irrelevant, it is a proof how degraded and corrupted they already are. So, embedded in that term 'gratuitous' is an unspoken model of how people are influenced. A bad model, even a stupid one, but one that hasn't ever been tested ... because it is 'obvious', isn't it?

Films are said to 'hook, 'drug' and 'degrade' their audiences, leading to claimed processes which look scientifically-explanatory: 'desensitisation', 'identification', and/or 'role-modelling'. The fact that these three processes, if they occur at all – which is not self-evident, since virtually all the research we've seen on these presumes their existence, rather than seeking to establish them – are probably incompatible and indeed mutually exclusive has never stopped their amalgamation. Above all, audiences are 'harmed'. This para-medical way of talking takes behaviour that the speakers don't like, and makes the people who show it into 'vicious victims'. They may think that they are choosing to behave these ways, but 'we' know better. They have been 'stimulated', or 'triggered' to it.

Note two central features about all these languages. First, they distrust what people say about themselves – they can't speak for themselves, since they are 'sick' and 'harmed'. And 'we' therefore have to control. A vast chunk of the folk-theoretic languages we have found are to do with control. They are not random – they contain implicit models. But no one is interested in testing those models, not even, by and large, people in our own field of academic research.

Implicit theories of the audience

Look again at our mast-head quotation. Richard Dyer is absolutely right – but the task is very hard, because folk-theories of the audience are so endemic. Here is an example of such folk theories at work. *The Guardian* recently featured an essay by Linda Grant, who sermonised on the awfulness of 'violent imagery' (and of course 'we all know' what that must encompass). Moving seamlessly from her own lack

of pleasure at films such as *Pulp Fiction*, she offered a judgement on those who do enjoy them:

> What makes me scream and close my eyes, some other viewers disdainfully dismiss as second-rate special effects. Try as I might, it always looks like blood to me, not ketchup. My disbelief is always willingly suspended. Theirs has to be coaxed. 'All is illusion', they cry. 'But see if you can persuade me otherwise'. My response would be explicable if I had no sense of humour, but violence has become slightly less funny to me after reading that teenage audiences in Los Angeles giggled their way through *Schindler's List*, not because they were neo-Nazis but because they could no longer recognise what was supposed to be serious and what was not, and who can blame them?[4]

How does she know that is why they giggled (assuming they did – such fables are famous for their 'travel')? It is easy to think of many other reasons: embarrassment, unease, misrecognition, a sense of exaggerated 'seriousness' about the film. And so on. But no: 'we' know how this has come about – and who can blame 'them'? Every sentence of this quotation contains assumptions which aren't based on evidence, and won't ever be tested – because their function is to preclude reasoned investigation.

Knowing about audiences

Graham Murdock, the media researcher, tells a delightful anecdote about the problems faced by media researchers. He was invited onto *Kilroy* to talk about the issue of television violence. Following a speaker, inevitably, from the National Viewers and Listeners' Association, Robert Kilroy turned to him and gave him three minutes to present his 'expert' opinion on the questions raised. Murdock did his best. When he finished, Kilroy turned to his studio audience and asked them: 'Well, now let's hear from you. After all, you're the experts, you all watch television'. Thus is all awkward research and critical thought dismissed – it's all 'opinions', isn't it? Unless, that is, you are talking about audiences who are be definition untrustworthy, or incompetent: the 'other'.

We've spoken to 'the other', and we had methods for listening and making sense of what they said to us. To this extent, we unashamedly claim the mantle of expertise. We know things about popular film audiences that politicians, policy-makers and moralists don't want to know, and that the audiences themselves would find hard to put into words themselves. We've listened to and analysed more people and more responses than has been the case before. We have discovered processes and patterns that can only be shown by analysis. In all this, however, we have been faithful to our promise to hear our audiences. What we have to say is inconvenient, because it isn't in the language that pundits want to hear. That's their problem.

Public Policy

As we begin to write this part, the telephone rings for one of us: it's Radio 5 Live, wanting Martin Barker to take part in a debate on the future of the British Board

of Film Classification. The BBFC is in the news because Labour's Home Secretary Jack Straw has refused to ratify a new Chairman of the Board because he is 'too liberal' on sex and violence, and because Straw is 'concerned' at certificates being granted to 'explicit' sexual and violent films. Radio 5 need someone to present a contrary point of view – leave the BBFC alone, the classification system is working OK, films aren't harmful. It happens that we can't – broadcasters don't ever seem to understand that researchers are not sitting waiting for the next phone call to rush to a studio. But the call is an apt reminder of just how constrained, narrow and driven public debates about films like ours are – and indeed, the role allotted to knowledge such as we've struggled to produce.

Truth is, only one kind of research is admissible and legitimate in most public debates. Only psychological research addressing one question is seen as relevant. That question is: 'does explicit violence in the media "harm" audiences?' If only we could so prostitute our research to ask that question, we could guarantee ourselves air-time, and probably get oodles of research money. Our problem is: we know the question to be, simply, stupid. It is meaningless. It is therefore also unanswerable. And for the simplest of reasons: there is no such thing as 'violence' that can be abstracted, understood and investigated independently of the contexts in which it appears. A cartoon is not a news report is not an Action film is not a documentary is not a war film is not a comedy disaster film is not a political thriller (just for starters...). A rape scene does not mean the same if it is filmed in close up or at a distance, if the victim is known to us or not, if it occurs at the start or end of a story, if it is presented as pure violation or violent pleasure, if it occurs in a western, a sex film, a thriller or a drama-documentary (among others...). The willingness of many researchers to sidestep these obvious truths, to take the money and run with the hounds is a scandal. The price is, always, that the real audiences become an 'other', a problem, a danger, a body of people about whom we ask questions we would never ask about ourselves. We've refused to do that – we have insisted on listening to film audiences talking in their own words about the things they value and care about. The moment researchers do drop that assumption, some remarkable findings start emerging.[5] Our own results have surprised us as much as anyone else.

Film policy in this country, more than most others, is a play-thing of various moralistic enterprises. The loudest moralisers, or the ones who manage to place their absurd documents in the most influential places, are the ones who steer policy the most. In 1996 Martin Barker was sent a copy of a paper issued to all MPs by one such body. Calling itself the 'Parliamentary All-Party Committee on Family & Child Protection' (APCFCP), this group of mainly evangelical religious extremists managed to pass off a body of bizarrely bad research as 'knowledge of the danger of films'.[6] Among its sources, quoted with no apparent sense of the absurdity of what they were doing, was one 'Professor Michael Bentine' who was used to substantiate their claim of the 'especial powers' of television and video. Bentine had claimed that early film viewers used to be 'hypnotised' by the frame-speed of films; but now television and video have made matters worse, and that this is the source of television's power to 'manipulate'. The whole thing is just silly. Any

305

report that deals in claims as daft as this has simply deserted the grounds of rational enquiry. But that report has been lodged physically within the Parliamentary library, and mentally within the consciousness of MPs. Barker's response, commissioned by the Video Standards Council and prepared in association with a number of other researchers, had trouble even reaching MPs. That, and a number of other genuine researches which listen to viewers, are to play no part in policy-making which is determined by the smell of scorched consciences, not by reasoned investigation.

Take the (at time of writing this) latest piece of publicised research on 'video violence', which looks to have won the ear of Jack Straw who is demanding more restrictions. Unlike the 'research' of bodies like that of the APCFCP, this is an honestly done study. It is also honestly impoverished. Kevin Browne and Amanda Pennell researched 80 young people, of whom 20 were violent offenders, 20 non-violent offenders, and 40 a control group. Their question? 'The research examined whether violent young offenders do view violent videos differently from non-violent offenders and non-offenders'.[7] The simple fact is that their research does not begin to answer the question – instead, it answers some different questions, such as how often the different groups watch, how much they remember scenes from them, and which had more violent childhoods. In between, it seems to answer that wider question, by asking: do violent offenders identify more often with violent scenes and characteristics? The fact that we do not have a single worked-out idea what it would mean to 'identify with a violent scene', let alone having some research tool for finding out who does or doesn't do this – that's irrelevant.

So what is their outcome? Well, unobtrusively, a result does appear which is interesting just by virtue of being puzzling: 'offenders were significantly more likely than non-offenders to choose soap operas (74 per cent compared with 35 per cent) and police dramas (40 per cent compared with nil). Violent offenders were more likely than non-violent offenders to prefer police dramas.'[8] We think this is worthy of thought – might it be that offenders prefer soaps because soaps offer an experience of belonging of which they feel cheated? It's worth a thought – and an experiment. Might it be that they prefer police series because these allow them to study police procedures, readying themselves for the 'next time'? Again, worth a thought, and a test. But of course to entertain these explanations – which we readily grant may be wrong – will be to overturn several favoured ideas. If they like soaps for this reason, they are desperate, not perverted. If they like police dramas for this reason, they are rational, rather than corrupted. Their own accounts of their behaviour would become resources – as in our study. And we might find, then, that their categorisations of media materials, the things that 'work for them', are quite different than presumed.

That can't possibly be allowed. Instead, Browne & Pennell's research gaily assembles a set of characteristics. We are told that when asked to name favourite actors, two thirds of offenders 'named stars like Arnie Schwarzenegger or Sylvester Stallone who typically play violent characters'. 'Violent characters'? But they also often play police officers! And naming a favourite actor is not, except in the most unthinking (folk-theoretic) world, evidence of 'identification with film

actors'. And if Arnie and Sly are their 'favourites', what are we to make of the subsequent claim that 'more offenders identified with a vindictively violent character' – who he? And what kind of analysis of films was conducted, to determine what shall count as 'vindictive' responses? We hereby add the expression 'vindictive violence' to our list of folk-theoretic terms, which need clarification, but which for sure will not get it.

Suppose, though, that this research made sense – what exactly should be done with it? How do we decide which films are dangerous, 'vindictive', likely to encourage 'identification'? The brutal fact is that there is no way of deciding – and that absence is just perfect, because it leaves the door wide open for a generalised restriction, or ban.

This book and its findings will almost certainly be ignored, but not for want of our trying. It will be ignored because its findings are a scandal to 'commonsense', the blind hurrying for the moral phrase and the cant expression that drives media policy in this country. But if it were to be heard, what would we be recommending? From the basis of what we believe we have learnt through this project, we would argue for the following, at least:

1 There is nothing wrong with good information about a film or television programme. If this is what 'classification' means, then that is fine. But classifiers need to be aware that the only people who will view this as 'information' will be those who are trying to manage or restrict others' viewing practices. For fans of a genre or medium, the 'information' takes its place in the array of publicity which is part of their relations of use, and part of their pleasure. To be meaningful, therefore, classification has to begin from the genres recognised by audiences; and the information has to be posed in ways that are understood by users.

Take an example: television programmes now frequently carry a warning that they involve the use of 'strong language'. If the intention of that is to warn off people who will be upset by that, then fine. But never forget that an implicit judgement is contained on anyone who says s/he likes 'strong language'. This is a real problem in the frequent measures which bodies such as the Broadcasting Standards Council take of public opinion on television violence. Faced with the question 'Is there too much/about right/too little violence on television?', what kind of a person are you if you say 'Too little'?! Be judged, little person! You are already harmed ...

2 One of the standard 'moves' by researchers and critics on our side of the debate is to argue for more media education. And indeed it is the deepest hypocrisy for politicians to belittle media education, and to squeeze it to the margins of the national curriculum, while expressing so much concern about children's supposed 'vulnerability' to the media. But while we applaud the general drive by media researchers to say that children should be given the opportunities to become media-literate critics, and while we applaud the wider ambition that children should be given the chance to understand the many roles that the media play in modern societies, we add these cautions. If media education is

conceived as some kind of vaccination against 'dangerous media', helping young people 'fight off' the bacilli of 'violence' and 'sex', it will not so much fail as be laughed off – and will contribute to the already rife disenchantment with education felt by many young people.

We asked several groups of young people what 'media education' did for them. Their answers were very clear, and were a surprise to us: 'critical viewing' is what you do when you are bored. If a film is good, one of the kinds you enjoy, you just bathe in it, in the ways you've learnt how. But if the film is boring, or slow, or not what you expected, then you go into the media studies mode of watching.

KB: *Um, you watch films at, in school, haven't you, as part of your courses and things, I mean, say this was one of the films you had to watch, as part of your course, what kind of things would you be looking out for in it then, I mean, what would you look for? How would you watch it then that's different?*

Anthony: I'd stay awake [laughter]

Chris: You would be questioning it wouldn't you, looking for hidden messages, that's what's the teachers are keen on, isn't it. What are they trying to say, how are you supposed to view it, whose point of view are you supposed to see it from, how as an audience [..?..] You'd have to think about it!

MB: *Do the rest of you think that, that's what you're asked to do, to look at it differently? [General: yes] Do you ever find you go to the cinema now and you find yourself doing that, because you've done it in school?*

Chris: Not during the film but afterwards you think about it

Anthony: Like on really rubbish films, I'm like always deconstructing it [Joe: Yeah] Like, on *Jurassic Park*, where he falls down, and gets killed by the dinosaur, and there's a little canister of like, DNA, and it gets swallowed up and I'd say 'Ah! There's something there, you could have a continuation of that'.

MB: *So does that include, when you find yourself doing that do you find that, you get irritated doing that and it spoils your enjoyment or do you enjoy it just as much or more?*

Chris: Well if I'm really bored, if it's a really boring comedy and you can just tell the whole plot straight away I'll just switch off, but if it's a horror film or a thriller, then you have to see it all that way through and then you start thinking about it. [Interview 32]

That does not make media studies or media education irrelevant, if they dare to set their task not as changing the tastes of young people, but letting them explore and understand their tastes. This does in fact happen in a good number of cases, within media studies. Within our limited knowledge, media studies teachers are often extraordinarily responsive to the involvements of their students. But of course the principle behind that approach is that in important senses people are, or can become, experts about themselves – the very premise behind our research, indeed.

3 So what about film classification, censorship, controls over videos, and so on? The answer from our research is: START AGAIN! That is not as radical or impossible as it sounds, though of course it won't happen. But the principles behind what we are saying are these:

(i) We know that the category 'violent films and videos' only has meaning for those who seek to control or ban them. The category is meaningless to those who actually choose them. If the aim of censorship were really to control effects, rather than to claim a moral high-ground, then governments and their agencies should care about the poverty of the research on which they are basing their actions.

(ii) We don't deny at all that particular films, under certain circumstances, might be used as a resource for actions which governments might want to control. It would be stupid to deny the possibility. But unfortunately, we don't have much evidence at all that this needs to be violent films or videos, nor, even more unfortunately, do we have any good evidence that it is the violence in such movies which constitutes the motivating factor. Least of all do we have any evidence which kinds of filmically-represented violence could ever be to blame. What is written and said about it is almost entirely wind and persiflage. If the real goal of censorship were to be able to mark out areas of danger, then governments and their agencies should care about our ignorance, and take steps to do better.

It is because we find little evidence, from the history of censorship or from current practices, that movements demanding control over films and videos are in any sense making demands based upon reason, that we do not expect the findings of this book to be listened to. Part of the responsibility that goes with being academics is not to give up trying.

1 Richard Dyer, *Stars*, London: BFI 1979, p.182.

2 See Richard Dyer, *Only Entertainment*.

3 Richard Dyer, *Only Entertainment*, p.29.

4 Linda Grant, 'Violent anxiety', *Guardian*, 28 September 1996, p.24.

5 Just for starters, see Philip Schlesinger, R Emerson Dobash, Russell P Dobash & C Kay Weaver, *Women Viewing Violence*, London: British Film Institute 1992; Annette Hill, *Shocking Entertainment*; and John Fiske & Robert Dawson, 'Audiencing violence: watching homeless men watch *Die Hard*, in James Hay, Lawrence Grossberg & Ellen Wartella (eds), *The Audience and its Landscape*, Boulder, Co: Westview Press 1996, pp.297-316.

6 Parliamentary All-Party Committee on Family & Child Protection, *Violence, Pornography and the Media*, London 1996.

7 Kevin Browne & Amanda Pennell, 'Effects of video violence on young offenders', *Research Findings No.65*, London: Home Office Research & Statistics Directorate 1997. This quote, p.1.

8 Kevin Browne & Amanda Pennell, 'Effects of video violence on young offenders', p.2.

BIBLIOGRAPHY

Dredd - related materials

Judge Dredd: the Movie, Director: Danny Cannon (Cinergi 1995).

Judge Dredd: the Official Movie Adaptation, written by Andrew Helfer, artwork by Carlos Ezquerra, London: Fleetway Editions 1995.

'Sunday Magazine', *News of the World*, July/September 1995. Script by John Wagner, artwork by Ron Smith.

Judge Dredd, Novel by Neal Barrett Jr., based on the screenplay by William Wisher and Steven E deSouza, London: Boxtree 1995.

Judge Dredd, Based on the novelisation by Neal Barrett, Jr., abridged by Edward Seago and read by Robert Firth, Castle Communications 1995.

Judge Dredd: Hershey's Story, by Richard Mead, London: Boxtree 1995.

Judge Dredd: Ferguson's Story, by Richard Mead, London: Boxtree 1995.

Colin M Jarman & Peter Acton, *Judge Dredd: the Mega-History*, London: Lennard Publishing 1995.

Mike Butcher, *The A-Z of Judge Dredd*, London: Hamlyn 1995.

The Art of Judge Dredd: the Movie, London: Boxtree 1995.

Jane Killick with David Chute and Charles M Lippincott, *The Making of Judge Dredd: In the Future, One Man Is The Law*, London: Boxtree 1995.

Judge Dredd: Study Guide, London: Film Education 1995.

Judge Dredd/Stallone: Production Notes, London: Guild Entertainment 1995.

Judge Dredd: Campaign Book, London: Guild Entertainment 1995.

Judge Dredd: Lawman of the Future - Writers' Guidelines, London: Fleetway Editions 1994.

Judge Dredd: Exclusive Film Supplement, London: Fleetway Editions (given away with *Judge Dredd: the Megazine*, Vol.3, No.1, 1995).

Judge Dredd: the Making of a Film, BBC2 7 July 1995.

Stallone's Law: the Making of Judge Dredd, Sky Movie Channel, n.d.

John Wagner & Colin MacNeil, *America,* London: Fleetway Editions 1991.

In addition, we consulted a large number of relevant editions of *2000AD*, *Judge Dredd: the Megazine*, and *Judge Dredd: Lawman of the Future*, as well as examining a large amount of ephemeral material produced in association with the film.

Books and Articles

Abercrombie, Nicholas, Stephen Hill & Bryan S Turner, *The Dominant Ideology Thesis*, London: George Allen & Unwin 1980.

Abercrombie, Nicholas, Stephen Hill & Bryan S Turner (eds), *Dominant Ideologies*, London: Unwin Hyman 1990.

Alvarado, Manuel & John O Thompson (eds), *The Media Reader*, London: British Film Institute 1990.

Anderson, Charles, *A City and its Cinemas*, Bristol: Redcliffe Press 1983.

Ang, Ien, *Watching Dallas: Soap Opera and the Melodramatic Imagination*, London: Methuen 1985.

Ang, Ien, 'Culture and communication: towards an ethnographic critique of media consumption in the transnational system', *European Journal of Communication*, Vol.5, 1991, pp.239-60.

Ang, Ien, *Desperately Seeking The Audience*, London: Routledge 1991.

Atwell, David, *Cathedrals of the Movies: a History of British Cinemas and their Audiences*, London: The Architectural Press 1980.

Bacon-Smith, Camille, *Enterprising Women: Television Fandom and the Creation of Popular Myth*, Philadelphia: University of Pennsylvania Press 1992.

Baker, Steve, *Picturing The Beast: Animals, Identity & Representation*, Manchester: Manchester University Press 1993.

Bakhtin, M M, *Rabelais and his World*, Bloomington: Indiana University Press 1984.

Bakhtin, M M, *Speech Genres and Other Late Essays*, Austin: University of Texas Press 1986.

Balio, Tino (ed), *Hollywood in the Age of Television*, London: Unwin Hyman 1990.

Barker, Colin & Paul Kennedy, (eds), *To Make Another World: Studies in Protest and Collective Action*, Aldershot: Avebury 1996.

Barker, Colin, 'Social confrontation in Manchester's quangoland: local protest over the proposed closure of Booth Hall Children's Hospital', *The North West Geographer*, Vol.1, 1997, pp.18-28.

Barker, Martin, *A Haunt of Fears: the Strange History of the British Horror Comics Campaign*, London: Pluto Press 1984.

Barker, Martin (ed), *The Video Nasties: Freedom and Censorship in the Arts*, London, Pluto Press 1984.

Barker, Martin, 'Television and the miners' strike', *Media, Culture & Society*, Vol.10, No.1, 1988, pp.107-11.

Barker, Martin, *Comics: Ideology, Power and the Critics*, Manchester: Manchester University Press 1989.

Barker, Martin, *Action: the Story of a Violent Comic*, London: Titan Books 1991.

Barker, Martin & Anne Beezer (eds), *Reading Into Cultural Studies*, London: Routledge 1993, pp. 81-100.

Barker, Martin, 'The Bill Clinton fan syndrome,: review article on Henry Jenkins, *Textual Poachers, Media Culture & Society*, Vol.15, No.4, 1993, pp.669-74.

Barker, Martin & Kate Brooks, 'Waiting for *Dredd', Sight & Sound*, August 1995, pp.16-19.

Barker, Martin, 'Review of John Tulloch & Henry Jenkins, *Science Fiction Audiences', Media Culture & Society*, Vol.18, No.3, 1996, pp.364-7.

Barker, Martin, 'Review of David Buckingham, *Moving Images', British Journal of Educational Studies*, Vol.45, No.1, 1997, pp.83-4.

Barker, Martin & Julian Petley (eds), *Ill Effects: the Media-Violence Debate*, London: Routledge 1997.

Barker, Martin & Kate Brooks, 'Bleak futures by proxy', paper presented to the International Conference on 'Hollywood and its Audiences: 1895-1995', University College, London, February 1998.

Barlow, Geoffrey & Alison Hill (eds), *Video Violence and Children*, London: Hodder & Stoughton 1985.

Baxandall, Michael, *Painting and Experience in Fifteenth Century Italy: A Primer in the Social History of Pictorial Style*, New York: Oxford University Press 1988 (first published 1972).

Billig, Michael, *Speaking of the Royal Family*, London: Sage 1993.

Billig, Michael, *Ideology and Opinions*, London: Sage 1991.

Billig, Michael et al, *Ideological Dilemmas*: *A Social Psychology of Everyday Thinking*, London: Sage 1988.

Billig, Michael, *Ideology and Opinions: Studies in Rhetorical Psychology*, London: Sage 1991.

Bird, S Elizabeth, *For Enquiring Minds: A Cultural Study of Supermarket Tabloids*, Knoxville: University of Tennessee Press 1992.

Bjorkegren, Dag, *The Culture Business: Management Strategies for the Arts-Related Business*, London: Routledge 1996.

Blumler, Jay, J R Brown & Denis McQuail, *The Social Origins of the Gratifications Associated with Television Viewing*, Report to the Social Science Research Council, 1970.

Blumler, J G & E Katz (eds), *The Uses of Mass Communication: Current Perspectives on Gratifications Research*, Beverley Hills, CA: Sage 1974.

Booth, Wayne, *The Rhetoric of Fiction*, Chicago: University of Chicago Press 1961.

Bordwell, David, *Making Meaning: Inference and Rhetoric in the Interpretation of Cinema*, Boston, Mass: Harvard University Press 1991.

Bordwell, David, *Narration and the Fiction Film*, London: Methuen 1985.

Bourdieu, Pierre, *Distinction: A Social Critique of the Judgement of Taste*, Cambridge: Polity Press 1984.

Brooker, Peter & Will Brooker (eds), *Postmodern After-Images: A Reader in Film, Television and Video*, London: Edward Arnold 1997.

Brooks, K, P Jackson & N Stevenson, *Reading Men's Magazines*, Cambridge: Polity Press, forthcoming.

Brown, Ray (ed), *Children and Television*, Basingstoke: Collier Macmillan 1976.

Browne, Kevin & Amanda Pennell, 'Effects of video violence on young offenders', *Research Findings No.65*, Home Office Research & Statistics Directorate 1997.

Bruzzi, Stella, 'Tempestuous petticoats: costume and desire in *The Piano'*, *Screen*, Vol.36, No.3, 1995, pp.257-66.

Buckingham, David, *Children Talking Television*, Brighton: Falmer Press 1993.

Buckingham, David (ed), *Reading Audiences: Young People and the Media*, Manchester: Manchester University Press 1993.

Buckingham, David, *Moving Images: Understanding Children's Emotional Reactions to Television*, Manchester: Manchester University Press 1996.

Burgin, Victor, James Donald & Cora Kaplan (eds), *Formations of Fantasy*, London: Routledge 1985.

Burman, Erica & Ian Parker (eds), *Discourse Analytic Research: Repertoires and Readings of Texts in Action*, London: Routledge 1993.

Burton, Frank & Pat Carlen, *Official Discourse: On Discourse Analysis, Government Publications, Ideology and the State*, London: Routledge & Kegan Paul 1979.

Carroll, Noël, *The Philosophy of Horror, or, Paradoxes of the Heart*, New York: Routledge 1990.

Cartmell, Deborah, I Q Hunter, Heidi Kaye & Imelda Whelehan (eds), *Trash Aesthetics: Popular Culture and its Audience*, London: Pluto Press 1997.

Cole, G D H & Raymond Postgate, *The Common People 1746-1946*, London: Methuen 1949.

Collins, J, H Radner, and A Preacher-Collins (eds), *Film Theory Goes to the Movies*, London: Routledge 1993.

Crane, Diana, *The Production of Culture: Media and the Urban Arts*, London: Sage 1992

Culler, Jonathan, *Saussure*, Glasgow: Collins 1976.

Cumberbatch, Guy, John Brown & Robin McGregor, *Television and the Miners' Strike*, London: Broadcasting Research Unit 1985.

Cumberbatch, Guy, John Brown & Robin McGregor, 'Arresting knowledge? A response to the debate about *Television and the Miners' Strike, Media Culture & Society*, Vol.10, No.1, 1988, pp.112-6.

Curran, James & Michael Gurevitch (eds), *Mass Media and Society*, London: Edward Arnold 1996.

Curran, James, David Morley & Valerie Walkerdine (eds), *Cultural Studies and Communications*, Edward Arnold 1996.

Damico, James, 'Ingrid from Lorraine to Stromboli: analysing the public's perception of a film star', *Journal of Popular Film*, Vol.4, No.1, 1975, pp.3-19.

Davies, Philip (ed), *Representing and Imagining America*, Keele: University of Keele Press 1996.

Davis, Howard & Paul Walton (eds), *Language, Image, Media*, Oxford: Basil Blackwell (1983), pp. 187-204.

Day, Gary (ed), *Trivial Pursuits?*, London: Macmillan 1990.

Dickinson, Roger, Olga Linné & Ramaswami Harindranath (eds), *Approaches to Audiences*, London: Edward Arnold 1998.

Docherty, David, David Morrison & Michael Tracey, *The Last Picture Show? Britain's Changing Film Audiences*, London: British Film Institute 1987.

Docker, John, *Postmodernism and Popular Culture: A Cultural History*, London: Routledge 1995.

Dream On: Bristol Writers on Cinema, Bristol: New Words 1994.

Driver, Stephen & Andrew Gillespie, 'Structural change in the cultural industries: British magazine publishing in the 1980s', *Media, Culture & Society*, Vol.15, 1993, pp.183-201.

Drotner, Kirsten, 'Ethnographic enigmas: the "everyday" in recent media studies', *Cultural Studies,* Vol.8, No.2, 1994, pp.341-57.

Dyer, Richard, *Stars,* London: British Film Institute 1979.

Dyer, Richard, *Only Entertainment,* London: Routledge 1992.

Dyson, Lynda, 'The return of the repressed? Whiteness, femininity and colonialism in *The Piano*', *Screen*, Vol.36, No.3, 1995, pp.266-7.

Essed, Philomena, *Understanding Everyday Racism*, London: Sage 1991.

Fairclough, Norman, *Discourse and Social Change*, Cambridge: Polity Press 1994.

Fairclough, Norman, 'Discourse and text: linguistic and intertextual analysis within discourse analysis', *Discourse & Society*, Vol.3, No.2, 1992, pp.193-217.

Feather, John, 'Book publishing in Britain', *Media, Culture & Society*, Vol.15, 1993, pp.167-81.

Ferguson, Marjorie & Peter Golding (eds), *Cultural Studies In Question*, London: Routledge 1997.

Flax, Jane, 'Postmodernism and gender relations in feminist theory', *Signs,* Vol.12, No.4, 1987.

Fokkema, Douwe & Elrud Ibsch, *Theories of Literature in the Twentieth Century*, London: C Hurst & Co 1995.

Foucault, Michel, *The History of Sexuality*, Vol.1, Harmondsworth: Penguin Books 1981.

Franklin, H Bruce, 'Future imperfect', *American Film*, Vol 8, No.5, 1983.

Garnham, Nicholas, *Capitalism and Communication: Global Culture and the Economics of Information*, London: Sage 1990.

Geraghty, Christine, *Women and Soap Opera: A Story of Prime Time Soaps*, Cambridge: Polity 1991.

Gerbner, George, Larry Gross, Michael Morgan & Nancy Signorelli, 'The scary world of TV's heavy viewer', *Psychology Today*, April 1976, pp.41-5, 89.

Gerbner, George, Larry Gross, Michael Morgan, Nancy Signorelli & M Jackson-Beeck, 'The demonstration of power: Violence Profile No. 10, *Journal of Communication*, Vol.29, No.3, 1979, pp.177-96.

Gillett, Sue, 'Lips and fingers: Jane Campion's *The Piano*', *Screen*, Vol.36, No.3, 1995, pp.277-87.

Gledhill, Christine & Gillian Swanson (eds), *Nationalising Femininity: Culture, Sexuality and British Cinema in the Second World War*, Manchester: Manchester University Press 1996.

Goffman, Erving, *Asylums,* Harmondsworth: Penguin 1961.

Golding, Peter & Marjorie Ferguson (eds), *Cultural Studies In Question*, London: Routledge 1997.

Gordon, Suzy, '"I clipped your wing, that's all": auto-eroticism and the female spectator in *The Piano* debate', *Screen*, Vol.37, No.2, 1996, pp.193-205.

Gramsci, Antonio, *Selections from the Prison Notebooks,* London: Lawrence & Wishart 1971.

Gray, Ann, *Video Playtime: The Gendering of a Leisure Technology*, London: Routledge 1992.

Gray, Herman, *Watching Race*, Minneapolis: University of Minnesota Press 1995.

Greenberg, Harvey M, 'Fembo: *Aliens'* intentions', *Journal of Popular Film and Television*, Vol.15, No.4, 1988, pp.165-71.

Gross, Larry, 'Big and loud', *Sight & Sound*, August 1995, pp.6-10.

Hall, Stuart, 'The hippies: an American moment', *Occasional Paper No.16*, Birmingham: Centre for Contemporary Cultural Studies 1968.

Hall, Stuart, 'Encoding and decoding in the television discourse', *Occasional Papers No.7*, Birmingham: Centre for Contemporary Cultural Studies 1973, revised in CCCS, Culture, Media, Language, London: Hutchinson 1987.

Handel, Leo, *Hollywood Looks At Its Audiences*, Urbana: University of Illinois Press 1950.

Harper, Sue & Vincent Porter, 'Moved to tears: weeping in the cinema in postwar Britain', *Screen,* Vol. 37: No.2, 1996, pp.152-73.

Hartigan, John, 'Unpopular culture: the case of "white trash"', *Cultural Studies*, Vol.11, No.2, 1997, pp.316-43.

Hay, James, Lawrence Grossberg & Ellen Wartella (eds), *The Audience and its Landscape*, Boulder, CO: Westview Press 1996.

Hayward, Philip & Tana Wollen (eds), *Future Visions: New Technologies of the Screen*, London: British Film Institute 1993.

Heidensohn, F, *Women and Crime*, Basingstoke: Macmillan 1985.

Hermes, Joke, *Reading Women's Magazines*, Cambridge: Polity Press 1995.

Hill, Annette, *Shocking Entertainment: Viewer Response to Violent Movies* Luton: University of Luton Press 1997.

Hill, Christopher, *The World Turned Upside Down: Radical Ideas during the English Revolution*, Harmondsworth: Penguin 1991.

Hill, Stephen & Bryan S Turner, *The Dominant Ideology Thesis*, London: George Allen & Unwin 1980.

Hillier, Jim, *The New Hollywood*, London: Studio Vista 1993.

Hodge, Robert & David Tripp, *Children and Television: a Semiotic Approach*, Cambridge: Polity Press 1986.

Hodge, Robert & Gunther Kress, *Social Semiotics*, Cambridge: Polity Press 1988.

Hollows, Joanne & Mark Jancovich (eds), *Approaches to Popular Film*, Manchester: Manchester University Press 1995.

Holub, Robert C, *Reception Theory: A Critical Introduction*, London: Methuen 1984.

Home Affairs Committee, 'Video violence and young offenders', *House of Commons*, London: HMSO 1994.

Hunt, Darnell M, *Screening the Los Angeles 'Riots'*, New York: Cambridge University Press 1997.

Hutchby, Ian, 'Power in discourse: the case of arguments on a British talk radio show', *Discourse & Society*, Vol.7, No.3, 481-98.

Hutchinson, Frances P, *Educating Beyond Violent Futures*, London: Routledge 1996.

Izod, John, *Hollywood and the Box Office*, Basingstoke: Macmillan 1988.

Jennings, Bryant & Dolf Zillman (eds), *Perspectives on Media Effects*, Hillsdale, NJ: Lawrence Erlbaum 1986.

Jenkins, Henry, *Textual Poachers*, London: Routledge 1993.

Jenks, Chris, *Visual Culture*, London: Routledge 1995.

Jensen, Klaus Bruhl & Karl Erik Rosengren, 'Five traditions in search of the audience', *European Journal of Communication*, Vol.5, 1990, pp.207-38.

Kerr, Paul (ed), *The Hollywood Film Industry*, London: Routledge 1986, pp.155-184.

Kipniss, Marc, 'The death (and rebirth) of Superman', *Discourse,* Vol.16, No.3, 1994, pp.144-67.

Klapper, Joseph, 'Mass communications research: an old road revisited', *Studies in Public Communication*, Vol.27, 1963.

Kress, G R & Trew, A A, 'Ideological transformation of discourse: or How the *Sunday Times* got *its* message across', *Sociological Review*, Vol.26, 1978, pp.755-76.

Kress, Gunther, 'Critical discourse analysis', *Annual Review of Applied Linguistics*, Vol.11, 1990, pp.84-99.

Kress, Gunther, 'Against arbitrariness: the social production of the sign as a foundational issue in critical discourse analysis', *Discourse & Society*, Vol.4, No.2, 1993, pp.169-92.

Kuhn, Annette (ed), *Alien Zone: Cultural Theory and Contemporary Science Fiction Cinema*, London: Verso 1990.

Lazarsfeld, Paul F & Frank N Stanton (eds), *Radio Research 1942-1943*, New York: Duell, Sloan and Pearce 1944, pp.3-33.

Lazarsfeld, Paul F & Frank N Stanton (eds), *Radio Research 1942-42*, New York: Duell, Sloan and Pearce 1944.

Lazarsfeld, Paul F & Frank N Stanton (eds), *Communications Research*, 1948-49, New York: Harper 1949.

Lee, David, 'Discourse: does it hang together?', *Cultural Studies*, Vol.3, No.1, 1989, pp.58-72.

Lent, John A (ed), *Pulp Demons*, Cranbury, NJ: Fairleigh Dickinson 1998.

Levinson, Stephen, *Pragmatics,* Cambridge: Cambridge University Press 1983.

Lewis, Justin, *The Ideological Octopus: An Exploration of Television and its Audience*, London: Routledge 1991.

Lewis, Lisa (ed), *The Adoring Audience: Fan Culture and Popular Media*, London: Routledge 1992.

Liebes, Tamar & Elihu Katz, *The Export of Meaning: Cross-cultural Readings of Dallas*, Cambridge: Polity Press 1993.

Livingstone, Sonia & Peter Lunt, *Talk on Television: Audience Participation and Public Debate*, London: Routledge 1994.

Macdonell, Diane, *Theories of Discourse: an Introduction*, Oxford: Basil Blackwell 1986.

Mannheim, Karl, *Ideology and Utopia*, London: Routledge & Kegan Paul 1960 (first published 1936).

Mayer, J P, *British Cinemas and their Audiences: Sociological Studies*, London: Dennis Dobson 1948.

McGregor, Graham & R S White (eds), *Reception and Response: Hearer Creativity and the Analysis of Spoken and Written Texts*, London: Routledge 1990, pp.11-36.

McQuail, Denis (ed), *The Sociology of Mass Communications*, Harmondsworth: Penguin 1972.

McRobbie, Angela, '*Jackie:* an ideology of adolescent femininity', *Occasional Papers*, Centre for Contemporary Cultural Studies, University of Birmingham 1978.

Melson, Hugh, 'The discourse of the illegal immigration debate: a case-study in the politics of representation', *Discourse & Society*, Vol.8, No.2, 1997, pp.249-70.

Miles, Peter & Malcolm Smith, *Cinema, Literature & Society: Elite and Mass Culture in Interwar Britain*, London: Croom Helm 1987.

Moores, Shaun, *Interpreting Audiences: the Ethnography of Mass Consumption*, London: Sage 1993.

Moran, Joe, 'The role of multimedia conglomerates in American trade book publishing', *Media, Culture & Society*, Vol.19, 1997, pp.441-55.

Moran, Albert (ed), *Film Policy*, London: Routledge 1997.

Morgan, David L, *Focus Groups as Qualitative Research*, London: Sage 1988.

Morgan, David L & Richard A Krueger, *Focus Group Kit* Vols 1-6, London, Sage 1997.

Morley, David, *The* Nationwide *Audience: Structure and Decoding*, London: Routledge 1980.

Morley, David, 'The *Nationwide* Audience: a critical postscript', *Screen Education* No. 39, Autumn 1981, pp.3-14.

Morley, David, *Family Television: Cultural Power and Domestic Leisure*, London: Comedia 1986.

Neale, Steven, 'Hollywood strikes back: special effects in recent American cinema', *Screen,* Vol.21, No.3, 1980, pp.101-5.

Neale, Steven, *Genre,* London: British Film Institute 1980.

Neibaur, James L, *Tough Guy: the American Movie Macho*, Jefferson, NC: McFarland & Co. 1989.

Newsinger, John, 'The Dredd phenomenon', *Foundation 52*, Summer 1991, pp.6-19.

Østerud, Svein, 'How can audience research overcome the divide between macro- and micro-analysis, between social structure and action?', Author's MS 1996.

Palmer, William S, *Films of the Eighties: A Social History*, Carbondale: Southern Illinois University Press 1983.

Parliamentary All-Party Committee on Family and Child Protection, *Violence, Pornography and the Media*, London: PA-PCFCP 1996.

Penley, Constance et al (eds), *Close Encounters: Film, Feminism and Science Fiction*, Minneapolis: University of Minnesota Press 1991.

Petersen, Richard A, *The Production of Culture*, London: Sage 1976.

Petersen, Richard A & Roger M Kern, 'Changing highbrow taste: from snob to omnivore', *American Sociological Review*, Vol.61, 1996, pp.900-7.

Philo, Greg, *Seeing and Believing: the Influence of Television*, London: Routledge 1990.

Philo, Greg, *Children and Film/Video Violence*, Glasgow Media Group Research Report, 1997.

Philo, Greg, '*Television and the Miners' Strike:* a note on method', *Media Culture & Society*, Vol.10, No.4, 1988, pp.517-23.

Potter, Jonathan & Margaret Wetherell, *Discourse and Social Psychology: Beyond Attitudes and Behaviour*, London: Sage 1987.

Pronay, Nicholas & D W Spring (eds), *Propaganda and Politics in Film, 1918-45*, London: Macmillan 1982.

Purvis, Trevor & Alan Hunt, 'Discourse, ideology, discourse, ideology, discourse, ideology ...', *British Journal of Sociology*, Vol.44, No.3, 1993, pp.473-99.

Radway, Janice, *Reading The Romance*, London: Verso 1986.

Radway, Janice, 'Reception study: ethnography and the problem of dispersed audiences and nomadic subjects', *Cultural Studies*, Vol.2, No.3, 1988, pp.358-76.

Richards, Jeffrey, *The Age of the Dream Palace: Cinema and Society in Britain 1930-1939*, London: RKP 1984.

Richards, Jeffrey & Dorothy Sheridan (eds), *Mass Observation at the Movies*, London: RKP 1987.

Roscoe, Jane, Harriette Marshall & Kate Gleeson, 'The television audience: a reconsideration of the taken-for-granted terms "active", "social" and "critical"', *European Journal of Communication*, Vol.10, No.1, 1995, pp.87-108.

Rosengren, Karl Erik, Lawrence A Wenner & Philip Palmgreen (eds), *Media Gratifications Research: Current Perspectives*, London: Sage 1985.

Rosengren, Karl Erik, (ed), *Media Effects and Beyond: Culture, Socialisation and Lifestyles*, London: Routledge 1994.

Rowland, Willard D, *The Politics of Television Violence: Policy Uses of Communication Research*, London: Sage 1983.

Ryan, Michael & Douglas Kellner, *Camera Politica: the Politics and Ideology of Contemporary Hollywood Film*, Bloomington: Indiana University Press 1988.

Sabin, Roger, *Adult Comics: an Introduction*, London: Routledge 1993.

Sammons, Paul M, *The Making of Starship Troopers*, London: Little, Brown & Co 1997.

Sanjek, David, 'Fans' notes: the horror film fanzine', *Literature/Film Quarterly*, Vol.18, no.3, 1990, pp.150-60.

Schlegoff, Emanuel, 'Whose text? Whose context?', *Discourse & Society*, Vol.8, No.2, 1997, pp.165-88.

Schlesinger, Philip, R Emerson Dobash, Russell P Dobash & C Kay Weaver, *Women Viewing Violence*, London: British Film Institute 1992.

Schrøder, Kim Christian, 'Audience semiotics, interpretive communities and the "ethnographic turn" in media research', *Media Culture & Society*, Vol.16, No.2, 1994, pp.337-47.

Sconce, Jeffrey, '"Trashing" the academy: taste, excess, and an emerging politics of cinematic style', *Screen,* Vol.36, No.4, 1995, pp.371-93.

Seiter, Ellen, Hans Borchers, Gabrielle Kreutzner & Eva-Maria Warth (eds), *Remote Control: Television, Audiences, and Cultural Power*, London: Routledge 1989.

Selden, Roman & Peter Widdowson, *A Reader's Guide to Contemporary Literary Theory*, Hassocks: Harvester Wheatsheaf 1993.

Sheridan, Alan, *Michel Foucault: The Will to Truth*, London: Tavistock Publications 1980.

Silverman, Kaja, 'Back to the future', *Camera Obscura*, Vol.27, 1992, pp.109-32.

Silverstone, Roger, *Television and Everyday Life*, London: Routledge 1994.

Simon-Vandenbergen, Anne-Marie, 'Image-building through modality: the case of political interviews', *Discourse & Society*, Vol.7, No.3, 1996, pp.389-416.

Sinclair, J McH & R M Coulthard, *Towards an Analysis of Discourse: the English Used by Teachers and Pupils*, Oxford: Oxford University Press 1975.

Slusser, George & Eric S Rabkin (eds), *Shadows of the Magic Lamp: Fantasy and Science Fiction in Film*, Carbondale: Southern Illinois University Press 1985.

Smoodin, Eric, '"This business of America": fan mail, film reception and *Meet John Doe'*, *Screen*, Vol 37, No.2, 1996, pp.111-29.

Sparks, Colin, 'Striking results?', *Media, Culture & Society*, Vol.9, No.3, 1987, pp.369-77.

Spender, Dale, *Man-Made Language*, London: Routledge & Kegan Paul 1980.

St Pierre, Roger, *Sylvester Stallone*, Romford: Anabas Look Books 1985.

Stacey, Jackie, *Star Gazing: Hollywood Cinema and Female Spectatorship* London: Routledge 1993.

Staiger, Janet, *Interpreting Films: Studies in the Historical Reception of American Film*, Boston: Princeton University Press 1992.

Stam, Robert, *Subversive Pleasures: Bakhtin, Cultural Criticism and Film*, Baltimore: Johns Hopkins University Press 1989.

Stansweet, Stephen J, *Star Wars: From Concept to Screen to Collectible,* San Francisco: Chronicle Books 1992.

Strinati, Dominic & Stephen Wagg (eds), *Come On Down! Popular Media Culture in Postwar Britain*, London: Routledge 1992.

Stubbs, Michael, *Discourse Analysis: The Sociolinguistic Analysis of Natural Language*, Oxford: Basil Blackwell 1983.

Tannock, Stuart, 'Positioning the worker: discursive practice in a workplace literacy programme', *Discourse & Society*, Vol.8, No.1, 1997, pp.85-116.

Thompson, Bill, *Soft Core: Campaigns against Pornography in Britain and America*, London: Cassell 1994.

Thompson, John B, *Studies in the Theory of Ideology*, Cambridge: Polity Press 1984.

Tomlinson, John, *Cultural Imperialism: a Critical Introduction*, London: Francis Pinter 1991.

Traube, Elizabeth G, *Dreaming Identities: Class, Gender and Generation in 1980s Hollywood Movies*, Boulder, CO: Westview Press 1992.

Tudor, Andrew, *Image and Influence: Studies in the Sociology of Film*, London: George Allen & Unwin 1974.

Tulloch, John & Henry Jenkins, *Science Fiction Audiences: Watching* Doctor Who *and* Star Trek, London: Routledge 1995.

van Dijk, Teun A *Communicating Racism: Ethnic Prejudice in Thought and Talk,* London: Sage 1987.

van Dijk, Teun A, '*Discourse & Society:* a new journal for a new research focus', Vol.1, No.1, 1990, pp.5-16.

van Dijk, Teun A, 'Principles of critical discourse analysis', *Discourse & Society,* Vol.4, No.2, 1993, pp.249-83.

van Dijk, Teun A (ed), *Discourse as Structure and Process: Discourse Studies,* Vol.1, London: Sage 1997.

van Leeuwen, Theo, 'Representing social action', *Discourse & Society,* Vol.6, No.1, 1995, pp.81-106.

Volosinov, Valentin, *Marxism and the Philosophy of Language,* New York: Seminar Press 1973.

Wasko, Janet, *Hollywood in the Age of Information,* Austin: University of Texas Press 1995.

Webster, Duncan, *Looka Yonder! The Imaginary America of Popular Culture,* London: Routledge 1988.

Weightman, Gavin, *Bright Lights, Big City: London Entertained 1830-1950,* London: Collins & Brown 1992.

Willemen, Paul, 'Notes on subjectivity', *Screen,* Vol.19, No.1, 1978.

Williams, Linda, 'Learning to scream', *Sight & Sound,* December 1984, pp.14-16.

Williams, Linda (ed), *Viewing Positions: Ways of Seeing Film,* New Brunswick, NJ: Rutgers University Press 1994.

Willis, Paul, *Learning to Labour: How Working Class Kids Get Working Class Jobs,* London: Gower 1977.

Wood, Robin, 'Return of the repressed', *Film Comment,* Vol.14, No.4, 1978, pp.25-32.

Wright, Adrian, *Sylvester Stallone: A Life on Film,* London: Robert Hale 1991.

Young Minds, *Screen Violence and Mental Health,* The National Association for Child and Family Mental Health 1994.

Ephemeral Materials

Bielby, Matt, L A Turner et al, *SFX,* No.2, July 1995, pp.22-41.

Bristol *Evening Post,* 21 July 1995., pp.24-5.

British Videogram Association, *Yearbook 1996.*

Buckingham, Lisa, 'The Time ... the Placement', *Guardian,* 11 Jaunary 1997.

Carty, Ciaran, 'AAARRGGH!', *Sunday Tribune,* 15 September 1985.

Chaudury, Vivek & Martin Walker, 'The petty crime war', *Guardian,* 21 November 1996.

Crace, John, 'Way Off Course', *Guardian,* 11 August 1997.

Ezard, John, 'Cold war takes a comic turn', *Guardian,* 21 February 1977.

Gabriel, Trip, 'Why I despise the past 10 years' (interview with Sylvester Stallone), *Guardian,* 15 August 1997.

Grant, Linda, 'Violent anxiety', *Guardian,* 28 September 1996, p.24.

Hodges, Lucy, 'The Trendy Travesty', *The Independent,* 31 October 1996 (see also her 'A degree in futility', London *Evening Standard,* 14 May 1997).

'I am the Law, and this is my Breakfast', *Loaded,* April 1997.

'Judge Dredd feels the chill', *Guardian,* 23 July 1995.

Jones, Alan, *Cinefantastique,* August 1995, pp.16-40.

'Judge Dredd to rule the world: tough guy Stallone's amazing outburst shocks Hollywood', *Sunday Mirror,* 2 July 1995, pp.12-3.

Lawson, Nigella, 'Is this trivia really worth studying?', *Times,* 4 July 1995.

Malcolm, Derek, 'Hollywood or bust', *Guardian,* 30 July 1996.

McFadyean, Melanie, 'It's not the blood money, a part of me died that day', *Guardian,* 4 January 1996.

McKinstry, Leo, 'DREDD-FUL WASTE', 'The Watchdog', *Sun,* 1 August 1995.

Morris, Betsy, 'The Brand's the Thing', *Fortune,* 4 March 1996.

Patterson, John, 'Testing, testing', *Guardian* Guide, 21 June 1997.

Ronson, Jon, 'Giants of the silver screen', *Guardian,* 21 August 1995.

Satellite TV, August 1994, pp.54-5.

Scott Penman, Scott, Letter to the Editor, *2000AD* Prog. 953, 18 August 1995.

Screen International, No.1026, 22 September 1995.

Screen International, No.1034, 17 November 1995.

Screen International, No.1039, 5 January 1996.

Screen International, No.1040, 12 January 1996.

Sean Dunne, 'Biff! Bam! Phew!, *Sunday Press,* 7 July 1980.

Stage, Screen & Radio: Journal of the Broadcasting Entertainment Cinematograph & Theatre Union, December 1995/January 1996.

'Stallone study on violence', *Sunday Express,* 25 June 1995.

'Stallone violence probe', *Mail on Sunday,* 1 January 1995.

Taylor, Pete, 'Licensed to make a killing', *Model & Collectors' Mart,* August 1995, pp.116-9.

'The Dredd of 2000AD', *Guardian,* 7 January 1995.

Wells, Dominic, 'Dredd reckoning', *Time Out,* 13-20 November 1991.

'Who says he's got no balls?', *Daily Record,* 23 June 1995.

INDEX